PICTURES
TO
PRINT

The nineteenth-century
engraving trade

For my wife, Norma,
who has so completely shared my interest;
and for my children and my parents,
who have encouraged me in many ways.

PICTURES
TO
PRINT

The nineteenth-century
engraving trade

Anthony Dyson

FARRAND PRESS
50 Ferry Street
Isle of Dogs
London E14 9DT

Distributed in North America by
The BOOK PRESS Limited
P.O. Box K.P. Williamsburg
Virginia 23187

Dyson, Anthony
Pictures to print: the nineteenth-century engraving trade
 1. Engraving — Economic aspects — Great Britain — History — 19th century
I. Title
338.4'776'00941 NE628
ISBN 1-05083-001-0
ISBN 1-05083-002-9 Limited ed.

Designed by students of the Department of Typography and Graphic Communication at the University of Reading.

Text set in Monotype 'Lasercomp' Palatino by Eta Services (Typesetters) Ltd. Half-tone origination and text and Plates printed on Fineblade cartridge, in Great Britain by Whitstable Litho Ltd.

Bound by Green Street Bindery, Oxford.

Limited Binding printed on St Barts Book Wove paper by Whitstable Litho Ltd. and bound by A. W. Lumsden, Edinburgh; frontispiece printed in 1984 at Thos Ross & Son from a plate engraved c. 1880 and taken from the Ross archives, hand coloured by Mrs Paula Allerton.

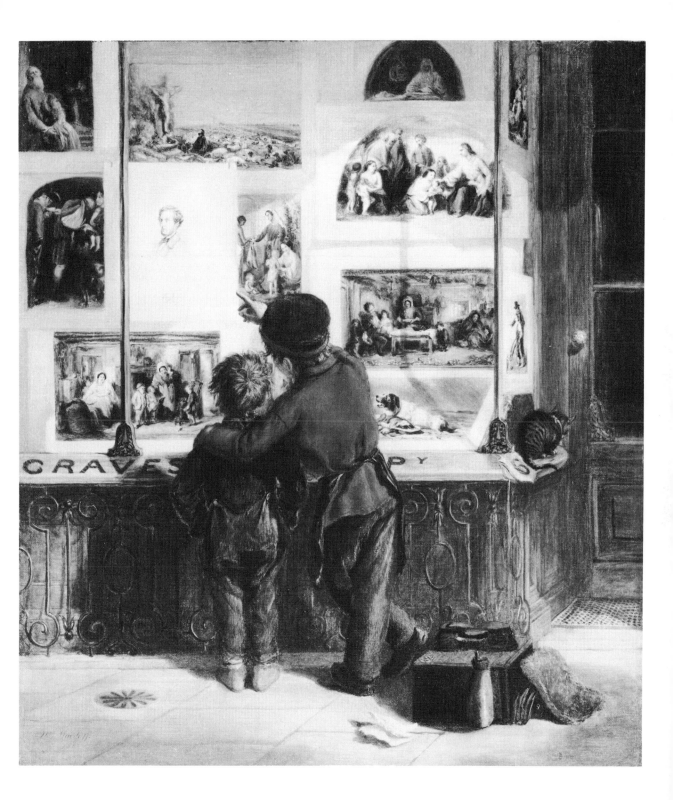

Subscribers

The publishers are very grateful to all who have, by subscribing to this book in advance of publication, shown their confidence in it as described to them and greatly assisted its appearance. Those who have agreed to be named are:

Charles M. Adams
Robert C. Akers
Richard Aldrich
David Alexander
Timothy Allum
American Antiquarian Society
Antiquariaat G. W.
L. L. Ardern
Art-Lore Inc.
The Ashley Book Company
The Ashmolean Library
Dr Theodore Bachaus
Iain Bain
Fanny Baldwin
Robin de Beaumont
Paul Bentley
Howard O. Berg
Gordon Bettridge
Bibliographical Society
Norman E. Binch
David Bindman
Birmingham Public Libraries
Maurice Bishop
Blackwell's New English Book
 Selection
Blackwell's Rare Books
B. C. Bloomfield
Pall Bohne
The Book Press Ltd.
Gavin Bridson
K. C. Brooks
John Buchanan-Brown
Buchanan and Kiguel
John Burgess
Peter Burnhill
Frances Butler
Judith Butler
George Calmenson
Chapin Library
William Andrews Clark
Memorial Library
Douglas Cleverdon

Frank Collieson
Ronald G. Cooper
Pamela Courtney
Claude Cox
Stanley Cox
Gywn Davies
Department of Typography
 and Graphic Communication,
 University of Reading
Nial Devitt
J. Hubert Dingwall
Anne Downes
Robert Druce
Durham University Library
Alexander A. Dzilvelis
J. Brian Edwards
Robin Ellison
Richard Faircliff
Dennis Farr
Donald Farren
Trevor Fawcett
John Feather
Feathered Serpent Press
Robin Findlay
Ruth Fine
John Ford
Colin Franklin
Stanislaw Frenkiel
Joan M. Friedman
Brian R. Gaines
Elizabeth Gant
Bamber Gascoigne
Geoffrey S. Geall
Brian A. Giles
Ephraim Gleichenhaus
Mike Goldmark
Brian Gough
Keith Grant
Elizabeth Greenhill
Charles Grosslight
Anthony Griffiths
John Griffiths

The Hampton Hill Gallery Ltd.
Vanessa Harding
Adrian Harrington Esq.
Peter Harrington
David Harrison
John G. Heal
Francis Herbert
Frank Herrmann
Luke Herrmann
W. J. Hildebrandt
The Hinton Gallery
Peter Holliday
Michael Hope
Basil Hunnisett
The Huntington Library
Ken Hutchinson
Charles Hutt
Ralph Hyde
Bert Isaac
Peter Isaac
The John Rylands University
 Library of Manchester
Arthur Johnston
Frank Kacmarcik
Kenneth Karmiole
Richard Kelly
The Kemble Collections on
 Western Printing & Publishing
Philomena Kennedy
Michael Kitson
Ronald Labuz
David Landau
Henry Larken
Poul Steen Larsen
Dr. Jeremy Lee-Potter
Edgar Lewy
John Lingwood
The London Library
Betty Lucas
Cornelius McCarthy
David McKitterick
Ruari McLean

P. N. McQueen
Maggs Bros. Ltd
Manchester City Art Gallery
Margolis & Moss
Alan Marshall
Katherine Martinez
Paul Mason Gallery
Massey College
Anthony M. Mazany
The Paul Mellon Centre for
 Studies in British Art
Pieter van der Merwe
Metropolitan Toronto Library
 Board
Vivian Meynell
Bruce Mitchell
Monk Bretton Books
Peter Morse
The Morton Arboretum
James Mosley
Peter Murray
Barrows Mussey
Robin Myers
Lindsay Nayler
National Book League
National Galleries of Scotland
National Portrait Gallery
National Railway Museum
Desmond Neill
Dr. Harry Neubauer
Robert Newman
Gordon M. Nutbrown
Wallace E. Nutbrown
Masatsugu Ohtake, bibliophile
Old Golf Shop, Inc.
Wilfried Onzea
Lionel Opie
Richard Ormond
Wesley H. Ott
F. E. Pardoe
Walter Partridge
Brian Perry
Dr. J. C. Phemister
Nancy M. Pike
H. Edmund Poole
M. Price
George Ratcliffe

Nancy Reinke
Brian Reynolds
Ann M. Ridler
Vivian Ridler
Marie-Christine Roberts
Pamela Robinson
Peter Rose
R. Burns Ross
Thos. Ross & Son
The Rowfant Club
Royal Borough of Kensington
 & Chelsea Libraries
Royal College of Art
Alfred Rubens
D. A. W. Russell
Dorothy Russell
Trevor Russell-Cobb
St. Andrews University
 Library
St. Bride Printing Library
St. George's Gallery Books
 Limited
Richard W. Saul
John Schappler
Paul Scheltens
Tom Schrecker
Uta Schumacher-Voelker
Thomas E. Schuster
Michael G. Scott
R. Keith Severin
Bernard J. Seward
Mildred L. G. Shaw
Sheffield City Polytechnic
 Library
Alex Simm
Sims, Reed, & Fogg Ltd
Nicholas Sloan
Henry Sotheran Ltd
John Smith & Son (Glasgow)
Spelman's Bookshop
Henry S. Spencer M.D.
Edward Stanham
John Steer
Joan B. Stevens
Peter Stockham
T. G. Stone
J. G. Studholme

Nigel Talbot
G. C. A. Tanner
G. T. Tanselle
Clive R. Tassie
The Tate Gallery Library
John Russell Taylor
William F. Taylor
James Thin Booksellers
Denis Thomas
Diana M. Thomas
Walter Tracy
Trent Polytechnic
Julian Treuherz
Trinity College Library,
 Cambridge
Raymond V. Turley
Michael Twyman
University of Lancaster
 Library
University of Liverpool
 Library
University of Warwick Library
George H. Utter
Peter Vernon
N. Waddleton
John Walton
Watford College Library
Barry G. Watson
Charles Willis Watson
Mr G. Webber
Lucille Wehner
F. & L. Weinreich
Jon Whiteley
Doreen and Gerry Wilcock
Stephen Wild
Graham & Nina Williams
Ruth Williams
James Wilson
Berthold Wolpe
Douglas Wood
N. J. Wood
Laurence Worms
P. K. J. Wright
Winifred Wroe
Yale Center for British Art
Johan de Zoete

Contents

Preface

The title of this book is purposely ambiguous. *Pictures to Print* implies a
process of translation from paint to ink; but it also implies the production
of paintings deliberately destined for printed reproduction. Between
about 1830 and about 1880 – the golden age (certainly in quantitative
terms) of reproductive engraving – paintings found their way into print
in both of these ways. Likely subjects were spotted by prospective
publishers, the permission of artist and owner obtained, an engraver
engaged, and the project launched. As the popular demand for
engravings grew, it became more and more common for painters to
make pictures with ultimate reproduction the chief motive; and as the
scramble for a foothold on the print-selling bandwaggon intensified,
publishing initiative was frequently taken by artists themselves, by
engravers in search of a lucrative vehicle for their craft, and quite often
by printers.

The book is arranged in three main sections. The first borrows its title
from a nineteenth-century advertising brochure issued by the South
Kensington Fine Art Association, an organisation supplying prints 'for
the Million'. This section contains three chapters in which the expanding
trade of the plate-printer, the collaborative network of which he was a
vital part, and the mounting fees commanded by engravers are
discussed. The second section adopts as its title words used by John
Burnet in defence of the art of engraving: 'a process of difficult
management'. The words aptly describe the delicacy of the whole
business, from the making of the copper or steel plate to the taking of
the final impression; and, accordingly, this section comprises five
chapters which examine various technical aspects of engraving and
printing. References in the first two sections are to items listed in the
Bibliography, to other sources listed on pp.xxix–xxx, and to the tran-
scripts in the third section. The third section contains annotated
transcripts from the nineteenth-century records of Dixon & Ross, copper-
and steel-plate printers since 1833. It is these records – ledgers, day
books, wage books, correspondence and assorted papers – that have been
the inspiration for this book. This section also includes transcripts of

letters from the archives of McQueen's, prominent plate-printers throughout the nineteenth century.

The Dixon & Ross records give an intimate behind-the-scenes view of the burgeoning engraving trade. In 1836, John Pye the engraver complained to a Select Committee of the House of Commons that the high price of glass in this country (more than eight times higher than in France) was a discouragement to the production of prints for framing; yet he could also say that the number of engravers in England had multiplied by five since the end of the Napoleonic Wars. In 1845, Henry Graves the print-publisher estimated (also in response to the questions of a House of Commons Select Committee) that his annual revenue from print sales in one city alone – Edinburgh – had, since 1830, increased from £30 to between £1,000 and £2,000. The expertness of the printers of copper and steel plates was of fundamental importance to the trade, and their close collaboration with artists, engravers, and publishers has so far been perhaps the least closely studied aspect of the whole episode.

A great deal has been written on the subject of the engraving trade, and other authors have dealt more fully than I with many of its aspects. There seems little point in repeating what has already been done perfectly well; this book, in giving prominence to plate printers, is essentially complementary. Thanks to the survival of so full a record of the transactions of Dixon & Ross, this is probably the first time that such a clear view of the trade has been available from the hitherto largely ignored angle of these obscure craftsmen.

The work began as a cataloguing exercise. I suspected on first coming across the nineteenth-century archives of what has now become Thomas Ross & Son's, that here was treasure-trove. It took me many months, however, to begin to make sense of the firm's record books. Only gradually did some kind of pattern emerge, and only slowly did I begin to discern the significance of all this material in the large context of the nineteenth-century art world. This book has been written in an effort to make that significance plain. It is offered to all – teachers, students, collectors, dealers – with an interest in nineteenth-century art and society, to all with a curiosity for technical ingenuity, and to all who simply share in an aesthetic enjoyment of the engraved image.

A.D.
Teddington
1983

Acknowledgements

I acknowledge gratefully the generous help I have received from very many people in the evolution of this book. They include: M.J. Aknin of the Musée National des Techniques, Conservatoire National des Arts et Métiers, Paris, who supplied photographs of items in the museum's collection; Iain Bain, Director of the Publications Department, Tate Gallery, London, to whose pioneering article on the history of Thomas Ross & Son's (*Journal of the Printing Historical Society* No. 2, 1966) I am indebted, and who originally suggested to me the cataloguing of the Dixon & Ross records; Mme. Madeleine Barbin of the Cabinet des Estampes, Bibliothèque Nationale, Paris, who indicated a path that eventually led to much interesting information on the activities of plate-printers in Paris; Mlle. Marie-Hélène Berthet, who did some checking and made photographs for me at the Musée de l'Imprimerie, Lyon; Gavin Bridson, Librarian of the Linnean Society, London, who attracted my attention to a great deal of relevant material and was endlessly patient in guiding me through it and answering my enquiries; John V. Brindle, Curator of Art at the Hunt Institute for Botanical Documentation, Carnegie-Mellon University, Pittsburgh, Pennsylvania, who helped me in my attempts to discover something about plate-printers in America; Michael Chater, Chairman of Grosvenor Chater & Company Ltd., St. Albans, who generously gave me complete access to his firm's nineteenth-century records; my children Paula, Christopher and Joseph Dyson, who helped with filing and other chores; Miss Phyllis Edwards, formerly Botany Librarian at the British Museum (Natural History) to whom I owe my discovery of Thornton's *Temple of Flora* and many hours of encouraging conversation; Dr. A.J. Flipse, Curator of the Museum Enschedé, Haarlem, Holland, who translated for me from the eighteenth-century Dutch the inventory of a plate-printer's equipment from the archives of the Plantin-Moretus Museum, Antwerp; John Ford, a director of Arthur Ackermann & Son Ltd., London, who has taken a keen interest in my project and has from time to time provided me with items of valuable information; Robert Frélaut of the Atelier Lacourière et Frélaut, Paris, who explained to me at great length the present-day ramifications

of the plate-printing trade in Paris, and who gave permission for me to measure and photograph presses and other equipment at his Montmartre workshop; Carole Hodgson, formerly of the University of London Institute of Education, who read and made helpful comments on several chapters; David Hooper, who was responsible for a number of the photographs of the Ross workshop; Dr. Basil Hunnisett of the Brighton School of Librarianship, who kindly allowed me to study his then unpublished thesis, *English Steel-Engraved Book Illustration of the Nineteenth Century* (University of London, 1978), which helped me considerably in writing my chapter on plates; William Joll of Agnew's, who was most helpful to me during my search of his firm's nineteenth-century records; Maurice Lallier of the Atelier Georges Leblanc, Paris, who gave me the run of his workshops for several hours of measurement and photography; Roger Ledeuil, manufacturer of copper-plate presses, whose workshop in Montrouge, Paris, represents such an interesting perpetuation of his nineteenth-century ancestors' activities; Charles Lee, engraver and printer, who has given me much technical information; Ralph Lillford, who kindly provided me with engravings after Rosa Bonheur; James Mosley and his staff at the St. Bride Printing Library, London, who have been unfailingly co-operative; Charles Newington, formerly of Editions Alecto, London, who dispelled for me many of the mysteries surrounding nineteenth-century engravers' ruling machines; Charles Newman and his family, who run the firm of R.T. Mauroo in Islington, London, and who kindly allowed me to examine and photograph their nineteenth-century copper-plate presses; Peyton Skipwith of the Fine Art Society, London, who not only gave me access to the Minute Books of the Society, but most generously invited me to consult his own notes on the documents; Jack P. Stocks of Penticton, British Columbia, who supplied me with a photocopy of the apprenticeship papers of his ancestor, Lumb Stocks the engraver, and with a copy of his personally compiled catalogue of Stocks' engravings; Richard Southall of the University of Reading, who made splendid photographs of a wooden press in the Plantin-Moretus Museum; Peter Thomas of the University of London Institute of Education, who with Mike Kerr printed most of the photographs; Don Thompson, also of the Institute of Education, who scrutinised the economic aspects of one of my chapters; Professor Michael Twyman of the Department of Typography and Graphic Communication, University of Reading, who made extremely valuable suggestions when the work was still at an early stage; Dr. Léon Voet, Curator of the Plantin-Moretus Museum, who supplied much material photocopied from the museum's archives; Dr. Christopher White, Director of Studies of the Paul Mellon Centre for Studies in British Art, London, who took to his Advisory Council my request for funds to help the research along; and Miss S. Wimbush of the National Portrait Gallery, London, who helped me track down photographs of

nineteenth-century engravers. I owe much, too, to Professor Michael Kitson of the Courtauld Institute, University of London, who supervised the doctoral thesis from which the book has evolved; and to Wendy and Sheena Smart, who enterprisingly deciphered the draft manuscript and transformed it to typescript with speed and efficiency.

Above all, my gratitude goes to Miss F.B. Pomeroy, Miss M. Dadds, Philip McQueen (now retired), Dudley McQueen and all at Thomas Ross & Son's. Every member of the staff has taken a kind interest in my work and has responded willingly and patiently to my many questions and requests. Of the printers I must thank particularly Alan Smith (now no longer with Ross's), who removed the protective wax coating from many steel plates to enable me to photograph them, and Peter Marsh who has taught me all I know about colour-printing from a single plate. There is at Ross's, in the persons of these living custodians of old printing procedures, a vast store of inherited and accumulated knowledge and experience which lends to the book such immediacy and life as it may have. In its attempt to give fresh insight into the nineteenth-century world of plate-printing, the book draws as heavily upon this inheritance of expertise as upon written and other sources.

Finally, I must thank the Committee of Management of the University of London Institute of Education for granting me sabbatical leave to complete the project; my colleagues in the Institute's Department of Art and Design for accepting uncomplainingly the extra burden that my absence must have thrown on them; my publisher Roger Farrand, whose resourcefulness and enthusiasm have been such a vital source of encouragement; and the students of the Department of Typography and Graphic Communication, University of Reading, for bringing so much care and good judgement to the design of the book.

List of Plates

Measurements of prints refer to the engraved area (work size) and not to the size of the plate. Vertical measurements are given first.

Frontispiece
1. William Macduff (fl. 1844–1866), 'Shaftesbury, or Lost and Found', 1862, oil on canvas, $18\frac{1}{2}$" × 16" (private collection). The boot-blacks are depicted looking in the shop-window of Henry Graves & Co., print-publishers, of 6 Pall Mall. To the left of the portrait of Lord Shaftesbury, reformer of laws relating to the employment of women and children, is a print of Millais' 'Order of Release', below it, Thomas Faed's 'Mitherless Bairn', and, in the bottom right-hand corner of the window, Landseer's 'Saved'.

2. Detail of the *Topographical Survey of the Borough of St. Marylebone*, 1832. Engraved by B. Davies, 1834. Scale $9\frac{1}{2}$": 1 mile (Westminster City Library).

3. The Hampstead Road workshop of Thomas Ross & Son, 1960s (photograph: Department of Typography and Graphic Communication, University of Reading).

4. The Putney workshop of Thomas Ross & Son, 1983 (photograph: Museum of London).

5. Edwin Long, R.A. (1829–1891), 'Samuel Cousins, R.A.', 1882, oil on canvas, *c*.48" × 34" (Royal Albert Memorial Museum, Exeter).

6. Address list from Dixon & Ross Day Book, 1872–81 (Ross Archives).

7. Advertisement, W. Power, Bookbinder, 104 High Holborn, London (Ross Archives).

8. Invoice of Solomon Marks, relating to miscellaneous purchases of paper, prints and frames, February 1853 (Ross Archives).

9. An order from Cowieson's Ready Money Warehouse, Edinburgh, 17 March 1877 (Ross Archives).

10. Request from the Fine Art Society for prints, 2 February 1877 (Ross Archives).

11. J.P. Mayall, photograph of Samuel Cousins, published 1884 in *Artists at Home*, ed. F.G. Stephens (National Portrait Gallery).

12. Thomas Landseer, photographed by John and Charles Watkins (National Portrait Gallery).

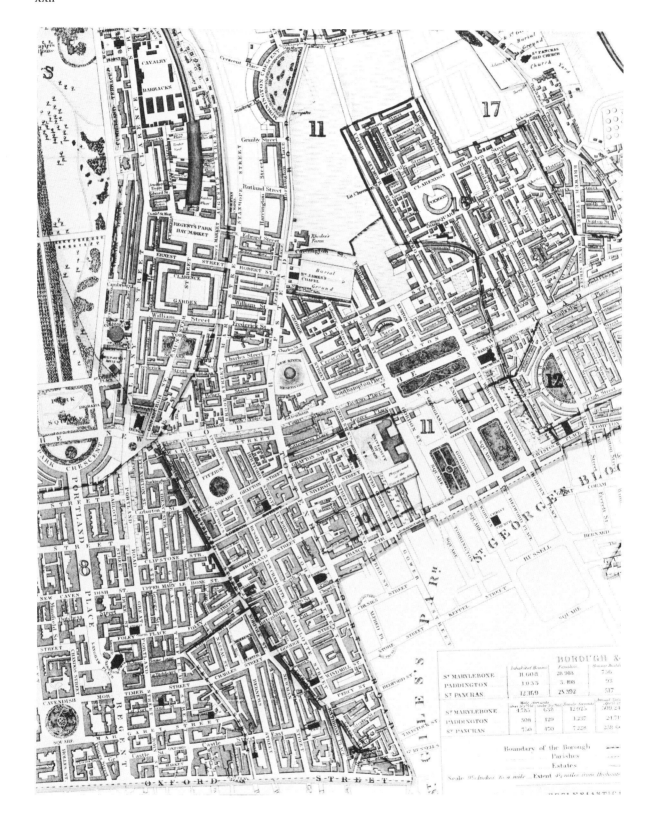

Introduction

What you really ought to do is to pay a visit to a proper engraver's printer, such as Messrs. Ross and Son, of 70 Hampstead Road.

Percy H. Martindale, writing in 1928 in his book *Engraving Old and Modern*, was recommending a firm that had been in existence for almost a hundred years, and that had enjoyed for the whole of that time a high reputation as an accomplished printer of engravings of all kinds. From 1833, the year of the firm's establishment at 4 St. James's Place, Hampstead Road, London, in the then newly built up area between the New Road (now Euston Road) and Mornington Crescent, its workshop was a meeting place for many artists, engravers and publishers of the first rank as well as for hosts of others practically unknown. Crutchley's *New Plan of London*, 1834, shows that St. James's Place was the name then given to a row of buildings of about 150 yards on the east side of Hampstead Road: the western side of a triangular block in the acute angle between Hampstead Road and George Street (now North Gower Street). The base of the triangle was bounded by Charles Street East, now an extension of Drummond Street. The Dixon and Ross workshop was close to the south-west corner of the block, 200 yards or so north of the junction of New Road and Hampstead Road and about the same distance south of St. James's Chapel. The firm's geographical location was no accident. In Hampstead Road, the workshop was within easy reach of the studios of many artists, engravers and other craftsmen during the years of expansion. The Landseer family, for instance, lived a little further south, in Foley Street. C.G. Lewis, the engraver of so many of Edwin Landseer's works, lived in Charlotte Street; and J.H. Robinson and Samuel Cousins, both prominent engravers, lived to the north – the former in Mornington Place, the latter in Camden Square. Dixon and Ross's competitors were close by, too: in 1832 McQueen's moved from Newman Street to Tottenham Court Road; and in 1851 Holdgate's set up business in Maple Street (formerly London Street) just south of

Plate 2.
Detail of the *Topographical Survey of the Borough of St. Marylebone*, 1832. Engraved by B. Davies, 1834. Scale 9½":1 mile (Westminster City Library).

Fitzroy Square. Thomas Boys the publisher was not far away, in Oxford Street. Others of his confraternity were clustered south and west: for example, Colnaghi's and Hodgson and Graves' in Pall Mall; Ackermann's in the Strand; Thomas McLean's in the Haymarket; and, from 1860, Agnew's in Waterloo Place. The plate-makers congregated to the east, around Shoe Lane and Fleet Street. At the Paris Exposition Universelle of 1855, the firm was one of three English plate-printing concerns that attracted special praise from the Jury (*Rapports du Jury de la XXVIe Classe*, 1856, p.75); and in 1882, in *Bartolozzi and his Works* (pp.99–102), Andrew Tuer numbered it among the five in London who were considered specialist 'fine art printers'. The business was established under the name of Dixon and Ross. The exact date of its foundation is not known, but the opening date of the earliest ledger is 21 June 1833; and on 1 July 1833, the Carpenters Society was employed to make alterations to a signboard (see Appendix I, p.176) – perhaps to add to the name of one partner that of his new collaborator. The relationship of the two families is not entirely clear and the precise identities of the individuals concerned not easy to establish. The names John Dixon, Henry Dixon and William Ross appear on the wages list in the earliest of the partnership's surviving Day Books. Whilst William Ross and Henry Dixon remain shadowy figures, the name of John Dixon is somewhat better known. Already in October 1812 an article in Ackermann's *Repository of Arts* had referred to 'John Dixon, who lives near Rathbone Place, and is at present the prince of printers' (Vol. VIII, p.191). John Dixon actually lived in Tottenham Street (then, as now, two or three hundred yards north of Rathbone Place). The earliest directory reference to him seems to be that in the *Post Office London Directory*, 1805: 'John Dixon, Copper-Plate printer, 29 Tottenham Street, Fitzroy Square'. There seems little doubt that this celebrated intaglio printer was to become the John Dixon of the Dixon and Ross partnership. Curiously enough, this conclusion is confirmed by an apparent inaccuracy in one of the London directories: Robson's *London Commercial Directory* for 1835 gives the address of Dixon and Ross as 5 Tottenham Mews. Tottenham Mews was – as it still is – in the close vicinity of Rathbone Place, and it thus seems likely that the compilers of the directory automatically – and, as it turns out, wrongly – gave the new business the familiar address of the long-established and well known John Dixon, at a time when it is quite certain that the firm was already installed at 4 St. James's Place. The *Topographical Survey of St. Marylebone*, 1834, shows that Tottenham Mews opened into Tottenham Street (as it still does), and it thus seems likely that the addresses 5 Tottenham Mews and 29 Tottenham Street were both part of the premises of the same John Dixon. The *Post Office London Directory* for 1835 not only wrongly places Dixon and Ross in Tottenham Mews, but also in that year omits the 'John Dixon, Copper-Plate printer, 29 Tottenham Street' entry – reinforcing the suggestion

that the latter was in fact the Dixon of the new partnership. However, the following year, the *Directory* got it right as far as the firm of Dixon and Ross was concerned, giving the correct address (4 St. James's Place); but, mysteriously, John Dixon of 29 Tottenham Street reappeared. It was the last mention of him at that address and by 1842, *Kelly's Post Office London Directory* showed that 29 Tottenham Street was occupied by a cloth-worker, Thomas Nicoll. A few bills and receipts in the archives of the Linnean Society refer to a John Dixon, copper-plate printer, and these introduce a further element of mystery. Three of the receipts (11 May 1835, 23 June 1836 and 9 November 1836) give the printer's address as 43 Gower Place, University. Gower Place was (and is) located about half a mile north-east of Tottenham Street and about a quarter of a mile south-east of the new Dixon and Ross workshop, so it seems unlikely that the John Dixon who lived there was the person associated with the St. James's Place business. This John Dixon (assuming him to have been a different Dixon) makes a very brief appearance in the London directories: the only reference seems to be in *Robson's London Commercial Directory* for 1838; and by 1842, *Kelly's P.O. London Directory* indicates that 43 Gower Place was occupied by Edward Williams, a tailor.

The recent discovery in the archives of the Linnean Society of a bundle of the firm's bills has helped bring into rather sharper focus one or two of the details of its subsequent history. The London Street Directories indicate that in 1864 St. James's Place was renamed and that No. 4 became 70 Hampstead Road (Bain, 1966, p.4). The deletion of the St. James's Place nomenclature and the insertion of the Hampstead Road

Plate 3
The Hampstead Road workshop of Thomas Ross & Son, 1960s (photograph: Department of Typography and Graphic Communication, University of Reading).

Plate 4
The Putney workshop of Thomas Ross & Son, 1983 (photograph: Museum of London).

address on a bill dated 30 October 1863, shows that this change took place rather earlier. According to Iain Bain's account (ibid., p.10), the Dixon family's interest in the business ceased from about 1880: another of the Linnean Society's bills shows that the firm was known simply by the name of Thomas Ross at least as early as October 1876.

In 1886, Thomas Ross Junior joined the business, and the firm assumed the name by which it is still known: Thomas Ross and Son. When Thomas Ross the younger died in 1905, Alfred Pomeroy (who had joined the concern as an apprentice thirty years earlier, and whose grand-daughter, Miss F.B.S. Pomeroy, still runs it) took over.

The recruitment in 1937 of Mr. George Hardcastle and in 1956 of Mr. P.N. McQueen meant that by the latter date and by a remarkable coincidence Thomas Ross and Son represented an amalgamation of the expertise and the resources of every one of the plate-printing firms that had been commended almost exactly a hundred years earlier by the Paris jury: Dixon and Ross; Holdgate; and McQueen. The Hardcastle family had been associated with Alfred Holdgate and Son since 1882: F.G. Hardcastle, the father of George Hardcastle, joined them as an apprentice in that year. Although George did not enter the trade until after Hardcastle senior had set up business on his own account, the latter represented a link with Holdgate's. Furthermore, when Holdgate's closed down before the Second World War their plate stocks were bought by Ross's (Bain, 1966, pp.15, 16). Mr. P.N. McQueen is the descendant of a printing house that was of considerable importance throughout the nineteenth century. Mr. Hardcastle brought with him his skills as a single-plate colour printer; Mr. McQueen contributed his family's stock of copper and steel plates, a large collection of proofs and

his extensive experience as a plate-printer. In addition to this union the firm has periodically added to its own original plate stock that of other printers and publishers going into liquidation. Large numbers of old proofs survive and are still used for reference and comparison, several presses, acquired a century or more ago, are employed daily in the reproduction of eighteenth- or nineteenth-century engravings, and the record of the firm's transactions since 1833 is virtually intact. The Putney workshop, whither the business was transferred in March, 1966, has thus become an unparalleled depository of evidence relating to an all but vanished art trade.

It is fortunate that the papers of Dixon and Ross (as the firm was known for most of the period spanned by this book) record in such detail the years from the 1830s to the 1880s — a time when that remarkable breed of pictorial interpreters, the engravers, to whom so many

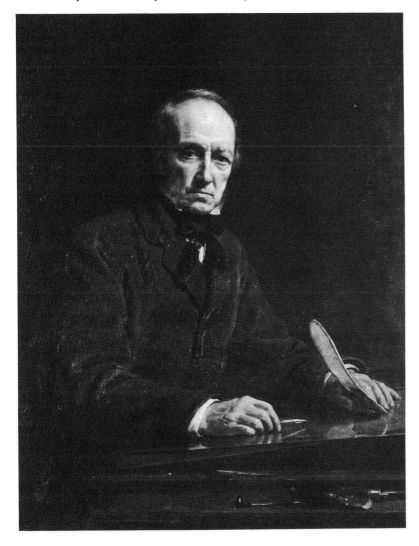

Plate 5
Edwin Long, R.A. (1829–1891), 'Samuel Cousins, R.A.', 1882, oil on canvas, c.48″ × 34″ (Royal Albert Memorial Museum, Exeter).

nineteenth-century painters in large measure owed their popular reputations, flourished as never before or since. The appearance of the firm in 1833, and its expansion and rapid modernisation during the next few years provide an interesting reflection of quickening activity in the London art trade as a whole, and mark the opening of a fifty-year period of unprecedented engraving and print-publishing enterprise: a period that, in the sphere of pictorial reproduction, we can now see owed much of its vitality to the coincidence of a continuing need for the skills of hand production with a startling acceleration of technical innovation. Such a coexistence could hardly last. It was eventually terminated by the ascendancy of photo-mechanical processes of reproduction and by the consequent decimation of the hand-engravers. The decision to adopt these particular chronological limits was further encouraged by the happy accident that the mature working life of Samuel Cousins, who may be seen as the archetypal Victorian engraver, corresponds exactly with the period. Cousins' name appears in the earliest ledger of Dixon and Ross and transactions with him are recorded in great detail until his retirement in 1884.

This book is the outcome of several years' study of the firm's archives. The labour of sifting, sorting, chronological arrangement, listing – and, in the interludes of bewilderment and indecision, the mere leafing through ledgers – all helped, in ways difficult to analyse, to recreate for the writer the working lives of the artists, engravers, publishers, printers and printsellers who made their living in the nineteenth-century London art trade. The very arithmetic of the enterprise was illuminating: listing the names of all the printers' contacts for example, demonstrated the expansion both geographically and in terms of sheer volume of the printers' business. Another advantage of listing was that it showed how comparatively thin on the ground the artistic celebrities were and in how many ways they were dependent for their growing reputations upon the obscure craftsmen and tradesmen with whom they collaborated. In the Dixon and Ross archives, Robert Havell, J.M.W. Turner, John Linnell, George Richomond, Edwin and Thomas Landseer, John Everett Millais and others rub shoulders with the far greater crowd of apparent nonentities. A further demonstration of this appraisal of the records was the sheer daily grind of producing editions of engravings: just as the huge obscure crowd is dotted here and there with recognisable individuals, so the tedious routine of the printer's workshop was enlivened only occasionally: by the start of a new enterprise; by the visit of an engraver, an artist or a publisher to check proofs; by the installation of new machinery or the adaptation of old; or by an excursion to an exhibition where might be admired the very paintings, perhaps, whose popularity was being ensured by the labours of the plate-printer.

Whilst this book depends heavily upon the Dixon and Ross records, it also draws substantially on other manuscript sources: on the papers of

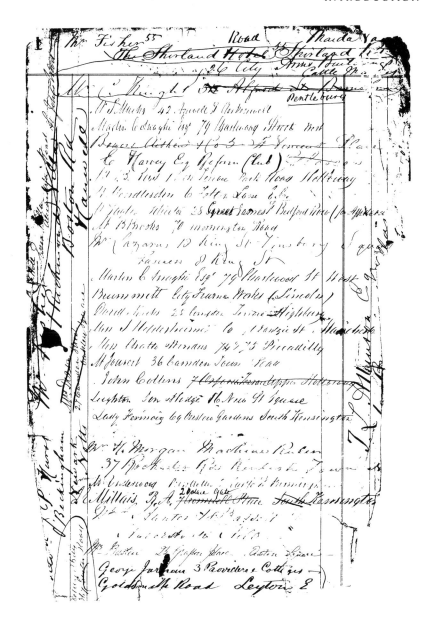

Plate 6
Address list from Dixon & Ross Day
Book, 1872–81 (Ross Archives).

Mr. P.N. McQueen, which include an important Delivery Book referring
to the second decade of the nineteenth century, a Ledger opening in
1886, and a bundle of letters (from which a selection of transcripts
appears below, in Appendix II, p.211); on the archives of Agnew's, the
London art dealers; on the Minute Books of the Fine Art Society, New
Bond Street, London; on the records of Lepard and Smith, paper
merchants (established in 1757, suppliers of paper to Dixon and Ross,
and now part of the Link Paper Group); on those of Grosvenor Chater,
also paper merchants (and also suppliers first to Dixon and Ross from the
1830s and still to Thomas Ross and Son); on the archives of the Linnean

Society, Burlington House, London; on the correspondence of Sir Edwin Landseer (in the British Museum Department of Manuscripts, the Victoria and Albert Museum Library, and the Library of the Royal Institution), that of John Ruskin (in the Victoria and Albert Museum Library), and on the archives of the Plantin-Moretus Museum, Antwerp. Also, other important aspects of the work have been the first-hand study of many plates, prints, machines and other equipment in England, France, Belgium and Holland, and the opportunity to observe plate-printers at work in London and Paris. All this is the basis of the present attempt to describe in detail the work of the nineteenth-century printers of copper and steel plates, their dealings with publishers, artists, engravers and other clients, and the effect upon their work of advancing technology.

Prints for the Million

Chapter 1

The Plate-Printer and Expanding Trade

Among the nineteenth-century papers at Agnew's there is preserved a letter of 1871 from the firm's Glasgow agent, Thomas Lawrie, regretting that the subscription list for engravings of Landseer's 'Ptarmigan Hill' is not longer, pleading that this was 'not for want of pushing', and going on to maintain that 'we think if the picture had had figures in it to have given more interest it would have taken much better. The Glasgow people are fond of pictures that tells them something.' In May of that year, Agnew's had written to Thomas Landseer, informing him that 'we rejoice greatly to have it in our power to give you the commission to engrave your brother's noble picture of a Deer family and the Ptarmigan Hill' and expressing their fullest confidence in the engraver's 'splendid talent of rendering [his] great brother's works' (*Agreements Book*, 1867, Agnew's archives). By the time the nineteenth century had run three-quarters of its course, the reproduction and dissemination of engravings was taking place on an unprecedented scale in response to the demand of a greatly increased clientele who were themselves distributed — both socially and geographically — more widely than ever before. In spite of what in one sense had become 'an undifferentiated, impersonal and anonymous mass' (Bourdieu, 1971), print publishers and their representatives had developed a keen sense of what was likely to please. 'Giving them the subjects which are suited to their tastes; that is the main thing . . .' said Henry Graves, one of the most astute students of the nineteenth-century print market; '. . . you may do fine things, and they will not buy them, if you do not give them a subject which they value' (House of Commons, 1845, p.169).

In 1839 Thomas Uwins had deplored the 'rat race', writing to John Townshend that in England there was 'nothing to place the artist above the necessity of satisfying the taste of the individual patron on whom his . . . bread depends . . .' (Uwins, 1858, p.105). Even as he wrote, things were changing: a generation later the artist's public had enlarged beyond Uwin's imagining, and the work of many modern painters was being reproduced and popularised by a new breed of entrepreneurs, who made it their business to see that the pictorial tastes of a society in

THE NEW SELF-SUPPORTING PORTFOLIO

Plate 7
Advertisement, W.Power,
Bookbinder, 104 High Holborn,
London (Ross Archives).

transformation were fully satisfied. Despite Uwin's melancholy, the 1830s in fact marked the preliminary phase in the development of one of the most remarkable episodes in the history of English art: a period of unprecedented (though sometimes vacillating) expansion, and one in which the works of living artists were presented with a persuasiveness and efficiency hardly outstripped by present-day advertising techniques.

The growing demand and change in taste were so closely linked with other important factors — social, economic, political, educational — that they can hardly be considered in isolation (see Perkin, 1978, *passim*). Their roots must be sought in the Industrial Revolution, inseparable from social change. They were aspects of — and symptoms of — a staggering 'rise in human productivity, industrial, agricultural and demographic . . . [accompanied by] drastic changes in society itself: in the size and distribution of the population, in its social structure and organization, and in the political and administrative superstructure which they demanded and supported' (*ibid.,* pp.3, 4).

One element in the evolution of English society during the nineteenth century was the impulse of the rising middle classes to emulate those they considered their social superiors. This contributed to the nineteenth-century burgeoning of consumer demand (*ibid.,* chapter 3 *passim*), and it was to just such a demand that the publishers of prints responded with alacrity and enterprise: the boom in print sales was probably brought about every bit as much by a desire to emulate as by any process of aesthetic enlightenment. These emulative tendencies were already shaping English society in the eighteenth century, during which period essential social and geographical lines of communication were established — lines of communication which were to facilitate the spread of art during the succeeding century. The Royal Society (looking

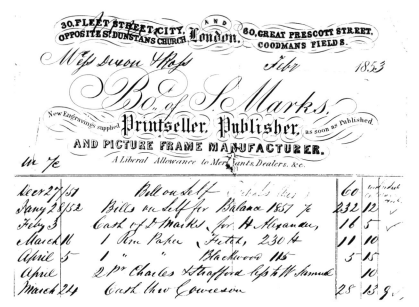

Plate 8
Invoice of Solomon Marks, relating
to miscellaneous purchases of paper,
prints and frames, February 1853
(Ross Archives).

for 'Noble rarities to be every day given in not onely by the Hands of
[the] Learned . . . but from the shops of Mechanicks . . .'), the Royal
Society of Arts (offering premiums 'for the encouragement of arts,
manufactures and commerce in Great Britain'), the Royal Institution and
the numerous philosophical societies which sprang up in many
provincial towns in the late eighteenth century, all drew their members
from a range of social strata and were often the means of bringing about
a kinship between men close in their enthusiasms though perhaps
separated geographically. Such institutions foreshadowed and were in
many ways exemplars for the early nineteenth-century Mechanics'
Institutes and the spate of societies committed to the encouragement of
the arts (*ibid.*, pp.67–70).

There is no doubt that these institutions exerted a considerable
educative influence, even during the first three decades of the
nineteenth century. Whilst a foreign visitor to the country could in 1835
raise an eyebrow at what he discerned as relatively restricted provision
for an appreciation of the arts (House of Commons, 1835, pp.1–9), much
interest had already been generated: not only in London, where the
foundation stone of the new National Gallery had been laid in February
1834 (Boase, 1959, p.204) but, as a result of the growing independence
and emerging competitive spirit of the industrial towns, in the provinces
as well. In 1800 there had been no art organisations anywhere in the
British Isles outside London, Dublin, Edinburgh and Glasgow, but by
1830 societies and institutions committed to the fostering of the arts had
been established in Norwich, Bath, Leeds and Liverpool, and public
exhibitions had been staged in many more provincial towns (Fawcett,
1974, p.1).

The spirit of social emulation affected art in that it helped bring about

a permeation through the social levels of an interest that until the early
nineteenth century had virtually been the prerogative of the gentry; but
the tastes of the new middle and artisan classes were inclined somewhat
differently from those that had been cultivated by the uppermost
stratum of society. The latter, whilst many of its members were quick to
appreciate and patronise modern talents, retained also its traditional
enthusiasm for the old masters and for the elevating influence of,
particularly, history painting; the new public tended to focus its
attention on modern English art, developing a partiality for subjects
reflecting the new world that was in formation around it. The artists
themselves naturally did all they could to see that modern works were
exhibited in preference to old masters. Thomas Lawrence joined in the
campaign to dampen proposals to stage displays of old masters at the
expense of living artists. Such events, he argued, should be held – if at all
– at 'long intervals . . . after the public . . . has been left to the undisturb'd
view of the effects of living genius . . .' (ibid., pp.7, 8).

Various other factors contributed during the early decades of the
nineteenth century to arouse the interest of the public in art. Among the
most influential was the wider diffusion of printed publications of all
kinds. Newspaper articles recommended the growing number of
exhibitions, thus playing a part in facilitating the educative function of
art (ibid., p.7). Cheap and popular periodicals such as the Saturday
Magazine and The Penny Magazine (of the Society for the Diffusion of
Useful Knowledge) made their contribution in '[conveying] instruction
to the very dwellings of the people' (House of Commons, 1835, p.49,
1836, p.vi); and in 1823 the fashion for illustrated annuals was
introduced into this country by Rudolph Ackermann – who, incident-
ally, had launched his monthly Repository of the Arts as early as 1809
(Ford, 1976, p.5).

The vogue for annuals was at its height during the 1820s and 1830s,
though some of the more enduring – such as the Keepsake, which
survived until 1857 (Beck, 1973, p.22) – continued to appear beyond
those decades. The annuals provided an important vehicle for the
publication of small-scale steel-engravings, and gave work to very many
engravers. Over the years the Keepsake, for example, reproduced a
number of J.M.W. Turner's compositions (Rawlinson, 1913, pp.222 ff).
Images of all kinds occupied their pages, but their popularisation of
works of modern art was far from negligible.

By the late 1830s public interest had been generated to the extent that
the formation of art unions ('voluntary associations of a number of
individuals, contributing by subscription, for an inducement of a prize, to
the promotion of Art') was encouraged. The first of these in Britain was
the Art Union of London, founded in 1837; its subscription list grew
from 352 in that year to almost fourteen thousand by 1844. The cash
prizes awarded by the Art Union of London were given on condition

that the money was used for the purchase of modern works on show in specified exhibitions; and the cause of modern art was further aided by the annual distribution to subscribers of an engraving of the work of a living British artist. Within seven years of the founding of the Art Union of London many others ('[whose] operations ... [appeared] ... to be in analogy with those of the London Art Union') came into being in centres as widely dispersed as Manchester, Liverpool, Birmingham, Norwich, Plymouth, York, Dublin, Belfast, Edinburgh and Glasgow (House of Commons, 1845, *passim*).

The education of public taste was given additional impetus when, in 1835, the Government formally took a hand in the process. Anxiety at the commercial competition of other European countries, to which Britain was considered 'greatly inferior in the art of design' (House of Commons, 1835, p.13), led to the appointment of 'a Select Committee ... to inquire into the best means of extending a knowledge of the Arts and of the Principles of Design among the People [especially the manufacturing Population] of the country ...' (*ibid.*, p.ii). The Select Committee went about its task with great thoroughness. Among many invited to give evidence were eminent foreigners who described the provision in their own countries for education in art and design, and one of whom included in his recommendations the wider employment of artists in public projects: 'The construction of the New Houses of Parliament ... afford[ing] an honourable opportunity for it....' (*ibid.*, p.9). Having heard all the testimony, the Committee regretfully drew the inference that 'from the highest branches of poetical design down to the lowest connexion between design and manufactures, the Arts have received little encouragement in this country. The want of instruction ... is the more to be lamented, because it appears that there exists among the enterprizing and laborious classes of our country an earnest desire for information on the Arts'. It was tacitly acknowledged that the Government was dragging its feet as the Committee went on to admit that this 'earnest desire ... [was already to some extent being met by] British capital and intelligence ... producing ... cheap publications upon art [which were] studied with interest by our workmen', and to express the hope that its own efforts would 'infuse, even remotely, into an industrious and enterprizing people, a love of art, and [would] teach them to respect and venerate the name of 'Artist'' (House of Commons, 1836, pp.iii–xi). The main outcome of the Select Committee was the setting up of the first Government School of Design, an establishment 'distinct ... from any of the academies of painting and sculpture [then] existing in England; and in which ... the system of instruction [was to impart] the arts of designing and modelling with purity and taste ...' (House of Commons, 1835, p.40). The state-sponsored public art education on which most of the present system depends was thus launched.

By the 1830s, then, many factors had converged to contribute to the spread of a popular interest in art in Britain: the example of the upper classes; the proliferation of art institutes and exhibitions; the growth of the provincial cities and their competitive spirit; the campaigning of the artists themselves; the proselytizing of enthusiastic newspaper editors and the enterprise of publishers of magazines and annuals; the rise of the art unions; important public projects such as the building of the new National Gallery and the Houses of Parliament; and Government sponsorship of public art education in response to commercial pressure from overseas.

Plate-printers played an important part in the success of this process of dissemination (and, naturally enough, sought to profit from it). The Jury of the 1855 Paris Exposition Universelle singled out an English printer, William Henry McQueen (spelled 'Mac-Queen' in the official report), for special praise, awarding him a First Class Medal and describing him as '[un] imprimeur . . . habile [qui] a exposé d'admirables impressions dans tous les genres et particulièrement dans la manière noir, gravure dans laquelle excellent les artistes anglais.'

The Jurors went on to observe that 'some of the most beautiful prints in the shop-windows of the foremost publishers of the United Kingdom came from the presses of this printer' (Exposition Universelle de 1855, 1856, p.75). They emphasised the high esteem in which they held the skills of plate-printers of whatever nationality:

> . . . chaque épreuve nouvelle est un nouveau travail de la main et de l'intelligence de l'ouvrier, c'est, pour ainsi dire, une nouvelle mise en train, puis-que l'encrage, l'essuyage, la pression peuvent, pendant un même tirage, avoir besoin d'être modifiés suivant les variations de la température, l'état de l'encre, la nouveauté ou la fatigue des tailles, et beaucoup d'autres circonstances. . . . Si nous insistons sur ces

considérations, c'est que l'importance de l'impression en taille-douce n'est pas toujours assez appreciée, et cependant c'est par l'épreuve produite par l'imprimeur que le graveur est jugé, car le tirage est à la gravure ce que l'exécution musicale est à la composition (*ibid.*, p.30).

Whilst the number of copper- and steel-plate printing firms altered little in the middle fifty years of the nineteenth century, the scale and scope of their enterprises broadened. It is the purpose of this chapter – taking special advantage of the illustrative opportunity afforded by the Dixon & Ross papers – to examine some aspects of this expansion. An increase in the sheer volume of business necessitated corresponding enlargements of staff; brought with it multiplied contacts with artists, engravers, printsellers and publishers, entailing not only numerical proliferation but also considerable geographical deployment; and compelled the printer, along with his artist, engraver and publisher collaborators, to consider and attempt to meet the needs and tastes of a vastly larger public than had ever before been catered for. Engravings for book illustration, as well as single subjects for framing, were in increasingly great demand. Of the popularity of illustrated annuals from the 1820s to the 1840s, T.H. Fielding remarked that the 'most beautiful productions of our best engravers [were] flung before the public at a price . . . which only an excessive sale could render profitable' (1841, p.29).

Figures relating to the printing trade in the nineteenth-century trade directories need to be interpreted with some caution, since different compilers apparently used different criteria of classification and the same compiler seems sometimes to have altered his criteria from year to year. The information is nonetheless helpful. Pigot's *London and Provincial New Commercial Directory* for 1822–1823 listed twenty-one copper-plate printers, but gave a second list comprising engravers who were also printers. This second list includes Robert Havell who. a few years later, was to undertake the engraving, printing and colouring (see p.20, below) of J.J. Audubon's *Birds of America*. For the same year, the number of lithographic printers was given as sixteen. The name of Charles Hullmandel appears here. Hullmandel, installed at 49 Great Marlborough Street, was a resourceful experimenter in lithographic printing techniques. Four years later the number of copper-plate printers in the metropolis reached fifty-one, though the apparent spectacular increase is no doubt due in part to a rearrangement of categories. One of these plate-printing firms, Chatfield, Coleman & Co., is described as a steel-plate printer's; and James Lahee of 30 Castle Street East is classified as a steel- as well as a copper-plate printer. These details are of great interest, marking as they do a time when steel plates were becoming more commonly available and heralding the impending obsolescence of unprotected copper. Robson's *London Commercial Directory* records very

nearly the same number of copper-plate printers – fifty two – in 1835;*
whilst the lithographic printers now totalled fifty-three as against the
sixteen listed twelve years earlier. In 1852, *Watkins' Commercial and
General London Directory* gave the figure of copper-plate printers as still
fifty-two (the lithographers having reached the staggering number of
141) and listed almost five hundred and fifty engravers of all classes.
(That year, Messrs. Clowes & Sons, furnishing the printing statistics
relating to the 1851 Great Exhibition Catalogue, remarked that
engraving was a profession followed by both sexes, and that no fewer
than 200 engravers had been involved in the production of the
publication. Almost all seem to have been wood engravers, litho-
graphers and engravers on stone.) A year later, Kelly's *Post Office London
Directory* – again, presumably, with some shifting of criteria – listed
sixty-seven copper-plate printers, including some working in processes
besides intaglio. The need for caution (see Norton, 1966) is underlined
by a comparison of Kelly's Directory of *Stationers, Printers, Booksellers,
Publishers and Paper Makers* for 1880, in which ninety copper-plate
printers and nearly five hundred lithographers are listed, and Kelly's *Post
Office London Directory* for 1884, which numbers the copper-plate
printers as forty-four and the lithographers as 250. Such apparent
discrepancies are explained in part by the fact that it became less and less
easy categorically to describe many printers as purely copper-plate
exponents. (Kelly's *Post Office London Directory* of 1853 had already listed
the activities of Mrs. Mary Eastman & Co. of 100, Cheapside, as copper-
plate, letterpress and lithographic printing as well as engraving.) An
advertisement of 1880 in Kelly's *Directory of Stationers, Printers,
Booksellers, Publishers and Paper Makers* gives some idea of the technical
variety that had by that date come within the scope of those engaged in
the printing trade: J.L. Leitch & Co., whose works were in Newcastle
Street, off Farringdon Street, produced electrotypes; were 'zinco and soft
metal engravers'; lithographers and photo-lithographers; undertook to
produce from copper plates or from lithographic stones 'copper-faced
electro zinco blocks' for printing by letterpress; and claimed that by a
special process of their own, 'electrotypes [could] be produced in the
short period of three hours'. There were also at this date in London
twenty-four other electrotypers, twelve photographic printers, and
twenty-two photolithographers (*ibid.*). It would be interesting to
discover how many of those copper-plate printers listed in the
nineteenth-century directories were concerned – if not exclusively then
at least to a significant degree – with the fine art trade. Very many were
undoubtedly involved in jobbing work; and Andrew Tuer, writing in
1882 (*op. cit.*, pp.99–102), named only very few he considered 'fine art
printers'. They included T. Brooker, Dixon & Ross, Holdgate Brothers
and McQueen Brothers. These were certainly names that had cropped
up with interesting regularity: McQueen's since about 1800; Dixon &

* Dixon & Ross, whose address is
given as 5 Tottenham Mews, appear
in this list. The firm's own records,
however, give 4 St. James's Place,
Hampstead Road as the address. The
same Directory lists, as an engraver
and Frankfort black maker, Thomas
Ross of Giltspur Street. This was no
doubt the 'Ross Senr.' who supplied
Dixon & Ross with ink and oil over
a number of years. (See Appendix I,
p.183).

Ross since their foundation in 1833; and Brooker's and Holdgate's from at least the 1840s onwards. Brooker had been consulted by Ruskin (see letters to John Le Keux, V & A) in connection with the printing of *Modern Painters* and by the Fine Art Society concerning the valuation of important steel plates and the recommendation of an engraver for Elizabeth Thompson's 'Inkerman' (Fine Art Society Minute Books, 19 December 1876 and 2 May 1877). Holdgate Senior, the founder of the firm, had taken his press to Buckingham Palace in July 1842, to demonstrate to the Queen and Prince Albert the printing of a Landseer plate (Manson, 1902, p.104). And in Paris in 1855 were noticed

> ... des gravures de diverses natures, dont l'aspect brillant et artistique
> faisait honneur aux graveurs, et aux imprimeurs Dixon, Ross,
> Holgate et Mac-Queen, dont les presses les avaient tirées (Exposition
> Universelle de 1855), *op. cit.*, pp.81, 82).

The fortunes of enterprises such as these were inextricably linked with those of the artists and engravers whose images they realised in print and with those of the many entrepreneurs involved in one way or another in the ramifications of the fine art trade.

Of the years at the turn of the eighteenth and nineteenth centuries, Abraham Raimbach (1843, pp.22, 23) noted that 'everything connected with (the arts) was at its lowest ebb . . . booksellers were, at this time, the only patrons of engraving.' The outlook for artists seems to have been so bleak that members and associates of the Royal Academy were exempted from certain taxes (*ibid.*, p.22). Raimbach spent nine years as a student at the Royal Academy since 'the actual state of engraving, still declining from bad to worse, left [him] ample leisure to adopt [this course].' Life was to be difficult for many artists throughout the Napoleonic Wars and beyond. In a letter of 14 May 1816, Thomas Uwins complained of hard times and artists' unsold pictures; and, in 1821 he was still deploring the difficulty of securing patronage as he wrote from Scotland '. . . artists here, as well as in every other part of His Majesty's dominions, are something thicker than three in a bed . . .' (*op. cit.*, pp.40, 167). Uwins, who in 1797 had been apprenticed to Benjamin Smith the engraver,* was one whose aspirations had to be scaled down to suit the smaller compass of book production. Between 1809 and 1818 his exhibits at the Society of Painters in Watercolours included illustrations to *Tom Jones, Pilgrim's Progress, Paul et Virginie, Peregrine Pickle, Young's Night Thoughts*, and works of Pope, Shakespeare, Thackeray, Voltaire and the Bible (Uwins, *op. cit.*, pp.149 ff). Cadell & Davies' 1817 publication of *Don Quixote de la Mancha*, with illustrations printed by McQueen's from plates engraved after the paintings of Robert Smirke (1752–1845), was no doubt typical of the kind of book work doled out to an overcrowded and under-employed profession. Raimbach mentioned working on some of the seventy-four small plates, newly returned from a post-war journey in the Netherlands (*op. cit.*,

* Benjamin Smith was one of the engravers employed by Boydell in the 'Shakespeare Gallery' enterprise. Alderman John Boydell launched his scheme in 1786, and commissioned in all about 170 Shakespearian paintings by leading British artists, to be published in engraved form. The story of Boydell's bankruptcy and the eventual sale by lottery of the paintings and the stock of engravings on 28 January 1805 is well known.

p.121). In the production of a book with a large number of illustrations there were considerations of speed; but the shortage of work must go a long way towards explaining the great number of engravers involved in this, not the most copiously illustrated of projects. A package of proofs of the *Don Quixote* illustrations, owned by Mr. P.N. McQueen, represents no fewer than fourteen engravers including, besides Raimbach, Charles Heath and Charles Warren (who was currently engaged on a project with his plate-maker, Richard Hughes, to evolve steel plates practicable for engraving). Partly as a result of a general economic depression (see, e.g., Mathias, 1978, pp.219–222, 353) but also to a large extent because of the popularity of 'old masters' – or pictures which would pass for them – many English artists were in considerable difficulty for several years following the war. An observer of those years could say that he had been present many times at Royal Academy private views when, 'excepting portraits of men and women, of horses and dogs, there was not a single picture sold by any artist throughout the day' (S.C. Hall, in Maas, 1975, pp.42, 43). One cannot, however, generalise: Wilkie (whose 'Chelsea Pensioners reading the Gazette of the Battle of Waterloo' had aroused such enthusiasm in visitors to the 1822 Royal Academy exhibition) and Landseer were among those to whom the twenties and thirties brought success despite the prevailing austerity.

A study of the fluctuations in the fortunes of the art trade during the nineteenth century reveals anything but a tidy correspondence with the general economic climate of the country. During the decade described by economic historians as the 'Hungry Forties', when the Irish potato crop failed and there were in England several years of poor harvests (Mathias, *op. cit.*, p.230; Hobsbawm, 1979, pp.93, 94), the Post Office Directories suggest a steady improvement in the affairs of artists, who were encouraged to swell their ranks from 168 in 1840 to 504 in 1850, with a corresponding increase in the numbers of printsellers and picture dealers (Maas, *op. cit.*, p.43). This decade saw the emergence of a new class of art patron, a class formed of 'traders and makers of all kinds of commodities . . . [who] started with the new notion of buying a picture which they themselves could admire and appreciate, and for the genuineness of which the artist was still living to vouch . . .'. These new patrons, products of the rise of commerce, 'turned their backs valiantly on the Old Masters, and marched off in a body to the living men' (Wilkie Collins, in Maas, *op. cit.*, p.43. See also Fawcett, *op. cit.*, pp.3–9). This new interest in the works of living English artists opened the way for new departures where the publishing of engravings was concerned. Reproductions of modern subjects by artists like Wilkie had of course appeared in the early decades of the century, but the majority of prints was of privately commissioned portrait plates (Agnew, 1967, p.61). Engravings of popular pictures by leading contemporary painters began to form the bulk of the greatly expanded trade of the print-sellers and publishers

during the 1840s. The Printsellers' Association was formed in 1847 in response to this expansion in the print trade and for the purpose of regulating publishing procedures – 'to ascertain and record the number of proof impressions of each grade taken from various kinds of engraved materials for the purpose of printing or otherwise reproducing Pictures, Drawings, and other Works of Art' (McQueen, c.1882–1886, p.4). By the mid-fifties, Holman Hunt was complaining of the difficulty of 'obtaining a first-rate engraver who is disengaged' (Maas, *op. cit.*, p.67): a far cry from the penurious plight of Raimbach and his colleagues a generation earlier.

The Great Exhibition of 1851 seemed, for the country as a whole, to be ushering in an era of unprecedented prosperity.* Even so, the art trade, after a decade or more of expansion, suffered a setback in the late fifties; there was panic, and one gallery after another went bankrupt (Maas, *op. cit.*, pp.96–97). The expense of the Crimean War and the Indian Mutiny must have had repercussions upon the general state of the country's economy yet, in a general sense, prosperity seemed to grow unchecked. The art trade steadily recovered for the sixties to become a decade in which the works of living painters attracted more attention than ever before. By May 1870, the *Daily News* was reporting rapid rises in picture prices. Rosa Bonheur's 'Scene in Brittany', originally purchased by William Agnew and sold by him in 1855 for £600 to Edwin Bullock of Handsworth, had just been bought back by Agnew at Christie's for 1,700 guineas:

> Thus, to say nothing of the value of the pleasure given by the picture, the investment produces about £1,200 profit in fifteen years. The great capitalists appeared to see this at Saturday's and Monday's sales, if the large sum which it was said was laid out by Messrs Agnew, amounting to about £27,000, may be taken as any indication (Redford, 1888, p.183).

Two years later the collection built up over nearly fifty years by Joseph Gillott, the inventor and manufacturer of the steel pen, realised a grand total of £164,530. The *Daily News* reported 'prices [surpassing] any hitherto given for English landscape; general interest extraordinary . . . rooms besieged and hundreds unable to glimpse the auctioneer'. Of the 514 pictures sold, 306 were oil paintings by English artists (*ibid.*, pp.184–186). A further gauge to mounting prices is provided by *The Times* report of the sale of the William Quilter collection in April 1875, when Copley Fielding's 'Rivaulx Abbey' was bought by William Agnew for nearly £1,000. The artist had received £40 for the work in 1842; it fetched £600 at the sale of the Elhanan Bicknell collection in 1863; and now Agnew's price contributed to the overall profit of 260% made by the Quilter sale (*ibid.*, p.205). Yet 1873 had heralded the so-called 'Great Depression'** which, with only partial lifting, was to hang upon the country until the closing years of the century. Judging from the deliberations of the several Government Committees and the Royal

* Matthias (*op. cit.*, p.215) urges caution where statements about economic fluctuation are concerned. Hobsbawm (*op. cit.*, pp.91–92) adds a warning related to these particular years: '. . . *relatively*, the poor grew poorer, simply because the country, and its rich and middle class, so obviously grew wealthier . . . [dripping] with excess capital, to be wildly invested in railways and spent on the . . . opulent household furnishings displayed at the Great Exhibition of 1851, and on the palatial municipal constructions [in] the smoky northern cities.'

** Economic historians have been looking afresh at nineteenth-century patterns of expansion and depression in Britain. S.B. Saul, in *The Myth of the Great Depression, 1873–1896*, London, 1969, discusses interesting ramifications.

No. 167 148, NEW BOND ST., W. _Feby 2_ 18_77_

PLEASE SUPPLY *On appro for a few Days*

/ea Prints Lucknow, Bolton Abbey, Evening Tay
/ " Fight for Standard, Christ Weeping, Slave Market
/ " Homestead, Farmyard, Coronation of Queen
/ " Marriage &c, Trial of Charles, Trial Strafford
/ " Pilgrim Fathers, Popes Bull, Seven Bishops,
/ Cranmer Traitors Gate

FOR THE FINE ART SOCIETY (LIMITED).

Mr Ross Signed _____

Plate 10

Request from the Fine Art Society for prints, 2 February 1877 (Ross Archives).

Commission on the Depression of Trade and Industry, the precise nature of the depression evaded analysis; but it seemed that it was a depression not of production but of prices and profits – 'a diminution, and in some cases, an absence of profit, with a corresponding diminution of employment for the labouring classes' (Royal Commission on Depression of Trade and Industry, quoted in Gregg, 1950, p.371). Those who remained in employment on fixed incomes benefited, however, from falling prices; it was apparently the employers and entrepreneurs who suffered and had to be content with smaller margins of profit. The situation finds its reflection in the minute books of the Fine Art Society whose agent, Dowdeswell, on 24 May 1876, reported very little business at the Society's Chancery Lane branch. On 13 January 1876, at the General Meeting held at the Society's headquarters at 148 New Bond Street, the Secretary noted that the '... retail business of the Society in drawings and engravings has been successfully carried out in spite of the unprecedented depression elsewhere felt in that branch of trade ...' but that the Chancery Lane agency had eventually failed, '... a result in some measure owing to the before mentioned stagnation'. The trade evidently continued to enjoy pockets of prosperity. The Fine Art Society's minute books show that investment in copyrights of Elizabeth Thompson's pictures was a continuing success at this time. Hutton, a canvasser, received a bonus of £5, subscription lists for the engravings of the paintings having reached the £1,000 mark in Birmingham and Leeds due to his exertions. By 31 December 1876, overall subscriptions for the 'Roll Call' ('Calling the Roll after an engagement, Crimea' – one of the century's most popular pictures) totalled £16,581.2.0d; for 'Quatre Bras' £11,069.2.0d; and for 'Balaclava' £6,582.9.0d. – representing a gross increase of £13,258.7.0d. in eleven months (Fine Art Society Minute Books, November–December 1876).

A further pocket of prosperity is indicated by a preview published on 24 April 1877 in *The Times*. Writing of the sale of the collection of Albert Grant (commonly known as Baron Albert Grant), to be held at Christie's a day or two later, the paper's art correspondent reported that

> ... the greatest curiosity and speculation have been created as to the
> prices likely to be obtained for pictures purchased during the last
> seven years when modern art has been at its zenith in this respect
> (Redford, *op. cit.*, pp.253–254).

And, a few months later, the Secretary of the Fine Art Society again recorded that 'success in copyrights of Miss Thompson's pictures has continued unabated' and that subscriptions were more numerous during the period covered by his annual report than in any previous time of similar length (Fine Art Society Minute Books, 5 December 1877).

The following April (1878), an estimated 15,000 viewers trooped through Christie's sale-rooms, attracted by the impending sale of the Novar collection, assembled by Turner's friend and executor, H.A.J. Munro.

> While some good judges did not hesitate to name very large sums
> others spoke of the bad times and doubted whether these
> exceptionally beautiful pictures of the great master [i.e. Turner] would
> hold their own as they had a few years ago when prices seemed to be
> at the zenith in the sale of the 'Venice' for 7,000 guineas.

In the event, the sale realised £73,520 – the largest amount ever reached in relation to the number of pictures sold (Redford, *op. cit.*, pp.270–271). And, for the third year running, those attending the General Meeting of the Fine Art Society were informed that '... sales in spite of the depression in the art market ... [had been] maintained at nearly their last year's level' (Fine Art Society Minute Books, 10 January 1879).

By May 1884, *The Times* art correspondent was sounding a note of resignation and searching for a silver lining in the clouds of economic gloom:

> It is said – and the accounts which we have lately printed of sales at
> Christie's seem to give ground for it – that the picture market is
> entering upon a period of depression, and that prices are falling and
> will fall. Perhaps this is not altogether to be regretted. Extravagant
> pictures are not by any means the best thing for art; they stimulate
> the supply unduly, and lead fashionable painters to work much too
> fast and too carelessly. Possibly a short spell of 'bad times' will have a
> stimulating effect of another kind, and lead artists to give more time
> and thought to the work to which they attach their names (Redford
> *op. cit.*, p.382).

The firm's wage and work books bear eloquent testimony to the fluctuating business fortunes of Dixon & Ross. The wage books record payments to each individual on the payroll; the work books give details of the work completed each week by individual printers. The lists in the

former are frequently longer than those in the latter, all the indications being that there were employees from time to time engaged upon work other than at the presses. The number of staff on the wages lists varied considerably throughout the period under review, according to the pressure or the relative lack of work: one Saturday in 1835 a single wage of 14/- was dispensed (Appendix I, p.178). The wages and work book covering the years 1839 to 1845 (this book, like several others, records both work completed and payment received) shows that over a twelve-month period from July 1839 the number of staff paid varied from one to five (Appendix I, p.182). The irregularity of the supply of work during the 1830s and 1840s is confirmed by Tegg's *Complete Book of Trades*, which makes the interesting observation that the consequence was 'a general depression in price for all but the best work' (see Bain, *op. cit.*, p.9). Dixon & Ross were beginning to attract their share of the 'best work' – which must have meant, or must at least have included, work for the fine art trade – and this must go a long way towards explaining the comparatively high wages earned by their most experienced printers when the going was good. The *Complete Book of Trades* estimates that 'ordinary workmen could scarcely count on more than a guinea a week . . . in an office of tolerable good standing. Better workmen get out 30s and upwards.' On seven Saturdays during the twelve-month period referred to above, William Ross, one of the partners, took home wages of well over 60/-; on one occasion £3.7.11½d. His wage seldom fell below the 40/- mark, though one week he earned only 16/4½d. During this time he was printing (for the partners themselves worked at the presses) such plates as that engraved by Samuel Cousins after Landseer's 'Bolton Abbey', obviously considered the 'best work'. John Dixon, working alongside him, topped 30/- on only twelve occasions, and sometimes earned as little as six or seven. One particularly slack week, only Ross was printing, but when the heat was on five pressmen worked simultaneously.

The 1839–1844 wages and work book shows that it was probably often the book jobs that brought greatest pressure. Casual labour was sometimes enlisted to help cope with this, and extra sums were paid for night work. During one week in September 1844, three printers dropped other commitments to produce between them 1,664 prints for Henry Bohn's publication of Claude's *Liber Veritatis*. It was evidently piece work (as, indeed, all the printing seems to have been) paid at the rate of near enough 7/- per hundred prints, the men earning respectively £2.9.10d for 712 prints; £1.16.4½d for 516; and £1.10.7d for 436. Meanwhile, the indefatigable William Ross, having mopped up other orders to the tune of nearly a thousand prints, took off a further 1,085 from the *Liber Veritatis* plates, earning an average wage of more than 57/- over four weeks. Work on the *Liber Veritatis* lasted two months – not including the usual prelude of proof-taking – and shortly afterwards, following an

interval devoted to miscellaneous orders, the printers' attention was turned to plates of *The Works of Sir Joshua Reynolds* for the same publisher (Appendix I, pp.182–3).

It is interesting to compare the earnings of the printers with those of other workers during the same years. One of the engineers attending to the firm's presses earned 45/- a week, and a millright 48/- (Appendix I, p.177). In the 1830s farm labourers in the north were earning an average of 11/1d, whilst in the cotton trade (taking into account the low wages of the many women and children employed), average earnings were only 9/2d, though cardroom operatives could earn up to 17/- and fine spinners 33/3d. By the end of the 1840s the farm workers were earning a few pence more – 11/6d – and the highest paid cotton workers could get up to 42/- (Perkin, *op. cit.*, pp.128–129, 144–145, 165). It will be remembered that the years around 1850 marked a time of expansion for the art trade, that the number of printsellers in London had increased substantially since 1840 and that artists had proliferated threefold. The Dixon & Ross Day Book covering the years 1848 to 1851 reflect this, recording lists of from eight to sixteen employees and wages of from 5/- for the apprentices to nearly £6 for a skilled man in a good week (Appendix I, p.189). The latter seems an exceptionally good wage, in view of the fact that the average for a journeyman printer at this time was from 33/- to 48/- in London and from 12/- to 30/- in the provinces (Great Exhibition, *Reports*, 1852).

The Dixon & Ross records relating to the year 1853 indicate a phenomenal growth. Saturday 14th May will serve as an example. One of the Day Books lists twenty-two on the payroll; the corresponding wage and work book, fifteen (Appendix I, pp.191, 193). As recently as the previous January, only six men were listed in a work book (Appendix I, p.190) but it would be ten years before the numbers fell again to that level. What could have provoked so sudden an expansion? And why the apparent decline beginning in the early sixties? There are several possible explanations for the increased volume of work in the early fifties. Perhaps the firm's transatlantic advertising, which began at least as early as 1851, began to bear fruit. A letter of that year from a Philadelphia printer-publisher, John Butler, refers to a consignment of prints sent by Dixon & Ross as an inducement to trade (Appendix I, p.187). In addition to whatever business it may have transacted direct with American enterprises, the firm was by the middle of the decade delivering large packing-cases of prints to entrepreneurs like David Marks for despatch to America (Appendix I, p.195*). The growth of this aspect of the trade was no doubt encouraged by the recently increased efficiency of transatlantic transport, I.K. Brunel's first iron ship, the *Great Britain*, having made the crossing in 1845 (Rolt, 1974, p.271). Between 1840 and 1870 seven million migrants made the voyage westward, as against only one million during the preceding forty years (Hobsbawm,

* This Day Book contains the names and addresses of several American clients, including: Jacobs & Myers, 62 Bayard Street, New York; Philip Levy (described as an importer of oil paintings), 3 North William Street, New York; and Williams Stevens, 353 Broadway, New York.

op cit., p.139). A brochure pasted into one of the Day Books lists well over a hundred engraved subjects and suggests that the firm's publishing enterprises were being expanded at this time (Appendix I, p.192). The list is not headed, but the fact that it contains most of the subjects mentioned in the correspondence with John Butler leads one to suppose that it represents Dixon & Ross's own publications.

It is certain, too, that the spreading web of the railway helped augment the volume of business with the provinces. The 2,441 miles of rail that had been laid by 1845 was being pushed steadily towards the 15,563 that would be accomplished by 1880 (Mathias, *op. cit.*, p.488), and the printers could deal almost as easily with Agnew's in Manchester during the fifties as they could with their London contacts. Finally, the firm obviously benefited from the decade of expansion − from the mid-forties to the mid-fifties − enjoyed by the art trade in general, and probably continued to do so for some time after the recession of the late fifties. Possibly the overseas trade was one of the factors that helped tide the partners over to the more sanguine years of the sixties. The comparative cheapness of engravings was no doubt also a factor in helping those in the printselling trade to withstand the recession rather better than those dealing in originals.

Though marking a busy time for the firm, the wage and work book for the years 1853 to 1856 shows the familiar fluctuation in the number of presses in action. For example, over twenty-five weeks during 1853, the number of printers averages thirteen, but this represents a fluctuation between nine and seventeen. The wages seem on the whole to be little changed from those of the preceding few years: the experienced men earning an average of 70/- or so, though they could sometimes reach the £6 mark (Appendix I, p.193). It is interesting to compare the men's earnings with the retail prices of the engravings they were printing: Bateman's 'Nothing Venture Nothing Have' was sold at 3/6d, of which the pressman's cut was a little over fourpence; for Jones's 'Gipsy Party', the man received slightly less than twopence for a print that sold at 1/-; and for printing Allen's 'Slave Market of Constantinople', selling at 8/-, he could earn just under sixpence. It is likely that these various percentages were related both to the pace at which the respective plates could be printed and to the retail profits. Twenty-two prints of the 'Slave Market', the same number of impressions from another plate, and a couple of proofs added up to a week's work for one of the men in 1853: it earned him £1.5.9d (compare pp.192 and 193, Appendix I).

The wage book covering the years 1856 to 1865 confirms continuing expansion for the printers in the late fifties, whatever the gloom experienced elsewhere in the art trade (Appendix I, p.195). The highest number of staff paid over the first eighty-eight weeks from November 1856 is twenty-seven when, on the 15th of that month the wages totalled £68.16.10d for a week. The lowest number of workers was

fourteen. By 1861, numbers had dropped to around twelve, and there follows a steady falling off until, by the early 1880s, an average of only five presses was rolling (Appendix I, p.204). Wages remained high during the whole of this period by comparison with the money earned elsewhere. The archives of Grosvenor Chater & Co. Ltd., paper merchants of St. Albans, Hertfordshire, show that during the 1860s the firm was paying binders 30/-, apprentices 4/- and rulers only 2/6d. The indenture (original owned by Miss F.B. Pomeroy of Thomas Ross & Son) of Frederick George Hardcastle, apprenticed for seven years from 1 March 1882 to Edward and Alfred Holdgate 'to learn the Art, Trade or Business of a Steel and Copper plate printer' contains details of the earnings and the hours of work of a trainee printer of the eighties:

Wages Year I – 2/6d
 Year II – 2/6d
 Year III – 4/6d
 Year IV – 9/-
 Year V – 13/-
 Year VI – 14/-
 Year VII – 16/-

Times of attendance were from 8 a.m. to 7 p.m. for the first two years, and from 9 a.m. to 7 p.m. for the remaining term. An hour for dinner and half-an-hour for tea were allowed. Work finished at 2 p.m. on a Saturday.

The clientèle of Dixon & Ross seemed already to be well established by the date of the firm's foundation. During the previous years of practice on their own account, the partners had no doubt built up extensive contacts. For example, John Dixon had been employed by Longman's on the printing of the plates for William Daniell's *Voyage Round Great Britain*, published 1814–1825 (Bain, *op. cit.*, p.21). It seems clear from the long lists of names and addresses both of suppliers and customers that appear in the earliest ledger and the earliest surviving Day Book that the partnership was entered into on the basis of reputations already made. As we have seen, there were evidently very few plate-printers specialising in work for the fine art trade when Tuer drew up his check-list in the 1880s. The number of prominent artists, engravers and publisher-printsellers that one encounters in the pages of the Dixon & Ross records from the 1830s onwards is so considerable that it is difficult to resist the idea that there was never more than a handful of such specialists operating in London during the fifty years here under review. At the very least, a survey of these contacts confirms that Dixon & Ross ran a business of great importance, and represented a point of focus for a large section of that part of the art world concerned with the reproduction of pictures.

It is difficult in most cases to pinpoint with absolute precision the dates when the partners first began their association with each of their

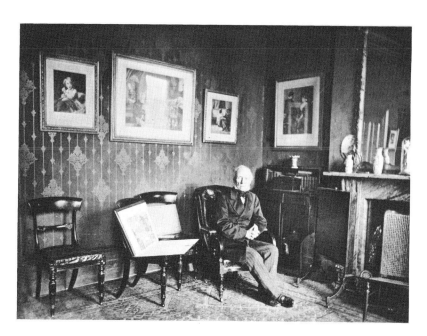

Plate 11
J.P. Mayall, photograph of Samuel
Cousins, published 1884 in *Artists at
Home*, ed. F.G. Stephens (National
Portrait Gallery).

many contracts; but, knowing the dates spanned by the books in which
particular names first appear, it is possible to arrive at an approximate
chronological sequence. It is entirely appropriate that Samuel Cousins
(1801–1887) should take priority in such a sequence. His name appears
in the earliest ledger, opening in 1833, and his presence looms with
impressive prominence in the affairs of the firm until his retirement in
1884. During all these years he represented a link with the top echelon
of contemporary English artists – men like Edwin Landseer and John
Everett Millais. The importance to Dixon & Ross of the business he
brought in may be judged from the many entries referring to him in the
firm's records. Over the two years from November 1838 to November
1840 there are in one Day Book alone (Appendix I, pp.179–82) nearly
hundred entries relating to Cousins. Five-and-a-half thousand proofs
were taken off for him in a single year.

Another of the printers' earliest clients was a 'Mr. Havell' of Oxford
Street, for whom a number of book plates of Dutch shipping were taken
off. This was in all probability Robert Havell who had engraved, printed
and coloured the illustrations to Audubon's *Birds of America* and was
himself shortly to settle in America, where he died in 1878. 'Mr. Havell'
could, however, equally easily have been Daniel. Both he and Robert
were aquatint specialists, and members of an extensive family of artists
and engravers.

The name Lupton also appears at this time. This must have been
Thomas Goff Lupton (1791–1873), already with the engravings of
Turner's *Harbours of England* and a number of the *Liber Studiorum* plates to
his credit. There is an interesting reference to 'Mr. Lupton' in the first

surviving Day Book; the entry is dated 15 February 1837 and records the firm's purchase of 'the Columbier press of Mr. Lupton's' for £30. It is just possible that the press was, in fact, a *Columbian* and was thus for letterpress rather than intaglio printing. If, however, the clerk was *not* guilty of a slip of the pen, the press would seem to have been a rolling press with a plank large enough to take paper of Columbier size (35″ by 24″).

A further indication of the printers' reputation is provided by the patronage of the Landseers. Thomas Landseer (1795–1880), a major part of whose work consisted in engraving his brother's compositions, was enlisting the firm's collaboration from at least 1839, in which year he collected '2 Pr[oo]fs Stag on Sh[ee]t Imp[eria]l'. It is not clear which painting these proofs related to, but it is likely to have been 'The Hunted Stag', exhibited at the Royal Academy in 1833. Most of the work done for Landseer seems to have consisted of the taking off of small numbers of proofs, but an entry in the Day Book covering the years 1848 to 1851 shows that this was not the only service provided: the engraver purchased from the printer 'a Copper Steam Apparatus, Table & Spirit Lamp &c.' at a cost of £6.6.0d. This equipment would be for heating plates during the application of etching ground; it must have been very like the device recommended by T.H. Fielding (1841): a tin box, about 12″ by 9″ by 3″ with a hole at one corner by which it was filled with water. Placed on a stand, with a source of heat below, the water was kept sufficiently hot to heat the copper or steel plate and soften the wax during its application.

Another engraver contact of Dixon & Ross during the early years of their establishment was David Lucas (1802–1881), whose standing was already such that he was Samuel Cousins' competitor for A.R.A. status in 1835. In 1824 he – like Cousins ten years before him – had been apprenticed to S.W. Reynolds; he had recently worked on Constable's commercially unsuccessful *English Landscape* (published jointly by Constable and Colnaghi's in 1833) and was to continue his ill-fated collaboration with the painter over the next few years. Following the failure of the *New Series of Engravings of English Landscape* which he himself published in 1846, Lucas had little but disappointment and ultimately poverty (Hind, 1963, pp.285–287).

Henry Cousins (c.1809–c.1864), the younger brother of Samuel and also a mezzotint engraver, and George Raphael Ward (1798–c.1878) of Fitzroy Square were also among the engravers who took plates to the presses in Hampstead Road. The name Simmons (variously spelled) also appears in the early books. This could quite feasibly have been William Henry Simmons (1811–1882) who engraved, for example: Millais' 'The Proscribed Royalist', published by Gambart in 1858; Hunt's 'The Light of the World', published by Gambart in 1860; and Faed's 'The Last of the Clan', published by Graves in 1868. Thomas Lewis Atkinson (1817–

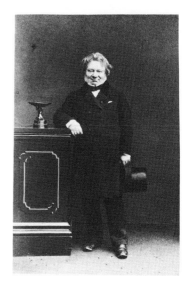

Plate 12
Thomas Landseer, photographed by John and Charles Watkins (National Portrait Gallery).

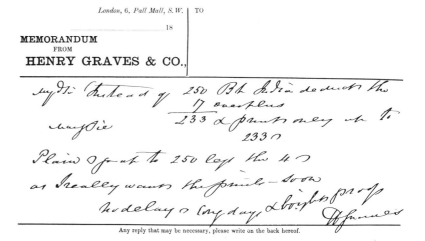

London, 6, Pall Mall, S.W. | TO

18

MEMORANDUM
FROM
HENRY GRAVES & CO.,

Any reply that may be necessary, please write on the back hereof.

Plate 13
An urgent order from Henry Graves:
'I really want the prints soon . . . no
delay & long days & bright proofs'.
Undated. (Ross Archives).

1889) was another engraver associated throughout his working life with
Dixon & Ross. Though he would have been only sixteen at the time of
the firm's establishment, he might have been in contact with the printers
even at that early age through Samuel Cousins, with whom he served an
apprenticeship. Atkinson, like Cousins, did much engraving after Millais,
but perhaps his most celebrated plate is that reproducing V.W.
Bromley's 'Flora', published in 1877 by Thomas McLean.

Artists who patronised Dixon & Ross from the thirties and forties
included John Linnell, Samuel Palmer's father-in-law, who lived in
Porchester Terrace, Bayswater, and later at Redhill, in Surrey; George
Richmond (1809–1896), Palmer's friend and fellow student; J.M.W.
Turner, who brought the printers a small amount of work in the summer
of 1837; and William Bell Scott, painter and poet, based in Newcastle
and with a London address at 3 Belgrave Street, South Pimlico.

The circle of printsellers, picture dealers and publishers who brought
business to the firm during its early years was impressively extensive,
and the names it contained serve to further emphasise the importance of
Dixon & Ross. In London, they dealt with Francis Graham Moon, whose
headquarters was at 20 Threadneedle Street; with Thomas McLean of
the Haymarket; with Joseph Dickenson of 114 New Bond Street; and
with the Belgian Ernest Gambart, whose arrival in England in 1840
heralded his long series of publishing and picture-buying coups. Many
of those with whom they were associated were involved in a variety of
partnerships: Boys, Hodgson and the Graves Brothers, for example. The
Graves brothers, Francis and Henry, eventually emerged from other
collaborations to run their own business at 6 Pall Mall where, from 1842,
it became known as Henry Graves & Company. Dixon & Ross worked
also for the Colnaghis who as P.&D. Colnaghi operated from 14 Pall
Mall East and as Colnaghi & Puckle from 23 Cockspur Street. Work
came increasingly from the provinces: from Agnew and Zanetti of 94

Market Street, Manchester, and from the Grundys who, with the Manchester firm, dominated the provinces. John Clowes Grundy, at 4 Exchange Street, Manchester, was Agnew & Zanetti's closest rival geographically; and his brother, Robert Hindmarsh Grundy, held sway in Liverpool from 26 Church Street. In addition to all these, the Linnean Society and the Society of Dilettanti began with Dixon & Ross an association that was to last at least until the end of the century, bringing to the presses many book plates for the illustration of their various publications.

The 1840s and 1850s brought multiplied contacts with engravers. One of these was John Burnet (1784–1868), who had pleaded the engravers' cause before the Select Committee of the House of Commons on the Arts in 1836, at a time when their struggle for professional recognition was at its height (see Fox, 1976). Burnet was a well respected member of the profession, not only by virtue of his painting and engraving activities but also as a result of his various publications, for example: *An Essay on the Education of the Eye, with Reference to Painting*, 1837. An undated scrap of paper in one of the Dixon & Ross books indicates that the partners were involved in printing the illustrations to this work: 'Mr. Carpenter will thank Mr. Dixon to send for the Plates to Burnet on Colour & Education of the Eye and to Print 50 sets of each as soon as it is convenient.'

Another of the firm's celebrated engraver associates was Frederick Stacpoole, whose name appears in the 1848–1851 Day Book, and who was to be associated with Elizabeth Thompson and the Fine Art Society in the fantastic success of the artist's battle pictures during the seventies.

The Findens – William (1787–1852) and Edward (1791–1857) – and John Richardson Jackson (1819–1877) were others who brought their plates to the Hampstead Road workshop. Henry Bohn joined the ranks of publisher contacts during these years, as did the firm of Ackermann. Rudolph, the founder of Ackermann's, had suffered a stroke in 1830 and had died in 1834. The firm now went under the name of Ackermann & Co. as distinct from R. Ackermann. Ackermann & Co. was run by Rudolph's younger sons. The eldest son, Rudolph Junior, had already set up on his own at 191 Regent Street in 1826. There were thus at this time two separate firms of Ackermann in London (see Ford, 1976).

During the late fifties and early sixties, Thomas Oldham Barlow (1825–1889), busy in his Kensington studio with portraits of inventors for Agnew's, and John Henry Robinson (1796–1871) are named in the ledgers. In the 1854–1861 ledger is entered the name of a Mr. Faed. This is quite likely to have been Thomas Faed (1826–1900) and, again, Samuel Cousins could quite easily have been the common factor: he produced the mezzotint plate of Faed's 'The Mitherless Bairn', published by Henry Graves in 1860. It is, however, equally possible that the Faed referred to was James, the engraver, born in Edinburgh in 1821.

The 1850s mark the time when the volume of overseas trade increased to a substantial degree for Dixon & Ross (see p.17, above). But the printers were now buying, as well as selling, across the water: French black from Bouju of Paris; and Frankfort black from the Hanlein Brothers of Frankfurt-am-Main.

Agnew and Zanetti had in 1835 become Thomas Agnew's and in 1851 Thomas Agnew & Sons. The Agnews did not open London premises until 1860, continuing to do business with Dixon & Ross from Manchester. In addition, the printers had contacts in Birmingham, Sheffield, Leeds, Bradford, Aberdeen and Glasgow. One of the Glasgow destinations for consignments of prints was Anderson's Royal Polytechnic Warehouse, a department store in Jamaica Street: an indication of the increasing extent to which those engaged in the fine art print trade were looking towards popular markets and catering for an increasingly anonymous, ever growing public.

An impression of the volume of trade in London during the sixties and seventies may be gained from an analysis of the amount of business the printseller and publisher Henry Graves transacted with this one printing firm alone. In the half year up to June 1861, he was provided by Dixon & Ross with 2,500 prints; in the half year up to June 1863, with 5,000. During the decade 1860–1870 he paid the printers some £7,500 – an average monthly figure of about £60.

By now the engravers, had they but realised it, were heading for virtual obsolescence. Already in 1870 William Bell Scott (painter and poet) had a presentiment of their eventual disppearance, as he wrote to

John Pye the eminent engraver (1782–1874) seeking his assistance in forming a collection of portraits of English artists and engravers, 'now that engraving has almost ceased to be so employed'. He referred, of course, to the competition of portrait photography (see Fox, *op. cit.*, p.23). However, there still remained for the engravers a decade or two of frantic activity. During these years, engravers named in the records of Dixon & Ross (which, as we have seen, became Thomas Ross in 1876 and Thomas Ross & Son ten years later) include representatives of an older generation: men like Francis Holl (1815–1884), who showed his work on the engraving published by Henry Graves & Co. in 1866. in the autumn of 1862 took delivery of Frith's 'Railway Station' to begin work on the engraving published by Henry Graves & Co. in 1866). There were among them younger men too, like Edward Gilbert Hester (born in 1843 and still active in 1913) who did much work in aquatint after hunting and sporting paintings by such artists as Sheldon Williams. They and many others less well known – including F. Joubert of Camden Town Road, who was commissioned by the Fine Art Society in 1876 to engrave Edward Poynter's 'Atalanta's Race' (Minute Books, Fine Art Society, 13 January 1877) – came to Hampstead Road for their tracings and proofs. Sir Frederick Leighton and John Everett Millais were among the artists who brought their patronage.

Novello, Ewer & Company, who operated the London Sacred Music Warehouse in Berners Street, ordered the reproduction of illustrations for their various musical publications; and the printers also did business with Goupil's, which firm had an office and stock-room in Southampton Street and had, in May 1873, taken into its employment the twenty-year-old Vincent Van Gogh (Bowness, 1968, pp.5, 6).

Things began to take on an even more international emphasis with the frequent travels – presumably to attract business – of Henry Dixon. According to the records, he went to France, Belgium, and the Channel Islands, and seems to have made regular trips across the Irish Sea. In Paris, Bouju the ink merchant had been succeeded by one D. Corniquet, also trading in the Marais district (Bouju had been based at 87 Rue des Marais; Corniquet was at 15 Rue de l'Entrepôt); and Paul Delarue of the Boulevard St. Germain placed small orders for hunting, shooting, and racing prints. There were German clients in Berlin and Dresden, and, early in the 1870s, the Berendsohn Brothers of Hamburg wrote several letters which show how the whole business of printselling was complicated by the intervention of middle-men such as themselves (Appendix I, pp.198–201). One of these letters shows that the enterprising Berendsohns had found it advantageous to carry the torch of English Victorian art to Denmark, Sweden, Norway and Russia where, however many may have been purchased, the sample prints were certainly well thumbed by the dilettanti of those regions. The brothers were emboldened to point out that

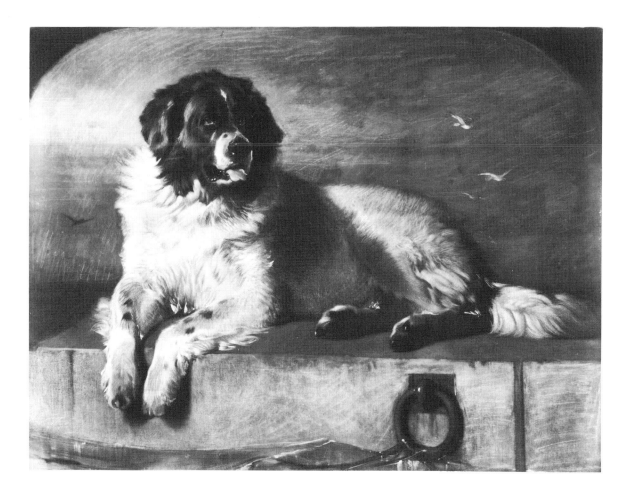

Plate 15
'A Distinguished Member of the Humane Society', mixed mezzotint engraving (18¾" × 24¼") by Thomas Landseer, proof 'touched' by Edwin Landseer. Published 1 November 1839 by F.G. Moon (Ross Collection).

. . . having already two complete sample boxes on the road, we loose much money, as these samples are all spoiled returning from the voyage.

We should feel theirfore very much obliged if you would send us one complete collection of your publications as samples. We will not have any direct advantage by your sending them uncalculated and would return them at your convenience. But we think it is in our mutual interest and would enlarge our business transactions. Our travelling expenses are already so very high that, loosing also the samples our profits would become too small.

The images disseminated by the Berendsohns included Wilkie's 'Blind Fiddler', 'Rent Day', 'Blind Man's Buff', and 'Village Politicians'; various hunting, shooting and stalking prints; and sets of Herring's Horses: the 'Cavalry Charger', the 'Hunter', the 'Lady's Palfrey' and the 'Farmer's Hack' among them. The Berendsohns had a very clear idea of what would sell, writing that

> You would oblige us if you would name us the house where we can
> get Cottage Devotion, Distinguished Member of the Humane Society,
> Doge Laying on a Stone, It is Finished, published 1851 at Herring &
> Remington and communicate us the price . . .

This may have been simply an innocent enquiry. It is equally likely that
it was an indirect request to Dixon & Ross to procure the prints. The
1871 catalogue of Dixon & Ross's own publications shows that they
themselves could have supplied prints of Landseer's 'Distinguished
Member of the Humane Society'. They would no doubt have been
willing to obtain from Lloyd Bros & Co. (see Printsellers' Association,
1892) prints of Thomas Faed's 'Cottage Devotion' and to track down the
other subjects for their clients.

The Hamburg dealers were evidently tirelessly vigilant in the

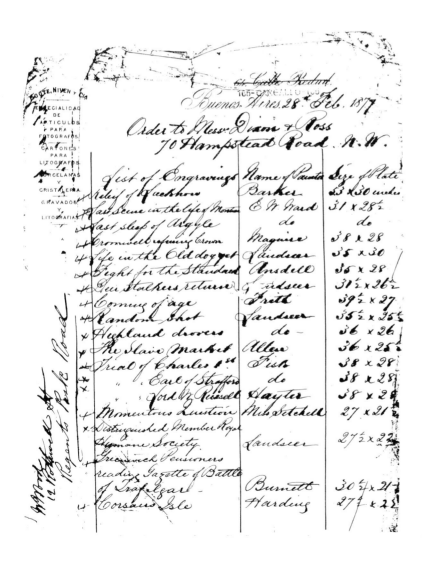

Plate 16
An order from Boote, Niven & Co.,
Buenos Aires, 28 February 1877
(Ross Archives).

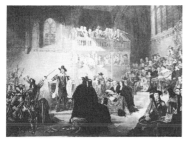

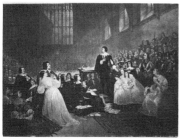

Plate 17
'Trial of Charles I' engraved by C.E.
Wagstaff after the painting by
William Fisk. Published 1846 (Ross
Collection).

Plate 18
'Trial of Thomas, Earl of Strafford',
engraved by W.H. Simmons after the
painting by William Fisk. Published
1846 (Ross Collection).

promotion of their enterprise, proposing a device which has today
become common:

> The list of your publications we saw at some of our customers ...
> you would oblige if you would send us one copy of it. Could you
> print us 200 Catalogues with our firm and prices, we think this
> would enlarge our busyness ...

English prints continued to pour into the New World during the
seventies, and again, the Dixon & Ross records provide a convenient
and no doubt representative encapsulation. Charles Coggeshall, of
274/278 Wabash Avenue, Chicago, took delivery of very large consign-
ments, one of which – in August 1875 – consisted of three packing cases
containing near enough three-and-a-half thousand prints valued at al-
most four hundred pounds. During the same year, Jacoby and Zeller, with
branches at 70 John Street and 104 William Street, New York, were the
recipients of prints invoiced at nearly £200. Another American citizen
busily involved in the print trade was Schaus of 749 Broadway, New

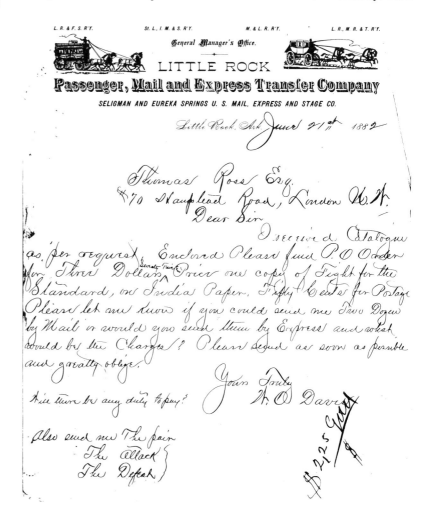

Plate 19
An order from Little Rock, Arkansas,
21 June 1882 (Ross Archives).

York. He was sufficiently energetic to make the journey across the Atlantic to attend a Directors' meeting of the Fine Art Society. He had a proposal to put to the directors; it was that he should exhibit Elizabeth Thompson's phenomenally successful 'Roll Call' in New York to prepare a demand for engravings, and that he would subsequently take a share of the print sales (Fine Art Society Minute Books, 3 May 1876). The proposal was considered, and Schaus would get his answer on his return to England two months later. There is no record in the Minute Books as to whether or not the answer was positive — probably not: there seems to be no evidence to suggest that the 'Roll Call' was ever exhibited in America. The picture had, anyway, been ceded by its original buyer to Queen Victoria two years prior to Schaus's negotiations with the Fine Art Society (Treble, 1978, p.79).

Wilkie, Landseer and the sporting painters and draughtsmen were meanwhile being popularised in South America as well as in the North: Boote, Niven & Company of Buenos Aires, 'specialists in photographs, porcelain, crystal, engravings and lithographs', ordered prints after E.M. Ward, Ansdell, Hayter and Burnet as well as after Wilkie and Landseer. The ever popular set of trials — 'Charles I' and 'The Earl of Strafford' by Fisk, and 'Lord Russell' by Hayter — were among the subjects ordered and, incongruous though it may seem, 'The Deer Stalker's Return', 'The Last Moments of Mary, Queen of Scots', and Burnet's 'Greenwich Pensioners' found places among the prints designated for the decoration of Latin American drawing rooms. Consolation, perhaps, for expatriates

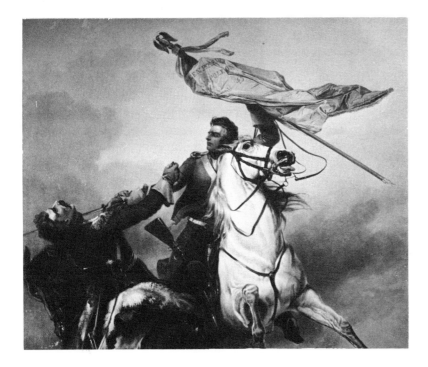

Plate 20
Detail of 'The Fight for the Standard', engraved by H.T. Ryall after Richard Ansdell's painting of 1848. Published by Dixon & Ross Unlimited, 1861 (Ross Collection).

whose residence in countries like Argentina and Chile was connected with the large investment there of British capital (Hobsbawm, 1979, pp.136, 148).

It is perhaps indicative of the engravers' thinning ranks that only one of any note seems to have embarked on an association with Dixon & Ross during the 1880s: John Douglas Miller, who worked after Leighton and upon portrait commissions between about 1870 and about 1903. Miller lived a short step from the printers, in Fitzroy Square, and frequently called to have portrait proofs taken off. Henry LeJeune, the painter of scriptural subjects, and Edwin Long, who painted the portrait of Samuel Cousins, of which the veteran engraver made his last plate (see Appendix I, p.204), were also among the clients of the eighties. During these years Arthur Tooth, of the Haymarket, brought much business to the firm; Tucks, in the City Road, purchased Landseers and various sporting prints; Letts, based in King William Street, had proofs taken off map plates of Europe, Arabia and China; and Macmillan's, of Covent Garden, sent to the press thirty book plates for a Dilettanti Society publication. Dalziel Brothers, the wood engravers, ordered proofs to the value of one pound; and another small spender was W.O. Davis, of the Passenger, Mail and Express Transfer Company, Little Rock, Arkansas. The latter bought a print of the twenty-year-old 'Fight for the Standard' (painted by Richard Ansdell, engraved by H.T. Ryall and published by Dixon & Ross Unlimited in 1861), and the epicurean subjects coyly entitled 'Attack' and 'Defeat'.

Chapter 2

Collaboration and Competition

Whilst this book is concerned particularly with the printing of metal plates engraved by one means or another for the purpose of reproducing works of art, no account of the activities of plate-printers in nineteenth-century London should neglect the fact that very few (if any) of them concentrated exclusively on work for the fine art trade. Dixon & Ross was one of the very few firms listed by Andrew Tuer in 1882 as being fine art printers (p.xxiv, above). There is plenty of evidence throughout the firm's records that even they undertook much work of a humbler and more ephemeral kind. Unhappily, there is less evidence from McQueen's, another firm described by Tuer as a fine art printer's. However, a delivery book covering the second decade of the nineteenth century and a ledger opening in the 1880s (both owned by Mr. P.N. McQueen) show a wide range of activity. Engraving as a means of reproducing original paintings or drawings should be seen as part of a continuum of activity which embraced the autographic printmaking of artists; the production of plates specifically for book illustration; for maps, stamps, and bank-notes; for trade labels, bill-heads, and so on. Fine art engraving was but one part of such a continuum. Often single individuals – artists, engravers and certainly printers – operated over an extensive section of it. William Holl (1771–1838), William Finden (1787–1852) and Charles Heath (1785–1848) exemplify the manifold activities of many engravers. All were involved in the engraving of bank notes (see Dyer, 1819) and, in addition, Holl engraved portraits, historical subjects and marble sculptures; Finden did much work in book illustration and after such artists as Landseer and Wilkie; and Heath engraved for the annuals and after the works of Thomas Lawrence and others.

Printing processes in general may also usefully be considered in relationship to each other: not only is it essential to consider the intaglio printing technique as being in a situation of competition with other printing processes such as lithography and the printing of engraved wood-blocks; it is also important to consider the cross-fertilisation that to some degree took place. The earliest directory reference to litho-

graphers appears in the *Post Office London Directory* for 1820, although
the process had been introduced into the capital some twenty years
earlier (see Twyman, 1974/1975).

By 1850, with the growth of firms such as Dalziel Brothers and
Messrs. Swain, wood-engraving had become a significant industry in
England (see Woodward, 1974/1975). There are frequent examples of
single individuals undertaking work in more than one process.
Admittedly, examples of such versatility seem to occur more frequently
early in the century. It seems likely that many engravers in metal became
excited by the possibilities of stone as lithography began to take root
during the first decades of the nineteenth century. Charles Heath was
among these enthusiasts, judging by his pen-drawn lithograph of a
mythological figure (Mars?) of which there is a proof in the Whitworth
Print Room, University of Manchester. Thomas Shotter Boys worked in
etching and engraving as well as in lithography (see Smart, 1974). Also,
Thomas Bewick, best known for his wood-engravings, worked on metal
to an even greater extent than on wood (Bain, 1975). There are certainly
many examples of publishers marshalling reproduction by intaglio,
lithography and wood-block — as well, of course, as by letterpress —
between the covers of a single book. Metal, stone, and wood were all
employed in reproducing the illustrations to, for example, Schomburgk
and Bentley's *Twelve views in the Interior of Guiana*, published by
Ackermann in 1841. There was cross-fertilisation in another sense, too:
the processes were often made to imitate each others' characteristics, and
even where the imitation was not deliberate there were sometimes close
resemblances. It was common for lithographs to be given the appearance
of line-engravings; and the engraver of metal plates had in his technical
repertoire many effects difficult to distinguish — though often quite
incidentally — from those of lithography. The scrap-book of Charles
Hullmandel (St. Bride's Printing Library, London) contains examples by
W.H. Kearney, printed by Hullmandel in the 1830s; and a prospectus of
10 May 1824 draws the attention of prospective clients to 'the
adaptation of Lithography to all commercial purposes ... Whether
required as fac-similes or in a Superior character in imitation of
Engraving ...'. (There is a copy of the advertisement, issued by C.
Ingrey, in the library of the Linnean Society.) A bill of 1836 (also in the
Linnean Society's library, and sent by Charles Hullmandel) indicates how
such imitations could be achieved: by 'Engraving transferred from
Copper and Printed from Stone'.

A further interesting complication in the matter of process is that of
the sporadic and by no means clear-cut infiltration of photo-mechanical
methods (see Cartwright, 1939). Developments in photographic tech-
nique had two basic effects upon the engraver in metal: on the one hand
they paved the way to the perfecting of processes such as photogravure,
which ultimately made his labours redundant (see Denison, 1895); but on

the other, they provided him with a novel and interesting tool. There are many instances of engravers making use of photography as an aid to hand production rather than succumbing to it as an insuperable opponent. The correspondence of Ruskin with John Le Keux (Victoria and Albert Museum, microfilm 85), mainly referring to the production of *Modern Painters*, reveals some intriguing harnessing of the evolving medium:

> I want to know if you think you can do one other plate before Xmas, containing two towers with a wall . . . to be copied from a Daguerreotype . . . If you think you can do it I will get it ready for you directly . . .

and:

> My purpose . . . is to show in the centre a Daguerreotype – <u>Nature</u> as far as I can, as she appears under Rembrandtesque light and shade (which you know the Daguerreotype or photograph always gives) and on each side of it – fig. 1. – the interpreting and explaining power of Dureresque art – in fig. 3. the vulgarizing power of modern Blottesque or water-colour art.
>
> So that, you must try to put into the Daguerreotype no more than you can see – giving <u>quite</u> its obscurity and indistinctness, but in doing so it may save you some trouble to have the pencillings on No. 2 by you, as you must <u>err rather</u> by clearing than further obscuring the photograph – but what I <u>want</u> is the photograph exactly . . . Rocks in fig. 4. to be copied from other daguerreotype – and sky put behind

The interesting point made by this extract is, of course, that the daguerreotype provided for the engraver a new kind of visual experience. Even though Ruskin was requesting 'the photograph exactly' – and the engraver's contribution to the collaboration may perhaps be regarded as somewhat passive – the transactions with Le Keux represents the introduction of a fresh way of seeing, and therefore a subtly new kind of image, into the repertoire of engraved effects.

A similar use of photography* is indicated by the inscription on Thomas Oldham Barlow's portrait of Samuel Crompton: 'Engraved from a photograph of the original picture by Allingham'. Barlow (1824–1889) was engaged by Thomas Agnew to reproduce the Crompton portrait, which was published in March 1862. The printing was by Brooker (another on Tuer's list, p.xxiv, above) – a detail worth noting in view of the paucity of acknowledgement to the printers of intaglio plates.** Photography must to some extent have deprived copyists of work. Paintings were frequently copied so that engravers could refer to the replicas, and so that the risk of keeping valuable originals for long periods in their workshops was avoided; but when, in 1862, Frith was commissioned by Ernest Gambart to paint a set of three large pictures ('The Streets of London') it was agreed that the engravers should ultimately work from photographs of the originals (Maas, *op. cit.*, p.158).

* Interesting postscripts to the question of what may be called a marriage of photography and engraving were provided by the exhibition *Pictorial photography in Britain, 1900/1920*, Arts Council of Great Britain, 1978, in which appeared several examples of photographs produced in deliberate imitation of mezzotint effects: e.g. J. Dudley Johnston, 'Liverpool – An Impression', 1907.

** Other names that appear from time to time on the margins of prints are McQueen's and Lloyd's.

Any impression that the arrival of new methods eclipsed the older processes almost overnight is far from accurate. The observation that 'every little while we hear of some new process going to do wonders; it starts and like others before it, fades . . .' (Woodward, *op. cit.*) was probably much more truly descriptive of the sheer untidiness of the process of supersession. Printing from intaglio plates, from lithographic stone and from wood blocks flourished in one way or another throughout the nineteenth century, joined ultimately – in the 1880s – by photogravure. There were printing firms that worked in two or more of these processes – McQueen's and Day & Sons for example.

McQueen's, best known as intaglio printers, had certainly taken up lithography by 1822, though unprofitably (Bain, 1966, p. 11). Details of the firm's subsequent enterprises in the process are obscure; evidence suggests that they may have printed their own lithographs later in the century, as opposed to farming out the printing to Vincent Brooks, Day & Son, Messrs. M. & N. Hanhart, and Messrs. Thomas Kell & Son which, according to the *Catalogue of Engravings* of F.C. McQueen & Sons (*c.*1882) they did during the 1880s. The memorandum of the association of the McQueen Brothers Ltd (incorporated as a limited company 26 July 1865 and liquidated 14 August 1876 to be succeeded by F.C. McQueen & Sons: Public Record Office BT31/1131/McQueen Brothers. Ltd/2305c) sets out the objects for which the company was established: 'To acquire the business of Plate Printers, now carried on by Messrs. William Benjamin McQueen, John Henry McQueen and Frederick Charles McQueen under the firm of McQueen Brothers . . . and to carry on and extend the said business in any branch, whether Printing or Lithographing, or adding thereto any department that may be deemed advisable'.

In 1857, Frederick Goulding the plate-printer was apprenticed to Day & Son, famous principally as lithographers (see Twyman, *op. cit.*, 1974–1975, p.30; and Hardie, 1910). In 1858 Goulding began printing large intaglio plates for Day's (e.g. C.G. Lewis's mixed engraving and mezzotint after T. Jones Barker's 'Allied Generals before Sebastopol', declared to the Printseller's Association 15 August 1856 by Thos. Agnew & Sons and J.G. Browne). The following year he was detailed to assist Whistler who visited Day's Workshop to proof his etchings (p.45, below); and in 1862 he demonstrated the method of printing engravings at Day's stand at the South Kensington Exhibition.

As noted above, there were many instances of books in which intaglio plates, lithographs and wood engravings appeared with the letterpress: the joint product of several artists, draughtsmen, engravers and printers. A further and spectacular example of such an undertaking is the *Official Descriptive and Illustrated Catalogue* of the Great Exhibition of 1851. Among the 200 engravers was one A. Petermann of Camden Town whose technique extended the range still further: he was an engraver on

stone, and produced the diagram of the exhibition's layout by this process. His collaborators were the four men who spent seventy days printing from the engraved stone and the six who ultimately spent fifty days hand-colouring the prints (Clowes & Son, 1851, pp.145 ff). One can imagine the magnitude of the task of co-ordination that fell to the publisher of such works. One is prompted to ask why his already complicated undertaking should deliberately have been made more so by the involvement of so many participants working in such a wide range of processes. In part, the answer must be that each process was recognised to be especially appropriate for particular reproductive functions. It is worth noting, by way of a further precaution against over-simplification, that in a century of indefatigable printing experiment, these were simply the salient processes in a welter of new techniques. Elizabeth Harris (1967/1970) has enumerated very many that appeared during the first few decades of the century. The inventors of many of them entertained high hopes: in the 1830s Sidney E. Morse in America and Edward Palmer in Britain developed a printing method which they called, respectively, ceragraphy and glyphography. Both dreamed that their wax-engraving technique would seriously compete with etching as a medium. Of the hand methods, traditional intaglio, lithography and wood engraving were winners by virtue of their essential simplicity, adaptability and versatility. Such survivors (and it should be remembered that all three still survive; only their commercial feasibility as reproductive methods has been affected) had to be processes that would meet the demands of artists working autographically, of publishers and printers demanding durability and predictability for the achievement of large editions, and engravers needing media susceptible to a repertoire of effects appropriate to their particular task, whether the reproduction in lithography of an original crayon drawing, the transforming inherent in the engraving of images on wood, or the subtle interpretation of the chromatic and tonal variations of a painting with acid and graver in a surface of metal.

Where the reproduction of original paintings of some importance was concerned, intaglio remained paramount for most of the nineteenth century. There is little doubt that intaglio (and, particularly, line-engraving) was considered throughout the period the most splendid means of reproduction, and publishers who could afford it would almost always have paintings interpreted by this means. Practically all the century's major paintings were reproduced by the intaglio process; comparatively few in lithography. When the challenge did come, it came from photogravure rather than from lithography or wood engraving. One of the important reasons for this must simply have been that by the time lithography had fully taken root — Michael Twyman (*op. cit.*, 1974–1975) has shown that by 1840 lithographic printing houses were tending to outnumber those of copper- and steel-plate printers — the

publishers and printers of copper and steel reproductions had amassed gigantic stocks of plates and had a firm grip on that particular aspect of the market. In a letter of advertisement sent to Philadelphia in 1851, Dixon & Ross claim to 'have a great variety [of plates] consisting of nearly one hundred subjects all of the best class of engravings . . .' (Appendix I, p.188). The firm's trade list of 1871 announced between five and six hundred subjects, including 'the last grand works of John Martin', engraved by Charles Mottram. By 1887, the date of the compilation of a notebook still in the firm's archives, it seems to have held nearer to seven hundred plates. The book contains what is probably a complete list of the plates then held. Titles are frequently abbreviated and interpretation is sometimes difficult, but the lists nonetheless yield much interesting information. For example, the owners of many of the plates are named, and the dates when plates were returned to them are indicated. These details show that the printer often held a publisher's plates for many years. The plate of 'Grace Darling' for example (engraved by George Zobel after the painting by Thomas Brooks), was declared to the Printsellers' Association by B. Brooks & Sons on 1 July 1869, and was held by Dixon & Ross (and then by Thomas Ross) until 1898. The firm held plates for Agnew, Colnaghi, the Fine Art Society, Graves, Thomas McLean, Frank Sabin, and Tooth, among many others.

Lithography — for its first twenty years the province of a few artists and considerable numbers of amateurs (Twyman, *op. cit.*, 1974/1975) — must have seemed the ideal vehicle for autographic expression. Following its amazing flowering and spreading after 1820, and once its relative cheapness and expeditiousness were fully realised, it made spectacular forays into the fields of book illustration, graphic journalism and jobbing printing (Twyman, 1970, *passim*). Perhaps another reason why the intaglio engravers and printers held on to the market for reproductive engraving was the fact that metal plates — even the most cumbersome of them — could relatively easily make the journeys between publisher, engraver, and printer that the collaborative nature of that particular aspect of the trade demanded. It was clearly out of the question to move very large slabs of limestone too often and too far from the lithographic press (Twyman, 1974/1975, p.5). By 1850, a little later than lithography, wood-engraving sprang into industrial viability in England. Although large engravings *were* possible in the medium, the biggest normally appearing were of the order of 9" by 12". Woodward (*op. cit.*, p.58) gives as an example of a very large wood-engraving the view of London which appeared as a frontispiece to the first volume of the *Illustrated London News* in 1842; to achieve it, sixty blocks and the labour of nineteen engravers were combined. The wood-engraving process was, of course, particularly convenient in circumstances where illustrations were to be combined with type: both could be printed in the same operation, since the depth of the block could be made to

correspond exactly with that of the type. A wood-block could also withstand very long print runs.

However many the participants in any reproductive enterprise, the constant point of contact was the printer: the man responsible for the final stage of production. Where the intaglio printer was concerned, the network of contacts was perhaps particularly elaborate. Everybody, from publisher to plate-polisher, was in close touch with him. Artist, engraver, publisher, and dealer kept a sharply vigilant eye upon his activities, since success ultimately hinged on his skill. The printer, in turn, kept an equally close watch on those other links in the chain upon which the quality of his workmanship in such large measure depended. The production of prints from engraved metal plates became in the nineteenth century a collaborative venture of unprecedented intricacy. A delivery book of William McQueen (p.xxix, above) shows that this was already the case in the first quarter of the century. A glance at the entries relating to the publication by Cadell and Davies of *Don Quixote de la Mancha* vividly evokes something of the pace at which the work seems to have been conducted. Plates and proofs went backwards and forwards between the publishers in the Strand, McQueen's at 72 Newman Street, and the addresses of Edward and William Finden, James Heath, Charles Warren and the other engravers employed. Partly completed plates were to be proofed for the engravers' reference in subsequent working, and plates with finished illustrations were sent to have their titles engraved or altered,* for the 'Publication to be Engraved', or 'to be cut down for small India' (that is, for a smaller format in which the illustrations were to be printed on the more expensive india paper; pp.166–7, below). References to the project begin:

Sept. 20 1817 Del'd to Messrs. Cadell & Davies 3 Plates
 Vignettes Don Quixote.
Oct. 7 Rec'd of Messrs. Cadell & Davies
 24 Plates Vignettes to Don Quixote
 9 do. Subjects wrighting finished
 14 do. do. do. not finished.
Oct. 8 Rec'd of Messrs. Cadell & Davies
 6 Plates Subjects Don Quixote
 Del'd of Messrs. Cadell & Davies three
 plates vignettes to Don Quixote by Mr. A. Smith.
Oct. 10 Del'd to Mr C. Warren two plates to
 Don Quixote.
Oct. 11 Rec'd of Messrs. Cadell & Davies 6 Plates
 Subjects to Don Quixote.
Oct. 14 Deliver'd to Messrs. C & D 10 Plates to
 D.Q. to have the Wrighting Finished.
Oct. 15 Delivered to Messrs. C & D 11 Plates to
 D.Q. to have the Wrighting Finished.
Oct. 20 " " " " 2 Plates to D.Q.

* This work was usually undertaken by a specialist. Several such specialists are listed in the various ledgers and day books of the Dixon & Ross archives. In the earliest surviving ledger, opening 21 June 1833, appear the names Becker, Sawyer and W. Downey, all described as 'writing engravers', and Becker as a polisher also.

Oct. 31 Rec'd back the plate of D.Q. from Mr. Finden.
Oct. 31 Delivered to Messrs. C & D the Proof of the
 vignette to D.Q. 25 in number but only 24 plates
 received by Mr. McQueen.
Nov. 4 Deliver'd to Messrs. Cadell & Davies 1 plate by
 Finden to have the wrighting and 1 plate to Don Quix.
 to have the wrighting altered.

The entries continue to July 1818 – the year of publication – with
particularly feverish activity during the months of February and March
of that year.

The complexity of the collaborative system and the need for every
participant to work with care and despatch is underlined by an undated
letter to William McQueen. The signature is illegible though, ironically,
the sender is obviously an engraver of titles (Appendix II, p.216):

122 Regent Street,

21st. April

My dear Sir

The awkward situation into which I am put by the delay and neglect
of Mr Finden is really very annoying. I repeatedly entreated that
proofs of the vignettes should be sent to me; and yet I was called
upon to supply the writing for the title of England Vol: II without
having any proof or copy of the vignette before me . . . At length a
copy of the vignette has been sent to me, and I find that instead of
Sir Thomas More answering Cardinal Wolsey it represents Cardinal
Wolsey addressing Sir Thomas More. Thus the subscribed writing is
inconsistent with the vignette . . .

The common procedure was for the engraver or an assistant to make
careful working drawings from the original painting or drawing to be
reproduced. During his apprenticeship to S.W. Reynolds (from 1814)
Samuel Cousins was despatched to various parts of the country to make
accurate pencil drawings of the portraits of Sir Joshua Reynolds, whilst
his master was engaged on the 360 small plates after these works
(Whitman, 1904). There were sometimes obstacles: when, in the 1830s,
Cousins was preparing for the engraving of Landseer's 'Bolton Abbey',
the Duke of Devonshire would not allow him to remove the original
from the wall at Chatsworth. He had to do the best he could with the
picture hanging eight feet above him (Whitman, op. cit.). T.H. Fielding
(1841) describes the usual method. Oil paintings were 'squared down'
with water colour (which could easily be sponged off afterwards) – black
on the light passages, white on the dark – and, by means of this
guidance, the subject was scaled down and drawn on smooth paper.
The paper could subsequently be damped, placed drawing side down on
a plate prepared with a ground of wax, and passed through 'a

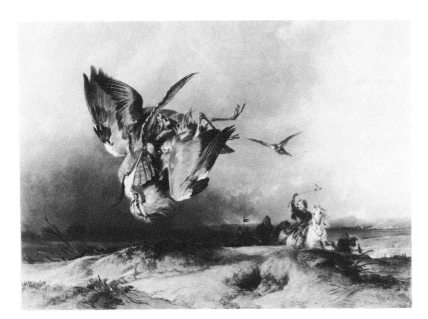

Plate 21
'Hawking' (also called 'Hawking in the Olden Time'), mixed mezzotint engraving ($22\frac{3}{8}'' \times 27\frac{3}{4}''$) by Charles George Lewis, 1842, after the painting by Edwin Landseer, by 1832 (British Museum, Department of Prints & Drawings).

Plate 22
'Hawking': detail of Lewis's preparatory drawing (British Museum, Department of Prints & Drawings).

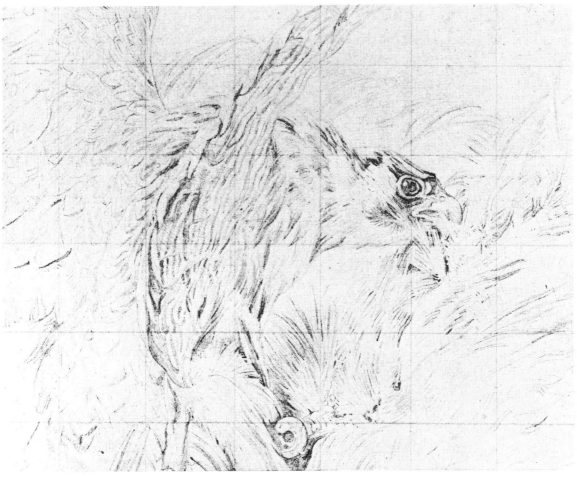

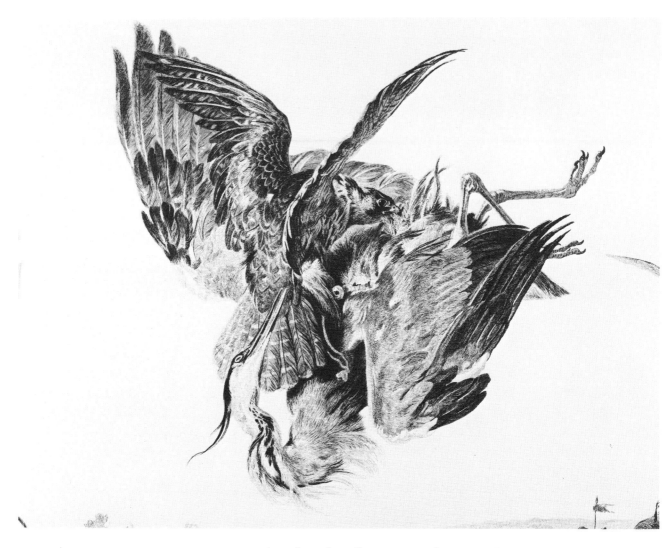

Plate 23
'Hawking': detail of etched state
(British Museum, Department of
Prints & Drawings).

moderately tight rolling press', whereupon the subject would 'appear reversed [on the grounded plate], in fine silvery lines', ready for the first stage of engraving. Water colours were squared down with threads. In cases where a drawing or painting was to be engraved with no reduction in size, the squaring procedure was obviously unnecessary: a direct tracing could be made and transferred to the plate as described above. Tracing paper was made by dabbing with rag or cotton wool a mixture of equal parts of spirits of turpentine and drying oil on to tissue paper or very thin, smooth writing paper. Paper treated in this way would be ready for use within a day or two (Fielding, *op. cit.*).

The first stage in working a plate remained by and large the same throughout the nineteenth century: the main outlines of the design were etched to provide guidance for the subsequent application of tone by whatever method — line engraving, aquatint, mezzotint, or a mixture —

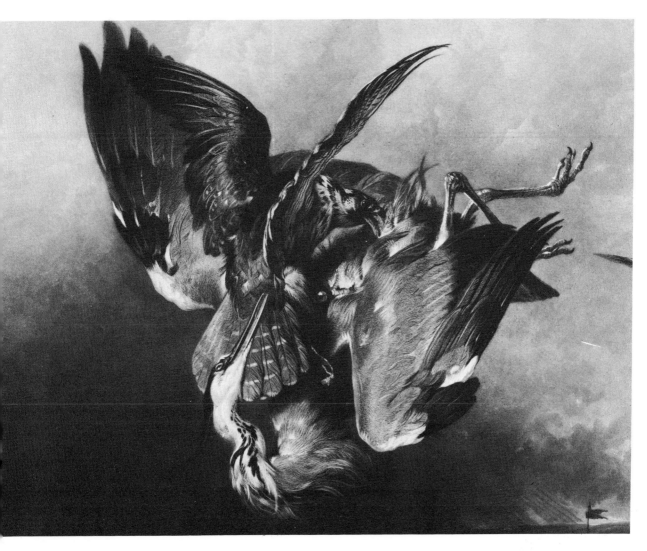

Plate 24
'Hawking': detail of proof 'touched' by Landseer.

happened to be current (pp.118–123, below). During the work's progress, the plate would be sent to the chosen printer for proofing. There were often many further complications before it was finally put to press: erasion and correction to parts of the design; the attentions of a ruling specialist (pp.126–130, below); the addition of lettering; the cleaning and polishing of margins on to which a graver or a mezzotint rocker had inadvertently strayed; or last-minute modifications on the instructions of the original artist.

The journals of Samuel Rawle (1771–1860), an engraver active in London during the first half of the nineteenth century, afford a further glimpse of the collaborative system and its ramifications. The Rawle papers in the St. Bride Printing Library comprise a bundle of family letters and two small notebooks. The books cover the years from 1820 to 1840. The earlier of these volumes has been compiled with great zest;

this exuberance, and the frequent references to collaboration with
'Father', suggest that the writer was the engraver's apprentice son. The
little book — lavishly ornamented with marginal sketches that are in
themselves an index to contemporary pictorial taste — vividly evokes the
young man's sorties to the workshops of Lahee (the printer of Turner's
Liber Studiorum plates) and McQueen; to the homes of artists like Daniel
and Robert Havell, for whose aquatints the Rawles were preparing the
preliminary etched outlines; to the coppersmith's for new plates; and to
the shops of men who specialised in laying wax grounds upon plates and
ruling lined areas for skies (pp.127–9, below). Rawle and his son evi-
dently worked very long hours side by side, frequently — when work was
pressing — on a Sunday. The younger man did a great deal of tracing and
scaling down of original drawings for transfer to the grounded plates;
and, when the needling was completed, did much of the etching. The
entries in the young man's notebook constitute a most interesting and
revealing inventory of the many tasks associated with the production of
prints, and a number of notables make an appearance in its pages:

> Mr. D. Havell called and brought ten drawings for me to etch nine of
> them views in France the other a view of Sidmouth the price for all ten
> guineas . . .
> Mr. [Rudolph] Ackermann sent two plates for me to etch . . . I etched
> one and Father another . . .
> I went to Britton's [probably John, the publisher, 1771–1857] and to
> Somerset House [where the Royal Academy was to be based until
> 1837] Exhibition . . .
> Bit in Britton's plate shewed him a prove he liked it gave draft
> on his Banker for £12.0.0. . . .
> Sunday began the reducing of Ely . . .
> I finished the etching of Ely and bit it in and proved it and took it
> home . . .
> Went to Mr. Havell's with painting of Ely and began the tracing of
> Strasbourg . . .
> Went to Shoe Lane [where plate-makers congregated] for plate of
> Strasbourg . . .
> I finished the reducing of Brignall Church [probably J.M.W.] Turner's
> drawing . . .
> Mr. Havell sent a drawing of an Urn for me to etch I traced it and run
> it through the press . . .
> . . . took the plate of Strasbourg to Mr Lahee to be printed and took
> and received Bill for two months to Mr McQueen . . .
> . . . to Society of Water Colours at Bullock's exhibition rooms [i.e. the
> Egyptian Hall, Piccadilly, where Géricault's 'Raft of the Medusa' was
> displayed to an estimated 50,000 visitors in 1820; Johnson, 1954]
> where they exhibited the first time . . .
> . . . went . . . to Martin's exhibition of the feast of Belshazzar [which
> was being shown under the auspices of the British Institution,
> arousing such interest that it had to be railed off to keep the crowds
> back; Boase, 1959, p.106] . . .

It is quite clear from entries such as these that work on most plates was governed by quite an elaborate division of labour. It is probable that a considerable number of specialists actually had a hand in the evolution of a plate that ultimately bore an acknowledgement to a single engraver. When Frank Howard (the author of various manuals on art) wrote to McQueen's with requests like these, it is likely that someone like Rawle was entrusted with the job.

> I fear you will think me very troublesome to you in asking you to do anything like business for me in town, but I know of no one else on whom to depend in the way of engraving. Will you oblige me by proving the enclosed three plates and if they are very indistinct get some experienced hand to rebite them to give sufficient depth to please me and the public, in short to match with the generality of the others. Will you favour me further by getting the dates altered of those which I have left undone. The fact is I am very considerably behindhand and cannot make the alterations, rebiting & c so well or so expediously as a more practiced hand. Let me have one proof of each plate as before on plain paper, both before and after the rebite if the latter is necessary. I shall not be in town for some time and shall not have the power to attend to these things myself if therefore you will get it done you will confer a great obligation upon
> Yours very truly . . .

Howard's postscript would have meant one of the McQueen apprentices making yet another special journey: to a polisher who would clean up the margins of the plate:

> NB – Has the plate altered from 11 to 13 been altered again to 12 as it should be? Did I mention to you in my last that I would wish you to get some one to remove the superfluous lines which I have not quite burnished out?

The choice of a printer to whom to entrust the bringing to fruition of labours that could sometimes have lasted years was obviously a matter of great importance: 'In a work which I am about to publish on the Bell Rock Lighthouse' (*An Account of the Bell Rock Lighthouse*, Edinburgh, 1824), wrote the engineer, Robert Stevenson, from Edinburgh on 10 February 1824, 'extending to Twenty-three Plates, there are three which I wish to be printed with care and attention. The engravers Messrs. Horsburgh and Miller have accordingly suggested that they should be sent to [McQueen's]'. The workshops of leading plate-printers were hives of industry. In a large concern, paying out wages to as many as thirty employees, there could have been up to twenty rolling presses in action. In the latter half of the nineteenth century, McQueen's are thought to have been operating as many as twenty-five to thirty presses (Bain, 1966, pp.12, 13). The work was likely to have been diverse in nature: trade labels and artists' proofs often being printed on neighbour-

Plate 26
Detail of the plate ($23\frac{7}{8}'' \times 28\frac{1}{2}''$ work size) of 'Maid and the Magpie', mixed mezzotint by Samuel Cousins after the painting by Edwin Landseer. The dark spots are corrosion in the steel. Published by Henry Graves & Co., 1862 (Ross Collection).

ing machines. Amid all this, proprietors obviously needed to keep a very careful watch on the progress of the really important work. A high degree of skill was demanded by publishers, artists and engravers of printers for whom the handling of fine art work was often merely one aspect of a very large sphere of business. The wide range of their activities only makes the standards they achieved seem the more remarkable. There are many instances of their successes and, understandably, of their shortcomings. Algernon Graves has reported that when Samuel Cousins' mezzotint plate after Lawrence's portrait of Pope Pius VII was sent to a printer other than the one usually employed the plate was ruined, and Cousins wept with disappointment and frustration (Whitman, 1904). Ruskin evidently had a happier relationship with John Le Keux, who undertook some printing as well as engraving in connection with *Modern Painters*:

> I cannot tell you how much I am pleased with all you have done for me . . . I am especially delighted with my own etching violet and azure in distance. I have written a request to Mr Brooker to send you the plate as soon as it is lettered and I shall be truly obliged to you if you will undertake thus printing it in two tints but I should like to see one with black in the foreground and blue black in the distance – as I am not quite sure about the violet.

The letter (Victoria and Albert Museum, microfilm 85) contains clear indications of Ruskin's reliance upon his printer's skill and judgement. It is plain that Le Keux was considered a collaborator rather than a mere executant.

The affair of the Pius VII mezzotint was not, alas, Samuel Cousins' only brush with a printer. On 13 October 1862 he wrote a letter of complaint to William McQueen: 'the plate of the Maid and Magpie has been put into the hands of Mr. Dixon at the particular desire of Mr. Graves, who complains, and with reason I think, of the manner in which you printed the plate of Lord Clyde [engraved from a portrait by Sir Francis Grant]'. By this date, the McQueens were installed in premises in Tottenham Court Road. The workshop of Dixon & Ross was a little further north, in Hampstead Road.

The plate of the 'Maid and Magpie', originally declared by Henry Graves in September 1862,* is now owned by Ross's. It measures over two feet by nearly three, and was engraved in mezzotint by Cousins after Edwin Landseer's original painting. Judging from the Day Books, it seems to have been in Mr. Dixon's hands by the middle of September 1862. Two artist's proofs went to Graves on the 24th; and, on 1st October, twelve more to him and five to Cousins – who didn't inform William McQueen until nearly two weeks later that he had lost the job! (Appendix I, p.197). Precisely how McQueen was at fault over the matter of the plate of Lord Clyde is not made clear either by the correspondence or by other records – so many things, from the damping of the paper or preparation of the ink to the handling of the plate itself could have gone awry. However, a letter (owned by Mr. P.N. McQueen) of May 1862 from Cousins to Graves, inviting the publisher to send him the plate, whereupon 'I will see what I can do to put it into a better state for printing', suggests that the condition of the plate was to be blamed for the unsatisfactory printing.

It is clear that there were many ways in which prints could be spoiled; but what is perhaps not as fully appreciated is the extent to which a printer had it in his power positively to enhance an impression. A few minutes spent observing the plate-printer's procedure would help to make this evident. When in 1859 Whistler arrived at the premises of Day & Son (plate printers as well as lithographers) to do his own printing, Frederick Goulding was detailed to assist. He learned, watching Whistler, 'that there was something in the printing off a plate beyond the mere filling of its lines with ink and cleaning with hand and whitening . . . that something of the artist's mind could pass through his fingertips to the inanimate copper' (Hardie, op. cit.). There are obviously many levels at which the work of printing may be carried out, from that of the artist-printmaker like Whistler, whose idiosyncratic treatment of the plate meant that no two prints were alike – the basic etched image being given almost monotype treatment – to that of the reproducer of

Plate 27
A page from a Dixon & Ross Day Book, recording the early stages of the printing of Landseer's 'Maid and the Magpie' (Ross Archives).

* The date of declaration to the Printsellers' Association was not necessarily the same as the date of publication appearing on the engravings. A Dixon & Ross Delivery Book (Appendix I, No. 20) contains a memo from Henry Graves & Co., dated 17 May 1865, and issuing the following instructions: 'In future when a plate is finally ordered to be put to Press the Date in the line of Publication is to be altered to that of two days after the first day's Printing.'

visiting cards, whose skill was of a more mechanical nature. But somewhere in between lies the field of activity of the printer of editions of reproductive engravings.

Apart from the application of overlays to create subtle variations of pressure and thus enhance spatial illusion, the printer of wood blocks was hardly in a position to further the work of the artist and engraver (Jacobi, 1890, pp.184 ff).* By contrast, the printer of intaglio plates – and, incidentally, the lithographer** – had it in his hands to further the creative process: 'the printing being in a similar relationship to the engraved plate as is musical performance to composition' (Exposition Universelle, op. cit., p.30). It is the very nature of the intaglio plate that makes this possible. The simple fact is that an engraved plate always prints intaglio and relief simultaneously. The pressure of the rollers, the resilience of the blankets and the suppleness of the damped paper combine to produce what is virtually a cast of the plate; and however thoroughly the plate's surface is wiped (pp.151–2, below) after ink has been deposited in its crevices, it still transmits the subtlest film of tone to the paper. The depth of this tone can be determined by the stringency or the restraint of the wiping; and such tones, with appropriate variation, may be distributed judiciously about the plate's surface for compositional enhancement.

> You will receive same day as this, the portrait for another proof.
> Kindly use same ink. Don't over wipe the background, but clear out
> face and hands.

This (a note from a client to Thomas Ross) would have come as a familiar instruction to any intaglio printer of pictorial plates. No plate, whatever the quality of the engraving, is incapable of enhancement by the printer. Seymour Haden's*** remark (in the prefatory note to About Etching, London, 1879) – and the implication that this is his ideal – is surprising, to say the least: '. . . a fine proof of Rembrandt's . . . is printed with the greatest simplicity . . . not a mark or a stain is there that has not its counterpart in the plate'. It is particularly surprising that such a remark should have been made of prints of the plates of Rembrandt, whose printed effects so often depended upon calculated residues of 'plate tone'. Perhaps Haden's pronouncement was simply an instance of perception conditioned by predilection.

The printer was sometimes at a disadvantage in being presented with a plate not sufficiently able to withstand the ordeals of the press. It is clear from contemporary accounts that the tendency of some plates to premature exhaustion was a matter of prime concern; even after the employment of steel there could be problems. Such difficulties were usually anticipated when agreements with engravers were drawn up. When Raimbach was commissioned to engrave plates for Suttaby's miniature editions for the poets he received, as well as twenty-five

* However, wood-engraving in the hands of a master should not be underestimated as a medium. Iain Bain has demonstrated, in a paper presented to a conference of the Association of Art Historians (1983), that Thomas Bewick (1753–1828) was adept at lowering by judicious paring of the surface those parts of his blocks that would otherwise print too heavily.

** Charles Hullmandel (in A Manual of Lithography, 3rd ed., London 1832, p.71), maintains that 'a lithographic printer . . . may be compared to an artist who is giving the last finishing touch to an Indian ink or sepia drawing; like the painter, the printer must study the effect of his drawings, and distribute his ink accordingly. If the light and delicate parts have taken too much ink, he must barely touch them with his roller, while the darker parts must be passed over several times . . .'.

*** Haden was the first President of the Royal Society of Painter-Etchers, founded in 1880.

guineas for each plate, fourteen guineas for 'reparations' during the printing of six to seven thousand impressions (Raimbach, *op. cit.*, p.109). In 1830, Alaric Watts asked McQueen's to 'let me see states of all my plates as soon as possible. I must know which keep up best as I will in future employ no engraver whose plates will not go a reasonable number' (McQueen archives) – a clear indication that the mechanics of the engraving process as well as the properties of the metal could affect the situation. Dark passages could be enlivened by the use of the drypoint technique, for example: burrs were raised in the metal by scoring it with a hard steel point; for a limited number of impressions such burrs would hold ink, but they would very soon flatten and the prints deteriorate. In one of the Dixon & Ross day books covering the years 1854 to 1857 (Appendix I, No. 15) it is noted that 'Mr Campbell, 2, St James Place, St. John's Road, will thoroughly repair the plate of Greenwich Pensioners [engraved by John Burnet after his own painting of 1837] for £25 in two months'. A highly skilled printer could often transcend shortcomings in the plate, although this naturally slowed down the printing. Careful inking and wiping could even disguise the fact that a plate had been cancelled. It was usual, after the declared edition was completed, to cancel a plate by scoring it diagonally from corner to corner; the score-marks could often be doctored and the inking controlled so that the disfigurement was barely discernible.

In view of the undoubtedly vital part played by the printers of plates, and of their wide scope for initiative, it is strange that so comparatively few acknowledgements to their skill appear in the form of imprints. McQueen is the printer's name perhaps most frequently seen on nineteenth-century plates. Possibly plate-printers simply inherited a tradition of anonymity, and such technical excellence as they achieved was inclined to be taken for granted. None of the printing awards at the Great Exhibition of 1851 went to plate-printers, and the Jurors' remarks following the 1862 International Exhibition held at South Kensington were somewhat laconic:

> In copper or steel plate printing there was scarcely room for
> improvement. The impressions of plates are not numerous. Those
> furnished by MacQueen Brothers . . . and others are as good as it is
> possible to make them (International Exhibition of 1862, *Reports by
> the Juries*, Class XVIII, Section C, 1863).

As we have seen, the plate-printer's art was apparently more fully appreciated in France than in England: the excellence of the McQueen's printing had earned them a First Class Silver Medal at the Paris Exhibition Universelle of 1855, and the enthusiastic applause of the jurors in the report published the following year (Exposition Universelle de 1855, *op. cit.*, pp.75, 81, 82).

However efficient the new mechanical processes were to become in the later part of the nineteenth century, the hunger for what one may call

the intervention of the hand seems repeatedly to have redressed the balance in favour of hand-produced plates. To some extent this explains the revival of etching as a reproductive medium in this period, at a time when photogravure had already seemed economically and technically victorious (and, incidentally, it goes some way to accounting for the new lease of life given to artists' printmaking since World War II). There had, of course, been a renewed enthusiasm for etching earlier in the century. The Etching Club and the Junior Etching Club had been formed early in the reign of Queen Victoria and had issued publications between 1841 and 1879 (Hind, *op. cit.*, p.329). Etching was extremely popular in France in the 1860s and early 1870s, and the French Etching Club was founded in New York in 1866 (*ibid.*, p.321). These revivals, however, were largely to do with the provision of an expressive vehicle for artists, amateur and professional. The late nineteenth-century revival of etching included to a significant degree the reproductive use of the medium. In the face of successive waves of innovation, there were advantages in favour of the hand-produced metal intaglio plate – almost all aesthetic in nature, it must be admitted. To start with, the metal plate engraved by hand is capable of a surface richness beyond all comparison with either lithography or wood-engraving, and most certainly with photo-mechanical methods. Then, metal is susceptible to unparalleled variety of treatment: many engravers, Charles Turner for example, combined etching and aquatint with line and mezzotint; and these, in combination with soft ground and the comparatively little-used sugar aquatint added up to a formidable technical arsenal. Masterpieces of book production, of which Thornton's *Temple of Flora* (folio, 1799–1807; quarto, 1812) is possibly one of the best known examples, had since the turn of the century demonstrated such possibilities. (*The Temple of Flora* plates were engraved by various processes: aquatint, mezzotint, stipple and line engraving, and a number of artists and engravers co-operated in its production. More than one man frequently worked on any single plate: William Pether, a specialist in nocturnal effects, provided, for example, an English village church bathed in moonlight by way of a somewhat incongruous background to the exotic Night-Blowing Cereus. These mixed intaglio plates were coloured by hand.) Again, whilst as early as 1728 – in John Martyn's *Historia Plantarum Rariorum* (Dawson, 1977, p.10) – colour printing from a single plate had been shown feasible in intaglio, the lithographic process had to await the experiments of Thomas Shotter Boys before it could compete in that particular way (Smart, 1974). Yet another advantage of the metal intaglio plate was that alterations, deletions and enrichment by superimposition with the use of scraper, burnisher, graver, and further bitings of acid were possible in a way that would be quite out of the question in other media.

Although the Dixon & Ross work books show that, considering the tediousness of the inking and wiping procedure, a remarkable speed

could be achieved by an experienced printer, a chief disadvantage of the intaglio printing process was its comparative slowness – certainly when important work was being handled. Writing to Landseer in October 1850, Henry Graves sought the painter's approval of a plate, anxious to put it to the press: '. . . I hope you will say . . . it is done . . . and enable me to print the first proofs as only 8 can be done in a day . . .' (Victoria and Albert Museum, MSS 86). Whilst as part of his week's work one man would print 1,000 bill heads, earning only 4/2d in the process, another could earn £3.1.10½d in achieving only 33 proofs (probably about four days' work) of 'Bolton Abbey' on India paper. Such work could not be rushed. The McQueen and Ross records clearly indicate all the pitfalls awaiting the less than meticulous printer, yet there was constant pressure upon them to match quality with speed. An undated letter to the McQueens from Charles Barry, winner of the competition for a design for the new Houses of Parliament (Boase, 1959, pp.191–202) asks for

> as many impressions of the National Gallery Designs as are dry
> enough; and if it is possible to expedite the printing of them by the
> employment of two men, Mr. Barry will cheerfully pay any extra
> expense that may be incurred thereby – at any rate Mr. Barry hopes
> Mr. McQueen will allow the man or men employed to work over
> hours – the entire number required will be 350 (Appendix II, p.214).

Another letter, written one Saturday morning, has none of Barry's polite persuasiveness:

> Mr. Clare Smith will thank Messrs. McQueen to take off <u>immediately</u>
> 700 of the Duke of York's Plate and not to fail in letting him have 300
> By <u>12 O'Clk on Monday</u> and the remaining quantity without delay,
> all of them to be Oct. size (Appendix II, p.212).

Another (Appendix II, p.214), sent to the McQueens at 184 Tottenham Court Road, and postmarked 22 January 1835, came from Dawson Turner, the Yarmouth banker and Cotman's patron. He 'begs to inform Mr. McQueen that he has brought with him to London 11 Copper Plates, which he will thank Mr. McQueen to send for to the Bar of this Coffee House' (the Salopian Coffee House, Charing Cross). He requests ten impressions of each and goes on to say that he 'would like to receive back his plates and the impressions and the bill by Saturday evening': a tall order, and only slightly less so than the peremptory Mr. Smith's, considering that the letter was dispatched only on the Wednesday and bearing in mind the slow and tricky business of drying out prints without the paper suffering permanent cockling.* A lady whose name is illegible urges 'Mr McQueen to proceed as rapidly as possible in printing the engraving which will be put into his hands this morning by Mr. Finden for her forthcoming work; and she requests that as they are completed he will send them, two or three hundred at a time to Mr. Gilbert [a letterpress printer. See Todd, 1972, p. 78], St. John's Square,

* The present-day procedure at Thomas Ross & Son's differs little from that adopted during the nineteenth century: the damp prints are interleaved with acid-free tissue paper and stacked between thick, absorbent fibre-boards beneath heavy iron weights. The drying takes several days.

Clerkenwell. Two thousand will be wanted, besides some proofs' (letter owned by Mr. P.N. McQueen). In an undated note the expatriate Auguste Pugin writes (Appendix II, p.213) that he is in such a hurry to have certain plates printed that he cannot wait for the busy McQueens and has sent the work to Barnett, another plate-printer: 'I could not delay even one hour . . .'.

It is certain that the pressure put by clients upon printers stemmed in part from pent-up impatience with the slowness of the engraving process. In 1867, Samuel Cousins undertook to complete in one year for Henry Graves a mezzotint after Landseer's 'Connoisseurs'. The work was finished in three months, though such despatch was all too rare. Whilst busy with the plate, Cousins wrote to Graves as follows: 'I have been very hard at work on the 'Connoisseurs' since the Etchings were taken, and have brought the plate to a forward mezzotinto proof (Dixon proved it yesterday) on this state of my work a payment of 100 Gs. is due . . . I now want a little holiday, and am going to Devon for 3 weeks . . .' (Victoria and Albert Museum, MSS 86).

On presenting the bill, Cousins remarked that he supposed Graves would be reluctant to pay the price of a year's work for labours that had cost the engraver only three months. The delighted Graves replied that he would have been only too pleased 'had Cousins been able to whistle it finished' (Whitman, 1904). Cousins' feat was all the more remarkable considered the three weeks' absence in Devon. The entries referring to the 'Connoisseurs' in the Dixon & Ross day book (Appendix I, No. 20) are worth quoting at length for the insight they give into the sequence of events typical in the printing of such a plate:

15 July 1867:	1 Pln. Connoisseurs. Mr. Cousins		
21 Aug.	Mr. S. Cousins.	1 Tracing. Edward	
9 Nov.	Mr. S. Cousins.	3 Ind. The Connoisseurs. 23 × 17	
	[The above measurements must refer to the		
	plate size: the work size was $16\frac{1}{2}''$ by 13'']		
16 Nov.	Mr. Cousins	4 Ind. The Connoisseurs.	
5 Dec.	,, ,, ,,	14 ,, ,, ,,	
6 Dec.	,, ,, ,,	14 ,, ,, ,,	
12 Dec.	Henry Graves		
	& Co.	12 ,, ,, ,,	
13 Dec.	,, ,,	14 ,, ,, ,,	
14 Dec.	,, ,,	13 ,, ,, ,,	
16 Dec.	,, ,,	14 ,, ,, ,,	
17 Dec.	,, ,,	16 ,, ,, ,,	
18 Dec.	,, ,,	18 ,, ,, ,,	
19 Dec.	,, ,,	19 ,, ,, ,,	
20 Dec.	,, ,,	20 ,, ,, ,,	
4 Jan. 1868:	,, ,,	14 The Connoisseurs Ind. AP	
6 Jan.	,, ,,	14 ,, ,, ,, ,,	28*
7 Jan.	,, ,,	17 ,, ,, ,, ,,	45

* The figures in the right-hand column represent totals of india Artist's Proofs.

8 Jan. „ „ 12 „ „ „ „ 57
9 Jan. „ „ 10 „ „ „ „ 67

The entries continue until 29 May 1868, by which date one plain proof, 147 india proofs, 310 artist's proofs, 107 india proofs before letters, 106 india proofs after letters and, at the end of the run, six extra india proofs and thirteen plain proofs had been recorded in the day book. These figures compare interestingly with the numbers declared by Graves (Printsellers' Association, 1892):

Declared		Recorded by Dixon & Ross
100 Artist's Proofs ("White spots on handkerchief")	£8.8.0.	147 (Presumably in the 1st state with spotted handkerchief. The 147 probably included the 25 Remarque proofs)
25 Remarque Presentation Proofs.		
300 Artist's Proofs	£6.6.0.	310
100 Before Letters	£4.4.0.	107
100 Lettered Proofs	£3.3.0.	106
		6 extra india.
		14 extra plain (including that of 15/7/1867)
Totals:		
625		690

Sixty-five impressions were thus made beyond the number declared to the Printsellers' Association. The engraver was entitled to a number of impressions as part of his deal with the publisher (see p.213 below) but the normal number seems to have been somewhere between six (see letter of S. Cousins, 22 March 1873, Agnew, *Agreements*) and twenty-five (see letter of T.O. Barlow, 17 June 1869, Agnew, *Agreements*). Of the 690 recorded impressions, only one (15 July 1867) would have been a working proof of the partly finished plate. If the work took only three months, as claimed by Algernon Graves, the three india proofs delivered to Cousins on 9 November 1867 must have been of the completed plate. Since Cousins' letter to Henry Graves was written on 12 September 1867, by which time the 'forward mezzotinto proof' stage had been reached, it follows — taking into account the three-week holiday — that the engraver must have finished the plate during the month of October. The size of the numerical discrepancy remains a mystery.

Cousins' speed (at least in this instance) was certainly out of the ordinary. However assiduously they worked, engravers were usually under the pressure of constant exhortation.

Ruskin early in his collaboration with John Le Keux wrote 'I am beginning to wonder what you are about . . . I have quantities of things ready for you, and if you can, finish off some of the plates at once . . .' (Victoria and Albert Museum, microfilm 85). Later, as he writes 'No

wonder you are in arrears – those plates must have cost heavy work . . .'
(*ibid.*) he seems to have gained some appreciation of the arduousness of
the engraver's task. Raimbach (*op. cit.*, p.15) recounts how, on
completing a plate, William Woollett (the line-engraver, 1735–1785)
would give vent to his relief by gathering his family on the landing of
his house in Charlotte Street and calling for three cheers; and Charles
Lamb (quoted in Salaman, 1910–1911) reports of George Dawe, portrait
painter and mezzotint engraver, that he was ordinarily 'at his graving
labours for sixteen hours out of the twenty-four.'

Whatever the lot of the engraver, who was not to subside completely
into the grave dug for him by photo-chemical processes for many a year
yet (Woodward, *op. cit.*, p.69), printers began to avail themselves of ways
of speeding their work. It was discovered in England apparently as early
as 1837 that galvanism could produce facsimiles.* This discovery paved
the way towards the production of electrotypes, as such facsimiles were
called (Clayton, 1919, pp.43–45). It seems to have been during the
spring and summer of 1839 that the public was first made aware of the
implications of galvanism for the printing trade. In April 1839, the
Athenaeum published the following item:

> GALVANIC ENGRAVING IN RELIEF – While M. Daguerre and Mr.
> Fox Talbot have been dipping their pencils on the solar spectrum, and
> astonishing us with their inventions, it appears that Professor Jacobi,
> at St Peterburg, has also made a discovery which promises to be of
> little less importance in the arts. He has found a method . . . of
> converting any line, however fine, engraved on copper, into a relief
> by a galvanic process.

There was a prompt response from a British inventor, C.J. Jordan, who
claimed priority in this use of galvanism, having begun experiments in
the summer of 1838 (*Mechanics Magazine*, 11 May 1839); and on 12
September 1839, Thomas Spencer, a picture-frame maker, described in a
paper read to the Liverpool Polytechnic Society similar experiments
begun by him even earlier – in September 1837 (Wilson, 1880, pp.93–
103).

William Vaughan Palmer had considerably extended the use of
electrotype when, in July 1844, he was called to give evidence before the
Select Committee of the House of Commons on Art Unions (1845,
pp.244–249). The Unions, at this time practically the only sponsors of
the process as applied to engraving, were by its use publishing
enormous editions of impressions for circulation to subscribers. Palmer,
though he could not give an exact date, claimed to have been the first to
apply the electrotype process to the reproduction of large engraved
plates. This development had taken place, he said, about two years
previously, since when he had produced some fifty large electrotypes
and very many smaller in scale. Palmer maintained that it was possible to
produce a virtually unlimited number of copper electrotypes from an

* For a full account of the discovery
see F.J.F. Wilson, *Stereotyping and
Electrotyping*, London, 1880, *passim.*
T.H. Fielding (*op. cit.*) was writing in
1841 of 'Electrography . . . [a] newly
discovered art . . . commonly called
electrotype . . .' maintaining,
however, that 'we prefer the name
chosen by [the] inventor, Mr
Spencer, of Liverpool'. Fielding
indicated that the process was
already in use among calico printers,
and reported that engravings on
wood could be multiplied ad
infinitum as readily as those on
copper. Fielding enthused about the
reproductive perfection of the
process, the faintest blemish in the
polish of the original plate being
faithfully preserved. He mentioned
Hughes, the coppersmith of Shoe
Lane, as a practitioner.

original engraved copper plate, each electrotype being a sharp and exact reproduction. He described a method whereby he placed the original plate perpendicularly opposite a blank plate of copper, the two some 6" apart, in a trough of solution of copper sulphate. Each plate was connected to a galvanic battery, and dissolved copper from the blank plate was gradually precipitated onto the surface of the original, thus forming a matrix from which the electrotype replica was subsequently made. Palmer declined to explain the means by which he prevented the original copper plate from dissolving. He had not only perfected the technique, but had speeded what was at first a long drawn out process lasting several weeks to one which could be accomplished in only two. Any number of matrices could be made without detriment to the original plate, claimed Palmer, and the electrotypes were as durable as the original. He gave an instance of an original plate that was exhausted after 1,111 impressions whilst its electrotype replica yielded 1,128. He even stated that engravers working an original plate destined for electrotyping could do so without inhibition, since he had solved the problem of making a matrix from a plate incorporating undercutting. To demonstrate the accuracy of the process he produced for the Committee two prints – one from an original plate and one from an electrotype version.

The scepticism of those engravers who for technical reasons opposed the use of the process stemmed, he said, 'from want of knowledge . . . the discovery [being] so late that [he had] experienced all the opposition that is natural to new things' (House of Commons, 1845, pp.246, 248). Questioned on the margins of profit made possible by the use of the process, he quoted the example of a plate of 'Rafaelle and La Fornarina' from which he had made three matrices and fourteen electrotypes at a total cost of only £255. Considering that 14,000 impressions had been sold at a guinea each to the subscribers of the Art Union of London, it was suggested to him that 'the public had been very much imposed upon'.

Palmer did point out to the members of the Committee that there were costs other than that of the electrotypes. William Finden the engraver estimated in his evidence to the Committee (ibid., p.232) that an engraver's fee 'for the execution of a good work' could be anything from £600 to £1,800; and William McQueen the printer would have charged between £735 and £882 for paper and 14,000 impressions (ibid., p.259). The Art Union's margin of profit would therefore not have been as large as the members of the Committee were inclined to suppose, though clearly it would still have been substantial.

Henry Graves, who felt it would have been 'a great blessing if it had never been found out', had already expressed to the Committee his disapproval of the Art Unions' use of electrotype and the consequent reduction in the price of prints which, since he 'liked a high price for [his]

prints, and to sell a few', would inevitably affect his business. He would, he said, rather pay the cost of periodically having one original plate repaired by the engraver during the printing run than use a succession of electrotype plates (*ibid.*, 170–171). Graves banked on keeping the original plate going since he was supplied with an especially durable copper from Manchester, beaten hard from many years of use in factories. Electrotype, he argued, was too soft (being deposited copper) and 'the moment the hand comes to be used upon it, it wears almost instantly'. The process was used 'by none but art unions . . . if you want so large a number as 20,000 it is the only means of getting them . . . [but] . . . 90 out of 100 issued by art unions are bad impressions . . .'.

Since it could eliminate the need for repair, the employment of electrotype meant less work for the engravers, most of whom naturally opposed it on those if not always on technical grounds. Repair, according to Dominic Colnaghi (who had no doubts at all as to electrotype's relative cheapness), could cost between seventy and one hundred and fifty guineas every few hundred impressions. Colnaghi, incidentally, thought the Art Unions were of benefit to the publishing and printselling trade: their activities had increased his framing business (*ibid.*, pp.228, 229). John Pye and William Finden, among the engravers submitting evidence to the Select Committee, each displayed a remarkable blend of generous impartiality and perfectly understandable self-interest (*ibid.*, pp.221 ff and 231 ff). Both admitted the probability of a growing public appreciation of art through the activities of the Art Unions, though both feared that the Unions' interest in prints would be to the ultimate detriment of the engravers' employment. Whilst inclined to 'consider the Art Union of London . . . the most valuable power that has ever arisen in Britain for the patronage of art', they felt at the same time that 'the electrotype . . . [if] extensively used . . . would be injurious, as it would in the end bring down all engravings to the maximum of a guinea.'

The engravers were evidently divided on the question of the technical quality of electrotype plates. Charles Wagstaff stubbornly maintained that, even were a matrix to be made from a scarcely worn plate, '. . . the use of electrotype would diminish the character of engravings' (*ibid.*, pp.165 ff). John Burnet, however, who had himself been one of the first to electrotype a large plate ('not for sale, but for experimental purposes'), raised no objection to the process 'except that it deteriorated the value of the prints by printing a large number . . .' and considered electrotyping 'much better for a large quantity than to have the plate retouched' (*ibid.*, pp.212 ff).

William McQueen, via whose presses the 14,000 prints of 'Rafaelle and La Fornarina' had recently been distributed to the subscribers of the Art Union of London, also came before the Select Committee. After all, a printer was likely to be the best judge of the durability or otherwise of

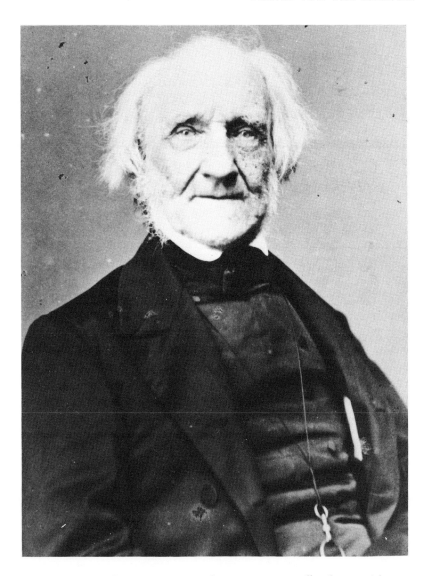

Plate 28
John Pye photographed by John
Watkins (National Portrait Gallery).

electrotypes; and McQueen stated quite categorically that an 'electro-
type [would] wear in the same proportion as the original plate' (*ibid.*,
pp.249–251). However, perhaps his most telling contribution to the
enquiry was his reticence on the matter of the length of printing runs.
The Committee, told earlier by William Finden that, whilst foreign
publishers based their reputations on strictly limited editions, it was
often the practice of publishers in England to multiply impressions to
such an extent that 'no confidence is placed in them', asked McQueen
what was the largest number of proofs he had ever known taken from
any plate. 'I would rather not answer that question' was the significant
response; and even when pressed he remained obdurate. 'You are
perfectly aware of the number, but you would rather not answer the
question?' – 'I would rather not answer it'.

Plate 29
John Burnet photographed by John
Watkins (National Portrait Gallery).

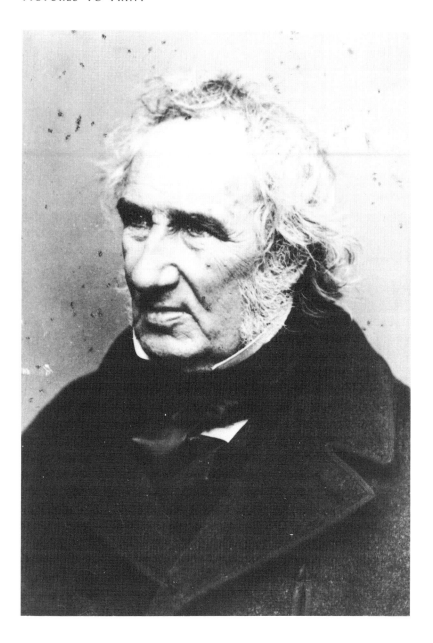

Chapter 3

Engravers and their Earnings

Prices and fees in the engraving branch of the art trade reflected not only commercial expansion but also the respect won for itself by the engraving profession as the nineteenth century progressed. The fight for professional status (see Fox, 1976) began ostensibly in 1768, with the Royal Academy's refusal to accept engravers on terms of equality with other members. John Landseer was one of the earliest systematic campaigners, accepting Associate Membership of the Academy in 1806 the better to advance the engravers' case from within (*ibid.*, p.6). The first half of the nineteenth century was marked by a succession of milestones in the struggle for recognition. In 1826, nine prominent engravers* took a pledge never to become candidates for election to the Royal Academy, thus asserting that the regulation preventing their election beyond associateship affronted the dignity of their profession. Ten years later they petitioned Parliament to investigate their predicament through a Select Committee on Arts and Manufactures, complaining that 'six engravers were merely worthy of standing at the door of the Royal Academy, whilst the professors of every other branch of Art were eligible to enter, and participate in all the advantages' (*ibid.*). It was agreed that the Select Committee should hear evidence relating to engraving, and John Landseer, John Burnet and John Pye were invited to appear before it. Burnet pointed out that '. . . no attention or respect is paid to engraving in this country. The public consider engravers only as a set of ingenious mechanics . . .'. Engravers were, he argued, concerned to achieve 'more a translation of a picture than a copying' and were practitioners of 'a process of difficult management' (*ibid.*). Pye reinforced this line of reasoning, submitting that 'the best plates engraved now appear to me as being free translations from pictures instead of being cold rigid copies' (*ibid.*). Their eloquence was fruitless. A petition to the King in February 1837 and a plea six years later to the General Assembly of the Royal Academy by R.R. Reinagle made no impact on the stubborn opposition to full recognition. In 1853 a petition addressed to the Queen was laid before the Academy. The petitioners, echoing the propositions of Pye and Burnet, '[looked] upon the Art of Engraving as

* G.T. Doo; John Pye; John Burnet; Charles Fox; Edward Goodall; William Finden; John H. Robinson; J.H. Watt; and Abraham Raimbach. See *Evidence Relating to the Art of Engraving taken before the Select Committee of the House of Commons on Arts*, London, 1836.

one akin to the Art of Translation', insisting, with Dryden, that 'to be a thorough Translator one must be a thorough Poet'. At the same time, the engravers found an advocate in C.R. Leslie, whose urging for a reconsideration of the controversy by the Academy provoked a series of meetings which finally culminated in a change of regulations, making provision for four engraver members – which number was to include Associate Engravers and, for the first time, Academician Engravers. This arrangement superseded the former six associateship places. Samuel Cousins, an Associate Engraver since 1835, was in 1855 the first engraver elected to full membership (Fox, 1976, pp.16, 21–23). On 10th February that year, a vigilant correspondent of the *Illustrated London News* (p.130) reported a rumour that '. . . the Academy is about to render tardy recognition to the noble art of engraving; and that Mr. Samuel Cousins, the distinguished mezzotinto engraver, will succeed Mr. Chalon and be the first English engraver admitted to the full honours of the Academy'. The fact of Cousins' election was confirmed a fortnight later, when the *Illustrated London News* (24 February 1855, p.175) urged the speedy election of a line-engraver to share academic honours with Cousins. Recommending G.T. Doo, J.H. Robinson or John Burnet, the writer pointed out that the Academy now had as a member 'the most eminent mezzotinto engraver in England; they should therefore admit the most eminent line-engraver'; and he went on to warn readers that 'the art of line-engraving is fast dying out amongst us'.

The irony, of course, was that by 1855 the profession was within a generation of obsolescence. Engravers as the nineteenth century knew them were in fact never to be admitted to the Royal Academy on terms of complete equality, with severe numerical restriction removed. When, in 1928,* the Academy finally abolished the distinction that had for so long disadvantaged engravers, the gesture was forty years too late and was virtually empty in that practically all the engravers who benefited were in fact artist-printmakers. The essentially different breed that had practised the 'Art of Translation' had been long extinct.

In the second decade of the nineteenth century Thomas Goff Lupton, working on Turner's *Liber Studiorum*, received only £5 a plate (Lindsay, 1966, p.259). The engraving profession owed a great deal to Turner, who, judging by all the accounts of his contacts with them, was something of an educator of engravers (see Rawlinson, 1908, pp.lxix–lxxiv). Not only were his instructions for the achievement of a translation from the language of evanescent colour into that of line minute in the extreme; he also developed a style of drawing designed to iron out to some extent the subsequent problems of the engraver. Turner's eye for engraving was evidently so sharp that on seeing a proof lying upside down on a table some distance from him, he could instantly diagnose the tonal faults – and would prescribe the remedy without bothering to turn the print round (*The Spectator*, 28 February 1874,

* The signatories of the petition to the Royal Academy that led to the resolution of the 'unhappy quarrel of long ago' were Frank Short, H. Macbeth-Raeburn, Malcolm Osborne, Henry Rushbury and F. L. Griggs (Fox, *op. cit.*, p.24). Whilst it is true that Short, for example, was responsible for a considerable amount of reproductive work after Turner and others, original work formed an important part of his œuvre (Hind, pp.244, 245, 287).

p.268). However, the apparently paltry fees paid to Lupton suggest that Turner, like most of his contemporaries, indeed considered engravers to be merely 'a set of ingenious mechanics'. But was Lupton's fee of £5 per plate unjustly less than the going rate; or, in spite of allegations of parsimony against Turner, was it perhaps simply – and appropriately – at the lower end of quite an extensive scale of payments to engravers of differing experience undertaking work of varying degrees of complexity? The size of an engraver's fee seems without doubt to have been related to his (or her) reputation. Thirteen engravers (twelve men, and a woman, Marie-Ann Bourlier) produced between them the plates for John Chamberlaine's 1812 quarto publication of Holbein's Portraits of *Illustrious Personages of the Court of Henry VIII* (see Dyson, 1983, pp.223–236). The book includes engraved portraits of Hans Holbein and his wife and eighty engravings after the celebrated Holbein drawings at Windsor. R. Cooper was paid thirty guineas for engraving the portrait of Holbein and ten guineas for each of the other sixteen portraits he contributed. Georg Sigmund Facius, on the other hand, was paid only sixteen guineas for the portrait of Holbein's wife and, like all his other collaborators with the exception of Cooper, 'from six guineas upwards, according to the amount of work . . .' for his other plates (Tuer, 1885, p.85). A manuscript list of engravings used in the publication of Cook's *Voyage to the Pacific Ocean*, 1784, shows that the fees of engravers of an earlier generation could also vary widely: J. Record was paid five guineas for the plate of 'Various articles in Northern Sound', whilst William Woollett's fee for 'A Human Sacrifice in Otaheete' was £157.10.0d. (Joppien, 1978, p.72).

Lupton's account of the work for the *Liber Studiorum* is interesting, though, in view of the fact that Raimbach (1843) claimed to have received £70 for engraving three book plates in 1801, one may have to quintuple the fee to get an idea of average earnings:

> The pounds, shillings and pence of the affair ran thus. Copper plate 7/6; mezzotint ground, 15s. My own labour seven or eight weeks. As to provings innumerable, resulting from the difficulty of obtaining an agreeable colour as nearly approaching to that of the drawings as possible; consequently the proving was not only difficult but expensive, even to the amount of two or three shillings a time . . . the engraver had also to lay the etching ground and trace the subject on the plate . . . (Lindsay, 1966, p.259).

Lupton and others who engraved for Turner could not claim that they were alone in receiving such modest recompense. In 1822 John Curtis, an engraver working on animal illustrations for the *Transactions* of the Linnean Society, submitted a bill for six plates, each measuring $8\frac{1}{4}$" by $10\frac{1}{2}$". His charge for engraving each plate was five guineas and, in addition, the coppersmith's price for each plate was just over 9/6d. Curtis's bill, in the Library of the Linnean Society, included further interesting information: the engraver's charge for the original drawings

was two guineas apiece; engraving each title cost 5/8d; paper and printing came to 14/- per 100 impressions; and hand-colouring and hot-pressing (to eliminate buckling) cost £3.7.0d per 100 prints. It should, however, be noted that the rewards for engraving an important subject on a large scale could be considerable at this date: following the 1816 R.A. exhibition, Charles Turner was engaged by John Martin to engrave the artist's 'Joshua' in mezzotint on copper for a sum 'not exceeding £500'. The plate measured 22" by 30" (Balston, 1947, p.95).

The engravers of Turner's *England and Wales*, published between 1827 and 1838 by Charles Heath in collaboration with Jennings & Co., each received £80 to £100 per plate (Rawlinson, 1908, p.xlviii). Samuel Cousins — already at twenty-six a seasoned engraver of twelve years' experience — was likewise commanding fees that seem to have been at the opposite end of the scale to Lupton. In 1827 he received £100 for engraving a plate $15\frac{1}{4}$" by $11\frac{3}{4}$" after Thomas Lawrence's 'Master Lambton' (Salaman, 1910–1911). We may take this to have been an average price for the kind of work involved in a plate of such dimensions. On the basis of letters written concerning progress with other plates later in his career (p.50) one can estimate that Cousins would have spent about three months on the 'Master Lambton'. Allowing for payments to his plate-maker, his ground-layer and the printer — for the working proofs — he would thus have earned something like £30 a month. This estimate is reinforced by the text of an agreement of 17 August 1837, between the engraver and the publishers Richard Hodgson and Henry Graves (British Museum, Department of Manuscripts 46140). Cousins undertook to engrave Landseer's 'Abercorn Children' 'in Mezzotinto, with Etching, in his very best style, on a Steel Plate . . . seventeen inches and a quarter long by about sixteen inches high'. He promised to finish the work in about ten months, to supervise

Plate 30
'Highland Drovers' Departure': detail of the etched state of the engraving ($18\frac{3}{4}$" × $28\frac{5}{8}$") by J.H. Watt (the animals etched by William Taylor) after the painting by Edwin Landseer (British Museum, Department of Prints & Drawings).

the printing and to keep the plate in good repair to the extent of a thousand respectable impressions. Hodgson and Graves agreed to pay 300 guineas for the work: 100 at the stage of first proofing; 100 at final proofing; and the balance within three months of the commencement of printing. In addition, Cousins was to get five guineas per 100 impressions (after the first 200 and up to 800) for running repairs on the plate. It would also be for Cousins to choose the printers (and to change them as and when he saw fit – something on which he always insisted).

The Graves papers (British Museum, Department of Manuscripts 46140) provide a convenient window onto the world of print publishing, with the numerous references they contain to the publication of Landseer's 'The Highland Drovers' Departure'. On 30 April 1836, Landseer issued his receipt for the first instalment of the copyright fee, and fourteen months later (24 June 1837) acknowledged the balance – 200 guineas in all. In February 1838 an agreement was signed between Hodgson & Graves and Thomas Agnew of Manchester, for sharing the rights to the engraving of 'The Highland Drovers'. Hodgson & Graves had owned a half share and James Henry Watt the engraver the other half. Hodgson & Graves agreed to sell half of their rights to Agnew for 350 guineas – 125 on signing the agreement, 125 on the submission of the engraver's proof to Landseer for touching, and the remaining 100 guineas on Watt's completing the plate. By late 1839 the plate was under way, and Watt wrote to Hodgson & Graves acknowledging receipt of £25, the first of a series of periodical payments for the work of engraving. This agreement, said Watt, would 'stimulate [him] to more vigorous exertion to finish the plate quickly' (*ibid.*, 4 October 1839). The following April, 1840, the engraver accepted Hodgson & Graves' offer of £700 for his quarter share in the plate of the 'Drovers' and his half share in another plate (*ibid.*, 7 April 1840). The composition had been

Plate 31
'Highland Drovers' Departure': detail of engraver's proof, 1841 (British Museum, Department of Prints & Drawings).

Plate 32
Charles George Lewis photographed
by John Watkins (National Portrait
Gallery).

etched by Watt in January 1838 (the animals by a collaborator, William
Taylor), in which state the print was issued by Hodgson & Graves for
advertising purposes — quite a common device. The finished plate was
finally put to the press and published on 18 June 1841 (British Museum,
Department of Prints and Drawings, C90), five years after the first
payment of copyright to Landseer. Graves, and presumably Landseer,
must have had further financial spin-off when the subject appeared again
in 1859, this time with the engraving attributed to Herbert Davis and
published by Drooster, Allen & Company of the Strand.

As the middle of the nineteenth century approached, the pickings for
engravers of the top rank were substantially increased. Members of the
profession were constantly on the alert for subjects which would not
only ensure financial reward but which would also advertise their skills
and enhance their reputations. For example, Charles G. Lewis (1808–
1880) fell over himself to secure as many commissions as possible to
engrave Landseer's work. His letters are full of eulogium: '. . . I dearly
love fine things and more than all, the works of Mr. E. Landseer . . .' he
wrote to Ernest Gambart on 28 September 1848 (Royal Institution,
Landseer file). But his praises were perhaps never more extravagant than
those lavished on the artist's 'A Random Shot'. In August 1848 he told
Jacob Bell how delighted he would be were he to net 'A Random Shot'.
Castigating Gambart & Co. for their hesitancy to launch the project, he
protested that 'they seem to think, a really beautiful piece of poetry and
of a most touching kind, cruel . . .' (ibid., 17 June 1848). Then, with an
impetuosity that caused him endless trouble in his professional
relationships and with the motive of advertisement evidently gaining

Plate 33
'Hunters at Grass', mixed mezzotint
engraving ($23\frac{3}{4}'' \times 36''$) by C.G. Lewis
after the painting by Edwin Landseer.
Published 1848 by F.G. Moon
(British Museum, Department of
Prints & Drawings).

Plate 34
'Hunters at Grass': detail of proof
'touched' by Landseer, September
1847 (British Museum, Department
of Prints & Drawings).

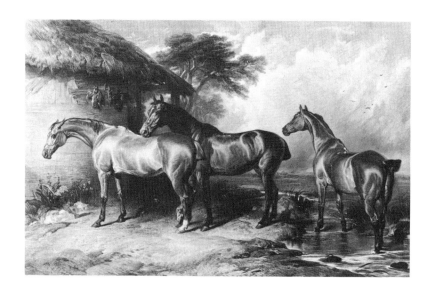

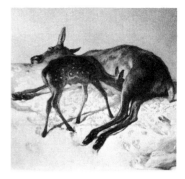

the upper hand, he burst out 'I think that picture the sweetest thing in the world . . . I would be glad to do it almost for love, it would be sure to sell . . .' (*ibid.*, 28 September 1848). Approaches to Landseer from eager engravers seem to have been quite common. In an undated letter (Victoria and Albert Museum, MSS 86) John Henry Robinson told him 'I have this morning fallen desperately in love with your little picture called 'Cottage Industry', and should like very much to be allowed to make an engraving from it'.

The publishers, no less than the engravers, knew they were on to a good thing and they struggled vigorously for a place on the bandwaggon of the growing popularity of modern painters. In one of his many surviving notes to Landseer's friend Jacob Bell, Charles Lewis suggested that a certain publisher's (Francis Moon's) mouth must have watered when the engraver, after a visit to inspect Landseer's 'Cover Hack', described to him the contents of the painter's studio (Royal Institution, 6 March 1849). Publishers carved up the market between them, and appropriate safeguards were built into their agreements. International arrangements were quite common: when in 1839 Hodgson & Graves and the Paris firm of Rittner & Goupil shared in the engraving of Paul Delaroche's portrait of Napoleon it was agreed that neither party would sell in the other's country. Incidentally, Delaroche's copyright fee was £20 (British Museum, Department of Manuscripts 46140, 12

Plate 37
'In Time of War', mixed mezzotint engraving (22″ × 33⅝″) by T.L. Atkinson (with the collaboration of F. Stacpoole) after the painting by Edwin Landseer. Published 1848 by Henry Graves & Co. and Thomas Agnew (British Museum, Department of Prints & Drawings).

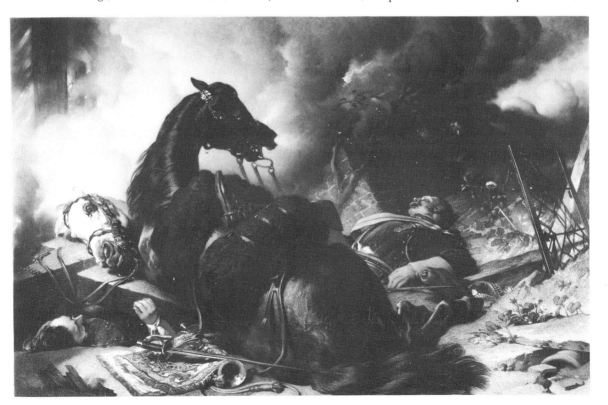

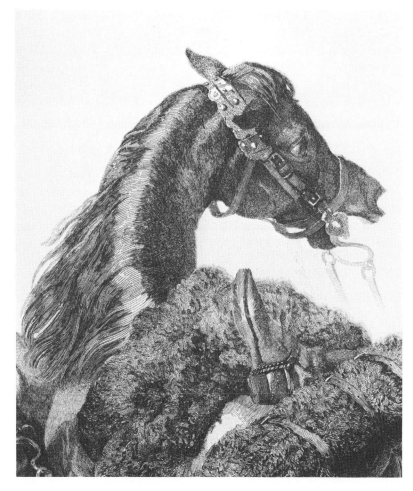

Plate 38
'In Time of War': detail of etched
state (British Museum, Department of
Prints & Drawings).

September 1839), a paltry sum when compared with the 200 guineas
Landseer was paid at about the same time for the 'Drovers'. A
meticulous apportioning of territory was also entailed in Henry Graves'
and Thomas Agnew's joint publication of Landseer's two subjects 'War'
and 'Peace'. It was agreed in April 1848 that Agnew should have the
right to exhibit the original pictures in Manchester for three clear weeks
to foster a demand for the prints. To further the advertising campaign he
was also to have proofs from the plates, then nearing completion by
Frederick Stacpoole and Thomas Lewis Atkinson. These privileges, plus
Graves' undertaking not to exhibit anywhere in Lancashire except
Preston and Liverpool, cost Agnew £1,500 (*ibid.*, 4 March 1848).

Ernest Gambart, whom Landseer (in a letter to Jacob Bell, 24 May
1848, Royal Institution) perceived to be 'all energy', provides us with an
interesting illustration of the relentlessness with which publishers were
capable of pursuing their projects. Late in 1849 he had been making
urgent requests of Thomas Landseer for a proof of Edwin's 'Drive of
Deer' in spite of the engraver's protest that it was in too unresolved a

state. Gambart claimed he had already taken many orders on the basis of the preliminary etching of the subject. Arguing that he, with his experience as a salesman, was the best judge of what should be presented by way of advertisement, he gave assurances that the proof he sought would 'only be shown privately to the trade with every warning of its unfinished state' (Royal Institution, 5 November 1849). Both Edwin Landseer and Jacob Bell quickly got wind of this, and the very day after Gambart had sent a man round to Tom's workshop in the hope of having him pick up the proof there and then, he was constrained to write the following explanatory note to Bell:

> The unfinished Proofs Publishers are in the habit to canvass with, are generally only shown to the Trade with all due intimation of their unfinished state [and this is] rather a favourable circumstance than otherwise since it leaves to the imagination to fancy the wonders that are coming . . . When a Plate is finished the illusion ceases, there is the fact, and in ninety-nine cases out of a hundred the interest abates (*ibid.*, 6 November 1849).

On the same day, a note was on its way from Landseer to Bell. The painter was by now tired of Gambart's machinations and inclined to take all his work out of the dealer's hands. However, with his usual dependence on Bell's judgement, he told his friend to 'give him his head if you like in this . . . [then] send him to the Devil . . .' (*ibid.*, 6 November 1849). Landseer was evidently undecided, and he wrote at least three times to Bell on that same day. In another of his notes, he protested chauvinistically that Gambart should 'by this time, be sufficiently English to know that the <u>tone</u> of his note is rather tyrannical'. He went on to express his conviction that 'the best <u>profit</u> is obtained by excellence and finish – not by <u>hurry</u> and <u>humbug</u>. It is true the print might be seen and appreciated in its present state – as true that it would come with greater effect in a more complete condition – What shall we do? Tom is working out my last touching and working hard. They would not have to wait long'. Edwin was obviously nettled by the affair, and scribbled yet again that day to Bell:

> The Etching is, I think, a better state for exhibition . . . than the last impression – people cannot find fault with the Etching – and they will take the <u>present</u> condition of the Plate for finish – or rather an attempt at completion . . . <u>more</u> subscribers may be secured by <u>not</u> offering [the] Engraving till [it is] as perfect as we can make it.

In his memoir, Raimbach refers to the 'enormous sums [that] begin to be exacted by painters under claim of copyright'. Without mentioning a figure, Jacob Bell wrote to Landseer on 1 September 1842 that Thomas Boys, the publisher, had 'just been here and consented to give our price for the copyright of the Royal Mother and brats' and saying that the price would include the privilege of 'exhibit[ing] it for a few days . . . to a select number of his friends, during the time that Cousins is not actually

engaged upon it . . .' (Victoria and Albert Museum, MSS 86). Landseer's income from copyright fees was substantial, to say the least, and his takings from this source seem to have gathered momentum during the 1830s. From the firm of Hodgson & Graves alone he received 1,300 guineas between April 1836 and March 1841: 100 guineas each for 'The Abercorn Children' and 'The Highland Whisky Still'; 200 guineas for 'The Highland Drovers'; 300 guineas for 'The Sutherland Children'; and 600 guineas for 'Horses Drinking' and 'The Duke of Beaufort's Dog' (British Museum, Department of Manuscripts 46140, pp.55, 68, 74, 122, 123, 160). In 1868, Landseer was to give practical expression to his appreciation of Graves' payments (and, incidentally, to his recognition of the publisher's determination to gain precedence) as he fended off overtures from the prospective photographers of sixteen of his works: 'Mr. Graves', he wrote, 'is now the only publisher who consents to give large sums for the loan of important Pictures for the purpose of Engraving, and as you know [he] considers his bold speculations greatly injured by photography. In . . . obligation [to him] I cannot consistently comply with your request . . .' (Victoria and Albert Museum, MSS 86, 12 August 1868).

On 8 September 1855, *The Illustrated London News* reported (p.287) that Rosa Bonheur's celebrated 'Horse Fair' was 'still in the hands of Mr. Gambart, the great dealer'. Gambart in fact bought the picture and the copyright for £1,600 and spent 800 guineas on its engraving (Maas, *op. cit.*, p.159). Thomas Landseer engraved the first – and largest – version, which was declared to the Printsellers' Association in July 1856; 1,000 Artists' Proof (signed by artist and engraver) at twelve guineas, 1,000 Proofs Before Letters (that is, before the engraving of a title: evidence that the plate was still near to its pristine condition) at ten guineas, Lettered Proofs at seven guineas and ordinary prints at four guineas were announced (Printsellers' Association, 1892). A complete sell-out of the first three thousand impressions would have raised £29,000 gross, not to mention the proceeds from ordinary prints taken subsequently from the steadily deteriorating plate (nor the proceeds from Gambart's next publication of the subject: the reduced version engraved seven years later by Charles Lewis). Even this kind of money seems insignificant when compared with the copyright fees sometimes paid during the'seventies: J. Dickenson & Co. in 1874 bought the engraving rights to Elizabeth Thompson's 'Roll Call' for £1,200 (Treble, 1978, p.80) and, encouraged by the picture's huge success, the Fine Art Society invested £13,500 in the transfer of the rights two years later (Skipwith, 1977).* The case of the 'Roll Call', however, should not be taken as representative: perhaps the £300 paid by the Fine Art Society to Edward Poynter for the engraving rights to his 'Atalanta's Race' (Fine Art Society, Minute Books, 24 May 1876) and the £300 paid three years previously by Agnew's for the copyright to Landseer's 'Lion and Lamb'

* Peyton Skipwith of the Fine Art Society, in a paper presented to a Conference of the Association of Art Historians.

(letter of 14 August 1873 from the owner, Henry Eaton, to Agnew's (*Agreements Book*)) were more typical sums. The increasingly heavy financial burdens placed upon them by the need to purchase copyright was, of course, one of the factors that led publishers to seek ever more expeditious and less expensive engraving techniques.

The sums of money for which plates changed hands are of interest, relating not only to the commercial success of the publishing venture with which they were associated but also to some extent to the original outlay. Shortly after Wilkie's death in 1841, the plates which had been owned jointly by Abraham Raimbach and the artist were sold at prices ranging from just over £50 to approaching £400. The 'Distraining for Rent' (the original of which had been Wilkie's one near-failure) was bought by Raimbach himself for £73.10.0d; 'Blind Man's Buff' and 'Rent Day' fetched respectively £204.15.0d and £210; and Henry Graves paid £367.10.0d for 'The Village Politicians' (Raimbach, 1843, pp.145–146). In 1848 John Martin, announcing that he proposed to abandon his engraving, printing, and publishing activities, wrote to McQueen's the printers (and presumably to others he though might be interested) offering some of his plates for sale. The list included 'Belshazzar's Feast'; 'The Deluge'; 'The Destroying Angel' ('... but little circulated having been withdrawn shortly after publication to receive material alterations and improvements'); and 'Marcus Curtius' ('only a few impressions taken off, the plate having been withheld with a view to selling it'). Martin offered the lot of nine plates for 3,000 guineas, or, sold separately, 500 guineas for the larger plates and 250 guineas the smaller (Appendix II, p.215). In 1851, Dixon & Ross in their letter (Appendix I, p.188) to John Butler of Philadelphia asked £100 for the plate of Fisk's 'Trial of Strafford'; and, in 1857, themselves offered William Yetts of Great Yarmouth £250 for a plate after Rankley's 'Scoffers' (Appendix I, p.190).

Destruction was the official fate of plates which had yielded the full editions of proofs declared to the Printsellers' Association and which were no longer capable of respectable prints. The *Illustrated London News* (27 October 1855, p.495) has left us a faintly ironic account of the ceremonial breaking up of a number of important plates. The piece is worth quoting at length:

> The friends of Mr. [Thomas] Boys who is about to retire from business after a career of nearly forty-five years, and the admirers of art generally, were invited on Wednesday last to that gentleman's premises, 467, Oxford-Street, to witness the breaking up of twelve of his most celebrated plates. A voluntary destruction of property to such amount is almost unprecedented; but Mr. Boys wisely determined on the step in order to enhance the value of their prints to previous purchasers, and to ensure a readier sale of the last lot of impressions to the trade and the public. The doomed plates formed no inconsiderable item of the stock which Sir Francis Moon handed over

to his old partner for upwards of £20,000 when he retired in 1853. Nearly five times that amount had been expended on the stock, which included from thirty to forty separate engravings, after Landseer. Eight out of the twelve plates were engraved by Mr. E.G. [actually C.G.] Lewis after this artist, to wit, 'The Three Hunters', 'The Return from Hawking', 'The Sanctuary', 'The Shoeing' [i.e. 'Shoeing the Bay Mare'], and 'The Deer-Stalker's Return' – each of the last-named three being also engraved on a small scale . . . The plates had been previously grooved in three-inch spaces, in order to facilitate the operation of breaking; and Mr. Lewis looked callously on, in company with Messrs. Boys, Gambart, Southgate, Dixon [the printer] and seven or eight others, while a ruthless Vandal in the shape of a mechanic mounted the table and, placing each plate on an anvil, knocked it neatly to pieces with a sledge-hammer . . . After an hour's enjoyment of this unique sight the company took their leave, with the parting toast that the plates might prove "as lucky in death as in life" – a wish which was, we trust, fully realised by Mr. Boys at the dinner trade sale on the following day

By the 1870s, when he was still bringing a vast amount of business to Dixon & Ross, Samuel Cousins, like many other engravers of the first rank, was commanding rapidly mounting fees. His letters to Agnew's reflect his prestige. On 8 March 1873, he was able to write in the faintly condescending tone of one who no longer needs to look for work:

As you are going to publish my little plate of the Strawberry Girl, I have made up my mind to make an engraving for you from the "Millais" provided the picture can be placed in my hands <u>soon</u> – say by the middle of this month – My terms would be . . . 600 gs. half the price to be paid when the plate is half done – the balance on completion . . . an early answer will oblige . . . (Agnew's, *Agreements Book*).

The picture referred to is 'Yes or No?', as Cousins' note of a couple of weeks later shows:

I have to acknowledge receipt of Mr. Millais' Picture the Title of which is, I believe, 'Yes or No?' – I Consent to make an Engraving from it of the dimensions of 15 inches broad by 19 inches, or thereabouts, high, for 600gs. and six finished proofs of the plate – . . .

P.S. I find that the Head will be $4\frac{1}{4}$ inches long, a handsome proportion (Agnew's, *Agreements Book*, 22 March 1873).

In the Spring of 1876 Cousins, by now an engraver of more than sixty years' standing, made the journey from Camden Square to 39 Old Bond Street, to which address Agnew's were in the process of moving. The purpose of his visit was to take measurements of Gainsborough's 'Duchess of Devonshire', William Agnew's most recent and most spectacular acquisition (Agnew, 1967, p.77). Following the visit he set out his terms thus:

My engagement will therefore be to make an engraving from the

above named picture, of the dimensions of 23″ by about 17¼″ and to do such retouching as the plate may require from fair wear and tear during the printing of the first six hundred proofs, and farther to sign the Artists proofs, if not exceeding that number, for the sum of Fifteen Hundred Guineas and eight finished Proofs of the said Plate (Agnew's, *Agreements Book*, 15 May 1876).

The picture was, alas, destined not to be interpreted by Cousins: it was stolen from the Old Bond Street premises some time during the night of 25/26th May, less than a fortnight after the engraver's reconnaissance (Agnew, 1967, p.79). The following summer, however, he undertook

To make an Engraving from [Millais' 'Yes'],* including re-touching for 500 Proofs and 500 Prints, and [to sign] the APs [for which the charge] will be 2000 Guineas (Agnew's, *Agreements Book*, 31 July 1877).

The plate turned out to be 22½″ by 17½″ and was thus in area about twice as large as the 'Master Lambton' for which, early in his career, he had received £100.

Details of the publication of Reynolds' 'Strawberry Girl' will serve to give some idea of the profits being made during the 1870s by picture-dealers of Agnew's standing. (Agnew was probably the most influential dealer of the latter part of the century, a distinction that Gambart had shared with Victor Flatou during the 1850s and 1860s. See Treble, 1978, p.12). The Publications Ledger shows that Dixon & Ross were the printers and that impressions were taken from the plate until 1911 by which date, presumably, its popularity had dwindled. Cousins was paid £272 for the plate, which measured 13¼″ by 10⅝″. In 1873, the year of publication, printing expenses amounted to £81.17.0d. There were other expenses, described as 'various', during the following year; this brought the total outlay to £453.17.0d. The balance of gross profit was £1,268. By May 1875, the plate needed revitalising, and Cousins' fee for the re-touching was £31.10.0d. Thus repaired, the plate underwent a further printing run, for which the charge was £35.7.6d. The profit that year was £378.5.0d. Up to 1911 the enterprise had cost Agnew's £518.5.3d and had yielded gross profits of £2,491.19.6d (Agnew's *Publications Ledger*). Such comparatively modest statistics are more typical than those relating to the engraving and publication of such pictures as Elizabeth Thompson's martial *tours de force* or Holman Hunt's manifestations of religious fervour. They correct impressions that may be formed from these spectacular money-spinners.

Frederick Stacpoole was associated with several of the latter. Early in 1874 he began work on the engraving of Holman Hunt's 'Shadow of Death', bought by Agnew's for £10,500 and promptly insured by them for that figure. The picture was exhibited first at 39 Old Bond Street and subsequently throughout the country; the resultant publicity ensured sales amounting to £20,000 from proofs alone (Maas, 1975, p.241). By

* Which, like 'No!' (engraved by Cousins in 1875), was a companion to 'Yes or No?'.

January 1879, Stacpoole had received fees totalling £3,560 from the Fine Art Society for his plates after Elizabeth Thompson's 'Roll Call', 'Quatre Bras' and 'Balaclava' — which three pictures, with the 'Inkerman', had been exhibited specially at the Society's New Bond Street premises in 1877 (Treble, 1978, p.79). The Fine Art Society's list of creditors at the beginning of 1879 contains a record of Stacpoole's fees for the individual plates:

F. Stacpoole. In respect of engraving 'Roll Call'	£600	
'Quatre Bras'	£1,380	
'Balaclava'	£1,580	

and the list continues:

Goupil. In respect of engraving 'Egyptian Feast' £700
J.T. Davey. 'Inkermann'

1st. pf. after bite in £100)		
Finished etching £200)		
After ground £200)	£1,100	
On advanced prf. £100)		
On compl. £500)		

F. Joubert. 'Atalanta'

Etchg. £300)		
Half done £300)		
Compl. £600)		
On rect. of £2,000)	£1,600	
from plt. £100)		
50% subs. profits to £300)		

S. Cousins. 'Princes in T[ower]'.	£1,050
J.G. Chant. 'Mrs. Langtry'	£105
Seymour H[aden]. Etching of Windsor	£750

The entries relating to Davey and to Joubert are particularly revealing. The procedure adopted in the case of the former was the fairly typical one of paying the engraver in stages. The list of stages confirms that, whatever the ultimate description of the engraving technique used in a particular plate, the early work was invariably achieved with the acid. The Printsellers' Association described the 'Inkerman' as a mixed engraving in its classified list (Printsellers' Association, 1892). Joubert's 'Atalanta' plate was classified by the Printsellers' Association as a line-engraving despite the apparently extensive etched element. Certain particulars in the financial arrangements with Joubert are of interest: he was to receive a lump sum of £100 upon sales of the engravings reaching the £2,000 mark; and was to have a half share of profits from subscriptions to the publication up to a figure of £300.

The other item worth mentioning in the above list is that relating to Goupil's, who received £700 from the Fine Art Society for engraving Edwin Long's 'Egyptian Feast'. In fact, the engraver was named by the Printsellers' Association (1892) as 'Edward Girardet' — in all probability

Edouard Henri Giradet, a Parisian, who showed an engraving at the Royal Academy in 1879 (Graves, 1895). It would appear that Goupil's received the fee on Giradet's behalf. It is probable that the Fine Art Society, having difficulty in finding an English engraver (p.75), had sought Goupil's help in this respect. It is also possible that the printing was done in France (p.73).

Quite apart from the fact that owner-speculators were reluctant to have a major picture out of circulation for the length of time it took to engrave it, the responsibility for its safe-keeping must have been a burden for the engraver. William Henry Simmons, undertaking to engrave a canvas for Agnew's, 'promised to take every care of the picture, locking it in his bedroom every night.' The picture referred to was Landseer's 'Well-bred Sitters', published by Agnew's on 18 March 1879. Simmons agreed (in an undated latter to Agnew's, *Agreements Book*) to complete the large plate (work size $22\frac{1}{4}$" by $28\frac{1}{2}$") in fourteen months for £500, but promised to make every effort to achieve it even more speedily – within a year – in which case Agnew's had offered a bonus of £25. To put at rest the minds of both a picture's owner and its engraver, an obvious expedient was to enlist the services of a copyist. Such a copyist was engaged by the Fine Art Society to produce a version of the 'Roll Call' for Stacpoole's guidance during engraving. He was a Frenchman, contacted through Goupil's, and the £300 offered for the job was withheld when Stacpoole and the artist found the copy wanting. The man was brought to England to 'perfect his work' and, after a few days' retouching, it was pronounced satisfactory (Fine Art Society, Minute Books, 17 October 1878). Artistic intercourse between England and France had been substantial throughout the century, and is amply documented; but this story indicates cross-channel transactions whose ramifications it would be interesting to investigate further. Ernest Gambart reported that in the two years between 1843 and 1845 there was a vast increase in the volume of prints exchanged between England and the Continent: in 1843 English engravings to the value of £5,000 or £6,000 were exported, and imported prints amounted to £10,000; by 1845 his business alone was handling £5,000 worth of exports and was shipping in £20,000 worth of prints (Maas, 1978, p.35). In 1858, having secured the services of the French engraver, Auguste Blanchard, to work upon the plate after Frith's 'Derby Day', he expressed a hope for 'more English pictures engraved by Frenchmen and more French pictures engraved by Englishmen' (*ibid.*). The extent to which at least the former was taking place by the seventies is hinted at by some letters to Agnew's (*Agreements Book*) from Charles Waltner (b.1846), whose Paris studio was in Rue Notre Dame des Champs near the Luxembourg Palace. In one note he offers to engrave, 'tres finie et avec beaucoup d'effet' a painting by Frank Dicksee. The sum requested is £400. Although the note is undated and the picture unnamed, another letter written in February

1878 refers to Dicksee's 'Harmonie' (declared by Agnew's in December 1879) and mentions a figure of 10,000 francs. Since the franc was worth at the time about ten pence sterling, the 10,000 francs represents near enough the £400 for us to assume that both communications refer to the same undertaking. Something of Waltner's anxiety to secure Agnew's patronage comes over in the February letter, as he consents to drop his price for the privilege of collaboration and ingenuously confesses the ulterior motive of gaining further commissions:

> ... quant à ce prix de 10,000 frs. je vous l'ai dit bien sincèrement,
> cependant comme le tableau me plairait beaucoup à faire et que je
> serais désireux d'entrer en relation avec Monsieur Agnew, la réduction
> de mille francs ne serait pas un obstacle pour faire ce travail. Je ferais
> cette concession dans l'espoir d'avoir d'autres planches à faire; et si
> celle dont nous parlons avait le succès que j'éspère, Monsieur Agnew
> verrait que ce prix n'était pas exagéré ...

The 9,000 francs was agreed, and Waltner promised to complete the work within a year, at the end of which he would send a proof for Dicksee's inspection. He also undertook to supervise the proofing, which suggests that a French plate-printer was given the job. That French printers were sometimes involved in the reproduction of English publications is made explicit by another letter in Agnew's file. It came from Paul Adolphe Rajon (1843–1888), who worked in London as well as in Paris and Dijon. Writing from his Brunswick Place address, he asked 200 guineas for etching the portrait of the Rev. James Martineau after George Frederick Watts (work size, 8″ by 10″). Vouching for the plate's durability, he indicated that it would be sent to Paris for printing:

> La planche pourra tirer jusqu'au nombre de dix milles épreuves, étant
> acierée ... comme toutes les planches d'eau forte. Mon imprimeur à
> Paris vous tirera les épreuves de ce portrait sur grandes marges au
> prix de un shilling par épreuve ...

Rajon's letter is tantalisingly undated, but its juxtaposition with Waltner's in this file suggests that all are more or less contemporary. If that is the case, it makes worthwhile a comparison of the prices charged by the Paris plate-printer with the rates of London printers like Dixon & Ross. French engravers would naturally incline to having their plates printed by compatriots whose workmanship they could supervise more closely; but perhaps it was also to the English publishers' financial advantage to have work printed across the Channel. Dixon & Ross were at this time pulling proofs of Millais' 'Pomona' at 4/- (india) and 3/- (plain), and of Samuel Cousins' portrait at 3/- (india) and 2/- (plain), making French charges seem startlingly low — if Rajon's quotation of a shilling a proof is anything to go by.

Why, though, were French engravers engaged in the first place? Apart from the aspirations to internationalism professed by Gambart, financial inducements must have entered into the matter to some degree. Both

Plate 39
Detail of 'Pomona', mixed mezzotint
engraving (17¾" × 13") by Samuel
Cousins after the painting by J.E.
Millais, R.A. Published 1882 by
Arthur Tooth and the Fine Art
Society (Ross Collection).

Waltner and Rajon were etchers, working with relative speed on copper
plates which were subsequently steel-faced (for substantiation, see the
latter's note, p.73): this meant a saving of time and thus of money. The
speed of etching was accompanied by a fluency of handling, and taste in
the seventies and eighties was veering towards prints with this
characteristic: 'Etchings are fashionable here just now' wrote W.J. Kelly,
one of Dixon & Ross's Manchester clients in 1887, 'have you got any?'
(Ross archives). It is also of significance in this connection that the Royal
Society of Painter-Etchers, with Seymour Haden as its first President, had
been founded in 1880. Furthermore, the ranks of English engravers
seemed to be thinning. On 21 January 1884, the Managing Director of
the Fine Art Society wrote to *The Times* as follows, replying to the
newspaper's obituary of Francis Holl:

'Fine engraving, whether in mezzotint or in line, is doomed.' Such is
the prophecy predicted by you . . . May we be allowed to draw your
attention to several causes which are conducing to the fulfillment of
this catastrophe? . . . you will agree with us that a branch of art which
alone enables the less wealthy . . . to enjoy fine translations of pictures,
the originals of which they cannot hope to possess, should not be
allowed to go down to its grave without an effort being made to
save its life.

He went on to enumerate the causes of the decline of engraving as he saw them, first blaming the 'miserable condition of the law of copyright' and pointing to the fact that the whole land was 'overrun with traders of the lowest class ... selling photographs of popular copyrights'. Publishers like the Fine Art Society hesitated 'to give large commissions to engravers and naturally prefer[red] processes involving little outlay'. The Society had, he wrote, published six engravings over the last four years, paying £7,000 for copyrights and £10,000 to engravers. In each case, within a month photographs were being hawked at 2/6d each. He next deplored the dilatoriness of engravers, who sometimes allowed 'months and years to drag on without a plate being completed, until the interest therein is gone, and publishers are perforce driven to adopt in future speedier methods of reproduction'. And, finally, he proposed one more reason:

> ... gaps which are being year after year made in the ranks of the profession without any fresh men coming to fill them up [Thomas Landseer had died in 1880; David Lucas in 1881; W.H. Simmons in 1882. Samuel Cousins was to die in 1887; and T.L. Atkinson and T.O. Barlow in 1889]. Since the retirement of Mr. Cousins and the death of Mr. Holl, the number of able engravers may be counted on the fingers of one hand. There is at present no better opening for a young student of talent ... who will be content with an uneventful life [a euphemistic indication, this, of the sheer slog of an engraver's work!], a fair income, and an almost certain place among the Academic body, than that of one who takes up engraving, whether line, mezzotint or mixed ... Mechanical work at present shows no sign of competing successfully with manual work accomplished by a real artist.

However, the tide of photo-mechanical progress was creeping relentlessly in, and hand-engraving in metal (as also in lithography and wood) was increasingly to become the province of the artist-printmaker. The issuing of hand-engraved plates slowed during the 'nineties as a result of the enthusiasm for photogravure. In the notice of its 26th Annual General Meeting, held on 28 April 1936, the Fine Art Trade Guild (incorporating the Printseller's Association) referred to '. . . the rage for photogravure which, in the '90s, practically stopped production of engraved plates for several years . . .'. Luke Fildes' 'The Doctor', for example, was reproduced by this process and issued by Agnew's in 1892, proving such a successful competitor with the manual work whose dwindling was so dolorously remarked in the letter to *The Times* that it was still in demand in the second half of the twentieth century (Agnew, 1967, p.66). The protagonists of photogravure were forthright and uncompromising in promoting the process:

> The object ... is to produce the most truthful and accurate reproduction possible of the original. As to accuracy of outline, there can be no serious contention that the engraver surpasses the

Plate 40
Detail (*c*.3″ × 2″) of 'The Doctor', photogravure (20¼″ × 29½″) of the painting by Luke Fildes. Published 1892 by Thomas Agnew (Author's Collection).

lens; and in interpretation, photogravure has a distinct advantage over the engraver, in employing half-tone, instead of line, to reproduce a half-tone picture ... there is no opportunity for the individuality of the engraver to leave an impress on the print antagonistic to that of the painter. It is the work of the painter in its entirety that the reproduction should portray – not a portion only of his work contaminated with the style and mannerisms of another (Denison, c.1895).

So much for the engravers and their 'Art of Translation'! Half way through the 1890s, however, the catalogue of Henry Graves & Co. already seemed to indicate – or perhaps to anticipate – the beginnings of a reversal of taste in favour of hand production. The firm's 1894 catalogue listed no fewer than 109 engraved works of Landseer, 'these subjects being engraved in various sizes', and claimed that Graves's possessed

the largest stock of engraved portraits in the world, embracing rare portraits of Ladies by the best engravers after the Old Masters in addition to Noblemen, Gentry, Scientific Celebrities of the past two centuries ... [and that they would] undertake to engrave portraits for private clients, for which [they would] be pleased to make quotations.

By this time, as *The Times* (16 January 1884, p.9) had claimed, 'fine engraving, whether in mezzotint or in line' may well have been doomed. It was doomed in the sense that most of the celebrated Victorian engravers were dead – most of them having succumbed during the 1880s – and in the sense that the discouragement stemming from photomechanical competition severely curtailed the number of new publishing ventures involving hand-engraved metal plates. But there was a sense in which engraving was, as yet, far from defunct: printers and publishers still held gigantic stocks of plates (Ross Archives, *Plate Book*, 1887, listing nearly 700 plates) – very many of subjects painted half a century or more earlier, and worked upon by engravers long gone – and prints from the most popular of these were in demand well past the turn of the century. Evidence from orders, invoices, and catalogues goes some way to upsetting established ideas about changing tastes during the nineteenth century, at least to the degree that those ideas have been based on the publication dates of engravings. The extent to which the demand for particular subjects continued *after* publication is an important factor in coming to a fuller understanding of fluctuations of taste; and a study of the records relating to sales provides a useful yardstick. Landseer's 'Bolton Abbey in the Olden Time', for example, remained in vogue for at least fifty years. The picture was painted in 1834, and on 9 May 1839, Thomas Boys published a large engraving of the subject, the first of several versions issued in various sizes by different publishers. The Dixon & Ross records show that there was a steady trickle of orders for the engravings (in large and small versions) during 1886 and 1887 (for example from W.J. Kelly & Co., 42 Stanley Street, Cheetham,

Manchester). The Thomas Ross Catalogue of 1903 was still advertising prints from the original plate (by Samuel Cousins and revitalised by Frank Atkinson) at £1.10.0d (india) and £1.1.0d (plain). The fluctuations in price are interesting: a list pasted in the back of the Dixon & Ross 1851–1854 Day Book gives the price as 9/-; in 1871 (Dixon & Ross trade catalogue) india prints from the newly restored plate were costing £1.5.0d; and in 1886–1887 (by which time the plate must again have been showing signs of wear) Kelly's were paying only 14/- for the large india prints. All this suggests that Romanticism did not surrender quite so unconditionally to the depictions of modern life – that it did not appear quite so 'inconsequent in the context of penny postage, the Factory Act, and the failure of the potato crop' (Beck, 1973, p.31), as has sometimes been suggested. Very many subjects of all kinds evidently retained their attraction long after their original publication.

Among the perennials were Wilkie's 'Village Recruit', painted in 1805, 'Village Politicians' (1806), 'Blind Fiddler' (also 1806), 'Rent Day' (1807), 'Blind Man's Buff' (1813), and 'Reading the Will' (1820). Orders survive from well into the 1850s (see, for example, Appendix I, p.191), and the engravings were still being advertised in the early years of the twentieth century (Ross, 1903), having remained popular for the best part of a hundred years. William Fisk's representations of the ordeals of Strafford and of Charles the First (p.29), published respectively in 1846 and

Plate 41
'Bolton Abbey in the Olden Time', mixed mezzotint engraving (22⅜″ × 28″) by Samuel Cousins (the plate subsequently revived by Frank Atkinson) after the painting by Edwin Landseer. Published 1839 by Thomas Boys (Author's Collection).

* This was not, in fact, accurate: it had been engraved as long ago as 1827 by Benjamin Gibbon (British Museum, Department of Prints & Drawings, C16, Vol.II, f31).

1850, also proved to be images of some endurance, being still advertised and sold in the 'seventies and 'eighties and even into the 1900s (Dixon & Ross, 1871; Ross, 1903). 'The Fight for the Standard' (p.30), exhibited by Richard Ansdell at the Royal Academy in 1848, was in demand in engraved form until after the turn of the century, and the showing of the original picture in Liverpool in 1908 (Beck, 1973, p.60) was further testimony to its lingering spell.

Landseer, as we have already seen, was an artist of persistent appeal. Engravings after such works as 'Interior of a Highland Cottage' (painted in 1826) and 'The Life's in the Old Dog Yet' (1838) were, like 'Bolton Abbey', sold well after his death in 1873 – the retrospective exhibition at the Royal Academy in the winter of 1874 perhaps adding fresh impetus to the sales. In May 1879, when the artist's 'Twa Dogs' came under the hammer at Christie's, the bidding stuck at 850 guineas. 'Gentlemen', coaxed the auctioneer, 'you are forgetting the copyright, the picture has never been engraved'*; after which the bidding reached £1,753.10s (Redford, 1888, p.288). In May 1881, Henry Graves & Co. announced their intention to publish a Library Edition of the works of Sir Edwin Landseer. It was to consist of 200 small engravings which were to be

Plate 42
Detail of 'The Life's in the Old Dog Yet', mixed mezzotint engraving (22⅝" × 28⅝") by H.T. Ryall after the painting by Edwin Landseer. Published 1865 by R.H. Grundy, Liverpool, and Goupil, Paris & Berlin (Ross Collection).

issued in sets of four up to the year 1893 (Printsellers' Association, 1892, and from 1892). During the 1880s, F.C. McQueen & Sons were still advertising nineteen Landseer subjects in their catalogue of engravings. In December 1884, an Artist's Proof of the 'Stag at Bay' was sold at Christie's for £58.16s (Redford, 1888, p.391). In February 1892, the Printsellers' Association was notified by Agnew's of the forthcoming publication of two Landseer subjects, 'Trim' and 'The Honeymoon', then being engraved by J.B. Pratt (Printsellers' Association, from 1892). In March 1894, another Artist's Proof of the 'Stag at Bay' was among a batch of Landseer prints sold at Christie's. It fetched £94.10s, and a proof of 'Monarch of the Glen' realised the even more startling figure of £113.8s (Graves, 1894, p.2). In April that year Henry Graves & Co. declared to the Printseller's Association a limited edition of Landseer's 'Godolphin Arabian' (Printsellers' Association, from 1892), and the firm's current catalogue (1894) of engravings listed over a hundred more of the artist's subjects. Engravings of John Martin's 'last grand works' were still being given star billing in the 1870s, their success assisted by the twenty-year tour of the paintings themselves, following their production during the last four years of the artist's life. The sale of very many sets of engravings – often coloured – during the 'fifties and 'sixties provides an interesting reflection of the extraordinary impact made by the pictures on the imagination of their viewers. Records show that the popularity of these apocalyptic subjects lasted until well past the turn of the century: Thomas Ross (1903) was advertising the Mottram engravings up to forty years after most of the excitement had apparently died away.

Portrait plates were commissioned throughout the nineteenth century, mainly for limited circulation to family and friends of the sitter, though a few seemed possessed of a magnetism more lasting and more widespread. Thomas Lawrence's 'Miss Peel' (1828) was engraved by Samuel Cousins in 1833 and was sufficiently in demand for a new plate to be made in 1846 (Appendix I, p.184). Prints of this portrait and of Landseer's 'Abercorn Children' were being cleaned and re-mounted as late as 1884 (Appendix I, p.201), and the latter was among the Landseer subjects listed in the 1880s by McQueen's (c.1882–c.1886).

Sir Frederick Leighton's tribute following the death in 1892 of Lumb Stocks, an engraver for sixty-five years, served every bit as much to signal the demise of an entire profession as of the individual; to mark the final dissolution of 'the ever-dwindling ranks of a delightful and once prosperous calling'.* The epilogue, however, has persisted to the present day, as surviving plates continue to yield impressions between the rollers of a few veteran machines: in May 1983, Thomas Ross and Son's (successors to Dixon & Ross) celebrated 150 years of uninterrupted activity as printers of the plates of this long vanished generation.

* Quoted in Stocks, J.P., *A Catalogue of Line Engravings by Lumb Stocks, R.A.*, revised and reprinted Penticton, British Columbia, 1978. The catalogue of the works of his ancestor has been compiled over twenty years by Mr. Stocks, and has so far been produced only for limited circulation.

A Process of Difficult Management

Chapter 4

Plate-Printers' Workshops and their Equipment

When Balthasar Moretus, the Antwerp printer, decided in 1714 to set up a small workshop for intaglio printing, he ordered a wooden press, blankets of woollen felt to give resilience to the pressure of the rollers, dabbers for working ink into the engraved lines of copper plates, a large covered vessel for boiling the oil used in the ink-making process, a marble slab and a muller for grinding ink, and, with a metal container for hot embers, a grille for warming plates (Voet, 1972, p.222). Moretus employed specialist intaglio pressmen, and there survives an interesting inventory with the value in florins of pieces of equipment that were the personal property of one of them. The printer's name was Gaspar Courtoy, and the list includes:

... a wooden tray, lead-lined, with a trestle [for damping paper]	f. 8-15
a walnut plank for the press	f. 14- -
an iron grille for inking plates	f. 3-10
an iron-clad bearing for the press	f. 1- 1
a large pair of tongs for use during the burning of oil	f. 0-10
a small pair of the same	f. 0- 6
a copper vessel [presumably for oil]	f. 0-14
earthenware pots for varnish and ink	f. 0- 7
a small box for chalk and ink	f. 0- 7
(in fact, probably two separate boxes, one for powdered ink and one for the whiting used in the wiping process)	
a wooden hammer	f. 1- 4½
[probably for use in straightening plates]	
a burin, burnisher and small file	f. 1-...

(Plantin-Moretus Museum, Arch. 697, No. 55).

In equipping his workshop, Moretus was guided by the treatise of Abraham Bosse, published in Paris in 1645; and his requisites correspond essentially with those of printers' workshops in the first half of the

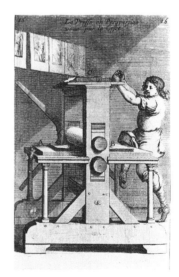

Plate 43
A plate-printer at work. Plate 16, Abraham Bosse, 1645 (St. Bride Printing Library).

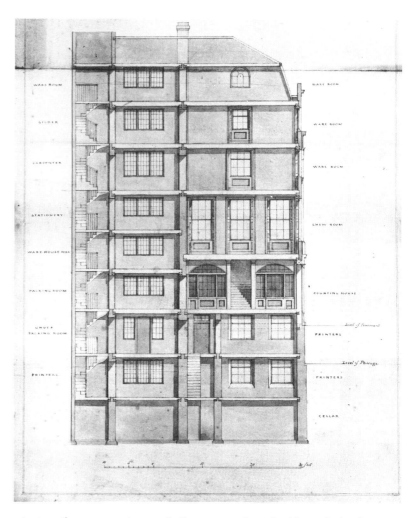

Plate 44
One of 52 drawings by J.B.
Papworth for Rudolph Ackermann's
new premises at 96 Strand, 1827
(British Architectural Library).

nineteenth century. As we shall now see there had been little change in
the equipment of an intaglio printer for at least the two hundred years
preceding the establishment of the firm of Dixon & Ross in 1833.

The latter event, however, seems to have been simply one indication
of an interesting spate of modernisation and expansion on both sides of
the English Channel. John Pye the engraver, when asked by a Select
Committee of the House of Commons to make a comparison between
the number of engravers active in England in the year 1836 and the
number working twenty years earlier, replied 'there may be five times as
many now as at that period' (House of Commons, 1836). This growth
was reflected in the corresponding enlargement and enhanced efficiency
of many printers' workshops.

It is characteristic of Rudolph Ackermann, whose wide-ranging talents
anticipated 'the great Victorian ideal of the marriage of fine art and
productive industry' (Ford, 1976, p.1), that he should have provided us
with one of the earliest instances of a fresh look at the design of intaglio

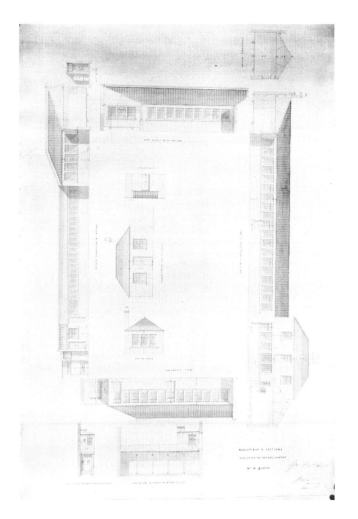

Plate 45
'Elevations & Sections for Printing
Establishment. Mr. McQueen. Geo.
Brookes. J. Finden, Architect, April
1832', from the original drawing
($22\frac{1}{2}'' \times 33\frac{1}{2}''$) owned by P.N.
McQueen (Plate 3 in Bain, 1966;
photograph by Department of
Typography and Graphic
Communication, University of
Reading).

printing workshops. Ackermann was one of the first in London to have
gas-light installed on his premises, apparently as early as 1812. As well
as enjoying the advantages of more efficient lighting, Ackermann's
copper-plate printers used the gas flame to heat their plates; hence
another welcome economy: no more prints spoiled by dripping wax
(Ford, 1983).* In 1827, Ackermann moved into extended premises at 96
the Strand (Ford, 1976, p.5). J.B. Papworth's designs for the new
premises show that a basement and sub-basement were to be occupied
by printers, and it is probable that the whole space was given over to
intaglio printing (R.I.B.A. Drawings, Ref. 95).

A few years later, the firms of McQueen and Dixon & Ross began an
expansion that was to continue for at least the next fifteen or twenty
years. Plans for large new premises at 184 Tottenham Court Road were
drawn for the McQueens in 1832 by the architect John Finden (Bain,
1966, plate 3); some correspondence of 1849 shows that the printers
were still at that time negotiating further expansion into neighbours'

* In a paper presented to a
Conference of the Association of Art
Historians.

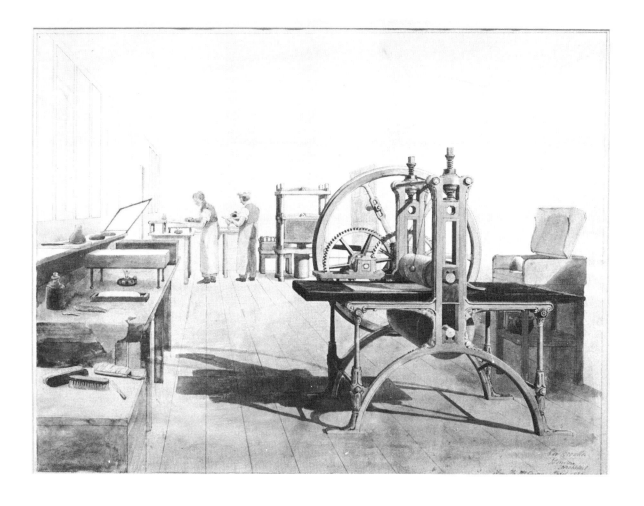

Plate 46
The McQueen workshop at 184
Tottenham Court Road. Wash
drawing (17″ × 28″) by George
Brookes, 1832 (colour frontispiece in
Bain, 1966).

leased premises (Appendix II, p.215); and, by the second half of the
nineteenth century, the space specified in Finden's designs had been all
but doubled to accommodate a total of twenty-five to thirty presses
(Bain, 1966, pp.12, 13). The McQueen workshops of 1832 were
undoubtedly among the first to be specially constructed to meet the
greater demands and increasing numbers of clients in the earlier part of
the nineteenth century, and they must certainly have been more pleasant
for their occupants than the basement floors at Ackermann's. The plans
show that the buildings were to be arranged around an open square so
that the maximum amount of daylight could be enjoyed, and that a
separate drying-house was to be placed in the centre. In an associated
wash drawing (which, with the plans, is owned by Mr. P.N. McQueen)
of part of the new premises, the architect seems above all to be
emphasising the light, spaciousness, and airiness his designs would
provide.

There is in the early records of Dixon & Ross much evidence of the firm's efforts to establish an efficient and well-equipped plant. Carpenters, sign-writers, and engineers were frequent visitors for a few years following the firm's beginnings. The summer and autumn of 1833 seem to have been a time of unusually brisk activity for the newly-established enterprise; the air of the workshop must have been heavy with the redolence of fresh paint and sawn timber as well as with the pervasive reek of the copper-plate ink. As carpenters installed heavy deal trestle tables and a new wetting-trough, large enough to take the Grand Eagle, Double Imperial, and Columbier papers in current use (Appendix I, pp.176–7), an engineer delivered a cast-iron inking plate weighing nearly one-and-a-half hundredweight, and also turned some rollers and drilled bearings for the presses. The work of improving and adapting presses continued for the next six or seven years, and in 1840 eleven gas lights and much other gas apparatus were fitted (Ledger B, 21/6/1833–11/10/1844). To judge from the lengthening lists of employees in their wagebooks, a continuing search for more elbow-room was as necessary for Dixon & Ross as for McQueen's. This is corroborated by the memorandum of an agreement of 1856 between the partners and a James Alwood Hutchings, in which:

> . . . Messrs. Dixon & Ross agree to take . . . the back room on the first floor of No. 1a Charles Street East, Hampstead Road . . . which said room abuts on the premises of Messrs. Dixon & Ross at the back . . . for the Term of Three years from the above date at the rent of Eight Pounds Ten Shillings per annum . . . The said Messrs. Dixon & Ross agree . . . to use . . . only the lighter sort of wooden cross press . . .

Besides the wealth of detail in the Dixon & Ross Ledgers and Day Books, there exist three other particularly interesting sources of information relating to the layout and the equipping of nineteenth-century intaglio-printers' workshops: the wash drawing of 1832, depicting the McQueen's new premises; Berthiau and Boitard's *Manuel de l'Imprimeur en Taille-Douce*, published in Paris in 1836; and the fascinating one-eighth scale model of a workshop that appeared in the 1855 Paris Exposition Universelle (pp.105–6).

The McQueen wash drawing depicts many of the tools and pieces of equipment whose counterparts were listed by Moretus and Gaspar Courtoy a century earlier: press-blankets, ink-dabbers, oil-vessels, marble slabs and mullers for grinding ink, and a wooden plank for the press. Innovations include the replacement of the grille for warming plates by a shallow metal box, probably water-filled, placed on a stand with a spirit-lamp as a source of heat beneath; the modern press, all metal except for the plank (p.104); and a hydraulic press, some six feet high, for flattening stacks of prints.

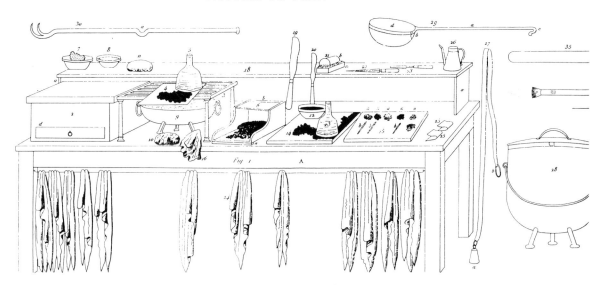

Plate 47
A plate-printer's work-bench. Detail
of Plate 2 in Berthiau & Boitard,
1836 (St. Bride Printing Library).

Berthiau and Boitard, the authors of the *Manuel de l'Imprimeur en
Taille-Douce*, provide a very full and detailed inventory of a plate-
printer's requisites. Their description – with one or two strangely old-
fashioned features – combines with the view of the McQueen workshop
and with the somewhat later scale model in Paris, to give us a very clear
picture of the intaglio printer's working ambience. The extensive list
includes: alum, for adding in certain circumstances to the water for
damping the paper; a wetting-trough with, adjoining it, a sloping stone
surface on which to lay the soaked paper; whiting made up into blocks
for applying to the printer's palm during the wiping of plates; stoppered
jars for powdered pigments; a gigger (a wooden box on which to place
the plate whilst wiping); brushes (one fine, for brushing away surplus
moisture and raising the nap of the paper prior to printing, and one
coarser, for brushing the surfaces of copper and steel plates); ladles and
cauldrons for oil, and other oil containers with spouts; wiping muslin;
spanners for adjusting the presses; callipers for locating points on the
reverse of plates corresponding to damaged or deteriorating areas on
the engraved surface (p.135); potash and quick-lime for removing the
solidified ink from inadequately cleaned plates; a water-tray to slide

Plate 48
Wetting-trough and other items of a
plate-printer's equipment. Detail of
Plate 2 in Berthiau & Boitard, 1836
(St. Bride Printing Library).

beneath the press and catch the drips of water squeezed from the damped paper; a scraping tool for removing obtrusive and possibly damaging burrs of metal from plates; a wooden box for black powdered ink; a work-table, with its arrangement minutely described; a wooden implement (*étendoir*; in English, a peel), somewhat resembling a paddle, for placing damp blankets on overhead lines to dry; a grille (this being one of the rather old-fashioned items in the list, although the authors do mention a recent invention, 'une sorte de boite en fer', with a smooth, polished top); a plumb-line which could be pinned to the leading edge of the blankets so as to keep them back over the impression cylinder of the press during printing; a polisher (*lissoir*) of ivory for polishing paper where flesh and other light passages are to print; a magnifying glass; a white marble slab for colour-mixing; mullers; hammers and mallets; pincers of card or thin metal (*mitaines* or *poucettes*) to protect paper from the inky fingers of the printer; a feather duster for keeping paper free of specks; a needle (*pointe d'éplucher*) for picking faults out of paper without causing undue damage; and wooden planks for the presses. The presses themselves, incidentally, represent perhaps the most surprisingly old-fashioned feature of the manual — those in common use are described as being of essentially wooden construction.

Most of the items in the above list are represented in the 1855 model, and the miniature workshop also contains a rack, consisting of an open box of wooden construction with ropes stretched vertically, into which the absorbent boards used for pressing damp prints can be placed for drying.

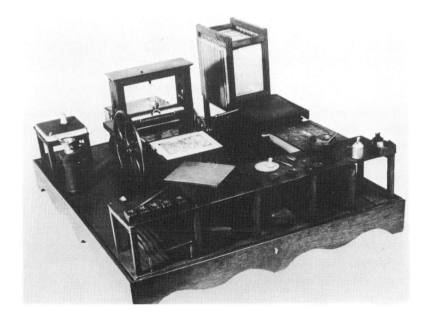

Plate 49
One-eighth scale model of a plate-printer's workshop, made by
H. Maubert of Paris for the 1855 Exposition Universelle (Musée National des Techniques, Paris).

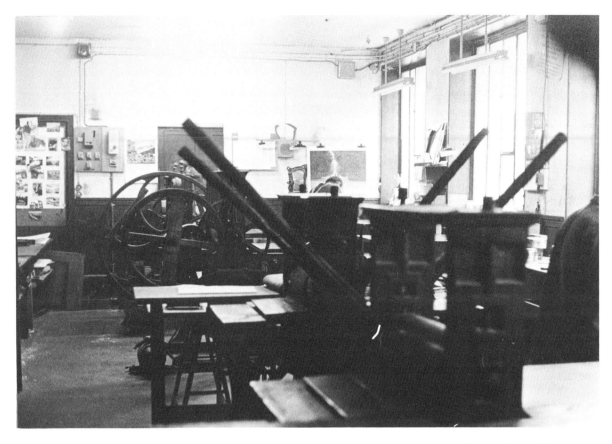

Plate 50
A workshop at the Atelier Leblanc, Paris, 1979. Two *presses à croisée* in the foreground.

In spite of all this, however, an even more striking and complete impression of a nineteenth-century intaglio printer's workshop is still available to us at the Atelier Georges Leblanc, 187 Rue Saint-Jacques, Paris, where nineteenth-century workshops remain largely unaltered, and where printing still proceeds with the use of nineteenth-century presses and with some equipment even from the eighteenth century. Unhappily, the drawings are all that remain to us of McQueen's efficient and carefully devised plant; and, although many of the plates, much of the equipment and most of the records of Dixon & Ross survive, the transplanting of the firm to Putney in 1966 meant that the material and the original premises that housed it can no longer combine to re-create — or perpetuate — for us the authentic atmosphere and layout of a nineteenth-century workshop. The Atelier Georges Leblanc, however, represents precisely such a perpetuation. It gives a very clear idea of what McQueen's premises in Tottenham Court Road must have been like, since its buildings are arranged in a similar open rectangle with, placed in the centre as at McQueen's, a separate drying-house, heated by a coal stove. The studio was originally founded in 1793, and quickly became a house of some consequence (Frèrebeau, 1974, pp.24–25). Jean-Charles Rémond, the first proprietor, opened his workshop at 15 Rue Saint-

Plate 51
The drying-house, Atelier Leblanc,
1979. The stove is in the foreground,
covered with press-blankets drying.
An *étendoir* hangs from the board-
rack on the left.

Jacques, and from that date until 1863 the business remained in the
hands of the Rémond family, among whose distinctions were the
printing of plates illustrating an important work on Napoleon's Egyptian
campaign (*ibid.*, also p.129, below), and of plates for albums of P.J.
Redouté's flower pieces. The thriving concern (by this time in the Rue de
la Vieille Estrapade, a few hundred metres from its original home) was
bought in 1863 by Alfred Salmon. The business grew to such an extent
that Salmon, like McQueen's and Dixon & Ross fifty years earlier,
needed far larger premises and decided to do the job properly.
Accordingly, he built the Ermitage Saint-Jacques, the secluded complex
of printing workshops and living quarters, set back some distance from
the street and accessible through the narrow entrance at 187 Rue Saint-
Jacques (see Frèrebeau, 1973). There, he installed no fewer than thirty-
seven presses (Frèrebeau, 1974, p.25), of which, in surroundings virtually
unchanged for the best part of a hundred years, eleven remain. Though
built fifty years later than McQueen's Tottenham Court Road workshop,
the Ermitage Saint-Jacques is so obviously planned according to the
same principles of ergonomics that we may consider it a reasonably
accurate re-creation of its London counterpart. Three iron cross-presses
(*presses à croisée*) form part of its equipment. They were constructed by
Ledeuil, the engineer from the Rue Poliveau, whose name-plate appears
on so many nineteenth-century machines and whose descendant, Roger
Ledeuil, is now installed in Montrouge in the suburbs of Paris, where he
continues to produce presses of essentially nineteenth-century design as
well as more modern machines. Another of the presses is the larger
Fleury, built by another celebrated mechanic working in the Rue
Froidevaux. One may also see in use at the Ermitage the iron-topped
heaters described in 1836 by Berthiau and Boitard (*op. cit.*) as the latest
thing; these are gas-fired. The drying-house is a feature of considerable

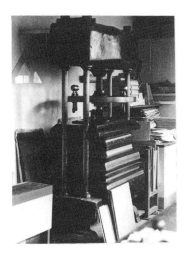

Plate 52
Prints being flattened between boards
in the *presse à satiner*, Atelier Leblanc,
1979.

interest: narrow-gauge rails run into it from the main workshop, so that trolleys laden with wet boards and blankets may be trundled easily into its warm, gloomy atmosphere. The heat is provided by a coal stove from which a metal pipe some nine inches in diameter runs round the room, further diffusing warmth. Much of the space is occupied by wooden racks, similar to that in the 1855 scale model, carrying scores of the millboards used for pressing damp prints. Cords cross the room overhead. On these, and on a wire grille over the stove, are placed the wet blankets. The blankets are hung up with the aid of a wooden *étendoir*, one of the implements described by Berthiau and Boitard. On low wooden platforms on the floor are stacks of damp prints, sandwiched between millboards and weighted with fifteen or sixteen 20 kg iron weights. One of the rooms at the Ermitage is set aside for the finishing and packing of prints, and this room houses a gigantic *presse à satiner* about eight feet high and capable of taking a stack of prints and boards three feet thick — the eighteenth-century ancestor of the hydraulic press depicted in the wash drawing of the McQueen workshop.

Another Paris workshop worth mentioning is that of Lacourière and Frélaut, in Montmartre. Although it is of comparatively recent establishment — 1929 — it contains a great deal in the way of early

Plate 53
A workshop at the Atelier Lacourière et Frélaut, Paris, 1979.

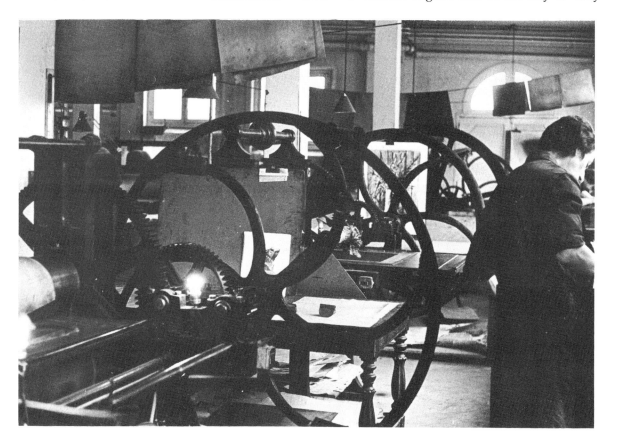

equipment and machinery: an eighteenth-century wooden copper-plate press; two large *presses à satiner* (used nowadays for squeezing surplus water from the soaked paper immediately prior to printing); and a number of nineteenth-century iron presses bought at various times by Roger Lacourière from printing concerns closing down. These presses include some by Ledeuil and by Fleury. There is also one carrying the name-plate of Dominique Van-de-Weghe of Faubourg Saint-Jacques, and another originally made for Coty, the parfumier, and used by him for the printing of trade-labels. This last is an interesting little machine – an iron cross-press with pressure-screws like small steering wheels, about ten inches in diameter. The firm concentrates exclusively on the reproduction of the work of twentieth-century artists, among them Marc Chagall and Henry Moore. Nonetheless, we rely on living enterprises such as this, with its continuing use of traditional methods and equipment, to amplify our picture of a once flourishing intaglio printing trade.

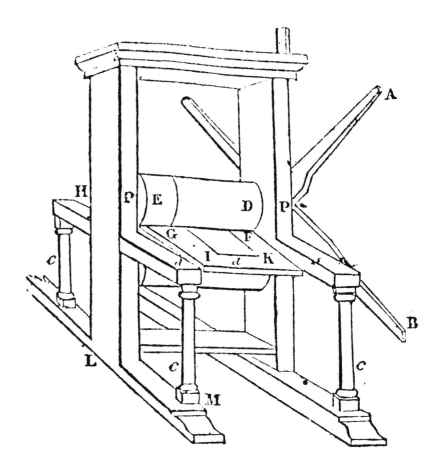

Plate 54
Diagram of a wooden rolling-press,
p.131, Partington, *c.*1825 (St. Bride
Printing Library).

Chapter 5

The Rolling-Press

In July 1833, a certain Ross Senior,* who provided Dixon & Ross with much of their ink and with sundries such as wiping canvas and dabbers, supplied three presses:

ROSS SENR.
1833
July By the small press 5-0-0
 By the 30 in. do. 16-0-0
 By the 46 do. do. 27-0-0 (Appendix I, p.176)

From their relatively modest price, these may have been ungeared cross-presses. Such presses made unusually heavy work for the printer, since they were operated by hauling on wooden spokes radiating directly from the spindle of the upper roller, without benefit of gears. Ross Senior's presses were probably constructed entirely of wood: the planks would have been of mahogany, and the rollers of elm and lignum vitae. One of the current manuals of engraving, compiled in about 1825 by C.F. Partington (p.131) gives a clear idea of what these presses must have been like; the design of such machines had been virtually unchanged since the fifteenth century (see Meier, 1941, p.173).

There were improvements generally in printing machinery during the first three decades of the nineteenth century. The traditional wooden press of the letterpress printer moved towards obsolescence with the use by 1803 of the Stanhope platen press, the arrival of the iron Columbian press from America in 1817, and the introduction by R.W. Cope a few years later of his Albion press (see Stone, 1966). Enthusiastic experiments were also being undertaken by lithographic printers to devise presses with the scraping action suited to their new process (see Hullmandel, 1832). The overhauling and improving of the Dixon & Ross presses during the early 1830s had therefore ample and widespread precedent.

Ross Senior had sold the printers a small press costing five pounds; a 30″ press costing sixteen; and a 46″ press costing twenty-seven. The measurements 30″ and 46″ refer to the lengths of the rollers, and therefore the widths of the planks.** These were both large presses – the

* This seems to have been Thomas Ross of 3 Giltspur Street, described by *Robson's London Commercial Directory*, 1835, as an engraver and Frankfort black maker, and classified with engravers and printers.

** Though the size of plank could be varied. See p.104, below.

46″ press something of a giant by early nineteenth-century standards. A year later, a new iron press with 22″ rollers and with gears was bought from Pinner's for thirty-eight pounds. This higher price – for a smaller press – as well as a checking of Ross's prices against the details of later work on presses for Dixon & Ross supports the suggestion that the presses delivered in July 1833 were traditional ungeared models, destined for modernisation. Four months after the arrival of Ross's 30″ press, the following entry appeared in a Dixon & Ross ledger: 'Putting 3 Wheel motion to 30 inch Press'; it is reasonable to assume that this refers to the machine recently arrived. Three months later the same press was fitted with a new iron bottom roller and brass bearings, and the elm roller it replaced was taken away in exchange. After a lapse of another few weeks, its plank was repaired and planed. The elm roller from the 30″ press was probably taken for re-use; Dixon & Ross considered it worth having the lignum vitae roller repaired in 1840, and it was to be many years before wooden components became completely obsolete.*

A press with 46″ rollers was also attended to by Pinner in June 1835 (Appendix I, p.177); again, one concludes that it was the machine bought from Ross Senior two years previously. Measurement of the presses in use today at the premises of Thomas Ross & Son reveals only one coincidence. The rollers of presses mentioned in the ledger of the 1830s are 22, 30, 40, and 46 inches long; those of the presses still in use measure 26, $32\frac{3}{4}$, 33, 46, 50, and $53\frac{1}{4}$ inches. One is tempted to conclude that the 46″ press has been in constant use – extensively modified – by the firm since 1833. Over £40 was spent on modernising a press costing originally only £27. This represents a considerable investment (Appendix I, p.177). Although there is no record of it, there seems no reason why such a press should not subsequently have been fitted with an iron frame (assuming it to have been originally of wood) or an improved iron frame, and have ultimately become unrecognisable as of early nineteenth-century origin. Such a conclusion is quite feasible: several of the iron Columbians and Albions of the first quarter of the nineteenth century are still serviceable. It was the waning of interest in these old presses for twenty years or so following World War II rather than their degeneration that sent so many to the scrap-yards. The art schools and the few enthusiasts purchasing copper-plate and other iron presses in those years could do so for a fraction of their original cost. (When McQueen's amalgamated with Ross's in 1956 they could get rid of their presses only by selling them at £1 per inch of roller length).

Scant attention has been given to the evolution of the rolling-press, except by Meier (1941). Even he concentrates on the press's development only up to the mid-seventeenth century. Its subsequent history he summarises thus:

> future generations did not change its principle but added mechanical improvements . . . the gear and pinion drive was introduced and wood gave way to metal (p.515)

* Mr. P.N. McQueen remembers using wooden planks as late as 1956. Such was the hardness of these that they sometimes blunted the mechanical planer when taken to a sawmill for renovation.

It has already been suggested above that plate-printers, exponents of a long-established craft, had by the nineteenth century inherited a tradition of anonymity and their skills were thus inclined to be taken for granted. This, allied to the fact that the mechanical needs of printers of pictorial plates were basically very simple — and have always remained so — helps explain the obscurity that cloaks developments in rolling-press design from the wooden machine in common use in the eighteenth century (and practically identical in design to the hand roller press introduced in Europe in the fifteenth century), towards the iron colossus of the mid-nineteenth century. There was throughout this period little in the way of fundamental change: the materials and the technology of the industrial revolution were simply applied to make an already perfectly practicable machine more durable, somewhat easier to operate, and per-haps capable of greater and more even pressure. Very few — if any — of the devices officially patented during the nineteenth century really took root in any general way: simple practicalities such as the application of gears and the conversion to iron and other metals proceeded unrecorded, except in the ledgers of those concerned. Some of the registered patents are, however, worth noting, if only to emphasise that their failure to achieve widespread adoption lay in their essential irrelevance to the needs of printers of pictorial plates.

For example, in 1803, Robert Kirkwood, an engraver and copper-plate printer of Edinburgh, patented a press which was of traditional construction except that it was fitted with a cut-away upper cylinder, D-shaped in cross-section, designed to allow the counter-weighted plank to run freely back through the press after each impression (Printing Historical Society, 1969, p.108. For an illustration, see Berthiau and Boitard, 1836). The object of this was simply to save time: the operator had no need to walk round to the far side of the machine to lift proofs from the plate. For printers working with large plates, from which it was possible anyway to make only very few impressions in the course of a normal working day, the time saved would have been negligible.

Fifty years later, inventors were still exploring the possibility of improvements. By early in 1853, Robert Neale had completed the work which, two years later, was to earn him a Second Class Medal at the Paris Exposition Universelle. He had invented a machine for inking, wiping, and printing intaglio plates (Printing Historical Society, 1969, pp.144 ff). His press was equipped with a stencil device, designed to make colour-inking possible; and with heaters for warming the plates. By March 1855, Neale had incorporated further refinements. The Jurors' Report following the Exposition Universelle recorded the presentation of a medal to the inventor, and concisely set out the advantages and limitations of his machine:

> La presse mécanique ... pour la taille-douce offre une grande
> rapidité d'exécution; mais, destinée aux timbres-postes [et] aux

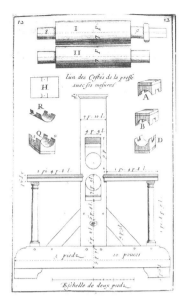

Plate 55
Diagram of a wooden rolling-press,
showing details of wooden bearings
lined with sheet-iron. Plate 12, Bosse,
1645 (St. Bride Printing Library).

billets de chemin de fer . . . il est douteux qu'elle puisse etre
appliquée aux gravures d'art (1856, p.60).

The same Jury had, in another context, described precisely that
characteristic of fine art plate-printing which rendered Neale's invention
unsuitable for that particular branch of the trade – a branch in which
'chaque épreuve nouvelle est un nouveau travail de la main et de
l'intelligence de l'ouvrier' (ibid., p.30).

Also in 1855, G.F. Rose patented an 'improved means of driving and
supporting the reciprocating beds of lithographic or copper-plate
presses' (HMSO, 1905, pat. no. 1968). In 1867 A.J., W.G., and S.H.
Waterlow designed a machine with an automatic wiper (HMSO, 1904,
pat. no. 3034) – one of Robert Neale's preoccupations; and in 1877, the
latter was still persevering with the improvement of his invention
(HMSO, 1893, pat. no. 1726).

Whilst inventions such as these left the fine art plate-printing trade
virtually unaffected, they are nonetheless interesting in that all were
derived from the classic rolling-press, and most represent genuine efforts
to enhance the efficiency of this basic machine. There were, however,
more basic modifications which provide a more immediate context for
the references in the Dixon & Ross records.

The Plantin-Moretus Museum in Antwerp houses an early example of
a wooden copper-plate press (Voet, 1972, p.222). The press has an
interesting pedigree, having been modelled on that described and
illustrated by Abraham Bosse in his influential manual of 1645: Traicté des
manières de graver en taille-douce. Moretus's emulation of Bosse is just one
instance of the latter's influence in matters pertaining to plate-printing.
For example, John Evelyn quoted him extensively in Sculptura, or the
History of the Art of Chalcography (London, 1662); and Thomas Hubbard,
in Valuable Secrets concerning Arts and Trades (Norwich, 1795), re-
commended to 'the curious' that they 'may amply satisfy themselves by
taking the trouble to read the treatise which Abraham Bosse has
purposely composed, on the art of engraving'. The printer Balthasar
Moretus ordered, through a paper merchant associate living in
Amsterdam, 'une presse de la dernière perfection pour imprimer
oeuvrages avec deux rouleaux, avec du bois de Guajac' and, by way of
accessories, 'des langes pour mettre dessus les planches et quelque fois
dessous* en imprimant; quatre tampons ou balles pour encrer les
planches . . .; le vaisseau ou marmitte pour faire cuire l'huile . . .; le marbre
et la mollette pour broyer le nois; [et] la poisle [poêle] et le gril pour
chauffer la planche'. The press and its appurtenances arrived in Antwerp
on 17 December 1714. The list of items (p.83, above) provides an insight
into the comparative simplicity of a plate-printer's requirements. Except
for the large iron bolts securing its main framework and the plate
reinforcing the junction of the four-armed cross, the press is built entirely
of wood. The construction is massive, the cheeks being solid and

* This reference to the occasional use
of blankets beneath the plate is
interesting and unusual.

sufficiently broad to take the bearings of all four rollers: the top and bottom ones of lignum vitae and those of smaller diameter designed to support the plank horizontally. The bearings – like the frame, the rollers, the cross and the plank – are of wood and their concavity matches the diameter of the rollers' spindles. The bearings are housed in the apertures cut into the cheeks, and the pressure of the top roller upon the plank is controlled by screws operating vertically downwards through holes drilled in the framework and given elasticity by the insertion of layers of thin card wedged between wooden blocks: one at each side in direct contact with the screw, and one bearing down upon the spindle. The plank is made from four longitudinal sections, held with lateral tenons at the ends.

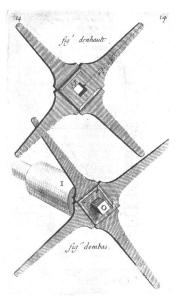

Plate 56
Diagram of the cross of a rolling-press. Plate 14, Bosse, 1645 (St. Bride Printing Library).

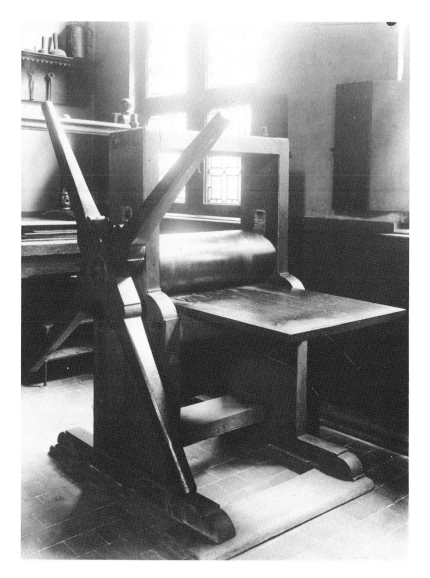

Plate 57
Wooden rolling-press, 1714 (Plantin-Moretus Museum, Antwerp).

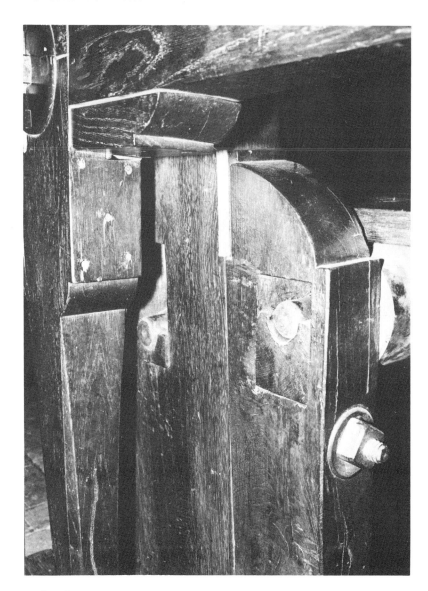

Plate 58
Detail of the Plantin-Moretus press
(photograph: Richard Southall).

The Plantin-Moretus press has been described at some length because it illustrates a continuing dependence on the archetypal model of Bosse, demonstrating not only the durability over a considerable span of years of the latter's simple practicality, but also its dissemination internationally. Many wooden presses built, like the Plantin-Moretus example, in emulation of the design of Abraham Bosse — whether directly or otherwise — were still in use many years after the first iron presses had begun to appear. At least one has survived in this country; it was acquired in 1875 by Charles William Sherborn, the engraver, who used it until 1912, and it is now in the Science Museum, London. The press is thought to have been made in the eighteenth century, and its close resemblance to various early designs — including that of Abraham Bosse

– certainly supports the suggestion. Despite its presence in this country, one should resist the automatic conclusion that the press is necessarily of English construction. It very closely resembles an eighteenth-century wooden copper-plate in the Musée de la Banque et de l'Imprimerie, Lyon (illustrated in Frèrebeau, 1974, p. 11). The press, though robustly built, is not as massive as the Plantin-Moretus model. It stands about five feet high. The cheeks are $9\frac{1}{2}''$ broad by $2\frac{5}{8}''$ thick. The rollers are 23″ long (the lower one slightly more) and the plank rather more than 22″ wide, $53\frac{1}{4}''$ long, and 2″ thick. The six-armed star-wheel measures about 7′4″ across.

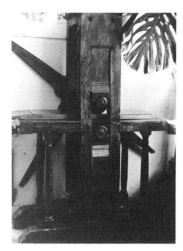

Plate 59
Wooden rolling-press, probably seventeenth century, at the Atelier Lacourière et Frélaut, Paris.

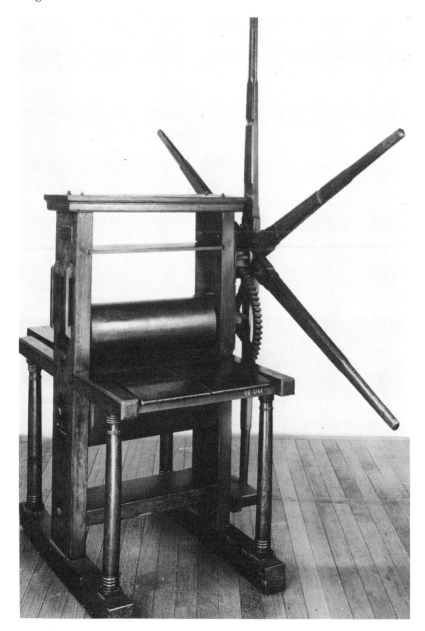

Plate 60
Wooden rolling-press, probably eighteenth century, with wheel and pinion gear (Science Museum, London).

Whilst the press incorporates several refinements, both mechanical and aesthetic, there are respects in which it is less sophisticated than the Plantin-Moretus machine. For example, there are no screws to regulate the pressure and the ends of the plank are supported on transverse rails rather than on rollers. Like that of the Antwerp press, the pressure roller is driven by a cross or, rather, a star – one of six arms – and a simple gear in the ratio 1:5:7 has been fitted at some time in the machine's history. This mechanism is certainly not original. The press was probably first constructed about the middle of the eighteenth century and the gear and other iron parts added in the 1830s – contemporary with the improvements recorded in the Dixon & Ross 1833–1844 ledger. The wheel and pinion gear very closely resembles one illustrated in Berthiau and Boitard (*op. cit.*). It is probable that the original wooden 'trunnions' were lopped off at the same time, and iron spindles inserted in the rollers. Also, the fitting of the gear wheel to the upper roller meant that the star-wheel could be positioned higher on the cheek, and its diameter could thus be greater and still allow the arms to clear the floor. The machine had until then probably been fitted with an ordinary cross of four shorter arms so that, when fitted direct to the 'trunnion' of the upper roller, it would clear the floor. The Lyon press (referred to above) is fitted with such a cross. The toothed gear wheel of the Science Museum press is fixed to the spindle of the upper roller and engages in a small pinion at the junction of the spokes. An iron protrusion from the lower roller makes it evident that it, too, at one time bore a pinion and was driven by the central gear-wheel. Again, there are cheeks to take the top and bottom rollers and their bearings; but the supports for the plank are carried by rails mortised into the upright cheeks and resting at their extremities on turned wooden columns. Both rollers – the upper one nine inches in diameter and the lower one twelve – are made of lignum vitae and have iron spindles. The plank is made from a single piece of wood, tapered down at one end to allow for easier insertion and removal and to minimise the risk of damaging the rollers in the process.

MM. Berthiau and Boitard, writing in 1836 in their *Manuel Complet de l'Imprimeur en Taille-Douce*, describe in great detail the typical press then in common use. Their account throws further light on the two machines discussed above. Whilst most presses had once been constructed from Dutch oak, the growing scarcity of that timber had led to the widespread use of substitutes, generally walnut or elm. Both of these materials were recommended, in spite of the tendency of walnut to split, and of elm to warp when not properly seasoned. Considerable space is devoted to a discussion of rollers for, the writers insist, 'C'est de leur bonté que dépendent les qualités d'une presse'. Rollers were by that date made from walnut, elm, lignum vitae, cast iron or brass, and each of these materials had its own particular qualities and uses. Walnut, even with its liability to split and with an inclination to be a little soft, made good rollers. Elm could generally only be used for bottom rollers, where

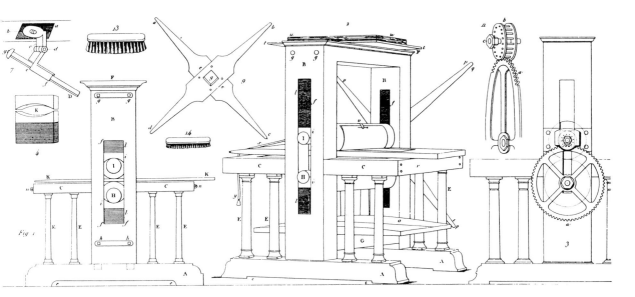

Plate 61
Diagram of a wooden ungeared rolling-press, with details of packing and bearings, cross, and wheel and pinion gear. Section of Plate 1, Berthiau & Boitard, 1836 (St. Bride Printing Library).

absolute trueness was not so crucial, since it refuses to absorb water evenly. Lignum vitae was the hardest of all these woods – so hard as to act rather harshly upon the paper and to stretch it. It was so tough that when used with rollers made of other woods it tended to break them, and so was usually paired with another of the same material – Moretus had taken this precaution – and five or six blankets were used (instead of the more customary four) to counteract their intractability. According to the authors, 'Rouleaux en fonte polie où en cuivre … [sont] presque indispensable pour le tirage des estampes à la manière noire … aquatinte et autres gravures légères'. The particular need of finely engraved plates for the kind of pressure metal rollers could provide was stressed by E.S. Lumsden, who, in *The Art of Etching* (1924, p.92) quoted Frederick Goulding, the printer (p.34, above), as saying that '… the finest lines need the most 'pinch''. All this makes the quality achieved by seventeenth- and eighteenth-century printers of mezzotint plates – with only wooden rollers at their disposal – the more remarkable.

The manual goes on to describe the preparation and care of wooden rollers: they were soaked initially in walnut or linseed oil and subsequently kept in condition by occasional rubbing with an oily rag. There follows some interesting discussion of the relative thickness of paired rollers: Berthiau and Boitard insisting that the precisely calculated greater diameter of the bottom roller is very important in helping attain even pressure and in increasing the gripping power of the press ('La presse serre plus exactement … l'impression en est plus belle'). 'Present-day printers', they complain, 'seem content as long as the bottom roller is simply greater in diameter than the upper. Old printers, however, sought exact relative proportions'. These 'old printers' apparently worked with presses whose bottom rollers were exactly one fifth larger in diameter than their top rollers. Berthiau and Boitard are not specific

about which 'old printers' they refer to. They cannot have meant Bosse, whose press design incorporated two rollers of equal thickness.

Planks were customarily of walnut, in a single piece free of knots and protrusions and of even thickness throughout. There were evidently planks of different size available to each press, to be used according to the scale of the work. As they wore – and small plates were particularly damaging in this respect – their hollows were compensated with paper packing. Eventually, when the concavity became too pronounced, the only solution was planing, but the repeated application of this remedy would lead ultimately to the plank becoming too thin and having to be replaced.

Berthiau and Boitard make interesting observations on bearings and on pressure. The bearings they describe are of solid wood and, to reduce friction as much as possible, the diameter of their extremely shallow concavities is much greater than that of the roller's spindles. The authors remark that Bosse had specified bearings and spindles with corresponding diameters, and criticise these as being susceptible to splitting as a result of the friction generated. Their bearings were lined with thin plates of polished iron – as Bosse's had been – to increase their durability; and both top and bottom bearings were packed with wads of thin card, trimmed to fit neatly into the openings in the cheeks of the press. (Similar packing is essential to all presses – even modern ones of iron construction – in combining with the blankets to provide resilience.) To achieve still less obdurate pressure, squares of felt were introduced at intervals in the stack of card. This basic press apparently had no pressure screws: simply, 'on augmente où diminue la nombre des cartons pour serrer plus où moins la presse. Leur élasticité donne une pression uniforme partout'. The standard cross described by Berthiau and Boitard is one of four arms; but they describe one of five or six ('la croisée de la presse mécanique') as being more usually attached to geared presses. The former corresponds with the cross of the Plantin-Moretus press and accords with the specification of Bosse; the latter with that of the Science Museum press. The 'presse mécanique' referred to by the authors was the standard wooden model modified by the attachment of a simple gear – exactly like that of the Science Museum press, probably very like the 'second hand wheel and pinion press' purchased in 1838 by Dixon & Ross (Appendix I, p.177), and like the press for which E.S. Lumsden (1924, p.92) expressed a preference nearly a hundred years later: 'Personally, I am fond of the single-geared, spider-wheel [synonym for 'star wheel'] press, as it enables one to feel what is happening, without undue labour'.

Berthiau and Boitard have much more to say about presses, and their manual is full of evidence to support the theory that the 1830s marked really significant advances in rolling-press design (*op. cit.*, pp.189–191). The authors describe a 'presse mécanique à volant', a wooden machine of

archaic appearance, but whose fly-wheel gave it the advantage of a smooth, even action. The action was, however, so slow that such presses were reserved for the most lucrative printing jobs. For cheaper work to be an economic proposition it apparently had to be achieved at speed with an ungeared press (*op. cit.*, pp.32–33). The manual also affords an intriguing glimpse of English enterprise: it contains a brief description of a 'presse mécanique anglaise', newly arrived in Paris. The French had so far seen only relatively small versions of this imported machine – 'pas plus de quinze à dix-huit pouces [roughly 15″ to 18″; at this time in Paris *un pouce* measured 1.094″] d'ouverture entre les deux jumelles'. Though the authors do not explicitly say so, this type of press seems to have been of mainly iron construction. The rollers were certainly of iron, and the cheeks, since they were not joined in the traditional manner of the wooden press by a 'chapiteau' (p.107, below), could hardly have been of any other material. Four small iron wheels, two or three inches in diameter, were positioned on the frame in such a way that they guided the passage of the plank, allowing no deviation and thus cutting out the risk of its being driven into one or other of the cheeks and breaking it. In this English machine, the cross was replaced by a heavy cast-iron wheel with five wooden handles equally spaced around its circumference – as in a ship's wheel. This is one of several unusual features incorporated in the press, of which, unfortunately, there is no illustration in the manual (*ibid.*, pp.33–36).

The account of Berthiau and Boitard, the Science Museum press, and much evidence in the Dixon & Ross records combines to show that these wooden presses, sometimes with modifications but essentially deriving from the fundamental design recommended by Bosse, were in common use in workshops on both sides of the Channel in the early decades of the nineteenth century. Frèrebeau (1974, p.15) reproduces a print of a French workshop of 1846, containing at least two copper-plate presses of this basic type. Despite technical advances (see below) it is evident that wooden presses continued to be used until well past the middle of the century, perhaps often alongside their more sophisticated iron counterparts. Judging from Dixon & Ross's agreement of 1856 with James Alwood Hutchings that no 'heavy or iron press but only the lighter sort of wooden cross press' should be used on the latter's leased premises (p.87, above), these early models were by no means ousted by this date.

Substantiation is provided by the scale model (p.89, above) of a plate-printer's workshop first shown at the Paris Exposition Universelle of 1855. It is at present in the Musée de la Conservatoire des Arts et Métiers, Paris. The model, constructed by H. Maubert,* was classified with various items of modern machinery relating to the printing trade, and was thus clearly intended to represent a typical, progressive workshop of the period. The miniature press, one-eighth original size,

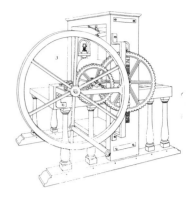

Plate 62
Diagram of a wooden rolling-press with gears and fly-wheel. Section of Plate 3, Berthiau & Boitard, 1836 (St. Bride Printing Library).

* Maubert lived in Rue du Faubourg de la Temple, a stone's throw from where his model is now housed. The model was in Classe VIe, sec. 11 (No. 1405), and was thus classified with, for example, Robert Neale's invention for the inking, wiping and printing of intaglio plates (p.97, above).

demonstrates the tenacity of the wooden-framed machine in France.
Berthiau and Boitard had referred in their manual to a two-geared press
with a fly-wheel attachment and with pressure screws built into the
apertures of the cheeks; the Arts et Métiers machine is of this type. The
frame is still of wood, but the rollers are brass. A heavy horizontal table
fits between the cheeks of the press and its four corners, like the
extremities of the rails in the Science Museum press, rest on wooden
classical columns. A large opening in this table accommodates the
bottom roller and, on either side of it, the smaller ones supporting the
plank. On one side of the press is a handle attached to a small lantern-
type pinion which engages the two toothed gear wheels. The 'lantern' is
formed of two iron discs held an inch or so apart by evenly spaced bars
close to the circumference. The teeth of the associated gearwheel fits the
spaces between the bars. Such 'lanterns' were the forerunners of the
toothed pinions which Berthiau and Boitard described as a characteristic
of 'la presse mécanique anglaise'.

On the *opposite* side – an unusual feature – is a large fly-wheel which
on a full-sized press must have had a diameter of 40" or so. The pressure
screws are housed inside the openings in the cheeks, and bear down
upon blocks which, with the bearings, sandwich the usual stack of card
packing. An interesting feature of this press is one also illustrated and
described by Berthiau and Boitard: a small, heavy roller is fixed by means
of a universal joint to the underside of the top cross-member. This was
for the purpose of holding the blankets smoothly in position round the
impression cylinder, thus preventing their creasing during printing. The
universal joint, combined with a simple sliding mechanism on the arm by
which the device is suspended, meant that the whole fitting (made
entirely of brass) could be swivelled and slid horizontally under the
cross-member when not in use. In other presses, the function of this
roller was sometimes performed by a heavy ball suspended from the
cross-member on a string; or by a plumb-line pinned to the leading edge
of the blankets and falling directly – or via an overhead pulley – back
over roller and plank. It finds an interesting echo in the expedient of
heavy wire-framed mahogany rollers suspended by string from the
ceiling above each press at the premises of Thomas Ross & Son today.

The persisting use of wooden – or largely wooden – presses vouches
for their effectiveness; but the iron machines whose appearance we begin
to notice around the 1830s were even more effective and, of course,
even more durable. The beginning of a spate of iron press development
evidently ran parallel with the continued production, improvement and
adaptation of wooden models. There was by no means a clearly
traceable process of supersession: wooden presses with progressive fly-
wheel and gear attachments seemed to appear simultaneously with
ungeared iron presses retaining the old cross or star wheel. A drawing
album (known as the Ransome album) dating from the 1840s, in the

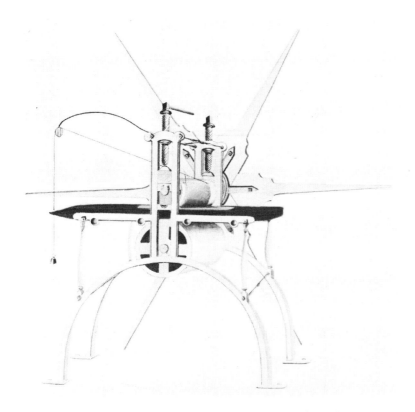

Plate 63
Drawing of an iron ungeared rolling-press with wooden plank and star-wheel, from the Ransome Album, 1840s (Museum of English Rural Life, University of Reading).

Museum of English Rural Life at the University of Reading, contains water-colour drawings of a press of the latter type. The cast iron construction of the frame gives an appearance of far greater lightness and curvilinear elegance. Wooden presses were always characterised by a certain cuboid monumentality. The top cross-member, called by the French *le chapiteau*, provided a convenient shelf for the stack of damped paper ready for printing. Since iron presses no longer needed the *chapiteau* for structural reasons – a slender bar at most would suffice – they lost the benefit of the shelf. The Reading press, however, is equipped with a substitute: a deal shelf with a row of pegs along one edge fitted into holes specially provided in the cast-iron frame, on a level with the plank. Semi-circular arches spring from the feet and from these arches rise, perpendicular, the cast-iron cheeks. Eighteen inches or so on either side of the cheeks the familiar columns, inherited from the wooden presses and now applied with new gracefulness, rise to meet the extremities of the horizontal rails. The two side-members of the frame are held some 20″ apart to accommodate the $19\frac{1}{2}$″ rollers between which runs the plank, made from a single piece of 'Spanish or Honduras Mahogany'. The plank is planed to a thickness of $2\frac{1}{4}$″ and is 4′2″ long by 19″ wide. Somewhat anachronistically, the press has no gears: a gigantic beech star-wheel, seven feet across and reinforced at the joints by an iron plate is fitted direct to the spindle of the impression cylinder. A further

anachronistic touch is provided by the bearings: though now of brass, they conform – in the manner criticised by Berthiau and Boitard – exactly to the circumference of the roller spindles. Two iron pressure screws, each 13″ long, bear down on iron wedges which sandwich between themselves and the upper bearings the usual wadding of card. The rollers are of iron: the top one $8\frac{1}{4}$″ in diameter and the lower one $13\frac{1}{2}$″ – a ratio that deviates considerably from that recommended by Berthiau and Boitard (p.103, above).

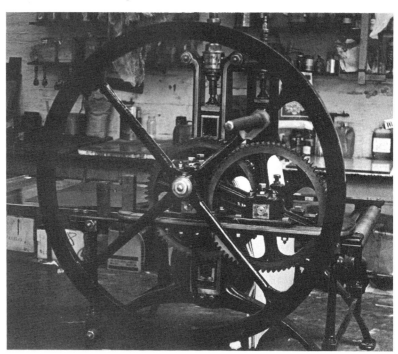

Plate 64
Iron rolling-press, probably 1830s, with gears, fly-wheel and metal plank (Editions Alecto, London).

The Reading press is one of a group that may with reasonable confidence be dated at around 1830. The frame design corresponds very closely with that of a press installed in the McQueens' new workshop in 1832, and with that of a press still in use today and owned by Editions Alecto, London – the latter inscribed 'Flanders, London'. Besides the general stylistic grounds for suggesting the 1830s as the probable time of manufacture of these machines, one is further encouraged to do so by the appearance of one of them in the McQueen depiction (p.86) of what must have been considered a thoroughly up-to-date plate-printing plant at the brand new premises in Tottenham Court Road. Whilst the frames of all three presses very closely resemble each other (and, incidentally, the 33″ press at Ross's, p.96, above) in all essential respects, the McQueen and Alecto presses are each fitted with a large fly-wheel and two wheel and pinion gears. The fly-wheels – the former with six spokes and the latter four – are fitted with an interesting device: in each case, one of the spokes is pierced by an elongated socket so that the

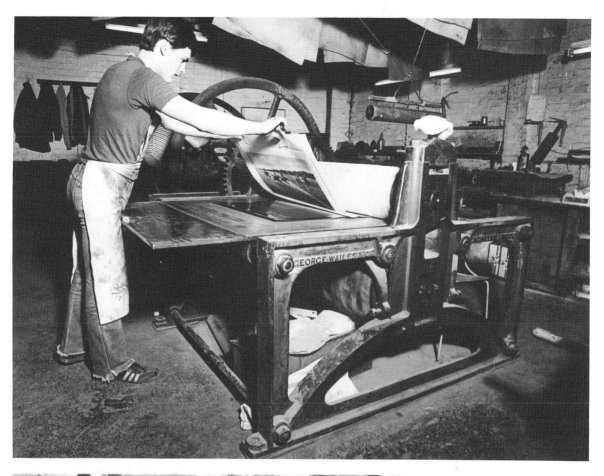

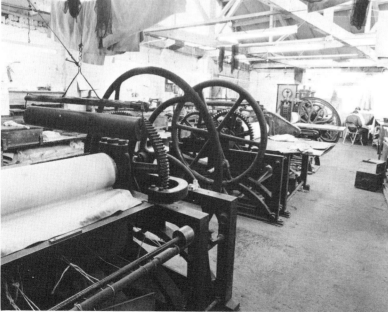

Plate 65
Iron rolling-press by George Wailes
& Co., London, owned by Thomas
Ross & Son (photograph: Museum of
London).

Plate 66
The presses at Thomas Ross & Son's
(photograph: Museum of London).

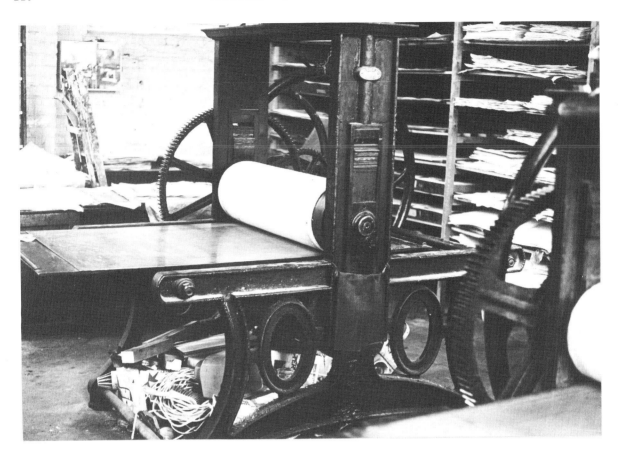

Plate 67
Iron rolling-press by Aubert, Paris,
probably late nineteenth century
(R.T. Mauroo, London).

position of the turning handle may be altered to suit the individual
operator. Like the Reading press, these two are fitted with brass
bearings. Rather than U-shaped, these bearings are box-shaped or
otherwise cut away so as to reduce friction. The McQueen press is
depicted with a wooden plank shaped exactly like that of the Reading
press and apparently also of mahogany. The Alecto press has now been
equipped with a steel plank. It seems certain that machines like these
would, at the time of the setting up of the new McQueen workshops
and at the time of the establishment of the firm of Dixon & Ross, have
been considered the last word in efficiency, and there is no doubt that
much of the work of conversion recorded in the Dixon & Ross ledgers
must have resulted in presses very like them.

Another firm in London doing similar work to Ross's is R.T.
Mauroo's, of Islington. Richard Leonard Mauroo came to England from
France in 1900 and set up as a plate printer. He was succeeded by his
son, Richard T. Mauroo, who died in 1972, when the business was taken
over by Charles Newman, who still runs it under the name of his
predecessor. The firm owns four presses: a six-arm star-wheel; a geared
press made by John Haddon & Co., of London; and two other geared

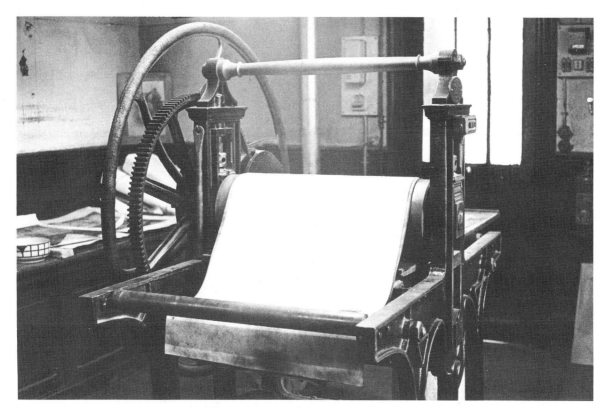

presses. All are iron machines, but the last two are particularly interesting. Unfortunately — as is often the case — there are no records relating to these presses; but one of them bears a maker's plate inscribed 'Aubert, Mécanicien, Rue Grenier-St. Lazare II, Paris'. The other has no maker's name, but is so closely similar to the Aubert press that one can safely assume that it was a product of the same workshop. The two presses have a most remarkable feature in common: although they are of iron, and therefore scarcely need it for structural reasons, each is equipped with a 'chapiteau' in imitation (conscious or otherwise) of wooden ancestors. This gives the machines a curiously archaic appearance, and makes them difficult to date.

It is also difficult to establish dates for the presses now in use at Ross's. Although essentially similar to those described above, the monumental solidity of the frames of most of them suggests a considerably later date of manufacture. The almost buoyant elegance of the iron machines of the 1830s seems to have been superseded by the lumpish functionalism of a later age.

Plate 68
Iron rolling-press by Fleury, Paris, probably late nineteenth century (Atelier Leblanc).

Plate 69
Detail (*c.*3″ × 2″) of 'The Spaniel',
line-engraving ($12\frac{1}{4}$″ × $15\frac{7}{8}$″) begun
by John Scott and completed by
John Webb after the painting by R.R.
Reinagle, R.A., published 1 July 1830
by Moon, Boys & Graves. For
relevant correspondence, see British
Museum Department of Manuscripts,
46140, f14 (Author's collection).

Chapter 6

The Engraving and Printing of Copper and Steel Plates

The most urgent needs of the print-publishing trade during the second quarter of the nineteenth century were, firstly, for the development of ever more expeditious engraving techniques and, secondly, for metal plates which would yield enormously long runs of prints whilst not inhibiting reasonably speedy engraving.

By this time stipple-engraving, once extremely popular in the hands of Bartolozzi and his followers, and aquatint, an art 'invented for the torment of man' (quoted by Fielding, 1841), had ceased to be seriously considered by the publishers of important large-scale reproductive engravings. The first was unfashionable and the second too risky technically. What did seem feasible was to bring back into prominence the mezzotint method (or something like it) that had been employed with such brilliance in the previous century by, for instance, the engravers of Joshua Reynolds (Clifford, Griffiths, and Royalton-Kisch, 1978, pp.29–59).

The mezzotint process was laborious enough. The engraver first roughened the surface of his plate by rocking systematically across its length and breadth a tool shaped rather like a broad, short chisel with a curved, serrated cutting edge. The ground being prepared, the engraver worked upon it with scraper and burnisher to achieve gradations of tone. The areas left roughest retained most ink and thus printed darkest; those polished smoothest held none, or little, and therefore produced highlights in the finished print (see Bayard and D'Oench, 1976, *passim*).

The line-engraving method gradually supplanted in this branch of the trade by mezzotint was, however, even slower. The engraver Abraham Raimbach, writing of the waning of Wilkie's popularity and the growth of Landseer's, emphasised the competition between the processes. His words also underline the dependence of artists on finding the right reproductive medium: 'Bolton Abbey appeared [engraved in 1837] and placed [Landseer's] reputation on a still higher elevation. Seconded by Cousins' admirable mezzotinto . . . the new lights (as in Aladdin's lamp) were preferred to the old' (Raimbach, 1843, pp.138–139). By the mid-1830s it was clear that Raimbach's technique of line-engraving was

already considered scarcely viable in commercial terms. Francis Moon (the publisher), David Wilkie and Raimbach held consultations on the prospect of publishing a large line-engraving of the painter's 'Christopher Columbus at the Convent of La Rabida', one of his six exhibits at the Royal Academy in 1835. Raimbach gave his estimate for the work, and was evidently so enthusiastic about the project that he was willing to cut his rates. Moon nonetheless considered the venture too risky. 'He felt compelled', wrote Raimbach, 'as a commercial man, to decline that which, as a sincere lover of art, he was most anxious to promote' (Raimbach, 1843, pp.140–141). 'Christopher Columbus' was eventually reproduced from a mezzotint plate engraved by H.T. Ryall.

There was, too, the question of taste. The line-engraver's 'beautiful but more or less mechanical arrangement of lines' (Fielding, 1841, p.7) had about it something which must have begun to look (to some eyes at least) rather dated, particularly by comparison with the freer appearance attainable through lithography, a craft which had 141 professional practitioners in London by half-way through the nineteenth century (Watkins' *Directory*, 1852).

T.H. Fielding, in his manual of 1841 (pp. 34–37), gives a detailed account of the conventions employed by line-engravers:

> . . . strokes of the graver should never be crossed too much in the lozenge manner, particularly in the representations of flesh . . . [but nor is it] proper to get entirely into the square, which would give too much of the hardness of stone . . . the graver should be guided according to the risings or cavities of the muscles or folds, making the strokes wider and fainter in the lights, and closer and firmer in the shades . . .

There follows advice on how to render hair, water, buildings decayed and new, sculpture, cloth of various textures, tranquil skies, and clouds.

In fact, mezzotint did not simply eclipse line-engraving. Some men – Thomas Landseer for instance – continued to the end of their days to adopt essentially the line method; but both the line-engravers and the mezzotinters departed from the pure conventions which, until the new commercial pressures were on, had governed their respective crafts. The engravers availed themselves of the ingenious ruling-machine (pp.126–130, below), originally developed in Britain in about 1790 by the engraver Wilson Lowry (1762–1824), and of such devices as the roulette. All used etching extensively, either to establish the composition prior to enrichment with the burin, or to embellish a relatively generalised image achieved in mezzotint.

This chapter gives an account of the background for which Raimbach's story of changing taste and commercial pressure provides a probably typical illustration. It will be necessary to consider some of the techniques applied to the engraving of plates; to examine efforts in the early nineteenth century to produce plates of steel with the optimum

Plate 70
Detail of 'A Distinguished Member of the Humane Society' (Plate 15, above), showing Landseer's chalk touching (British Museum, Department of Prints & Drawings).

Plate 71
Detail (*c.*2″ × 3″) of 'Baffled', etching
(18¾″ × 27½″) by Herbert Dicksee,
1908. Published by Arthur Tooth &
Sons, London, Paris & New York
(Author's collection).

combination of tractability for the engraver and durability for the printer
(a valuable contribution to the intaglio process as a whole, but
particularly important in encouraging the re-emergence of mezzotint as
a major reproductive medium); and to outline the devising in the later
nineteenth century of a method of protecting copper with a facing of
harder metal.

There is a sense in which the main distinction between a line-
engraving and a mezzotint is like that between a drawing executed in
pen and one in a broader medium such as, say, charcoal. The pen
draughtsman must achieve tone through a marshalling of line – the
richest shadow being built up with an inevitably slow system of cross-
hatching. The draughtsman with charcoal at his disposal can lay in his
arrangement of tones comparatively quickly, sharpening and modifying
his image on the basis of his initial unified composition; and if we add to
his technical repertoire the possibility of rubbing the surface of his paper
to introduce highlights into dark passages the analogy becomes even
more helpful. The line-engraver, working directly upon the polished
surface of his plate, cuts grooves with a burin (or etches them). Each
groove will receive ink in readiness for the printing process and will
produce a black line on the paper. In the mezzotint process, however, a
plate inked at the stage when the over-all roughening (p.113, above) has
been completed will hold so much pigment that a print taken from the

plate will appear as an overall black. In the early years of the process the roughening was achieved with the use of a toothed roulette; it was later discovered, however, that a more regular ground could be produced by using a rocker (p.113, above). John Evelyn (1620–1706) gives an early account of its use:

> Lay the plate . . . upon some even table, and with your HATCHER [rocker], the assistance of yr. hand, and . . . yr. breast, press it on the plate with so much force as is convenient to make it leave a sufficient marke; and this being begun at one of the sides of the plate, passe it to the other with a wriggling but uniform motion and force . . . (Bayard and D'Oench, 1976, p.8).

Evelyn was describing the methodical texturing of the plate lengthwise, crosswise and diagonally so that no portion is left untouched. Later mezzotinters were to calculate mathematically the course of the rocker, to cover the plate in as many as seventy-two changes of direction (*ibid.*, p.8). According to Thomas Lupton (p.59, above) a copper plate required rocking in between twenty-four and forty directions; a steel plate as many as ninety (Beck, 1973, p.19).

When the ground was ready, the engraver began to work at the tonal gradations. Fielding (1841, p.26) describes an interesting variation: to achieve delicate tints he suggests taking off the plate's polish with emery paper or with pumice finely powdered, and burnishing out from the slightly roughened surface such highlights as are necessary.

It is only in a very general and imprecise way, then, that one can talk of line engraving giving way to mezzotint in the nineteenth century. It is far safer to say that engravings with the *character* of line-engraving gave way to engravings with the *character* of mezzotint; that engravings

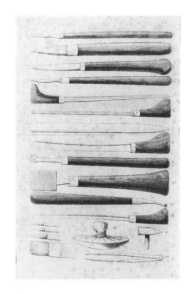

Plate 72
Engraver's tools, Fielding, 1841 (St. Bride Printing Library).

Plate 73
Detail (*c.*2″ × 3″) of 'Rt. Hon. Henry Dundas of Melville', pure mezzotint (13″ × 10⅞″) by John Raphael Smith, after the portrait by Reynolds. Published 1783 (Author's collection).

which depended for their rich orchestration of tone upon a slow build-up
of hatching gave way to engravings in which tone could be achieved
with relative speed. In the case of 'line-engraving' it is not that the
removal of metal with a burin (slow and painstaking though this must
be) is necessarily the retarding factor: it is simply that the traditional
linear convention adopted by the engravers of such plates demanded
infinitely more deliberation than the tonal devices related to mezzotint.
In a letter of 17 July 1880, Samuel Palmer complained to H.M. Cundall
of the arduousness, for him, of the etching process 'through over
devotion to that great time-killer, chiaroscuro . . . (Victoria and Albert
Museum, MSS 86). Chiaroscuro was hardly escapable for a line-engraver
attempting to do full justice to the chromatic range of an original
painting. Unlike Palmer, such a man would have had no choice.

In both line-engraving and mezzotint much of the work was bitten
rather than literally engraved or rocked. T.H. Fielding (1841, p.7) makes
an interesting distinction between etching 'as the beginning of line-
engraving, or as practised by line-engravers' and etching 'as generally
executed by painters': between 'the engraver's beautiful but more or less
mechanical arrangement of lines' and the more fluid draughtsmanship of
the painter-etcher.* This is an extremely important distinction, not only
in that it emphasises the existence of two quite different attitudes to
etching but also because it is a salutary reminder of the imprecision that
so often marks the use of the word 'engraving'. The 'beautiful but . . .
mechanical arrangement' of the engraver's lines is as often achieved with
the acid as with the burin; and only a practised eye will distinguish
between the slightly ragged attack of the acid and the sharp incision of a
tool. Written in 1841, at such a crucial time of technical transition and
commercial expansion, Fielding's is a particularly illuminating work. His
pronouncements amplify the evidence of the eye: 'formerly', he writes,
'it was the custom to begin and finish a plate with the graver only; but
this method has long been laid aside, as the use of the etching needle
gives so much greater freedom in the representation of almost every
object.'

It is certain that etching was used extensively throughout the
nineteenth century and earlier by men popularly considered pure line-
engravers. William Woollett, for example, in his engraving of 'Macbeth'
(published in 1770) employed large areas of vigorous etching in the
landscape background, reserving the burin for certain passages in the
middle and far distance and in the sky, where atmospheric brilliance was
required. The figures, too, were largely engraved rather than etched. The
juxtaposition of etched and engraved line is peculiarly effective, the
clustering of velvety bitten blacks emphasising and enhancing the clarity
and delicacy of the cutting. Fielding might almost be describing
Woollett's procedure as he goes on to recommend that, in general, the
outlines of a composition and the darker parts should be etched and that

* The term 'painter-etcher' probably
became common currency in England
only after the founding of the Royal
Society of Painter-Etchers in 1880,
and may not have been used at the
time Fielding was writing. It is likely
to have been an adoption of the
French *peintre-graveur*.

light and delicate passages should be laid in with the dry-point or graver (*op. cit.*, pp.32–38).

Engravers obviously needed to be every bit as well acquainted with the chemical action of acids and the composition of grounds as with the methods of using the burin, rocker and scraper. Ruskin asked John Le Keux to

> Give me a delicate bite over the bit of tower . . . the bits I want darker are double touched, so take care not to overbite, but keep delicate. Then on the pillar below, pitch into it well. I want it to come up as black as velvet – so let the acid <u>hiss</u> again – I want it as jetty as you will see by proof returned for lettering . . . (Victoria and Albert Museum, Microfilm 85).

Fielding (*op. cit.*, pp.22–23) gives the following recipes:

Acid for copper: Nitrous (strong) :1 part
 Water :5 parts
 Small portion of
 sal ammoniac
 (hazelnut size per
 one pint)

Acid for steel: Pyroligneous acid :1 part
 Nitric acid :1 part
 Water :6 parts.

Hunnisett (1980, Chapter II, *passim*) has pointed out that the corollary to the discovery of a suitable way of preparing steel for engraving was the search for an effective etching fluid for the metal. During the 1820s it was not unknown for engravers on steel to offer considerable sums of money for the secret etching recipes devised by colleagues (Hunnisett, August 1977, p.590). In May 1835, Pierre Deleschamps was awarded a medal of La Société d'Encouragement pour l'Industrie Nationale for the invention of a new mordant for steel (Deleschamps, Paris, 1836). John Martin was apparently an adventurous experimenter with acid, sometimes risking the work of weeks by biting his plates with some new recipe (Balston, 1947, p.105). John Harvey (1970, Appendix 1) has given an account of the etching process as employed by George Cruikshank (who, 'when biting up plates . . . would smoke more . . . to drive away the fumes of the acid'), Hablot K. Browne and others. The process evidently held a spècial fascination for many: Ruskin (1886, p.vi) was once seized with such impatience that he etched in the wash-basin of his hotel room in Dijon; and Queen Victoria and Prince Albert took up etching in 1840, instructed by Landseer (Manson, 1902, p.104).

The preliminary to etching was to protect the bare plate with a coating of wax, laid on with a mushroom-shaped dabber, padded and covered with fine wool and a layer of silk. C. Tomlinson (1854, p.608) describes a contemporary method of making wax etching grounds: two ounces of white wax, half an ounce of Burgundy pitch and half an ounce of black pitch were melted in a crucible over a slow fire, whilst two

ounces of finely powdered asphaltum were gradually stirred in. The composition was poured into cold water so that it became sufficiently firm to be worked into balls, which were tightly tied up in small pieces of silk. The plate would be warmed on a heater so as to melt the wax sufficiently to ensure even application. The heating device described by T.H. Fielding consisted of a tin box 12" by 9" by 3", with a hole at one corner by which it could be filled with water. The box rested on a stand, beneath which was a small charcoal stove to heat the water. When the needling (see below, p.123) was completed, a wall of bordering wax ('3 lb. of Burgundy pitch; 1 lb. of beeswax melted; and 1 gill of sweet oil added') was attached to the plate's edges so as to form a tray for the acid. At the time of Fielding's treatise, wax etching ground was produced commercially at 1/- a ball, but many engravers made their own, as did Wilson Lowry:

> To 2 oz. of asphaltum add one of Burgundy pitch and $1\frac{1}{2}$ oz. of white virgin wax. The asphaltum must be finely powdered and then melted in a glazed earthen vessel over a moderate fire, before the Burgundy pitch is put in; the wax must be added last, when the whole composition must be well stirred, and then poured into warm water, to be further incorporated by means of the hands, and made up into balls. (Fielding, 1841, pp.8, 21–22, 25, and advertisement pages).

Etched work was frequently added to a partially completed plate, or, in order to revitalise it, to a wearing plate. For this purpose a transparent ground was needed, so that the new work could more surely correspond with the existing design. Samuel Cousins, in a letter of *c*.1840, advised his erstwhile apprentice, T.L. Atkinson, on such a preparation:

> Dear Atkinson,
> I have found my memoranda of the quantities for making transparent etching ground to be
> 'Equal parts of Resin, Burgundy Pitch, and White Wax will make it hard enough <u>for Winter</u> –'
> <u>For this time of year</u>, put <u>two</u> parts of the <u>Resin</u> to <u>one</u> each of the other ingredients –
> <u>Melt the Burgundy Pitch first</u> to get rid of the water that is generally in it –
> Stir it in the Pipkin to mix the ingredients well, and don't let it boil . . . (Victoria and Albert Museum, MSS 86. QQ, Box 1a).

Most of the work of Cousins, and of the majority of the other nineteenth-century exponents of mezzotint, incorporated etched line and stipple by way of enrichment. This was to some extent all part of the search for more despatch in the production of plates. Many mezzotinters of the previous century had achieved their velvety richness through the exclusive use of rocker and scraper – but it took time, and their plates were more vulnerable. The darkest passages were produced by those areas of the plate where the metal, vigorously displaced by the rocker,

Plate 74
Detail (*c.*3″ × 2″) of 'The Return from Inkerman', mixed mezzotint (21″ × 40″) by W.T. Davey after the painting by Elizabeth Thompson (Lady Butler). Published 1 March 1882 by the Fine Art Society (Author's collection).

was left more strongly textured – almost like the pile of a rug. It was these parts that were most susceptible to flattening during the printing process. In this respect mezzotint is closely related to the even more vulnerable drypoint, in which lines are scratched or incised in the metal with a sharp steel point, throwing up a ridge at the side of each furrow which holds ink and prints a beautifully rich velvety line – but only for very few impressions. Darks achieved by biting into the plate's surface with acid would, however, have considerably greater longevity.

Plate 75
'Flora', mixed mezzotint
($29\frac{3}{4}'' \times 16\frac{1}{2}''$) by Thomas Lewis
Atkinson after the painting by V.W.
Bromley. Published 1 January 1877
by Thomas McLean (Author's
collection).

Plate 76
Detail (*c*.$3'' \times 2''$) of 'Flora', Plate 75.

Plate 77
Detail (*c.3″ × 2″*) of stipple engraving by Francis Holl. Published 1 October 1860 by Lloyd Bros. & Co. (Ross Collection).

The basic technique of etching consists of laying the ground of wax and drawing into this prepared surface with a needle point, thus exposing the metal to the attack of the acid; there are variations of this: different ways of removing the ground so as to produce new qualities of line (as in soft-ground etching), and different ways of laying acid-resistant grounds, like the speckled ground of melted resin or asphaltum globules which produces the characteristic grainy appearance of aquatint.

Plate 78
Detail (*c*.3″ × 2″) of soft-ground
etching. Unattributed, undated
(Author's collection).

As early as the middle 1770s, Thomas Gainsborough had begun to
employ that variation of the etching technique known as soft-ground
(Clifford, Griffiths and Royalton-Kirsch, 1978, pp.18–19); and in his
preface to the 1880 edition of *The Seven Lamps of Architecture* (p.vi),
Ruskin provides us with a conveniently succinct account of his own use
of the method:

> . . . I wanted mere spaces of gloom got easily; and so used a
> process shown me, (I think by a German engraver – my memory
> fails me about it now –) in which, the ground being laid very soft,

a piece of tissue paper is spread over it, on which one draws with a
hard pencil – seeing, when the paper is lifted, approximately what
one has got of shadow. The pressure of the point removes the wax
which sticks to the tissue paper, and leaves the surface of the plate
in that degree open to the acid. The effect thus obtained is a kind
of mixture of mezzotint – etching – and lithograph . . .

Aquatint, too, made its appearance in England in the eighteenth century,
introduced by Paul Sandby, who used it from 1775 (Hind, 1914, pp.44–
45). C.F. Partington, writing in about 1825, warned that

no printed directions whatever can enable a person to practise it
perfectly. [The success of aquatint] depends upon so many niceties,
and attention to circumstances apparently trifling, that the person
who attempts it must not be surprised if he does not succeed at
first. It is a species of engraving simple and expeditious, if

Plate 79
Copper plate engraved by the soft-
ground method, Thomas
Gainsborough, 1797 (Thomas Ross &
Son, on loan to the Tate Gallery.
Photograph: Department of
Typography and Graphic
Communication, University of
Reading).

Plate 80
Detail (*c.2″ × 3″*) of a topographical
aquatint. (Author's collection).

everything goes on well; but it is very precarious, and the errors
which are made are rectified with great difficulty (p.124).

The principle is as follows: powdered resin or asphaltum is sprinkled as
evenly as possible (often with the assistance of a special box in which the
powder can be agitated and allowed to settle like a light snow-fall) onto
the plate. The plate is heated so that a ground of melted globules forms.
Many successive layers of acid-resistant varnish can be applied during
the subsequent biting, so as to produce subtle gradations of tone, in
close imitation of washes of water-colour. The great hazard with
aquatint is over-biting so that the tiny crowns of metal break down and
the clarity and durability of the characteristic grain is impaired. 'A
magnifier is . . . useful to examine the grain', wrote Partington (*ibid.*), 'and
to observe the depth to which it is bit. It must be observed, that no proof
of the plate can be obtained till the whole process is finished. If any part
appears to have been bit too dark, it must be burnished down with a
steel burnisher; but this requires great delicacy and good management
not to make the shade streaky . . .'.

The engraver's repertoire was extended still further when, in about
1790, a remarkable labour-saving device was invented by Wilson Lowry

(1762–1824), himself a member of the profession. One of the basic skills expected of an engraver was 'the capability of laying flat tints, and of ruling parallel lines excessively close without running into each other' (Fielding, 1841, p.33) with ruler and needle on a grounded plate. Lowry devised a machine to perform this tedious task. The contraption, which within a few years of its invention had become a standard accessory, was described thus:

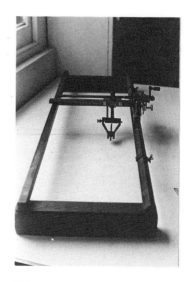

Plate 81
Engraver's ruling-machine, date unknown (Editions Alecto). The needle travels across a grounded plate, the whole mechanism sliding backwards and forwards along the lozenge-section bar.

> On a straight bar of steel is placed a socket, which slides backwards and forwards with a steady, but even motion. To the side of the socket is fitted a perpendicular tube, called a pen. This pen has a point like an etching needle, and is pressed down by the action of a spring. If then, a copper plate covered with the etching-ground is placed under the ruler, which should be supported at each end, and raised about an inch above it, the point of the pen may be caused to reach it; and if the socket to which the pen is attached be drawn along the bar, it will form a straight line upon the plate, more even, but in other respects the same as if that line had been drawn by hand with a ruler. Now, if the plate or the ruler be moved, backwards or forwards, in a direction parallel to this first line, any number of lines may be drawn in the same manner.
>
> In the machine, therefore, a very exact screw, acting upon a box confined by a slide and connected with the bar or board upon which the plate rests, produces the requisite motion; and a contrivance or index is used to measure the exact portion of a turn required before any stroke is drawn. Such is the principle of the machine most generally used; but the point or pen employed should not be made of steel, which however well tempered will require frequent sharpening, and must therefore inevitably draw strokes deficient in perfect uniformity. The pen should have a diamond point, which when once properly figured remains constantly the same, and imparts an admirable degree of regularity and sweetness to the work (*ibid.*, pp.32–33).

Lowry evidently invented various ruling machines, including one capable of generating mathematical curves with a radius of five feet or so (*Rees's Cyclopoedia*, Vol. 13, 1809, article on etching). He ruled 'with the diamond and other hard stones, instead of the steel point, which gave an unexampled beauty . . .' (Redgrave, 1878, p.277). Evidently, these machines were often owned and operated by specialists to whose workshops engravers or their apprentices took grounded plates for ruling (p.42, above). Ernest Gambart referred to Charles Mottram as 'the ruler generally employed by all the Engravers for such work [as skies]' (Royal Institution, 28 September 1848). The machine's point ploughed minute furrows in the wax, revealing – but scarcely scoring – the metal beneath. Then, back in the engraver's workshop, the classic process of progressive immersions in acid would begin. The full tonal range of a sky (for example) would be achieved by skilfully 'stopping out' with

protective varnish those parts which were to emerge as white in the finished print. Next, after a suitably brief bite, those parts where only the lightest tone was required. The progressive stopping out would continue until the darkest parts of the sky had been left longest exposed to the acid and were therefore the most deeply bitten. This is no doubt how an engraver would meet the typical request to 'keep the sky light ... Graduate it down evenly from the top and leave the clouds pure white – just stopping them out' (Ruskin to Le Keux, Victoria and Albert Museum, Microfilm 85). One of the routine visits of Samuel Rawle's apprentice son (p.42, above) was 'to Mr Porter's and took plate of Strasbourg for him to rule in sky'; after which, the following day, 'Father bit in sky of Strasbourg'.

The circumstances in which it was considered appropriate to use such mechanical aids were outlined by the Jurors of the 1855 Paris Exposition Universelle. Whilst in their view the reproduction of works of art generally required the life and warmth that could be imparted only by the hand,

> ... si l'objet à copier n'est composé que de lignes, comme dans les démonstrations scientifiques, si l'ombre et le clair-obscur n'y jouent que des rôles secondaires, si le modèle est sans vie, le mérite de la copie sera dans la fidélité des lignes et la régularité des tons (1856, p.48).

Plate 82
Engraver's ruling-machine by Conté and Gallet, *c.*1805 (Musée National des Techniques, Paris).

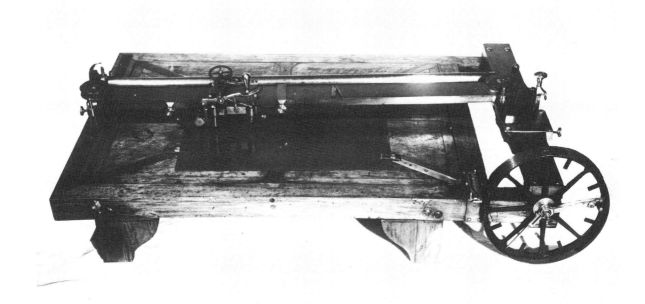

When the French engraver Conté was commissioned in 1805 to illustrate the projected *Description de l'Egypte*, launched at the instigation of Napoleon, he enlisted the help of Gallet, a mechanical engineer* to help him achieve the task more economically. With Gallet's collaboration, a machine was devised and was used ('[procurant] plus de 250,000 francs d'économie') to engrave the skies, water, backgrounds and architecture of Conté's plates. In describing the achievement of Conté and Gallet, the Jurors of the 1855 exhibition referred to the previous invention of the ruling machine in England. The date of the first appearance of mechanical engraving in this country was, however, given as 1803 – thirteen years after Lowry's invention – and, anyway, said the

* One of whose machines is in the collection of the Conservatoire des Arts et Métiers, Paris (Inv. 3054).

Plate 83
Detail (*c*.3″ × 2″) of a ruled book-plate engraved for the Society of Dilettanti by J. Roffe after the original drawing by John Gandy.

Jurors, 'le mérite de Conté ne pourrait en être diminué, puisqu'il n'a pu connaître leurs instruments et que sa machine avait une puissance bien supérieure!' (1856, p.49). In view of some interesting evidence given to the House of Commons Select Committee on Patents in 1829 (*Minutes of Evidence*, p.137) it is not surprising that the date of the first appearance of mechanical engraving in England was uncertain: 'Mr. Lowry . . . used [his machine] in secret for many years . . . secretly doing a common operation . . . which any careful person could have done as well as himself . . .; at length his secret got out, through the workman he employed to make and repair his apparatus, and other machines came into use

Throughout the first half of the nineteenth century there appeared very many variations and improvements on the basic idea. The earliest machines had been capable of ruling only parallel lines, straight or undulating; in 1819, for the benefit of the Bank of England commissioners, a persuasive canvasser for a new method of printing banknotes was enthusing about a considerably more versatile device: a machine which produced 'a species of turning <u>totally distinct</u> from any heretofore practised or known, the beauty of which speaks for itself'; a machine which 'designs its own patterns; so that when it is changed, like the kaleidoscope, the inventor himself could not set it again to the same pattern' (Dyer, 1819, pp.26–27). By the following year, the devising of mechanical engravers had caught the attention of the Society of Arts, which offered awards for improvements (Hunnisett, 1980, Chapter II).

In 1825, spectacular innovations were claimed for a French engineer, Collas, who had hit upon the idea of replacing the simple ruler principle (in which the engraving point was made to travel across an immobile plate) with a machine in which the plate could be moved in a great variety of directions beneath a fixed graver. Subsequent refinements meant that the plate could be pivoted; and circles, ovals and spirals were added to the machine's dazzling and intricate repertoire (Exposition Universelle, 1856, pp.49–52). It was a repertoire that seemed hardly more extensive, though, than that of the 'geometrical lathe' whose gyrations had in 1819 provided such a spectacular decorative foil to the hand-engraving of specimen notes for the Bank of England (Dyer, 1819, p.7). In 1837 Percy Heath in England gained one of the awards of the Society of Arts for an improved ruling machine (Hunnisett, 1980, Chapter II); and by 1855 the ingenious Collas had produced three further variations (a machine to make five copies of an original image simultaneously; one for reducing the scale of an original; and one for reversing an image, so that prints would emerge the same way round as the original), gaining the Grand Medal of Honour at the Exposition Universelle (1856, p.52).

In the early years of the nineteenth century, the plate from which the printer was expected to make impressions would still almost invariably

be of the traditional copper. By the early twenties, however, plates of steel had become quite commonly available; and their availability was the culmination of a ferment of experimental activity that seems until then to have been somewhat obscure from the point of view of the ordinary printer. The general public was certainly unaware of the innovation until at least 1822. According to Hunnisett (August 1977) the first use of a steel plate as opposed to a steel block was by Charles Warren in September of that year (in connection with an illustration to Milton's *Paradise Lost*, engraved after Thomas Uwins in the publication by F.C. and J. Rivington and other proprietors). In about 1825, C.F. Partington, reporting on the advantages of the new metal where the long runs needed for book production were concerned, pointed out that 'it is often the case in this country, that from 4 to 6 copper plates are worn out in one edition, and not half the impressions perfect. A hardened steel plate will print more *proof impressions* than the above number of copper plates can furnish, even of common impressions' (pp.127–128). 'The late Mr. Prior, one of Turner's engravers', told W.G. Rawlinson (1908, p.xl) that fifty to a hundred fine impressions were obtainable from copper (according to the quality of the copper and the nature of the engraving); and that many hundreds could be taken from steel before any wear was detected.

By 1826 James Lahee and Chatfield, Coleman & Co. were being described in the London Directories as steel-plate printers (p.9, above); and within a few years most engravers had found it necessary to come to terms with an even tougher life than had traditionally been theirs in an age of copper:

> Bending double all through a bright sunny day, in an attic or close
> work-room, over a large steel plate, with a powerful magnifying
> glass in constant use; carefully picking and cutting out bits of metal
> from the plate . . . working for twelve or fourteen hours daily,
> taking exercise rarely, in early morning or late at night; 'proving' a
> plate, only to find that days of labour have been mistaken, and
> have to be effaced, and done over again . . .*

On the subject of the newly developed metal, Abraham Raimbach observed with some chagrin that:

> To the introduction of steel engraving, by multiplying almost
> indefinitely the number of impressions each plate would produce,
> may in a great degree be attributed the decline and debasement of
> the art, exercised on a small scale (1843, p.143).

We are left in no doubt that others, too, considered the introduction of steel a mere commercial expedient, damaging to the art of engraving. T.H. Fielding's criticism of the metal also implied some of the advantages it was seen to possess. He berated all the evils arising from engraving on steel and went on to say that:

> . . . when the hardness of the metal was found to admit of finer

* Extract from a passage by C.W. Radcliffe, artist, published in the preface to a catalogue of engravings by Birmingham engravers, 1877. According to Rawlinson (*op. cit.,* pp.lxvii and lxviii) the passage was originally written in the 1860s.

work, then came in fashion the excessively finished style of the
present day, which, whilst it increases the mechanical difficulties,
tends to reduce all engravers to the same level, or what is still
worse, allows some whose only merit consists in a capability of
laying lines closer than others, to usurp the place of real talent.
This is indeed an evil, and we are afraid that many years must pass
away before the vitiated taste of the public can bear the works of
real genius, unfettered by the microscopic finish of the present style
(1841, p.31).

Malcolm C. Salaman, viewing in retrospect (1910–1911) the nineteenth-
century print boom, deplored the introduction of steel plates in words
that would have seemed quixotic to a Victorian print publisher. He could
not, he said, forgive William Say 'for having been the first to encourage
by his own practice the introduction of steel plates . . .' The attribution to
Say of the introduction of steel plates is apparently based on a note by
the engraver's son on the margin of a proof of 1820. Say's son claimed
that the print – Say's smaller portrait of Queen Caroline – was the first
attempt to use a steel plate in mezzotint (Hind, 1908, p.284). This
contradicts Charles Warren's claim to precedence (p.131, above). Thomas
Lupton, too, was evidently considered an important exponent of steel. In
1820 John Martin, exasperated by the slow progress of the engraver
Charles Turner on the plate of 'Joshua' (commissioned following the
picture's success at the 1816 R.A. Exhibition) himself set about
reproducing in mezzotint on copper his 'Belshazzar's Feast'. Hearing of
Lupton's work with steel, Martin considered it worth scrapping the
copper plate and, assisted by Lupton, he began again on the harder metal
(Balston, 1947, pp. 94–105). But there is no mistaking the nuance of
disapproval as Salaman writes (1910–1911) of Lupton's later accomplish-
ment in 1823 that 'the Society of Arts actually awarded him a Gold
Medal for his application of soft steel to mezzotint'. In rather more
detached vein, Arthur Hind, writing in 1908, made observations on the
use of steel which provide an interesting gauge to fluctuations of taste:

> The new development was an attempt to revive an art already in
> its decay . . . For some ten years the use of steel was often paraded
> in the lettering as an attractive novelty. From about the same time
> there is a marked deterioration in the depth and richness of
> mezzotints in general. What proportion of this is due to the harder
> quality of impressions from steel, and what to the decay of real
> power in the engraver, it is difficult to decide . . . the general
> decline of the school of painting, on which the engravers relied for
> their models, except in the one field of landscape, should also be
> reckoned in the account (p.284).

Few of these critics, however, seem to have realised that many of the
technical difficulties connected with steel plates had already been
grappled with considerably earlier than the years 1820–1823, the period
pin-pointed by most writers. The compilers of the 1851 Great Exhibition

catalogue attributed the invention to Richard Hughes in as late as 1822. Describing a 'steel plate for mezzotint, prepared with the finest surface and of even temper throughout', they went on to say that 'thin steel plates, similar to this, were first invented by Richard Hughes in 1822' (vol. 2, p.657, exhibit 609, Class 22). What Hughes seems in fact to have discovered in that year was a more effective means of softening steel plates by a process of decarbonisation. Partington (*op. cit.*, pp.128–129) describes the process as he knew it in about 1825:

> In order to decarbonate the surfaces of cast steel plates, cylinders, or dies, by which they are rendered much softer and fitter for receiving either transferred or engraved designs, the inventors use pure iron filings, divested of all foreign or extraneous matters. The stratum of decarbonated steel should not be too thick for transferring fine and delicate engravings; for instance, not more than three times the depth of the engraving: but for other purposes the surface of the steel may be decarbonated to any required thickness. To decarbonate it to a proper thickness for fine engravings, it is to be exposed for four hours in a white heat, inclosed in a cast iron box, with a well closed lid. The sides of the cast iron box are made at least three-quarters of an inch in thickness; and at least a thickness of half an inch of pure iron filings should cover or surround the cast steel surface to be decarbonated. The box is to be suffered to cool very slowly, which may be effected by shutting off all access of air to the furnace, and covering it with a layer six or seven inches in thickness, of fine cinders. Each side of the steel plate, cylinder, or die, must be equally decarbonated, to prevent it from springing or warping in hardening. It is also found that the safest way to heat the plates, cylinders, or dies, is by placing them in a vertical position.

Steel plates for engraving are thought to have been produced in England as early as about 1793, but they were apparently too hard for the burin. In November 1795, the printer Thomas Hubbard published his *Valuable Secrets Concerning Arts and Trades* which, according to the sub-title, was a compilation of contributions from various artists and craftsmen. Among his secrets was one to 'cause the transmutation of iron into the finest German steel':

1. Take of clean soot one pound; oak-wood ashes twelve ounces, and four of pounded garlicks. Boil all together in twelve pounds of common water, reduced to a third, or four pounds. Strain this, and dip in it the iron pegs, which you will afterwards stratify with the following cement.
2. Take burnt wood's coals, otherwise called *cokes*, and quick lime, of each three pounds; soot dried, and calcinated in an iron pan, one pound; decrepitate salt, four ounces. Make of this and your iron several beds alternately one over another; and, having well luted the vessels in which you shall have made those beds of iron and cement, give them a reverberating fire for three times twenty-four hours, and the operation is done (p.10).

Hubbard's recommendation for softening steel consisted of boiling peeled garlic in nut oil to produce a paste, covering the steel with that composition 'to the thickness of half a crown', and consigning it to the forge. To restore the metal to temper it was heated cherry-red and plunged in cold water (*ibid.*, p.18). Hubbard also proposed various recipes for acids with which to etch the steel (*ibid.*, pp.1–2). It is clear that the basic technology was already by this date simply awaiting refinement, and that there was no lack of interest in the challenge.

The problem was that of producing a version of the metal sufficiently soft to engrave and yet susceptible to subsequent hardening, so that plates would endure for longer the punishment of the rolling-press. Hughes evidently became interested in the experiments of Charles Warren, the engraver, whose search for a practicable solution led to the acceptability of steel to the profession at large. Warren used the process known as 'cementation', following the example of the Birmingham manufacturers of buttons and similar articles (Hunnisett, 1980, Chapter II, *passim*) and, in essence, like that suggested by Hubbard. By 1836, in Paris, Berthiau and Boitard (*op. cit.*) were recommending 'acier de cémentation', listing its qualities as follows: compactness of texture; freedom from impurities; of open but extremely regular molecular structure; perfect homogeneity; and linked properties of hardness and ductility. These were the qualities sought by Charles Warren as he decarbonised a hard steel saw blade.

Following industrial precedent, he embedded the metal in layers of iron filings and crushed oyster shells within a cast iron box. This container was heated in a furnace and kept for several hours at a temperature just below the melting point of the iron. Two or more such 'cementations' were usually necessary and, after each, the plate had to be hammered to flatten it and to dislodge residual compound. What Richard Hughes did was to substitute for the iron container one of refractory clay. The melting point of the iron was no longer a restriction; greater heat and thus softer steel could be attained (Hunnisett, 1980, Chapter II, *passim*). It is interesting to note that a method of decarbonising steel long since superseded by Hughes's use of a clay container was still being described in the 1850s as a standard procedure:

> In order to decarbonize the plates they are placed in a vertical position in cast-iron boxes not less than $\frac{3}{4}''$ thick, and surrounded on all sides by a stratum of iron filings not less than $\frac{1}{2}''$ thick; the boxes are then placed in a furnace, and after being heated are cooled very slowly by stopping up all the air passages, and covering the boxes with cinders to the depth of 6 or 7 inches. The decarbonized plates are then reconverted into steel by enclosing them in boxes as above, and surrounding them with fine charcoal made from leather; they are left at the proper heat for from 3 to 5 hours, and on being taken out are immediately plunged in a vertical position into cold water (Tomlinson, 1854, p.608).

Warren's experiments were no doubt given impetus by his association with Perkins and Fairman, two Americans who, attracted by the lure of a £20,000 prize, had arrived in this country in 1819 with the object of persuading a commission seeking ways of preventing the forgery of banknotes, to adopt for the Bank of England their techniques of reproduction: techniques involving the use of steel softened and hardened according to the demands of the engraving and printing process (see Dyer, 1819, *passim*). The plates used in the Perkins and Fairman solution could perhaps, however, more appropriately be called slabs: to obviate the buckling that was one of the risks involved in the case-hardening technique discovered by Perkins in 1804, these slabs were over $\frac{1}{2}$" thick, and specially designed machines were thus necessary for the printing. Warren was looking for ways of producing hardened steel plates of the same thinness and flatness as the traditional copper plates. It was necessary to produce plates of this thinness so that they could be used on traditional copper-plate presses, for which the 'slabs' already achievable in the very early years of the nineteenth century were quite unsuitable. Another important characteristic of thin plates is that mistakes can be rectified by 'knocking-up' from the back and re-engraving. Fielding (1841, op. cit.) explains that the 'part to be knocked-up is gauged with calliper compasses . . . [the] plate placed on . . . an anvil and the back hammered with a rounded hammer', the work on the part to be erased having been carefully taken out with a scooper, leaving a clean, smooth hollow. For minute effacements, a punch rather than a hammer was used. It was probably as a result of his collaboration with Charles Warren that Richard Hughes eventually went on record as the inventor of the 'steel plate . . . of even temper throughout'. His perfecting of the steel plate was the culmination of nearly three decades of aspiration.

The proposals of Perkins and Fairman for the prevention of the forgery of Bank of England notes found an eloquent advocate in J.C. Dyer who, in December 1819, submitted to the commissioners his full description of the plan (*op. cit.*). The description included several remarkable printed specimens, each incorporating engraved work in a variety of styles by, among others, James Heath, William Finden, William Holl, and Fairman himself. It is significant for the eventual general adoption of the metal by engravers that many of the most important and influential members of the profession had an early opportunity of examining and testing the new system. In addition to the three English engravers mentioned above, Charles Warren, William Daniell, John Pye, and Abraham Raimbach were among the eighty-one signatories whose statement vouching for the impressiveness and effectiveness of the plan was appended to Dyer's submission. Robert Smirke, Rudolph Ackermann, and Mark Isambard Brunel were also listed, as was Benjamin Davies, a 'writing engraver' of Compton Street, who was probably

responsible for the microscopic lettering of the specimens.

The process revealed to these men had been described by Dyer in a paper read before the commissioners on 30 July 1819. Dyer's startling arithmetic provided a harbinger of the way steel was shortly to revolutionise and inflate publishing enterprises in England:

> ... steel plates are in the first place prepared, so as to receive the engravings of the first artists, in their best style of execution and finish, the same as upon copper plates; after which, these same engravings are transferred to steel cylinders, in reverse, and from these latter, the pictures are again impressed, or indented, upon either copper or steel plates, whichever may be preferred for printing, and from one of these original engravings (judging from experience, and intending to speak within bounds) we may safely assert, that twenty indenting cylinders may be made, without any perceptible deterioration of the original plate, or die, and from each one of the cylinders so made, at least five hundred copper plates, or one hundred steel plates, may be indented. Taking these data therefore, and supposing copper plates to be used, and that each plate will give two thousand impressions, the numbers will be $20 \times 500 \times 2,000 = 20,000,000$, say twenty millions of impressions from one original die, even by the use of copper plates; but if steel plates be indented and used instead of copper, (which it is hoped will ultimately be the case), as it has been proved that one such plate, will give half a million of impressions, without being perceptibly worn; and as each of these plates, will also serve as dies to make new indenting cylinders, the number of impressions which may thus be obtained from one original, will run so high, as to authorize our taking it for all practical purposes, as absolutely unlimited (1819, p.26).

The process was common knowledge by the time C.F. Partington summarised it six years later in his *Complete Guide* for engravers:

> A steel plate is engraved or etched in the usual way; it is then hardened. A cylinder of very soft steel, of from 2 to 3 inches in diameter . . . is made to roll backwards and forwards on a copper or soft steel plate, and a perfect fac-simile of the original is produced of equal sharpness (p.126)

In December 1819, the special machinery having arrived from America and having been already investigated by the admiring English artists, engravers and engineers, Dyer was ready to describe it to the commissioners:

> The press used for printing with the steel plates, consists of a cast-iron cylinder, four feet in diameter, which revolves three times in a minute, and carries round thirty-six plates the size of a bank note, say two plates a-breast, and eighteen in succession, which fill the periphery.
> The steel plates are made about five-eighths of an inch thick, and bent to the curve of the cylinder, upon which they are fitted and

held in their places by screws passing from the inside of the
cylinder, and screwing into the plates about two-thirds of their
thickness. Thus secured upon the cylinder, the plates are accurately
turned and faced. They are then taken off, and <u>decarbonated</u>, when
the intended work is to be indented, and otherwise wrought upon
them. After which they are to be <u>hardened</u> and finished, and
replaced upon the cylinder for printing (1819, p.10).

The system had been adopted by American banks since 1809 (*ibid.*,
p.16). Its chief advantage in confounding the efforts of counterfeiters
was that several small originals, worked simultaneously by separate
engravers, could be impressed in combination upon an indenting
cylinder to produce a single design of practically inimitable complexity.
Pending the Bank's decision, Perkins and Fairman, in collaboration with
Charles Heath, set about preparing steel plates for English engravers,
and within little over a year of their arrival in this country had
distributed over a thousand (Hunnisett, 1978, chapter II). It is likely that
it was on one of these that William Say made the engraving that earned
him the reputation of 'having been the first to encourage ... the
introduction of steel plates' (p.132, above).

By 1851 the Sheffield forges were, as a matter of course, producing
plates of excellent quality, and the authors of the Great Exhibition
catalogue remarked that:

An entire change in engraving has taken place by the substitution
of steel for copper plates. Copper speedily wears [but such is] not
the case with steel [: there is an] instance on record of 500,000
copies from one plate.

And, a mark of the extent to which the system of Perkins and Fairman
had been assimilated:

The multiplication of a steel plate is a feature of some importance: a
plate is engraved and hardened; from this an impression is taken on
a softened steel roller; this ... roller is then hardened, and softened
steel plates being passed under it, an impression is imparted to
them; they are in turn hardened, and are equal to the original as to
their impression.

The compilers went on to remark that the method had been adopted for
bank-note engraving and that postage-stamp plates were produced by
the same means. By 1842, six thousand impressed plates had been
reproduced for stamps from an original engraving of the Queen's head.
Among the steel plates shown at the Crystal Palace was one 36" by
$26\frac{1}{2}$", made by John Sellers of Sheffield. It was machine-ruled 'to show its
fitness for the etcher and engraver'. Another of Sellers's plates had been
engraved with great delicacy by Charles Mottram (p.127, above), the
makers claiming that

the sky tint upon this plate is perhaps the most severe test to
which a steel plate can be subjected; the surface is free from spots
or seams; and it is exhibited to show that steel is well adapted to

* The invoice is among a bundle in
Senate House Library, University of
London. The invoices are those of 89
different British manufacturers
sending all manner of goods to 109
Philadelphia and 2 New York
importers. See Pettifer, Maureen,
*Some 19th century British Invoices
relating to Philadelphia*, handlist, MS.
675, University of London Library.

** E. S. Lumsden (*The Art of Etching*,
London, 1924, p.18) points out that
although 'the deposit is usually
termed 'steel' ... this is chemically
incorrect; as when steel is used in the
bath to electrically deposit the one
metal on the other, it loses its carbon
and becomes a peculiarly hard iron'.
Steel-facing plants specialising in the
protection of engraved copper plates
still exist at 52 Rue Mouffetard,
Paris, and at Thomas Ross & Son's.

*** Mariel Frèrebeau (L'Imprimerie en
Taille-Douce', *Nouvelles de L'Estampe*,
No. XVI, Paris, July/August 1974,
p.13) quotes Jules de Goncourt's
Manette Salomon, describing the
Delâtre workshop: 'Là, dans une
pièce pleine d'un jour blanc dont le
plafond laissait pendre sur des ficelles
des langes pour l'impression, devant
une presse à grande roue, dans le
silence de l'atelier, ayant pour tout
bruit l'égouttement de l'eau qui
mouille le papier, le basculement
d'une planche de cuivre, les
pulsations d'un cou-cou, les coups de
la presse à satiner qui tourne, il avait
une véritable anxiété à suivre la main
noire du tireur encrant et chargeant
sa planche sur la boîte, l'essuyant
avec la paume, la tamponnant avec la
gaze, la bordant, la margeant avec du
blanc d'espagne, la passant sous le
rouleau, tournant la roue, et la
retournant. . . .'

the wants of the etcher and engraver (Great Exhibition, 1851,
Exhibit 147, Class 22).

By way of an ironic postscript to the early nineteenth-century import
from America of printing techniques involving steel: on 24 December
1873, William Jessop & Sons of Sheffield despatched steel plates to
Philadelphia. The invoice was inscribed: 'special steel manufactured
expressly for William Barber, Esq., the engraver to the United States
Mint.*

The new steel plates were, of course, more susceptible to corrosion
than copper. However careful their custodians were, it is evident that
disfiguring rust could develop. In the summer of 1844, for example,
Moon the print-publisher was charged £10 for 'cleaning rust & c from
55 various plates' (Dixon & Ross Day Book, 1844–1848).

Steel facing brought with it the same disadvantage, i.e. of rusting;
although – perhaps surprisingly – the deposit of harder metal if skilfully
applied did little if anything to impair the detail of the copper engraving
which lay beneath.** This method of extending the life of a plate could
now and then bring an unexpected bonus: Frederick Goulding, on
removing an over-thick facing from a plate of Whistler found, on
printing from the bare and preserved copper, that it yielded 'a
wonderfully beautiful result' (Hardie, 1910).

The plate, one of sixteen forming the 'Thames set', was first printed
by Auguste Delâtre, of Paris, in 1898.*** The set was sold to Keppel of
New York and finally cancelled in 1897. If Goulding's understanding –
that these were the first fine plates ever steel-faced – was correct, the
earliest use of the process may be placed between the late 1850s and
1871, by which latter date the set was completed and issued (Hind, 1908,
p.325). The process was certainly well established in Paris by 1866, in
which year Maxime Lalanne, in his treatise *Gravure a l'Eau Forte*,
recommended Jaquin & Cie., of 71 Rue Notre Dame des Champs as
steel-facing specialists (Frèrebeau, 1974, p.15). Mariel Frèrebeau claims
the invention of the process for a Frenchman, Garnier, in 1857 (*ibid.*,
p.15). According to McQueen family tradition the French seem to
have had precedence: the McQueens were in 1894 writing to an H.
Capel of Paris to seek advice concerning the steel-facing apparatus they
had installed. Also according to this tradition, F.G. Hardcastle (appren-
ticed as a copper- and steel-plate printer in 1882 to Alfred Holdgate &
Son) built 'probably the first steel-facing plant [in England] in his own
house' and in 1898 set up on his own as a steel facer, enjoying much
support from the engraving trade (typescript owned by Mr. P.N.
McQueen). The suggestion is that steel-facing became widely used in
England only comparatively late in the century. Its advantage was that
the engraver could once again work upon copper – more tractable than
soft steel – and, whether in mezzotint or any other technique, the plate

would, by virtue of the steel deposit, emerge as durable as if originally engraved in that metal.

The plates handled by a printer could range in size from the tiniest book-plate to something as large as four feet by two and a half or more. 'Boston Harbour', one of the larger plates at present held by Ross's is 42" by 28½". One of the presses still in use at Ross's is quite capable of taking a plate even larger: its plank measures 69" by 44". The sheer weight of a plate of such large dimensions makes it difficult to handle; constant lifting from gigger to press and back again is heavy work. A small plate, though, presents its own problems: it is very difficult to prevent its shifting on the gigger during inking and wiping. Possibly for this practical reason as well as to save time during the actual printing, two or more subjects were frequently engraved on a single plate.* This seems to have been a procedure often adopted in the preparation of plates for book work, and it is referred to in ledger entries such as this:

Chatto & Windus
To printing 50 sets 56 plates (4 subjects on a plate) Moore's Melodies on India paper only . . . cutting up when printed and squaring and cutting each subject and mounting same on backs supplied by you and putting plate mark to each subject and cold pressing same as per estimate and your supplying the backing paper only (McQueen Ledger, 1886–).

Plate-marks may have been something of an embarrassment to book-binders; but the reference here to the simulation of plate-marks may mean that by now such indications of hand-production had taken on a special attractiveness. Gavin Bridson, erstwhile librarian of the Linnean Society, has suggested that, far from being the attractive feature they have become, plate-marks were, in the nineteenth-century, probably a nuisance. Where funds would run to it, subjects for book illustration were probably engraved on plates with generous margins precisely so that the plate-marks could be trimmed off: this was certainly the case in all but the 'office copies' of the volumes of *Transactions of the Linnean Society*, London, from 1791. Cold-pressing was for the purpose of restoring to the paper the smoothness lost during the damping process prior to printing. Sheets were placed singly between thin glazed boards, and iron or zinc plates were introduced into the stack at intervals. The whole pile was subjected to a hydraulic press for several hours. Hot pressing was carried out in the same way, except that hot plates were used.**

Apart from the printing there were many other tasks connected with the plates. The printer was frequently left with the task of bevelling and polishing the edges, so that paper and blankets would suffer no tearing during printing; of 'boiling out' solidified ink from the engraved surface (i.e. with a solution of caustic soda or potash); of burnishing out scratches

* This is a most interesting subject which deserves fuller investigation. Frequently, several subjects were engraved on a single plate simply because it was intended that the whole sheet should be displayed in that form. An example of this kind of arrangement is the sheet of 'Hunting Incidents' engraved after the original drawings by Sheldon Williams, and published 1 August 1883 by G.P. McQueen and Stiefbold & Co., Berlin; E.G. Hester was the engraver. The same subjects were also published in larger versions, separately printed. Four subjects printed in a block, two above two, on a single sheet were described as 'four up'; four subjects printed in one horizontal row were described as 'four on'.

** Publications connected with the Great Exhibition of 1851 involved the hot pressing of 6000 reams of paper; the whole operation took four men and four boys seventy-five days (see statistics of printing furnished by Messrs. Clowes & Son, *Official Catalogue*, Supplementary Volume, pp.145 ff).

and other marks from the plate's margins; of inscribing or altering lettering; of laying the acid-resistant grounds and making tracings on them preparatory to further work by the engraver. It is evident from the Dixon & Ross records that such jobs were frequently farmed out; the books contain the names and addresses of a number of men who made a speciality of these chores. The Rawle journals (see p.41, above) in the St. Bride Printing Library further emphasise the elaborate division of labour that existed in the engraving and printing sectors of an already complex collaborative system. The little books (2 volumes, 1820–40) – like the far more voluminous records of Dixon & Ross – show that it was quite common for a single plate to receive the attentions of several specialists before it was ready for the press. In view of this, the scruples expressed (though quickly withdrawn) by Ruskin in a note to Le Keux were perhaps not necessary:

> I don't know what delicacies there are about one engraver's touching another's work – It is seven years since he did (that vignette) . . . and he won't know now if it is his work or yours – and I shall never get him to do what I want . . . although it is not much – would you have any objection to do it making the proper charge? (Victoria and Albert Museum, Microfilm 85).

If for book work, the plate may have arrived at the printer as one of a batch, each plate wrapped in paper on which the title or other identification was inscribed. Great care would customarily be taken to return each plate to its own wrapping after printing; considerable inconvenience could otherwise ensue, particularly as the plates' detail was often obscured by the protective layer of wax or bitumen that helped preserve it during storage. Auguste Pugin (1762–1832) appended a testy postscript to one of his letters to the McQueens, exhorting them 'please to take care that the wrappers should not be changed as owing to that I have been thrown into great confusion'! (Appendix II, p.214). Not only was there much fetching and carrying of the plates of London clients – the omnibus fares noted almost daily in the Dixon & Ross journals (see p.185, for example) testifying to their heaviness – but plates frequently made long journeys by waggon, mail-coach or sea. The delivery book owned by Mr. P.N. McQueen is full of notes like that of 13 September 1816: 'A packing case for Mr. Green of Ambleside by the Kendal Waggon'*; and a letter from Robert Stevenson, the lighthouse engineer, informs the McQueens that '. . . by this Evening's Mail (from Edinburgh) I am therefore to send you a Box containing . . . two half and one whole Plate . . . P.S. Please be careful in unscrewing the nails of the Box' (Appendix II, p.212). In August 1818, a J. Milligan announces in a covering letter (Appendix II, p.212) the imminent delivery of copper plates from Paris, asking the McQueens to pass them on to Taylor Combe, the Keeper of Antiquities at the British Museum. There was no doubt also a traffic in engraved plates across the

* In 1814 William Green of Ambleside had produced *A Description of a series of Sixty small Prints of the Lakes*, etched by the author after his own drawings. The Delivery Book suggests that the McQueens were perhaps returning these very plates to Green after the printing of his publication had been accomplished. The lapse of two years could mean that there were further editions of the work following that of 1814; or that McQueen's sent back on the Kendal waggon plates and/or prints relating to a subsequent publication; or, simply, that the sixty small plates of the lakes were tardily returned to their owner.

Atlantic. At least, the Dixon & Ross records include evidence of transatlantic feelers in the form of a letter from John Butler, the plate-printer from Philadelphia (p.68, above. See also Appendix I, p.187). The firm had sent Butler some impressions on a speculative basis: a note on the fly-leaf of one of the Day Books (1848–1851) is headed 'Plates to Philadelphia' and lists eighteen plates with prices. The list includes 'Waiting for the Ferry' (engraved by William Giller after J.F. Herring); 'Frugal Meal' (engraved by J. Burnet after J.F. Herring); and 'Mountain Spring' (engraved by F. Bromley after F. Tayler). One must conclude that it was proofs from these plates that were despatched to America. Another of the listed plates is 'The Trial of Strafford', and this was a subject that aroused Butler's interest:

> ... At the present time I think I could sell quite a number of the 'Trial of Strafford' provided I could buy the plate for a reasonable sum say $250 – or perhaps I could arrange with you to furnish me the impressions from the Plate at a low rate ... (Appendix I, p.187).

The draft of Messrs. Dixon & Ross's reply indicates that the offer of $250 – about £56 at the then rate of exchange – was tartly declined: their price was £100. Butler had guilefully pointed out in a postscript to his letter that he could have the plate copied in America for just over £100; Dixon & Ross clearly felt inclined to let him get on with it! Whilst the firm sent consignments of prints in plenty across the Atlantic, there is no clear evidence that any of their actual plates made the same journey. That the plates themselves were not sold to Butler seems evident from the mention of several – including the Strafford – in an inventory of 1887 (p.36, above).

But where the identification of plates is concerned, one can never be sure: increasingly during the nineteenth century plates were copied by one means or another (p.52, above), so that the mere appearance of a title in a catalogue or inventory is certainly no guarantee that one has identified the original plate. Also, many successful prints were produced in various sizes: Landseer's 'Maid and Magpie' was originally repro-duced as a large mezzotint by Samuel Cousins; a smaller version was scraped sixteen years later by W.H. Simmons; and the year after that, W.S. Coleman produced a much smaller etching of the subject.* 'Bolton Abbey in the Olden Time' had also made more than one appearance in engraved form (p.76, above). And a letter to Landseer from Jacob Bell, the friend who acted as his business manager, suggests further variation in the process of multiplication:

> Boys [i.e. the print-publisher] has just been here ... he has an idea of publishing as two small prints by Cousins the girl in Bolton Abbey with the fish and the boy with the herons – the figures to come to the same size as in the original plate. Have you any

* Cousins' version was published by H. Graves & Co., 1862, work size $23\frac{7}{8}$" by $28\frac{1}{2}$". Simmons's version was also published by Graves, 1878, work size $15\frac{1}{4}$" by 18". Coleman's etching was published by Thomas McLean, 1879, work size 8" by $9\frac{1}{2}$".

Plate 84
'The Falconer's Son' engraved by
William Chevalier. The subject, like
its companion 'The Angler's
Daughter' (engraved by William
Finden), is derived from Edwin
Landseer's 'Bolton Abbey in the
Olden Time'. The engravings
($17'' \times 11\frac{1}{4}''$) were published in 1844
by Thomas Boys, London, and
Goupil & Vibert, Paris (Ross
Collection).

* The procedure of removing
selected figures from an original
compositional context and re-
presenting them finds interesting
echoes in, for example, the wood-
engraving of the central figures of
Elizabeth Thompson's 'Scotland for
Ever' (pp.580–581 of *The Graphic*, 11
June 1881. See Treble, R., *Great
Victorian Pictures*, Arts Council
Catalogue, 1978, p.80); and, later, in
some photographs by F.J. Mortimer,
with the title 'The Gate of Goodbye',
1917. Three of these photographs
were shown at the *Pictorial
Photography* exhibition held in 1978
at the Hayward Gallery, London
(organised by the Arts Council in
association with the Royal
Photographic Society); they were
numbered 111, 112, and 113. No.
111 is a photograph of troops about
to entrain. Nos. 112 and 113 are of
figures removed from the original
photograph and placed in different
settings.

objections to sanction it and touch the proofs? (Victoria and Albert
Museum, Landseer correspondence).

The project came to fruition and prints were published with the titles
'The Falconer's Son' and 'The Angler's Daughter'. The plates are still at
Ross's.*

Many of the plates handled by the printer were extremely valuable
and his was therefore a heavy responsibility. On 19 December 1876 it
was recorded in the Minute Book of the Fine Art Society that Brooker
the printer (p.42, above) had valued the steel plates engraved by
Stacpoole after Elizabeth Thompson's 'Roll Call' and 'Quatre Bras'
together at £3,903.10.0d. Fully aware of the importance of these plates
to their owners, the plate-printer had perhaps an advantage over other
trades when faced with the perennial problem of clients' bad debts: a
terse note in a McQueen ledger (1886–) reads 'Bad Bill. Holding
Plates'.

Plates would usually arrive with – or preceded by – precise
instructions for the printer, sometimes fresh from the engraver's hands:

Mrs. [Helm?] will be much obliged to Mr. McQueen to proceed as
rapidly as possible in printing the engraving which will be put into
his hands this morning by Mr. Finden for her forthcoming work;
and she requests that as they are completed he will send them, two
or three hundred at a time to Mr. Gilbert, St. John's Square,
Clerkenwell. Two thousand will be wanted, besides some proofs
(letter owned by Mr. P.N. McQueen).

And 'I send you herewith 10 Coppers to take 2 proofs of each, one on
hard paper, the other on soft, and please to send them with the coppers
when they are well <u>dried</u> and <u>flat</u>' writes Auguste Pugin (Appendix II,
p.214). Far more detailed requirements are listed by John Le Keux in a
letter of 1830 to McQueen's:

I herewith send one of the plates of Mr Agnews . . . take off 15
India for Mr Agnew . . . then return the plate for me to get the
writing engraved . . . you are then to take off 150 india and 150
French and <u>again</u> return the plate to me to have the letters
strengthened . . . I shall then finally send the plate to have 350
plain printed . . . P.S. I also send a note for Ackermann for him to
deliver the paper to you (Appendix II, p.214).

Each intaglio plate would presents its own particular problems – usually
associated with the technique of its production and with the degree of
intricacy of its execution. A line-engraving, an etching, a dry-point, a
stipple-engraving, an aquatint, a soft-ground etching, a mezzotint: each
made its own characteristic demands. Present practice confirms that the
character of the plate's surface was a very important factor in determining
the printer's procedure: the choice of paper; the consistency of the ink;
the chromatic warmth or coolness of the black; the extent to which the plate
needed warming prior to printing to persuade the ink from the most deli-
cate of depressions to transfer to the paper; the degree of resilience of the

packing between the bed of the press and the plate; the adjustment of the pressure – all these (not to mention the subtleties of the wiping process) would be affected. A line-engraved plate was considerably more enduring than most others. This had long been realised. The relative shallowness and breadth of an etched line gives a less sharp print. Voet (1972, p.220) has shown that in the seventeenth century the burin rather than the acid was always used for long printing runs. The Antwerp printer J.J. Moretus, in a letter of 1754 to an engraver, wrote that 'these plates must be engraved by you entirely with a burin and not etched or engraved with spirits or by any other means . . . my copper-plate pressman is very experienced . . . [and can print] more than 4000 copies before the plates have to be re-touched'. Still, passages of close cross-hatching in such a plate could be very tricky to print in that there was a strong tendency for the ink to streak on being wiped. A mezzotint plate seems to have been easier to ink and to wipe: easier in the sense that a simple, strong wipe is possible with a mezzotint plate without too much danger of the ink being plucked from the crevices. A mezzotint plate, in fact, needs a hard wipe if it is not to print too densely black. This hard wiping, of course, contributed to its vulnerability; the printer had constantly to be preoccupied with the plate's condition. During the printing of Landseer's 'Maid and Magpie', for example, the plate was sent back to Samuel Cousins at very frequent intervals to be revitalised. He attended to it after the first seventy-five Artist's Proofs and again after a further similar number. When printing had reached the three-hundred-and-fifty mark he spent four days on the plate. It was again in his hands before the total of 725 Artist's Proofs was two-thirds accomplished (Appendix I, p.197). Given that a mezzotint plate needed this kind of attention during the early stages of an edition, it is hardly surprising that the prints produced during the later part of the run were retailed at a much lower price. The Artist's Proofs of the 'Maid and Magpie' were sold on publication at ten guineas; the later impressions at three. Still, Raimbach reminds us that no plate, produced by whatever method, could go very long without repair. Writing of some of the plates he engraved after Wilkie, he pointed out that:

> very considerable and constant reparations were of course rendered necessary by the wear and tear of the plates in the process of printing, amounting in some cases to as much time probably, in their execution, as might have sufficed for a re-engraving of the plate . . . the plates, being brought to a sound and serviceable state, were rendered capable of producing a great many more impressions of at least a decent appearance; to restore them to their pristine bloom and vigour was quite out of the question (1843, p.134).

Although, as Raimbach rightly said, the 'pristine bloom and vigour' of a much repaired plate was gone for ever, the printer's skill could do much to make amends (pp.45–47, above). Clearly, though, a plate in a bad state would seriously slow down the rate of production. For one thing, great care had to be taken during the wiping process so that the ink should not be

plucked from crevices worn so smooth (mainly, ironically enough, by that very friction of muslin and bare palm) that their quality of retention was seriously impaired.

Perhaps there was more to the supplanting of line engraving by an adaptation of mezzotint than was fully realised even by those intimately involved (p.113, above). When one considers the awesome task of an engraver faced with the necessity of translating into line the evanescence of one of Turner's paintings for example, the gap between the respective visual languages seems immense. The increasing tendency of nineteenth-century painters to abbreviate the handling of peripheral elements in their compositions, a tendency that culminated in Impressionism, may be seen as a development that brought about a progressive widening of that gap. Perhaps it is no wonder that the line-engravers, for all their virtuosity, were overtaken by the revival of mezzotint with its capacity for generalisation and subsequently by the enthusiasm for etching with all its potential for freedom and its attractiveness to the autographic aspirations of artists; nor is it any wonder that lithography (which, ironically, in its early development had been used to imitate line-engraving) became in some ways such a serious competitor.

Chapter 7

Inks, Inking, Colour-Printing and Print Colouring

The nature of a plate determines that of the ink, the consistency and 'colour' of which needs adjustment according to the character of the engraved surface. For example, Lumsden's view (1924, pp.95–96) is that 'for a very heavily bitten plate a warm ink is not so suitable; but for very delicate etchings the ink may be very brown if desired'. Lumsden goes on to explain that in a plate containing a range of depths of line 'the *colour* of the ink changes in relation to the *depth* of the line from which it is squeezed', and suggests that this is a very good reason for keeping the ink for such plates as cool and neutral as possible. The same ink can appear different when applied to plates of contrasting treatment: an ink suitable for a vigorous line-engraving may well be quite inappropriate when printing from a delicate aquatint. The matching of ink to plate (and, of course, to paper) was always a matter of great concern: 'Two proofs on plain paper not with Strong Black ...' was the typical message in one of Samuel Cousin's memoranda to Messrs. Dixon & Ross. In May 1975, an exhaustive ink-selection exercise – which has has every reason to suppose was a re-enactment of earlier procedures – was conducted at Thomas Ross's. The exercise was based on seven plates of dissimilar treatment: etched; aqua-tinted; photogravured; mezzotinted; and engraved in various degrees of strength and delicacy. Six different inks were used and every plate was printed with each, with the result that a range of spatial effects was obtained. The inks were all black, but varied in strength and in 'colour': some were solid black, some bluish, and some brown-black. This brings to mind John Martin's experimental attitude to the use of inks. His son, Leopold, reported that

> he would pull a plain proof of the plate, using ordinary ink: then work or mix the various inks. First he made a stiff mixture in ink and oil; secondly one with oil and less ink; and thirdly, a thin mixture both of ink and oil. Lastly he worked up various degrees of whiting and oil with the slightest dash of burnt umber, just to give

a warm tint to the cold white. In working or inking the plate, the thick ink (No. 1) went to the darkest tints, No. 2 to the medium ones, No. 3 to the lighter shades; the inks consisting chiefly of whiting the most difficult to work, and the most artistic. Separate dabbers were required for each description of ink. (Balston, 1947, pp.104–105).

The ink for printing from intaglio plates needs to be reasonably viscous so that it will lie with some tenacity in the plate's crevices; but it must also be capable of being removed from the surface without too much difficulty; and, above all, it must be so thoroughly ground and thus so free from grittiness that no scratching of the plate will occur during the inking or wiping processes. In his manual of 1645, Abraham Bosse described a technique of ink preparation that was to change little over the next two hundred and fifty years:

the black is called noir d'Allemagne and comes from Frankfort. The very best is the colour of black velvet and soft as fine chalk or flour to the fingers. There is an imitation made of burnt lees of wine; it is not such a beautiful black, tends to be rough and gritty, and can damage the plates. To prepare the ink, first take a good quantity of purest nut oil and put it into a large iron pot. Place it over a good fire, and let it boil, but watch it carefully, since the house could catch fire. Keep stirring until the oil itself catches fire and then remove it from the heat. It may burn for half an hour or more, after which you should let it cook a little and pour it into storage vessels. For stronger oil, burn a good deal longer, stirring until it becomes thick. Some people put an onion or a crust into the oil to help reduce greasiness. The black should be ground on a

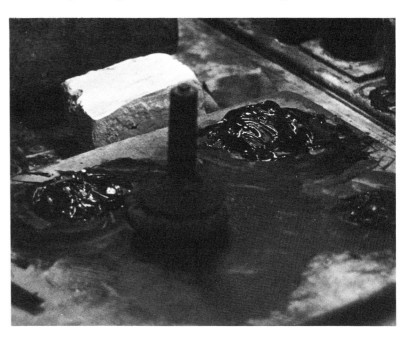

Plate 85
A plate-printer's ink ready for use.

marble slab with a good large muller, about half a pound at a time, and the weakest oil should be added. The mixture should be ground until perfectly smooth, and then as much strong oil as would fill a hen's egg may be added. If the plates are worn, or the engraved lines shallow, the ink may be on the weak side. It is vital to match the consistency of the ink to the character of the plate – above all to avoid undue thinness; this is to ensure that the pigment will transfer more readily to the paper.

It is not quite clear what Bosse meant by 'an imitation made of burnt lees of wine', since Frankfort black itself was made in this way. According to Chambers's *Cyclopoedia* the composition of the latter was wine lees burnt and washed, ground with burnt ivory, peach stones and bones of sheep's feet (Bloy, 1967). It is probable that the imitation referred to by Bosse was a local French product prepared in a similar way to Frankfort black, but for some reason failing to match it in quality. Frank B. Wiborg (1926, p.151) distinguishes between blacks made from the tendrils of the grape vine and vat sediment, and those made from bone or ivory. The former ('so-called Frankfort blacks and vine blacks') he terms 'soft blacks'; the latter, 'hard blacks'. 'Nut oil' probably means walnut oil, but this, too, is rather puzzling, since linseed is the oil usually specified for copper-plate ink-making. De Champour & Malpeyre, however, (1856, quoted in Bloy, *op. cit.*) recommend a mixture of both walnut and linseed. Hullmandel (1832, p.14) writes that 'linseed and walnut oil are best for the purposes of lithography', and goes on, interestingly, to suggest that 'oils a year old are far preferable to those which are fresh made'.

According to a typescript owned by Mr. P.N. McQueen, his ancestors were burning their own linseed oil as late as 1896. The burning of oil could easily get out of control, as Bosse had pointed out, and was later banned in London. Ink-making had on occasion led to serious fires in the city. Hullmandel (1832, pp.15, 16) describes in detail the burning of linseed oil, which 'must be heated until it catches fire (it is safer to light it with a piece of paper, or by warming some of the oil in an iron ladle until it flares, and bringing the oil thus lighted to the contents of the kettle); if the flame crackles and spreads to the sides of the kettle, it must immediately be taken off the fire, and the cover . . . put on; otherwise the oil would boil over, and cause very serious accidents'. He also explains the function of the bread as an absorber of grease and is quite specific about the precise stage at which the bread should be put in. A footnote emphasises the dangers of fire: 'even two quarts of oil will sometimes . . . flare up to the height of fourteen feet, and spread itself in all directions.' T.C. Hansard (1841, quoted in Bloy, *op. cit.*) reported that one of the largest fires in the city of London around 1820 had been caused by ink-making. The McQueens produced weak oil by burning a ten-gallon quantity for three and a half hours; medium oil by burning for four and a half hours; and strong oil for six hours (which makes the half-an-hour prescribed by Bosse seem hardly adequate).

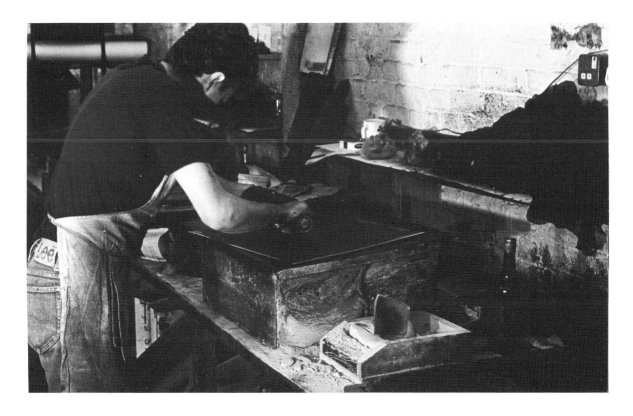

Plate 86
Inking a plate (Thomas Ross & Son's, 1983).

Most nineteenth-century printers ground their own inks with a muller on slabs of marble, in the manner described by Bosse, or on lithographic stones – and this is still the practice at Thomas Ross & Sons and at the other plate-printing establishments described above (p.90). It would, however, be interesting to discover when prepared ink became generally available. Charles Lorilleux, of the Imprimerie Royale, set up the first intaglio ink manufactory in Paris as early as 1818, and sold his products to other printers (Frèrebeau, 1974, p.14). Whatever the fortunes of the Lorilleux business in the intervening years, Kelly's *Directory of Stationers, Printers, Booksellers, Publishers and Paper Makers* (1880) lists among ink manufacturers of all kinds a Charles Lorilleux of Rue Suger, Paris, whose London agent was Charles Mayer of 62 Holborn Viaduct, E.C.; and, judging from the evidence of labels on old ink-tins, the family of the Franch ink-maker ultimately gained a more direct involvement in the English trade when the partnership of Lorilleux and Bolton was based at the Eclipse Works, Tottenham Hale, in North London.

T.C. Hansard (quoted in Bloy, *op. cit.*) described in 1841 the method of preparing ink in England for work of good quality. His account differed little from that of Bosse:

> The ink for fine ornamental work is based on the finest Frankfurt
> Black ... ground on the stone and mixed with weak linseed oil
> until it is like a thick paste; a little strong burnt oil is then added

and the whole ground again ... A drier is added ... Prussian blue
may be added ... Inks for common work ... [are] prepared in the
same way except [that] Prussian blue [is omitted]. Common English
black [is used] instead of Frankfurt.

The curious thing about this description is the mention of driers, a common
enough ingredient in inks for relief and lithographic printing, though not
(except that prussian blue has a drying effect) in intaglio inks. Prussian blue,
discovered in the eighteenth century, had long been considered
indispensable as an ingredient in good quality ink. It seems that indigo
could also be used: during the eighteenth century the Moretus intaglio
printers used it, but also used prussian blue – 'Fransche Berlins blouw' – as
an alternative (see Voet, 1966, p.234). Hullmandel (op. cit., p.14)
recommended the addition of indigo to lithographic ink 'to obtain a very
dark printing-ink in order to imitate line-engraving'. Thomas Ross bought
prussian blue during the 1880s at 3/6d per lb. from Henry Conolly, the
glass, lead, oil and colour merchant a short distance along Hampstead
Road, according to an invoice in the 1872–1881 Day Book. Of relief
printing inks, Jacobi (1890, p.169) writes that 'some makers [intensify] the
depth by a little indigo or Prussian blue'.

In 1836, Berthiau and Boitard (op. cit.) had expressed their preference
where the preparation of ink was concerned, giving:

les proportions du mélange qui nous a paru le meilleur:

Noir d'Allemagne [Frankfurt Black]	2 liv[res] 9 onc[es]*	
Noir de fumée calciné [lamp-black]	5	„
Bleu de Prusse superfin	1	„
Mine de plomb [black-lead] très friable	1	„
Total	3 liv[res] 0	„

They would begin by powdering the black-lead as finely as possible in a
brass mortar and would continue the grinding process with muller and
marble slab. The prussian blue, Frankfort black and lamp-black were
similarly ground – separately and then all together – before the oil was
added. The lamp-black (see Wiborg, 1926, pp. 152–156) recommended
was one of 'second quality', supplied by Bouju of La Rue des Marais (p.24,
above) at three francs a livre: preferable, for some unexplained reason, to
that of 'first quality', at four francs. The authors described the function of
each ingredient: Bouju's black was included to impart brilliance and life to
the sombre Frankfort; the prussian blue to give lustre, to accelerate drying
and to counteract any tendency to yellowing; and the black-lead to reduce
any possible harshness of texture and to facilitate the wiping process. They
emphasised the superiority and indispensability of Frankfort black as
against its French equivalent (perhaps the 'imitation' referred to by Bosse?),
pointing out that the English, too, are dependent on it for 'superior work'.

* At that time in France the 'livre'
was equivalent to about 1.1 lb. in
English weight; the 'once' was one-
sixteenth of the 'livre'.

The recipe compares interestingly with those in contemporary use for relief printing and for lithography. Savage, in 1832, gave 'a recipe for good black ink for ordinary work':

Balsam of capivi	9 oz.
Best Lampblack	3 oz.
Indigo or Prussian blue	$1\frac{1}{4}$oz.
India Red	$\frac{3}{4}$oz.
Turpentine dry soap	3 oz.

(Jacobi, 1890, pp.170–171).

And, in his manual of the same year, Hullmandel explained of lithographic ink that 'in France the printing-ink is composed of burnt oil, or varnish, and lamp-black; in certain cases, a twentieth part of indigo is added: in Germany, wax, grease, and tallow, are often added to the above materials'. In lithography, the search was for 'a composition possessing sufficient consistency not to spread under the pressure, and yet liquid enough to avoid its adhering to the pores of the stone'. The characteristics of the process led lithographers to 'employ thick oils, and black composed of the finest particles'. The rejection for purposes of lithographic printing of 'all blacks composed of charcoals, such as blue black, ivory black and what is called Frankfort black; these . . . being the produce of the calcination of bones or very coarse resinous substances . . . [tending] to clog together' led lithographers to rely on lamp-black, 'the produce of the smoke proceeding from the combustion of select resinous substances' (pp.10–12).

There were other recipes in plenty for relief and lithographic printing inks: all seem to have used lamp-black as their basis. Lamp-black, however, was not favoured by intaglio printers (except, perhaps, as a minor ingredient; p.149, above) since its lightness gave it a tendency to streak during wiping. As an alternative to Frankfort black they frequently used the one known as French. The latter – like genuine Frankfort no longer obtainable today – was a very dense black that required considerably more grinding than the finer Frankfort variety, and it often cost three times as much. During the 1840s, Dixon & Ross were buying Frankfort black at 1/3d a pound, whilst French black was costing them 3/6d (1840–1851 Ledger). Blacks are variously referred to in their books as 'French', 'Frankfort', 'Foreign' and simply 'Black'. Prices for the last three seem fairly consistently to be the same, so it may be that the three are synonymous.

Dixon & Ross seem to have obtained their ink from various suppliers. A certain 'Mr. Ross Senr.' (p.95, above) was one of their chief sources; he also boiled oil for the printers, sometimes twenty gallons at a time, and provided such items as dabbers (at 1/- each) for the application of ink.* During the first ten years of the firm's existence, Ross Senior delivered to the Hampstead Road premises oil, black pigment – in all probability Frankfort black – and wiping canvas to the value of over £450 (Appendix I, p.176). The respective quantities of oil, of pigment, and of canvas are not specified; this, as well as the fact that supplies were

* Also among the ink merchants who supplied Dixon & Ross were: Isidore Denizard, 15 Brewer Street, Golden Square, close to Piccadilly (1835–1838 Day Book); Hughes (probably Richard; see p.12, above) of Shoe Lane (1848–1851 Day Book); Hanlein Brothers of Frankfurt (1857–1862 Day Book); and Governor & Co., 'importers of Frankfort blacks, Dealers in Weak and Strong Oils', New North Road, Hoxton (1872–1881 Day Book).

bought from tradesmen other than Ross Senior, makes it difficult to estimate how much ink a firm like Dixon & Ross would be likely to use in a year. Another supplier – unnamed – delivered to the firm more than half-a-ton of 'F. Black' in casks between August 1838 and April 1841 (Appendix I, p.177). Again, to judge from the price, this was probably Frankfort rather than French black. At £9.10.0d a hundredweight* it came close enough to what seems to have been the customary price per pound for the former.

Among those who despatched ink to Dixon & Ross was the same Bouju of La Rue des Marais (p.24, above) whose lamp-black was recommended by Berthiau and Boitard. He sold inks for relief and lithographic as well as intaglio printing, and in 1833 was awarded a Silver Medal by the Société d'Encouragement Pour l'Industrie Nationale in recognition of the excellence of his products. His splendidly lithographed bill of 27 May 1856, records that on that day he sent off to Messrs. Dixon & Ross two casks of 'Noir Supérieure': French black, no doubt. It is possible that Dixon & Ross ordered direct from Bouju in an effort to cut out the middle-men. We have seen (p.150, above) that they had been paying 3/6d per lb. for French black during the 1840s; Bouju supplied his 'Noire Supérieure' at three francs – roughly 2/6d – per lb. Bouju seems to have acquired a considerable reputation overseas as well as in France: E.S. Lumsden (1924, p.86) uses the ink manufacturer's name adjectivally, referring to 'Bouju Heavy French'.

Records and written descriptions confirm that inking and printing procedures still used at Thomas Ross & Son's are a continuation of traditional practice. Major differences today, though, are that the heaviest oil is no longer obtainable and thus plates may often be inked without the heating that was once essential; and that the traditional blacks no longer exist. It was usual during the nineteenth century to lay the plate on a heater so that its warmed surface would encourage the stiff ink more readily to enter the recesses, into which the ink was vigorously worked with a dabber. (At Ross's the plates are still heated just before being put to the press. This assists the transfer of the ink from the plate's crevices to the paper.) When the crevices were filled with ink the wiping would begin. Wiping was done with a kind of muslin, and with what is referred to in the Dixon & Ross records as 'canvass'. The wiping ensured that the ink was thoroughly pushed into the engraved lines and simultaneously removed most of the surplus from the plate's surface.

The amount of heat required by any individual plate depended mainly upon the gauge of the metal and upon the consistency of the ink; but once the greater part of the ink had been shifted and the margins wiped as clean as possible, the plate was slid from the heater to the adjacent wooden gigger where the wiping would be completed whilst it retained sufficient heat to keep the ink suitably loose. The final stage of the

* An 1841 stocktaking ledger of the Birmingham ink suppliers, Thornley's, notes the surprisingly low price of 66/- a cwt. for Frankfort black. Perhaps this, compared with what we know printers were paying for the ink at this time, is an indication of the merchant's margin of profit.

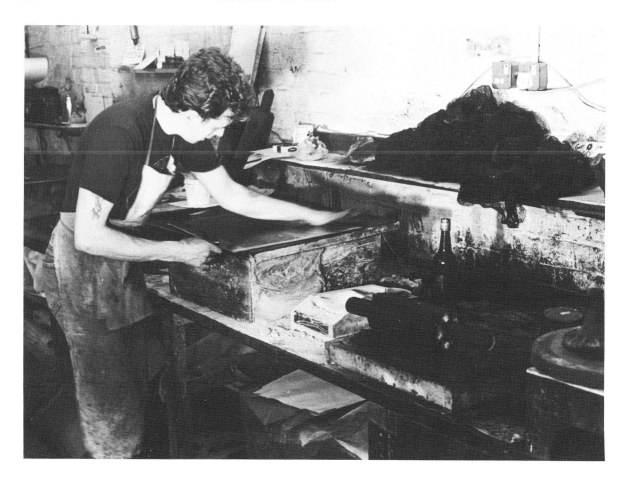

Plate 87
The hand-wipe (Thomas Ross &
Son's, 1983).

wiping was done with the printer's bare palm – a process sometimes
made more effective by the occasional rubbing of the hand on a block of
whiting. 'One proof wiped rather close and <u>clean</u>' requested Frederick
Stacpoole in a note to Dixon & Ross: meticulous and vigorous
application of hand and whiting would be needed to achieve this; and it
was probably this stage of Whistler's wiping that Frederick Goulding
watched with such fascination at the workshop of Day & Son (p.45,
above). The hand-wiping accomplished, the plate's bevelled edges
would be cleaned, it would again be heated for a minute or two to loosen
the ink, and then it would be placed on the plank of the press and the
damped paper laid upon it. Since the plate had to be inked and wiped in
this way before each impression, the process was slow. Much depended,
of course, on the size of the plate, but also on the class of job. During one
week in February 1844, one employee of Dixon & Ross took off over a
thousand prints of miscellaneous illustrations and wrappers. In the same
year, working on a Henry Bohn publication of Claude's *Liber Veritatis*,
another printer achieved in a week between fifty and sixty impressions
of each of thirteen plates, reaching a total of more than seven hundred

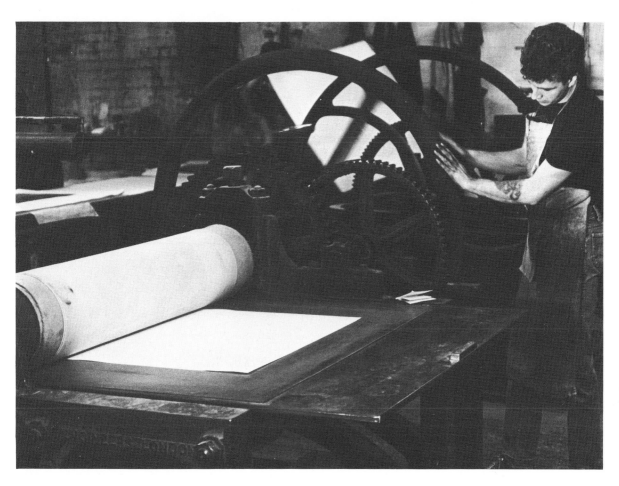

Plate 88
Taking the impression (Thomas Ross & Son's, 1983).

(Appendix I, p.182). However, as we have already seen (p.49, above), Henry Graves, in a letter to Landseer, acknowledged the slowness of the careful printing demanded by an important reproductive job and expressed his anxiety to get the work under way, since only about eight prints could be made from a large plate in one day.

Even slower, though, were the various methods of producing intaglio prints in colour. In the early eighteenth century the process of colour separation — printing a number of superimposed impressions, each from a different plate carrying a separated colour — was developed in France. It was obviously an extremely complicated procedure: the engraving of the various plates had to correspond exactly, so that satisfactory registration could be achieved; and a further complicating factor, making precise registration difficult, would be the contraction and expansion of the paper, according to its degree of dampness. This method of colour printing in fact still survives at the Paris studios of Frélaut and Leblanc (pp.90–3, above); both studios use the system of piercing all associated plates with tiny holes in exactly corresponding positions so that a needle may be used to help achieve precise registration. Each printer has a piece

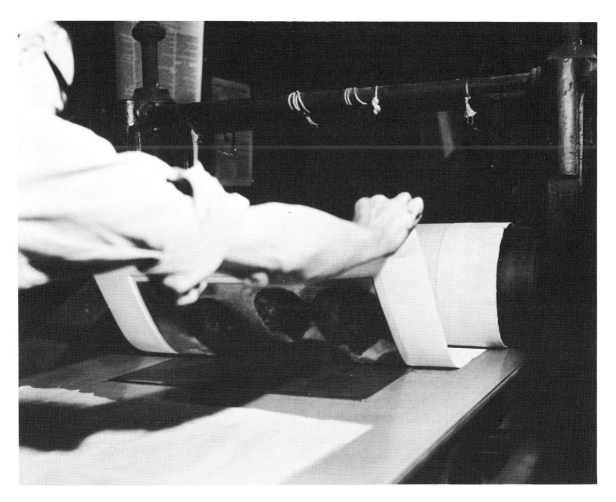

Plate 89
Lifing a proof (Thomas Ross & Son's,
Hampstead Road, 1960s. Plate 8a,
Bain, 1966. Photograph: this, and
numbers 90–92, are by the
Department of Typography and
Graphic Communication, University
of Reading).

of cork glued to the frame of his press, and his needle is stuck into it so as
to be always available. All the related plates are inked, each in its
appropriate colour or colours (ground, like black, in linseed oil), and
printed one after the other to produce the full colour print. Superimpo-
sition is carried out in this way, without loss of time, so that each sheet
of paper retains its dampness throughout the process, and the difficulties
caused by shrinking are minimised. The trickiness of this colour-
separation method must go some way towards explaining the survival
throughout the nineteenth century (and well beyond) of the single-plate
colour-printing system still used at Ross's.

It was apparently Jakob Christoph Le Blon who, on his arrival in
London in 1720, introduced into England the process of intaglio colour-
printing involving the placing of one plate over another. The intricacy of
his process, however, eventually caused its abandonment in favour of
the single-plate method which had been developed even earlier – at the
end of the seventeenth century – by Johannes Tayler, a native of
Nijmegen. Julia Frankau (1906, pp.60–151) described the technique; in

doing so, she had the advantage of personal acquaintance with an old printer who had used the method in collaboration with Francesco Bartolozzi (1727–1815), and of contact with two firms still using the single-plate system:

A copper-plate, engraved and ready for printing, was given to the workmen, . . . with a water-colour drawing for a guide to the colours . . . The printer commenced by selecting the ground-tint. He noted the prevailing tone, generally a brown, or black, or grey of greater or lesser strength, and with this he inked or filled in the work over the entire plate, as if he were preparing for monochrome . . . having inked the plate, he went over it with the muslin in the endeavour to get it as nearly clean as possible, leaving only the tone or neutral tint on which to build up his picture. Having thus secured the ground-tint, the next point was to select the . . . colours . . . with brush, poupée, or stump, he inked in the hat or the ribbon, the dress or the drapery, with the colour he had prepared. This inking had to be very neatly, very accurately done . . . the colour had to be rubbed into the engraving in such a manner as to fill the

Plate 90
A colour-printer's palette (Thomas Ross & Son's, Hampstead Road, 1960s. Plate 6a, Bain, 1966). Bain, 1966).

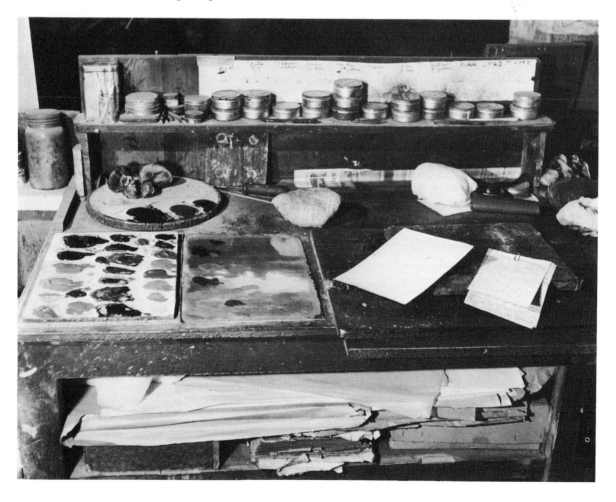

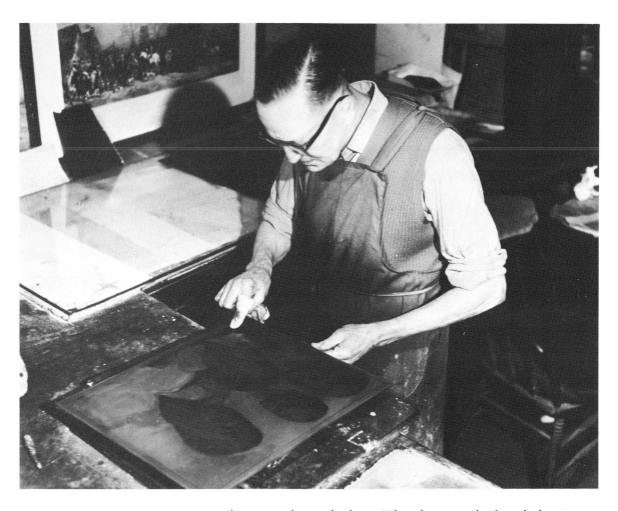

Plate 91
George Hardcastle colouring a plate
à la poupée (Thomas Ross & Son's,
Hampstead Road, 1960s. Plate 6b,
Bain, 1966).

line or stipple completely . . . When the principal colours had . . .
been inked in, the application of the flesh-tints, which were always
left to the last, was a formidable task still to tackle . . . And when
all this had been done . . . all the colours . . . had to be adjusted,
blended, and again toned. Shadows were put in . . . highlights were
wiped . . . the whole fused or blended with the muslin . . . It was at
this stage also that dry colour [could be] dusted on, to heighten a
complexion or accentuate the fold of a drapery . . . The printer
worked with two tables . . . one [heated] and the other cold. He
painted on the cold table, moving the plate now and again to the
other as it were for refreshing (pp.146–151).

Frankau expressed her conviction that the oral evidence provided by the
veteran printer, and the tangible evidence of the workshops she visited
represented accurately the methods of working that had been employed
throughout the nineteenth century. Colour prints are still produced at
Ross's in exactly the manner described by Frankau. In single-plate
colour-printing, the plate is first inked with a 'ground colour': the ink

worked into the crevices and wiped in the usual way.* This ground colour is rarely simply black. It is much more usually grey (achieved by the addition of titanium white to the standard black ink), sepia or some other fairly neutral colour, carefully calculated to harmonise with the full chromatic effect. The working notebooks of a colour-printer are preserved at Ross's, and these show that the choice of a ground colour is far from arbitrary. (In some cases the ground colour is deliberately omitted.) Colours are then applied to the plate's surface and worked into the engraving with strips of cotton fabric, or by means of the printer's finger covered with a muslin rag. The application of a full range of colours, one by one, to a large plate is obviously a slow and laborious process, and it is therefore not possible to achieve more than two or three impressions in a day. Once all the colours have been applied, the plate is very delicately wiped with muslin. The skill consists in softening the chromatic frontiers whilst avoiding undue blurring; for this reason there is very little hand-wiping. It will be seen that a plate coloured by this method contains ink in its recesses and also carries films of colour to a significant degree on its surface, so that it prints simultaneously as an intaglio and a relief plate (which, of course, is to some extent true of intaglio prints in monochrome). Some idea of the complexity and arduousness of the work may be gained from the example of the mezzotint portrait of H.M. Queen Elizabeth which Ross's printed in 1957 (see Bain, 1966, p.20). About fifteen colours were applied to the face alone, and there was time for only two impressions a day.

The colour notebooks at Ross's were used by Mr. George Hardcastle, and were begun in the early years of this century. They list a great number of subjects and specify meticulously the colours and admixtures to be used for each:

Boy & Rabbit, Raeburn

G[round] C[olour]	Bright [black][+] $\frac{1}{2}$ special red
Sky	Black[+]5th blue[+]touch per[manent] Crim[son][+]1$\frac{1}{2}$ Cobalt
Cabbage leaves	Raw Sienna[+]5th Crome & 5th blue
foreground	Burnt Sienna[+]5th blue[+]black 2 [3rd?] [+] Ochre $\frac{1}{2}$ [+] transparent white
Hair	special red
Hat	Per[manent] blue & black
Flesh	Winsor & Newton Light red[+] 5th raw sienna[+]10th per[manent] crim[son] & black 10th for the light parts 3rd for the shading.

and

Party Angling

Ground Colour	[$\frac{1}{2}$] Burnt Umber [&] $\frac{1}{2}$ Weak [black]
Trees	$\frac{1}{2}$ Ochre [+] 1$\frac{1}{2}$ Winsor [& Newton]

* Frankau (p.148) writes that 'instead of wiping the ink lightly *into* the lines or dot . . . [the printer wipes] it *out* of them . . . leaving only [a] slight tone'. One of the colour-printers at Leblanc's in Paris explained (in 1979) that the procedure described by Frankau is adopted with aquatint plates or others in very shallow relief; but that in the case of more deeply bitten or engraved plates, bistre, brown, black or some other suitable neutral ink is worked *into* the recesses before the application of colour. This was confirmed by Peter Marsh, Ross's colour-printer, also in 1979.

	Raw Sienna [+] 10[th] burnt Sienna
	[+]$\frac{1}{4}$ Prussian blue Winsor [& Newton]
Sky	Burnt umber 10th per touch of blue
„ blue part	$\frac{1}{2}$ Cobalt $\frac{1}{2}$ prussian blue
Boat	$\frac{1}{2}$ weak bl[ac]k 10th burnt sienna
Water	$\frac{1}{2}$ weak bl[ac]k 5th prussian blue
Distance	Ochre [+] 5th burnt sienna [+] 5th blue
Serving man	burnt umber [+] $\frac{1}{2}$ Raw sienna [ordinary]
red cuffs, etc.	light red [+] 5th per[manent] [+] 5th Amer[ican] [red]
hair	burnt umber
Man sitting down	Coat Bl[ac]k Claude
breeches	$\frac{1}{2}$ raw [sienna] [+] $\frac{1}{2}$ blue
Standing up figure	Coat raw sienna [+] $\frac{1}{4}$ blue breeches same as above
Lady standing up	Light red [+] touch of scarlett [with] burnt umber shadows
Fichu	$\frac{1}{2}$ bl[ac]k [+] $\frac{1}{2}$ Naples yellow
Hair	C[h]rome & burnt sienna
Face	Newman's light red [+] 10th scarlet & blue
Hat & Feathers	Bl[ac]k

Julia Frankau in her study of eighteenth-century colour prints makes the point that 'printer in colours' and 'print colourer' are not interchangeable terms. Prints are coloured at Ross's by persons answering to both descriptions. A clear idea of nineteenth-century brush colouring procedures may be gained from the present practice and the reminiscences of those still undertaking such work at Ross's; and further helpful insight is provided by the evidence of a number of recently discovered bills and receipts for hand-colouring work carried out during the nineteenth century for the Linnean Society.*

Hand-colouring with washes of water-colour was usually carried out by specialists in their own homes, often assisted by their families. The Dixon & Ross records contain the names and addresses of several such colourers at work during the nineteenth century;** and the accounts of Miss Marion Dadds, still engaged in similar work for Ross's, point to an unbroken (though now almost extinct) tradition. During her early employment at Ross's Miss Dadds, as she delivered rolls of prints for colouring, frequently met elderly people who were the survivors of families specialising in the hand-colouring of engravings and got from them descriptions of their working procedures. Some families had high reputations and they tended to be given the most important work, charging appropriately higher rates. Apparently, when children were involved in the work, they were given the simplest – and least interesting – tasks: they coloured the boots and top hats of the sporting

* I am indebted to Gavin Bridson, former Librarian of the Linnean Society, for drawing attention to this material. It is part of a batch containing also a series of bills for the printing of many plates for the Society by Dixon & Ross between 1835 and 1873; and documents relating to Vincent Brooks, William Day and Charles Hullmandel, the lithographers, and to many others involved in the printing trade during the nineteenth century.

** For example:
Ayton, White Hart Street, Kennington (12).
Bayfield, 14 Cadogan St., Chelsea (15) and 25 Elizabeth St., Chelsea (18).
Bennett, 10 Trafalgar St., Walworth S.End (12); 11 Westmoreland Row (15); and 6 Providence St., South St., Walworth (21).
Cross, 55 Red Lion St., Clerkenwell (12), (18).
Faulkner, 2 Crown Court, Portpool Lane, Gray's Inn Rd. (21).
Mason, 34 Princes Sq., Kennington Cross (18), (21).
Outlaw & Murton, 19 Dorris St., Princes Rd., Lambeth (21).
Wilson, 6 Pratt St., Lambeth (15), (18), (21).
Wilson, J., 3 Waterloo Rd., (21).
(Figures in brackets refer to the firm's record books as they are numbered in Appendix I.)

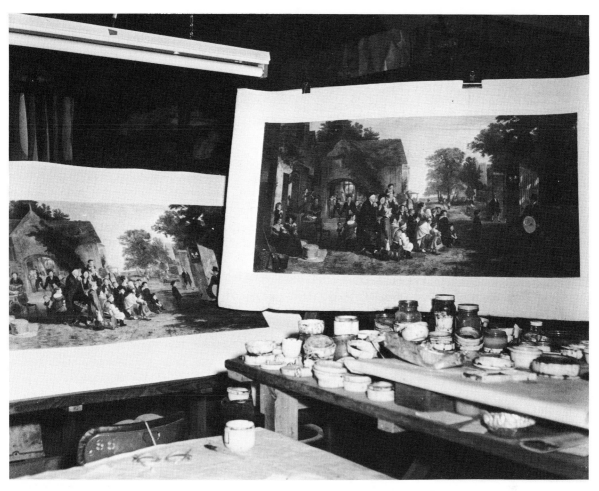

Plate 92
The hand-colouring studio (Thomas Ross & Son's, Hampstead Road, 1960s. Plate 8b, Bain, 1966. The engraving is Lemon's, after Thomas Webster's 'Punch').

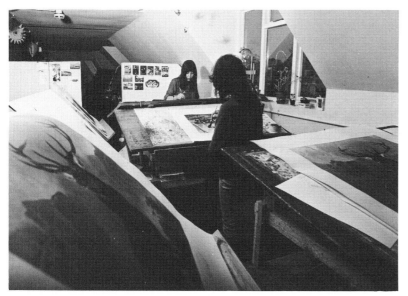

Plate 93
The hand-colouring studio (Thomas Ross & Son's Putney workshop, 1983. Photograph: Museum of London). In the foreground are impressions of Thomas Landseer's engraving (1852) after Edwin Landseer's 'Monarch of the Glen'.

prints that formed the bulk of the work, using a 'black' achieved with a mixture of prussian blue, crimson lake and gamboge. These three are the basic colours still in use today at Ross's, and we may suppose – bearing in mind the firm's unbroken involvement in such work over nearly a hundred and fifty years – that this was also the nineteenth-century palette. Among the few additions to the basic and versatile range are, occasionally, vermilion (usually for the coats in hunting scenes) and chinese white (sometimes used in flesh tints). Ox gall and saliva are important ingredients: a drop of the former acting as a de-greasing agent and lessening the tendency of the black printing ink to repel the water-colour; and a lick of saliva on the brush helping smooth application.

The Linnean Society material relates to the work of J.T. Hart, a London print colourer, and records details of more than twenty thousand prints tinted by him between 1835 and 1878. The black and white prints – some lithographs, but mainly intaglio impressions – were delivered to Hart in batches of from 100 to 2,500, and his charges were fairly consistent throughout the forty-three years he worked for the Society: usually between 3d and 9d a print, depending on the amount of detail. All the plates were for the illustration of the *Transactions of the Linnean Society*, which began to appear in instalments from 1791, and all measured something like $10\frac{1}{2}$" by 8". Colouring rates seem to have been at this level for most of the nineteenth century. In 1823 John Curtis (see also p.59, above), draughtsman, engraver and colourer, charged the Society 8d for colouring each of a batch of prints. Curtis's bill (5 February 1823, Library, Linnean Society) contains much interesting information besides his colouring prices. It refers to work undertaken by him for Vol. XIII of the *Transactions of the Linnean Society*, 1821–1822. Curtis had been commissioned to work on six plates of the size usually used by the Society: about $10\frac{1}{2}$" by 8". He charged two guineas each for the preliminary drawings (Canis familiaris, Pl.23; Viverra Linsang, Pl.24; three species of Arctomys, Pls.27, 28 and 29; and Lamia Amputator, Pl.30); five guineas for engraving each plate; 5/8d for lettering each plate; 14/- per hundred for printing 3000 impressions (which item, with the previous one, was probably undertaken by the appropriate specialist); just over 9/6d for each plate of copper; and £3.7.0d per hundred for colouring and hot-pressing Pl.30. The animal on this last plate is about $6\frac{1}{2}$" long, and there is no background depicted, so we can gain some idea of the amount of work Curtis did for his eightpence.

The occasional notes that accompany Hart's estimates for the Linnean Society combine with the bills and receipts to reveal much of the nature, extent and conditions of his work. In August 1862, he wrote a note undertaking 'to color two plates of Butterflies . . . in permanent colours, & with the same care & effect as original Patterns, at 9d. each plate, or £3.10.0 per 100'. He evidently felt the need to give an account of his previous experience in colouring such subjects: 'Entomological works

wh[ich] I have color'd', he wrote, '[include] Drury's Insects, Harris's Aurelian, Stephens Entomology, Kirby & Spence, Dr. Horsfield's Insects (etc)'. The appending of this footnote seems to emphasise the specialist nature of the work of many colourers. Judging by the date of the previous receipt signed by Hart — 22 November 1837 — there could for some reason have been a substantial interruption in his association with the Society and he perhaps felt it expedient after all that time to remind his patrons of his particular expertise. The two plates concerned were Nos. 55 and 56, Volume XXIII of the Transactions. The black and white impressions were in fact lithographed, No. 55 containing seventeen drawings of butterflies and No. 56 containing thirteen. By an interesting coincidence many batches of proofs for colouring were delivered direct to Hart from the presses of Dixon & Ross. The Dixon & Ross bills in the library of the Linnean Society show, for example, that the printers worked on Vol. XXIII from 6 November 1860 to 30 October 1862, producing impressions at 9/- per hundred.

A letter of 3 September 1864 shows how the colourer worked out his prices. He informed the Society's representative that:

> ... having color'd the two plates del[ivere]d yesterday by the Clock
> I could not say less than 9d. ea[ch] pl[ate], & seeing the two plain
> plates, making 4 plates, wh[ic]h are very full, that they must contain
> as much work, if not more, I can not see my way clear to say less ...

His argument was accepted, and in due course he received the total sum of £41.5.0d for colouring 900 impressions. A letter of a few years later gives an insight into some of the preliminaries that were necessary before the colourer could proceed with a large batch of prints. It refers to Volume XXVI of the Transactions, for which Dixon & Ross printed many of the plates.* Writing to Richard Kippist, an official of the Society, Hart informed him that:

> I recd. from Mr. Brooks [probably Vincent Brooks, lithographer, of
> King St., Covent Garden] 300 impressions of Tab. 42, Trans. Linn.
> Soc., Vol. 26, on Tuesday afternoon, & the remainder of my
> number [500] yesterday [Wednesday]. Mr. Butler has approved of
> my pattern, & a number of the plates are now in hand.

Butler was the author of a paper on butterflies, which the plates were to illustrate. It is interesting that the colourer rather than the original artist was responsible for the production of the pattern.

Another of Hart's notes to Kippist stresses that the price of 15/- per hundred illustrations to 'Dr. Lindsay's Lichen Spores' is subject to the impressions being on hard paper. Clearly, absorbent paper slowed the job down considerably, and it was probably necessary for the colourer to size it if he wished to achieve the gradations that would be quite impossible on a spongy surface. It is evident that the printer was sometimes specially asked to use hard paper for certain plates.

In February 1876, Hart warned Kippist that 'as I did not give you an

Estimate for the colouring of the Slug plates, I think it best before I proceed further to inform you by enclos'd Memorandum the cost of colouring the same. I fear the 250 of each will take me longer than a Month'. He quoted a price of 6d a print. Unfortunately the note mentions neither the volume number nor the plate numbers referred to; nor does Hart even say how many plates are involved. '250 of each' establishes that impressions of at least two were to be coloured; and 500 colourings at 6d each over a month would give him a wage of about £3.2.6d.

Hart must by the late seventies have come to the end of his career. The last receipt signed by him for the Linnean Society is dated 30 January 1878; and further correspondence with the Society is signed 'W. Hart'. The likelihood that this was the son of J.T. Hart reinforces the probability that hand-colouring, like engraving and printing, was, in the nineteenth century, often work undertaken on a family basis.

Chapter 8

Paper for Plate-Printing

The paper for intaglio printing needs to be damped so that it becomes supple enough to be pressed into the deepest of a plate's recesses and to pick up ink from the finest of engraved lines. The damping has to be undertaken with care. The method employed depends upon the degree of absorbency and the structure of the particular paper being used; but it is usual, the day before printing, to pass each sheet through the water-trough and, the full number having been wetted and piled on a draining surface adjoining the trough, to place the whole stack beneath a board and heavy weights and leave them overnight so that each sheet is fully permeated by the time printing starts. The paper must be in exactly the right state for printing: if too dry it will not come into contact with much of the ink, and if too wet it will repel inks of certain consistencies.*

The standard paper employed during the nineteenth century for intaglio printing was known simply as plate-paper. The care with which it was made was matched by the meticulousness with which it was selected by printers and publishers. In the eighteenth century, paper made in French mills was considered by English plate-printers to be the best obtainable. There were, of course, efforts in England to match the quality of the French product: in 1787 the Royal Society of Arts awarded its Silver Medal to William Lepard, founder of the paper firm that eventually came to be known as Lepard & Smith's, 'as a mark of [its] approbation of his attempt to accomplish the intention of the Society in offering the premium for making, in England or Wales, paper for taking impressions from engraved copper plates equal to that imported from France' (Owen, 1957), whence at that time 'paper was extensively imported for superior work' (*Paper Record*, June 1890).

Perhaps the most complete account of the paper-making process in mid-eighteenth-century France is provided by La Lande in his treatise *Art de faire le papier* (*c*.1750). (For Britain, see Balston, 1954 and 1957.) Besides describing in great detail the methods of paper-making, La Lande provides much interesting information about the quantities of material, the costs and the rate of output of a typical mill of the period. A year's

* For a detailed discussion of damping paper preparatory to printing see Lumsden, 1924, pp.145 ff; also Berthiau & Boitard, 1836, pp.136 ff. The extent to which a particular paper is sized will, of course, determine the manner of damping. A heavily sized paper will require more soaking than one with less size. Whilst unsized or very lightly sized paper is ideal for plate-printing, a more heavily sized paper is preferable if hand-colouring is to be added.

Name	Sheet	Half Sheet	Quarto	Octavo	Weight lbs.
ANTIQUARIAN	53 × 30½	30½ × 26½	26½ × 15¼	15¼ × 13¼	
DOUBLE IMPERIAL	42 × 30½	30½ × 21	21 × 15¼	15¼ × 10½	150 to 400
GRAND EAGLE	40 × 27	27 × 20	20 × 13½	13½ × 10	120 to 300
COLUMBIER	35 × 24	24 × 17½	17½ × 12	12 × 8¾	90 to 220
ATLAS	34 × 27	27 × 17	17 × 13½	13½ × 8½	100 to 220
IMPERIAL	30 × 22	22 × 15	15 × 11	11 × 7½	60 to 150
SUPER ROYAL	27 × 20	20 × 13½	13½ × 10	10 × 6¾	40 to 90
ROYAL	25 × 20	20 × 12½	12½ × 10	10 × 6¼	40 to 80
MEDIUM	23 × 18	18 × 12½	12½ × 9	9 × 6¼	40 to 70
DEMY	24½ × 17½	17½ × 12¼	12¼ × 8¾	8¾ × 6	28 to 60
POST	20 × 16	16 × 10	10 × 8	8 × 5	
CROWN	21 × 14	14 × 10½	10½ × 7	7 × 5¼	
FOOLS CAP	16 × 13½	13½ × 8	8 × 6¾	6¾ × 4	

McQUEEN. BROTHERS. COPPER PLATE PRINTERS, 184, TOTTENHAM COURT ROAD, LONDON, W.

Plate 94
McQueen Brothers' table of paper sizes. Undated. (McQueen collection).

* La Lande gives prices in livres (francs). Sterling equivalents are here calculated on the basis of 1 franc equalling about 10d.

** i.e. 75 aunes or ells.

***For French measurements see La Lande, *ibid.*, pp.99–102 and also Berthiau & Boitard, *op. cit.*, pp.146 ff. These measurements are given in pouces and lignes. The pouce was roughly equivalent to an inch, the ligne one-twelfth of an inch. According to the Department of Weights & Measures, Science Museum, London, there were slight variations in different parts of France. In Paris in the early nineteenth century one pouce was equal to 1.094".

continuous production required 600 quintaux (60 tons) of cotton and linen rags which, when pulped and made into paper, would reduce to 40 tons and would provide about 3,000 reams in various formats. The year's supply of rags cost £200.* Other requirements included glue, for sizing certain papers (3 tons, costing about £8.15.0d in all); alum (about 4 cwt., costing £1.13.4d); and woollen felt for laying between sheets of freshly made paper as it dried in a stack (100 yards at £6.5.0d).** The cost of wood and coal came to £6.5.0d and grease, soap, and general upkeep cost a further £4.3.4d. Wages and food for four workmen (a foreman and three vat-men) amounted to £56.10.0d over the year; and for three women, employed for sorting and washing rags, £19.5.10d. The mill's total annual costs were thus just over £300 (La Lande, c.1750, p.83).

The vat-men could produce daily between them one ream of paper of very large format – Grand Aigle, for example, measuring 27" by 40"*** – or several reams of smaller size (*ibid.*, p.104). La Lande's estimate of an annual output of 3,000 reams suggests a daily average, for the kind of mill he describes, of a little over eight reams; the range of sizes must therefore have been considerable. The author lists no fewer than fifty-seven sizes with the larger dimension longer than ten-and-a-half inches and mentions that, in addition, paper was produced in many more

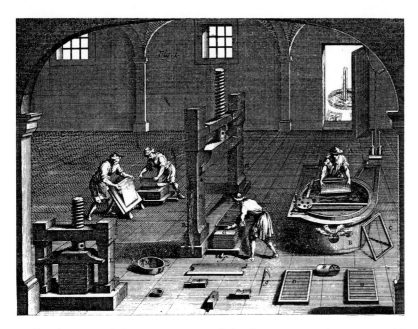

Plate 95
An eighteenth-century paper-mill.
Plate XI, fig. 1, La Lande, *c.*1750 (St.
Bride Printing Library).

smaller formats (*ibid.*, pp.99–102). Of the larger sizes, the men could produce daily two reams of Colombier (24" by 34½"); five of Grand Raisin (19" by 25"); or rather more than seven of Couronne (9" by 14½").

By the nineteenth century there were very many such mills in France. Those most usually patronised by the Paris plate-printers were in the region of the Vosges, of Annonay, Charcon and the Auvergne; and, for sized papers, the area around Rive (Berthiau & Boitard, 1836, p.145). Statistics of 1851 indicate 210 mills in France, with a total annual output of 40,500 tons. The average of 200 tons per mill was five times that of the kind of mill described by La Lande (*op. cit.*) – doubtless an indication of the spread of mechanical processes.

Paper for plate-printing was ordinarily unsized and needed to be absorbent without being too soft or spongy; was smooth in texture, of regular thickness, and free from roughness, lumpiness, and specks of foreign matter; and was of a suppleness that resisted crumpling. When pure white, the best paper achieved its brilliance by virtue of the quality of its pulp rather than through the introduction of bleaching agents which would, anyway, produce only a relatively short-lived effect (Berthiau & Boitard, 1836, pp.136–138). Such paper accepted the copper-plate inks cleanly and evenly, but an inferior product could cause endless trouble. As early as 1829, J. Murray (1829, pp.69, 98) in Edinburgh was complaining about the detrimental effects of bleach on paper – British manufacturers tending more readily than the French to use chemical additives – and about the use of materials other than linen and cotton rags. In 1831 Alaric Watts the publisher, keeping a sharp eye on the quality of the paper used for the printing of his plates, wrote rather crossly to William McQueen, asking:

> Will you oblige me by sending me states of all my plates on Mr.
> Dickenson's paper and also on [William Lepard] Smith's. It is idle
> for me to have engravers' proofs unless they are something more
> like engravers' proofs than these I have. Either they are very
> carelessly printed or the paper is bad. I think it right to say that I
> have the same complaint to make of Messrs. Dixons two plates . . .
> Of some plates I have not seen one good impression after the
> proof of the engraver himself. The Engravers complain on all hands
> of the hardness of the paper if this be the case I had rather sacrifice
> the quantity that remains than destroy the appearance of my toil
> (Appendix II, p.214).

Berthiau, the Paris plate-printer, took a keen interest in English paper
manufacture whilst visiting this country, and made some interesting
comparative comments in the *Manuel* of 1836 (pp.138–139). He found
that English mills were producing paper that matched the French variety
for beauty of texture but not for stability of colour, and wondered
whether this could be accounted for by a difference in the quality of the
raw materials or by different procedures in the manufacture. After visits
to several mills, he realised that the main difference was in the process:
he discovered that the English paper was prone to rapid yellowing
because it was whitened chemically in the making. He also observed a
further interesting variation: the English vatmen would form each sheet
with two layers of pulp – one of ordinary consistency and then, on the
side of the sheet destined to take the impression, a second extremely thin
layer of especially fine pulp, completely free of foreign matter and thus
not needing the plucking that was the usual prelude to printing
engraved plates. He further noted that the consumption of machine-
made paper, in England as well as in France, was, by the 1830s,
prodigious. Henry and Sealy Foudrinier had set up their first paper-
making machine at Frogmore near St. Albans in 1803; and within three
years, about twenty of these devices were producing between them one
eleventh of the country's annual paper output, estimated at 17,000 tons
(Balston, 1954, p.51). Berthiau's main criticism of machine-made paper
was that it had a very rough reverse side and that, whether used for
intaglio printing or at the typographic press, it did not accept ink as
satisfactorily as its hand-made counterpart.

 Besides the standard plate-paper, nineteenth-century intaglio printers
frequently used india paper – called by Berthiau *papier de Chine*. India
paper was obtainable both sized and unsized, the latter far preferable for
plate-printing; but it had to be chosen with great care since it tended to
be flowed by specks of fibrous material. It was bought by the sheet or by
the quire, and was obtainable during the 1830s in France at the
equivalent of about 4d for a sheet of good quality (Berthiau & Boitard,
1836, pp.140–145). At the same period, Dickinson's in England were
selling 'Mock India'* at 9d a sheet (Appendix I, p.175). It was the

* Clearly some kind of substitute,
though I have been unable to
discover its exact nature.

smoothness and fineness of its texture, and its readiness to accept ink, that made india paper attractive; but it was extremely flimsy and therefore, when used for plate-printing, was always mounted on a backing-sheet of plate-paper.

According to Berthiau and Boitard, the printer's first task was to pluck out with a needle any speck which, whilst it may have seemed insignificant on the unprinted sheet, would probably be more obtrusive in the finished impression. Next, the paper would be prepared for mounting. The reverse side of each sheet would be sponged with starch paste (or sometimes with a weak solution of gum arabic; but never, say Berthiau and Boitard, with flour-paste, since that causes yellowing) and hung on cords to dry, taking the precaution of allowing only the unpasted surfaces to come into contact with the cord. When dry, the sheets would be taken down, piled very carefully and evenly and put into a screw-press to flatten; after which the edges were removed in a trimming-press so that the sheets were slightly smaller than the plate to be printed. This was to keep the flimsier paper clear of the depression of the plate mark and thus to minimise the risk of the edges being plucked. Next, the prepared india paper was interleaved with sheets of damped plate-paper, the former placed centrally so as to leave even margins. The pressure of the printing would ensure complete adhesion. Curiously, English printers seem to have used flour-paste — that is, if Percy Martindale's account of the process may be taken as a description of a technique inherited from the nineteenth century:

> ... pieces are cut a little smaller than the plate, and either pasted on the back or dusted with flour and then laid face down, paste or flour upwards, on the plate, and immediately another larger piece of ordinary plate-paper over it, and passed through the press (Martindale, 1928, p.164).

Of the paper-merchants who supplied Dixon & Ross from the 1830s onwards, at least three are still in existence today, either independently or as part of a new partnership. These three are Grosvenor Chater, Lepard & Smith's and Dickinson's. They were founded in 1690, 1757 and 1804 respectively.

The firm of Grosvenor Chater is now established at St. Albans and has an archive as interesting in its own way as that of Thomas Ross & Son (for the firm's history see Chater, M., 1977). A study of the firm's records affords a glimpse of the nineteenth-century printing trade from yet another angle. Among the earliest of the Grosvenor Chater documents is a small volume of 1784, *Paine's Complete Pocket List of all the Duties on Paper &c* ('The Papermakers & Stationer's Assistant, being a correct List of all of the Different Papers their Tables, rates, and sizes with the new and Additional Duties and the Three Five per cents thereon exactly calculated by John Paine Junior'). Included in the list is the information that Colombier, for example, had at that time a value of £2.10.0d a ream

and that the total duty on the ream was 12/-. Grand Eagle cost £4.0.0d a ream and the duty was 17/3d. The 17/3d duty on Grand Eagle, for example, was arrived at as follows: 11/- imposed in 1781; 4/- imposed in 1784; and, on top, a further 2/3d, being 15% of the combined 1781 and 1784 duty.

This hand-book serves as a reminder that until the removal in 1861 of the heavy duty on paper, the trade in England and Wales suffered considerable Government restraint. The imposition of duty may help in part to explain the substantial discrepancy between French and English paper prices. During the 1830s, every separate ream had to be weighed and stamped by Government officials and the windows and doors of warehouses had to be sealed with wax every night to prevent surreptitious violation of regulations. Nearly thirty years after the removal of the duty, the *Paper-Makers' Circular* (9 April 1887) described the early nineteenth-century situation:

> The numerous provisions of the law as to the entering, folding, weighing, sorting, labelling and removing were more than any man could retain in his memory, while compliance was enforced under numerous penalties.

Paper-mill owners had to give at least twenty-four hours' notice before changing any paper; different rooms, engines, vats, presses and chests had to be numbered. Labels had to be pasted onto every ream, and failure to comply brought a heavy penalty. One of these labels (undated) survives in the archives of Grosvenor Chater at St. Albans. It is about 6" square, bears the mill's number – 298 – and the following notice: 'When this Ream or Parcel is opened the word OPENED must be written upon the Label or the Label must otherwise be cancelled. Penalty for neglect £10.' There is a space for the signature of the Excise Officer. Excisemen could demand admission at any hour of the day or night and, if he had more than one mill, a proprietor could not transfer paper from one to another without notice (*Paper-Makers' Circular*, op. cit.). All this explains the curious letter received in April 1836 by William Lepard Smith:

> Gentlemen,
> I beg leave to inform you that I have in my possession two wrappers delivered with their respective reams of paper from your warehouse NOT HAVING THE EXCISE STAMP ERASED. You have therefore incurred the liability of a penalty of ONE HUNDRED POUNDS for each wrapper . . .
> Now, gentlemen, as I am <u>VERY POOR,</u> I beg to know what remuneration you will make for giving up [the] wrappers in question. The favour of a speedy answer BY POST will oblige.
> Your obedient servant
> A.B.C. (Owen, *op. cit.*)

It explains, too, the meticulousness with which paper was counted and

the care with which it was selected for a particular edition. Requesting some printing work of the McQueens, Robert Stevenson sent from Edinburgh a specimen of the paper used for work done locally in Scotland: 'You have also a sheet as a specimen of the Paper on which the other 20 Plates are to be printed. I might have sent you paper from this, but it was thought unnecessary as you, I understand, can easily procure equal if not superior paper to the specimen sent' (Appendix II, p.212). In one of the Dixon & Ross day books it is noted among many other such entries that Mr. Boys is the firm's creditor 'by 50 Sheets of Bolton paper'. Clearly, Boys the publisher had selected and provided the paper specially for the issue of Landseer's 'Bolton Abbey'. Sometimes the printer provided the paper from stock; there would always have been a supply of plate paper in standard sizes for proofing purposes. A glance at the records of paper-buying transactions in the ledgers shows, though, that on the whole, precise quantities of paper seem to have been specially ordered for each individual job. Entries are far too frequent and quantities ordered vary too much for it to be otherwise.

The Grosvenor Chater ledgers (Petty Ledger, 1811–; Town Ledger No. 1) show that the firm's London customers during the 1820s and 1830s included Robert Havell, the aquatint engraver, of Oxford Street; Charles Hullmandel, the lithographer, of Great Marlborough Street, who between 1826 and 1833 purchased reams of Atlas, Imperial and Colombier plate-paper, and india paper to the staggering value of almost £3,000; Rudolph Ackermann, of the Strand; the publishers Longman Rees & Co. of Paternoster Row; John Murray, of Albemarle Street; Colnaghi, Son & Co.; the Trustees of the British Museum who, in 1828, bought a consignment of paper costing £22.15.0d, no doubt in connection with one of the Museum's publications; and the printer James Lahee, who from January 1831 to December 1832 took delivery of a number of reams of plate Colombier and plate Double Elephant worth almost £500. The records also show that by the 1820s, Grosvenor Chater was exporting paper to Munich, Moscow, New Brunswick, and Philadelphia.

Some idea of the extent of the paper-making industry in this country in the 1840s may be gained from a notebook among the firm's papers. The book contains a manuscript list of paper mills in Britain, 'corrected to May 1841'. No fewer than 592 mills in England, seventy-eight in Scotland and over fifty in Ireland are recorded.

By the time they began to deal with Dixon & Ross, Lepard's had become William Lepard Smith & Co. (for the firm's history see Owen, R., 1957).* Among the firm's surviving papers is a stock list which shows that in 1790 it dealt in handmade papers in various sizes and varieties: Printing Demy; Wove Demy; Double Large; Super Royal; Elephant and Colombier. The range remained very much the same during the first half of the nineteenth century. The paper was made at Hamper Mill near

* Lepard's became William Lepard Smith & Co. in 1820 and Lepard & Smith in 1856. The firm has now become part of the Link Paper group.

Watford, and the firm's London warehouse was in a house in James Street, Covent Garden, to which destination a laden waggon trundled daily from the mill. It would have been from James Street that the paper supplies of Dixon & Ross were delivered; and later, when expansion compelled Lepard & Smith's to seek larger premises, it would be from King Street, also in the Covent Garden district. Some idea of the vast stocks held by the paper merchants towards the end of the last century may be gained from figures in a salvage catalogue, which shows that supplies saved after a fire in 1878 included 16,000 reams of writing, printing, and other papers and, in addition, about 200 tons of mixed stock. This country's paper consumption during the nineteenth century provides an interesting gauge to general industrial expansion: in 1839 the figure was estimated as forty thousand tons; in 1851 – when there were reckoned to be more than three hundred paper mills in England as against about two hundred in France* – it was over sixty thousand tons, and ten years later it was half as much again.

An extract from the references to Dickinson's in an early ledger (1833–1844) of Dixon & Ross shows the main varieties, sizes and prices of paper in common use by intaglio printers at the time:

DICKINSON & CO.

1836				Drs.	Crs.
Jan	9	17 Qrs. Plate D.E.			12-15-0
	27	By 1 Quire of Mock India			18-0
Feb	5	By 166 Sheets of Plt. Col. used			
		from Hodgson's			3-10-0
Mar	22	By 1 Rm. D.E. ins.			13-10-0
		By 5 Quires of Mock India			4-10-0
Jun	4	By ½ Rm. Plt. D.E.			8-12-6
Jul	25	By 19 Shts. of Plt. D.E.			0-13-6
Aug	5	By ½ Rm. „ „ ins.			8- 0-0
	6	By ¼ Rm. „ „ Col.			2-12-6
Oct	24	By ¼ Rm. „ „ Mock India			4-10-0
		By 30 Sheets of Plt. Col.			0-15-0
Dec	21	By 26 Sheets of Mock India			0-19-6
		By ¼ Rm. Plt. D.E. pft.			4- 2-6
1837					
Jan	3	By 27 Sheets of Mock India			1- 0-3
Apr	24	By 13 Quires Plt D.E. ins. used			
		from Moons			11-14-0
Jun	6	By ½ Rm. Plt. Col. pft.			6-12-0
					————
					84-14-9
					————

* *Paper Makers' Circular, op. cit.* It is interesting that the Grosvenor Chater notebook of 1841 lists 592 paper mills in England and Wales (p.169, above) as against the much smaller number calculated in 1851. Can this be put down to inefficient gathering of evidence; to the employment of different criteria (one of the compilers choosing, perhaps to ignore all but mills above a certain size); or did the installation of machinery in some mills put others still resorting to hand methods out of business in the ten year interval?

			Drs.	Crs.
Jul	7	To Part of Mr. Boys 89-5-0 Bill	40- 0-0	
Aug	30	To Part of Mr. Moons 52-9-6 Bill	10- 0-0	
Jul	13	By $\frac{1}{2}$ Rm. D.E. ins.		6-12-0
		By 12 sheets of Mock India		9-0
Aug	17	By $\frac{1}{2}$ Rm. D.E. ins.		6-15-0
Aug	30	By 1 Quire of Imperial		9-0
Sep	12	1 Rm plt. Imperial ins.		10-10-0
Sep	15	1 Rm. plt. D.E.		13-10-0
		Bt. from Page 5	58- 8-6	58- 8-6
Sep	27	By $\frac{1}{2}$ Rm. of plt. Imp. ins.		5- 5-0
		By 7 Quires of Plt. D.E.		6-12-0
				193- 5-3
1838				
Jan	15	By 1 Rm Imperial		8- 5-0
		To cash	8- 5-0	
		Carried forward	116-13-6	201-10-3

The sizes noted in the extract are Double Elephant (D.E. – 40″ by 26″); Columbier (Col. – 34$\frac{1}{2}$″ by 23$\frac{1}{2}$″); and Imperial (Imp. – 30″ by 22″). These are the sizes given in many printers' manuals. A table printed from a copper-plate by McQueen's shows some variations: it gives the Colombier size, for example, as 35″ by 24″. The abbreviation 'pft.' indicates a 'perfect' ream (or fraction of a ream). A ream termed 'perfect' was one containing 516 sheets – the extra number allowing for spoilage. 'Ins.' probably refers to an 'inside' ream, — one numbering 480 sheets (Jacobi, 1890, pp.248–250).

The quality of plate paper was a subject discussed in some detail at a Board meeting at John Dickinson's in January 1887. The firm's plate papers had won a high reputation and, 'sheeted most carefully for the least speck', were employed for 'Virtue & Company's publications and Whymper's prints of the Alps' (Evans, 1955, pp.137–138). The Board, anticipating a waning of public interest in the photogravure process and a consequent revival in the plate paper trade, determined on a policy of revising their standard qualities and prices. The directors were discussing paper of a type that had already become a rarity and of a quality that has today all but disappeared.*

* Advertisements in trade journals of the 1890s show that efforts were still being made to provide rags for the handmade paper industry. Jacobs Brothers of Featherstone Street in East London sold 'Rags . . . carefully prepared for the vats', as they had since 1840. (See, for example, the *Paper Makers' Circular*, 10 March 1891). Today, probably the clearest idea of a nineteenth-century paper mill may be gained from a visit to Hayle Mill, near Maidstone, Kent. The mill is run by Barcham Green & Co. Ltd., paper-makers since 1805, and its entire output is hand-made.

Appendix I

Catalogue of Nineteenth-Century
Records of Dixon & Ross,
with Annotated Transcripts

Introductory note

Since the firm was known as Dixon & Ross for most of the period covered by this book, the records preserved at what is now Thomas Ross & Son's will usually be referred to as the Dixon & Ross records.

The firm's archives contain: Day Books, in which day to day transactions are concisely noted; Ledgers, usually organised with clients' names in alphabetical order, recording in full detail the work commissioned; Delivery Books, containing information relating to the collection and delivery of plates as well as that of consignments of prints; Wage Books which quite literally record only the amounts earned; Work Books which give details of the weekly output of each printer, with the titles of plates and number of impressions, but with no note of actual earnings; and Wage/Work Books containing information both on earnings and on the nature and quantity of the printing. Much of the information given in greater detail in the Ledgers, Delivery Books, Wage and Work Books is referred to briefly in the Day Books which, in addition, contain much information about routine events like the purchase of small amounts of material or the sums spent on omnibus fares by apprentices delivering or collecting plates. Miscellaneous letters, trade cards, price-lists and assorted memoranda among the leaves of many of these books constitute a considerable enrichment of what amounts to a huge reservoir of information.

Although the firm's record since 1833 is largely intact, there are gaps, one of the most tantalising being the absence of the earliest Day Book. There are other interruptions in the sequence of books in the various categories. None of these is so serious as substantially to obscure the firm's history, but they do occur to the extent that they discourage cataloguing in accordance with the various types of book. So, it was decided that probably the most satisfactory arrangement would be strictly chronological. The books have been arranged in order of opening dates, regardless of type.

The items and their opening dates:

Ledgers	Day Books	Work and/or Wage Books	Delivery Books	Bill Book
(1) 21/6/1833				
	(2) 5/11/1835			
	(3) 26/11/1838			
		(4) 13/7/1839		
(5) 5/1/1840				
			(6) 20/7/1840	
	(7) 16/12/1840			
	(8) 20/5/1844			
	(9) 28/7/1848			
(10) 1849				
		(11) 12/1/1850		
	(12) 8/5/1851			
		(13) 16/4/1853		
(14) 4/2/1854				
	(15) 22/4/1854			
		(16) 25/10/1856		
		(17) 15/11/1856		
	(18) 4/7/1857			
(19) 17/12/1858				
			(20) 1/1/1861	
	(21) 11/1/1862			
		(22) 18/10/1862		
		(23) 1/7/1865		
	(24) 8/2/1867			
(25) 14/2/1867				
		(26) 27/6/1868		
				(27) 23/9/1871
	(28) 1/1/1872	(29) 1/1/1872		
		(30) 27/7/1878		
		(31) 28/5/1881		
		(32) 18/8/1881		
	(33) 2/1/1882			

(Figures in brackets refer to Catalogue Numbers)

Catalogue Number: 1
Item: Ledger (B)
Dates: 21/6/1833 to 11/10/1844
Page Size: $7\frac{7}{8}''$ by $12\frac{3}{8}''$*

DICKINSON & CO.

	Drs.	Crs.
1833		
22 June By 2 quires of P.D.E.		1-18-0
To Cash	1-18-0	
29th. To Goods		3- 4-6
1qr. Plate Col.		12-0
2 Augt. To Goods		3-16-0
By Cash	12-0	
By Cash	6-18-6	
allowed	2-6	
	£ 9-10-6	9-10-6
1834		
June 10 $\frac{1}{2}$ Rm. of Plate D.E. ins.		7-10-0
30 Shts. of Damaged Ind.		15-0
July 4 150 Shts. Do.		3- 2-6
Aug 18 1 Rm. Plate Col.		11-10-0
Oct 24 2 Qrs. Plate D.E. pft.		1-10-0
Nov 11 16 Do.		12- 0-0
Nov 25 5 qrs. 19 Shts. Do. ins.		4-12-6
1835		
Apr 2 By Cash	10- 0-0	
Oct 24 By 12 Sheets of Mock India		8-0
Apr 7 $\frac{1}{2}$ Rm. of thin plt. D.E.		5- 0-0
Nov 30 3 Quires of plt. D.E.		2-10-0
		48–18–0
1836		
27 Feb To Bill on Colnaghi & Co.	26-19-0	
To „ at two Mos.	10- 0-0	
Discount	1-19-0	
	£48-18-0	
	58- -6	58- 8-6

DICKINSON & CO.

	Drs	Crs.
1836		
Jan 9 17 Qrs. Plate D.E.		12-15-0
27 By 1 Quire of Mock India		18-0
Feb 5 „ 166 Sheets of Plt. Col. used from		
Hodgson's		3-10-0
Mar 22 „ 1 Rm. D.E. ins.		13-10-0
„ 5 Quires of Mock India		4-10-0
Jun 4 „ $\frac{1}{2}$ Rm. Plt. D.E.		8-12-6
Jul 25 „ 19 Shts. of Plt. D.E.		0-13-6
Aug 5 „ $\frac{1}{2}$ Rm. „ „ ins.		8- 0-0
6 „ $\frac{1}{4}$ Rm. „ „ Col.		2-12-6
Oct 24 „ $\frac{1}{4}$ „ „ „ Mock India		4-10-0
„ 30 Sheets of Plt. Col.		15-0

* Note: horizontal measurements are given first.

Dec 21 „ 26 „ of Mock India		19-6
„ $\frac{1}{4}$ Rm. Plt. D.E. pft.		4- 2-6
1837		
Jan 3 By 27 Sheets of Mock India		1- 0-3
Apr 24 „ 13 Quires Plt D.E. ins.		
used from Moons		11-14-0
Jun 6 „ $\frac{1}{2}$ Rm. Plt. Col. pft.		6-12-0
		84-14-9
Jul 7 To Part of Mr. Boys 89-5-0-		
Bill	40- 0-0	
Aug 30 „ „ „ Mr. Moons 52- 9-6		
Bill	10- 0-0	
Jul 13 By $\frac{1}{2}$ Rm. D.E. ins.		6-12-0
12 Sheets of Mock India		9-0
Aug 17 $\frac{1}{2}$ Rm. D.E. ins.		6-15-0
Aug 30 By 1 Quire of Imperial		9-0
Sep 12 1 Rm. plt. Imperial ins.		10-10-0
Sep 15 1 „ „ D.E.		13-10-0
Bt. from Page 5	58- 8-6	
	58- 8-6	58- 8-6
Sep 27 By $\frac{1}{2}$ Rm. of Plt. Imp. ins.		5- 5-0
7 Quires of Plt. D.E.		6-12-0
		193- 5-3
1838		
Jan 15 By 1 Rm. Imperial		8- 5-0
To Cash	8- 5-0	
Carried forward	116-13-6	201-10-3

DICKINSON & CO.

	Drs.	Crs.
1838		
Brought forward	116-13-6	201-10-3
Apr 17 To Bill on G.R. Ward	15- 6-5	
To Cheque	20- 0-0	
May 5 By 1 Rm. of P.D.E. Pft.		10-10-0
1839		
Jul 17 To Bill on Moon at 6 Mos.	140- 0-0	
By Cheque		76- 8-4
Discount Error	4	3-11-8
	292- 0-3	292- 0-3
1839		
May 10 By 48 Sheets of Mock India		1-16-0
Jul 3 By $\frac{1}{2}$ Rm. Colombier		7- 7-0
Aug 6 „ $\frac{1}{4}$ „ „		3-13-6
Oct 9 „ 1 Quire of India		18-0
Oct 16 „ 120 Sheets of „		4-10-0

1840
May 1 To Bill on Moon at 6 months 120- 0-0
 Discount 3- 1-6
 By Cheque 90-14-0
Sep 24 To Bill on Boys 65- 8-10
 Discount 2- 9-1
 Cheque 58- 3-0
 By ¼ Rm. of Mock India 4-16-0

 185- 8-10 185- 8-10

THE CARPENTERS SOCIETY Drs. Crs

1833
(to Cash)
 (12- 6- 1)

22 June The wetting trough & stand 15- 6
 The three Boards gd. aigle 1- 3- 9
 Painting the above three times 7- 6

24 „ Making a table 18 feet long with
 ledges under & 4 framed trussels
 for the same of 1½ inch deal
 ledges screwed to do & fixing
 under window. 1-11- 3

26 „ Making and fixing by blocks a
 do board 18 feet long 8- 9
 Making an 8 ft. table 2-6 wide
 and 4 trussels 2-6 high for long
 table & fixing the same 1- 3-10
 Altering a trussel 3- 6
 Making a top to wetting
 Trough & painting the same 5- 2

25 „ Making a 1½ Deal table with
 trussels framed 3 ft. high &c 18- 6

1 July Making a table 8 ft. long
 trussels &c 15- 6
 Window boards 8 ft. do. 4- 5
 The sign board 8- 7
 12- 6- 1 8- 6- 3

THE CARPENTERS SOCIETY Drs. Crs.

1833
Bt. Forward 12- 6- 1 8- 6- 3

1 July By addition to sign board 2- 7

2 July „ Beech for loading 12 pieces 4- 0
 fixing sign board 2- 0
 the large gigger 10- 0
 altering do and making a 1- 0
 new top to a gigger 2-10

2 Aug making the large box 1-17- 2

13 Sept „ the shaving box 19- 9
 _____ _____
 12- 6- 1 12- 6- 1

ROSS SENR. Dr. Cr.

1833
25 June Oil &c included in the 12-2-0
 account below

 July By the small press 5- 0- 0
 „ „ 30 inch do. 16- 0- 0
 „ „ 46 do. do. 27- 0- 0
 „ „ Bricklayers account 9-10- 0

 Bill for black & Oil &c to Xmas 12- 2- 0

1834 Bill for Black & Oil &c to Xmas 25- 5- 0

1835 By Black & Oil & Co to Xmas 29- 2- 8

1836 By Oil, Canvass &c to Xmas 59- 8- 3

1837 By Oil, Canvass &c to Xmas 54-10- 8½

1838 By Oil, Canvass &c to Xmas 67- 5- 0

1839 „ „ „ „ „ „ 51-11-10½

1840 „ „ „ „ „ „ 60-17-10

1841 „ „ „ „ „ „ 26-10- 5

1842 „ „ „ „ „ „ 27- 5-11½

GORTON Dr. Cr.

1833
Nov 27 Cast Iron Ink Plate
 1 cwt. 1 qr. 19 lb. 1-14- 6

 Lining and shutting Roller
 Spindle Wedgd
 Turning Roller & Bearings &c. 2-15- 0

 2 Men attending to fix Press with
 wedges &c. 14- 0

1834
22 Feb Work done to the large Press
 Turning and repairing the two rollers
 putting new action to it &c &c &c 15- 0- 0

BARGE

1834
3 Jan By 3 yds. Swanskin 2/6 7- 6
 6 „ „ Dbl. Raised 6/6 1-19- 0

 [etc. etc.: £13-15-10½ spent on swanskin
 and fine white cloth between Jan 1834 and
 Dec. 1835]

PINNER Dr. Cr.

1833
6 July By turning or reducing a roller &c 13- 0

29 „	Planing planks &c	8- 0	
	do do	6- 0	
	to Making Plank taking & bringing	14- 0	
Nov 7	Removing L. Press use of Wood & Cartage	2-12- 0	
	Planing plank altering Cross Bracket Bds.	1- 7- 6	
	Turning Chn Roler Repairing Block & Carriage	13- 0	
	Shifting L. Press Planeing L. Plank	13- 0	
	Turning top Roller	7- 0	
	Bringing home Roler & L. Plank Rep.	4- 0	
	Putting 3 Wheel motion to 30 inch Press	7- 0- 0	

1834

Feb 29	A new 30 inch Iron bottom roller & Brass Barings and taking Elm Roler in Exchange	10- 0- 0
Apr 29	Planing Repairing & Carriage for 30 inch plank	10- 0
Nov 6	A New 22 inch Iron Press 3 Wheel Motion	38- 0- 0

1835

Jun 10	New 46 inch Iron Top Roller	16- 0- 0
	Turning bottom Roller	5- 0- 0
	Applying 2 34 inch wheel & pinions & large fly Wheel to the Large Press	14- 0- 0
	New barings Painting taking Down Refixing Cartage	5- 1- 0
	Muller	2- 6

1837

6 Aug	By the 41 inch Press Iron Rollers & fly wheel motion	60- 0- 0
	taking large press down & refixing	10- 0

1838

9 Feb	By a new top roller 40 inches long repairing brass bearing a false cap bolts &c &c &c	10- 0- 0

PINNER Dr. Cr.

	By altering a Press to 3 Wheel motion	5- 0- 0
	a new wooden block with brass bearing	8- 0
	a second hand wheel & pinion press	25- 0- 0

MESSRS. BRAITHWAITE MILNER & CO.

1837

14 Jan	By repairing 9 in. Cast Iron Roller &c	7- 1- 3
19 May	By an Engineer ¼ day	1-10½
7 Aug	„ repairing Iron Roller &c	3-19- 7
9 Aug	„ do	4-15- 6

5 Sept „	reducing teeth of 6 in. pinion	5- 6
23 Sept „	returning a 2 ft. wheel	10- 6
29 „ „	an Engineer ¾ day	5- 7½
1 Nov „	repairing a wood roller &c	4- 6
1 Dec „	a man's time 8¼ hours	5- 0

1839

22 Jan „	returning 10 in. roller &c	5-17- 3
1 Mar „	a man's time 3 hours	2- 5
4 „ „	refixing spindle &c	4- 4-10
6 July „	a man's time ¼ day	2- 0
2 Sept. „	repairing roller &c	4- 4- 9
17 Sept „	a tooth to pinion	3- 6

1840

4 Jan	By repairing roller &c	6-18- 9
13 Feb „	do.	4-10-10
17 Feb „	cutting 8 slots in 4 brasses	5- 0
11 Apr „	an Engineer 1½ hours	1- 2
30 June „	filling a small brass	1- 6
7 Aug „	repairing roller &c	6- 1- 8
„	Turning do. &c	2-19- 2
„	4 wrought iron wedges	2- 8
„	spindle shortening wood frame &c &c	2- 7- 1
„	5 Elm Blocks	3- 9
„	A millwright ¾ day	6- 0
10 Aug	By 1 ft. super of 1 plnd. Oak board	10
13 Oct „	repairing lignum vitae roller	17- 7
4 Dec „	returning a lignum vitae roller Iron ends &c*	4- 5- 8

[* i.e.: probably spindles]

MR. MULLER Cr.

1834

3 Feb	By engraving title to Plate	2- 6
10 Oct	By card plt. Rawlinson & co.	9- 6
	By label Wheaton	8- 6

MR. WM. GRIFFITHS

1835

Jan 17	By Castors & fixing them on Wetting Trough	2-10

[SUPPLIER NOT NAMED]

1838

21 Aug	By Cask F. Black 224 lbs. 9/10/-*	19- 0- 0
	cask	2- 6

1839

3 May	„ 1 „ „ 1.2.14**	9-15- 0

1840

24 Nov	„ 1 „ „ 1.0.12	6-10- 0

[* i.e.: per cwt.]
[** i.e.: 1 cwt 2 qr. 14 lb.]

1841
17 Feb „ 1 „ „ 2.2.4 24- 2- 0
30 Apr „ 1 „ „ 6.0.12 48-16- 6

Catalogue Number: 2
Item: Day Book
Dates: 5/11/1835 to 24/11/1838
Page Size: 7⅝" by 12"

Monday, November 16th. 1835
Mr. Linnell 14 The Rev. G.A.E. Marsh 1/10 Ind.
 13 do. 1/6 „

Paid for Stamp 6d. 6

H. Wallis 1/4* Ind Prf 7

[* i.e.: ¼ sheet size].

17th.
Henshall 250 Rotterdam 250 Yarmouth
 Thin Paper
250 Bay of Naples 250 Cheddar 250 Hurst Castle
259 Rowland Graemes 250 Yarmouth
250 Bruges 250 Kenilworth 250 Burgundy
250 Abbeville 250 Greenwich

Paid for Liq. Potasse 10

Bennison Cr. By Cash 14-12- 6
 Dr. to Discount 7- 6 15- 0- 0

18th.
Paid for Candles 2/8 Porter -/2 2-10
W. Lge. Smith & Co.
 By 14 Quires plt. Royal pft. 37 lbs. 2-15- 6
 „ 2½ Quires plt. Colombier 15 „ 1- 2- 6
Shade 100 Cds. Parsey

19th.
Shade 1Pf. on 1/8 D.E. 5

20th.
Pryor Cr. 8ft. 6in. Best Pipe 1/0 8/6
 3 elbow joints 2/3
 1 Wall hook 4
 Painting part of do. 6 0-11- 7
Gardner 13 each of 2Dble. Elpht Plates 15- 6
19th. H. Wallis 1 Pf. Small plate 4

21st.
Paid for Turpentine 6

Mr. Cousins 2 Bolton Abbey D.E.
Paid Wests for fetching and taking back the plt.
 „ Wages Bradley -/14s.

Monday, November 12th. 1838
Q. Mr. Cousins 41 Lettered pfs.
 „ Boys 10 Village Recruits
 „ Cousins 2 Hawking

Paid for Wax 9
Recd. Prfs. Phillips & Tracing 1-10
Mr. Linnell 2 Pfs. Copper plt. ½ D.E. 2nd. proving
G.R. Ward 2 Prfs Duke of Wellington ½ Col.

13th.
Mr. Gardner 500 Small Map of Panama
B.A. Mr. Cousins 20 Bolton Abbey
Mr. Boys 28 Prints Sir R. Peel
Paid for Candles 2- 3

14th.
Hodgson & Graves 37 Prints Abercorn Children
Mr. Gardner 1 Prf. each of 12 Long Railway Plts.
 1 ½ Sht. Straits of Magellan
 2 ¼ Prfs.
Mr. Sadd 1 Pf Portrait ¼ D.E.
Cards & Post 1- 5
Mr. Scott 1 Pln. & 1 Ind. ¼ Col. (Horse)
Mr. Shade 100 Cards Molineux

15th.
Q. Mr. Moon 8 Strained Lettered pfs. Queen
 „ Ross By 4 Galls. ext. strong* 2-12- 0
 „ „ „ 3 „ strong 1-13- 0
Mr. Gardner 300 Barometer Plt.

[* i.e.: linseed oil]

16th.
Recd. of J.H. Robinson for Prf. 2- 0
Turps -/5d. James -/6d. Candles 1/- 1-11
Shade 100 Bills Molineux Ornt.
Mr. Gardner By Check 10- 0- 0
Q. Mr. Cousins 40 Lettered Proofs The Queen
Recd. for Pfs. 1- 8
Mr. Gell 400 Cards printed both sides
 „ „ By Zinc 1- 6
Paid Postage Pencils Candles 1- 7½

17th.
Messrs. Colnaghi & Co. To Trimming & Mounting
 Paul preaching at Athens & Charge to Peter
Hodgson & Graves 15 Prints Abercorn Children
Mr. Boys 42 Prints Sir R. Peel
Paid for Candles 3- 6½
Wages W. Ross
 Little
 Jordan 2- 4- 0
 T.T. Ross 1- 1- 0
 Smith 18- 4
 James 17- 0
 Henry 0- 0

Catalogue Number: 3
Item: Day Book
Dates: 26/11/1838 to 15/12/1840
Page Size: $7\frac{5}{8}''$ by $12\frac{5}{8}''$

26th. Nov. 1838	Mr. Cousins		40 Prints Bolton Abbey
27	„	„	28 Lettered Proofs The Queen
29	„	„	2 Prfs. Small Queen Sht. Colbr.
30	„	„	30 Lettered Prfs. The Queen
3rd Dec.	„	„	3 Prfs. Lord Egerton Dble. Impl.
4	„	„	46 Lettered Prfs. The Queen
5	„	„	25 Bolton Abbey
7	„	„	30 Lettered Prfs. The Queen
8	„	„	41 Prfs. Mr. Biddle
11	„	„	30 Lettered Prfs. The Queen
12	„	„	2 Prfs. Mr. Earle
			25 The Queen Lettered Prfs.
13	„	„	2 Prfs. Small Queen
17	„	„	4 Prfs. Henry Earle
18	„	„	30 Lettered Prfs. The Queen
19	„	„	43 „ „ „ „
			25 Prints Bolton Abbey
			A Dble. Impl. Mill Board Returned.
20	„	„	3 Prfs. Small Queen Sht. Colbr.
24	„	„	25 Lettered Prfs. The Queen
27	„	„	30 „ „ „ „
29	„	„	36 „ „ „ „
31	„	„	25 Prints Bolton Abbey
			14 Lettered Prfs. Queen
1st. Jan. 1839	„	..	31 „ „ „
3	„	„	100 Cards
5	„	„	40 Prfs. Mr. Earle
7	„	„	12 Bolton Abbey
10	„	„	4 Prfs. on $\frac{1}{2}$ D.E. Revd. Readshaw
11	„	„	62 Mr. Biddle
12	„	„	40 Impns. H. Earle
21	„	„	74 Mr. Biddle
23	„	„	125 Mr. Earle
	„	„	70 Mr. Biddle
25	„	„	39 „ „
31	„	„	12 Bolton Abbey
			63 President
	„	„	21 Biddle
1st. Feb.	„	„	24 Mr. Earle
2	„	„	16 Prints Queen Strained
4	„	„	44 The Queen Prints
6	„	„	20 Prints The Queen
	„	„	9 Prints Bolton Abbey
7	„	„	32 Biddle
8	„	„	20 Mr. Earle
	„	„	31 Mr. Biddle

9	„	„	29 Biddle
	„	„	500 Impns. Mr. Biddle 20. 0. 0
			250 Sheets of D.E. 8.10. 0
			250 Sheets of D.C. 9. 2
			Tissue & the
			Plate ———
			28.19. 2
			———
			By Cash 28.19.2
9th. Feb. 1839	Mr. Cousins		16 Prints the Queen
11	„	„	3 as 2 The Little Queen Sht. Col.
	„	„	4 Rev. Readshaw
12	„	„	50 Prints The Queen
13	„	„	48 Prfs. Revd. G. Readshaw
15	„	„	50 The Queen
19	„	„	50 Mr. Earle
	„	„	22 Prints Bolton Abbey
21	„	„	4 Prfs. Mr. Neeld on Sht. Impl.
	„	„	50 Prints The Queen
23	„	„	56 Mr. Earle sent yesterday
25	„	„	28 Prints Bolton Abbey
	„	„	20 Prints The Queen
27	„	„	30 „ „ „
5th. Mar.	„	„	35 „ „ „
8	„	„	25 „ „ „
11	„	„	3 Prfs. Duke of Cambridge Sht. D.E.
12	„	„	50 Prints The Queen
13	„	„	51 Prints Bolton Abbey
14	„	„	530 Impns. H.J. Earle 21. 4. 0
			265 Sheets of P.D.E. 9. 0. 0
			265 „ „ D.C.T. 0.10. 0
			& the Steel Plate ———
			30.14. 0
			———
16	„	„	50 Prints The Queen
			By Cash of J.G. Perry
			Esqre 30.14. 0
			By Cash Readshaw 8.13. 6
20	„	„	25 Prints The Queen
22	„	„	25 „ „ „
23	„	„	10 „ „ „
26	„	„	40 „ „ „
27	„	„	55 Prints Bolton Abbey
28	„	„	26 „ The Queen
38	„	„	24 „ „ „
2nd. Apr.	„	„	41 „ Bolton Abbey
	„	„	3 Prfs. Small Queen Sht. D.E.
3	„	„	25 Prints The Queen
5	„	„	18 „ „ „
6	„	„	41 „ Bolton Abbey
12	„	„	2 Prfs. Small Queen Sht. D.E.
	„	„	33 Prints The Queen

15	Mr. Cousins	42	„ „ „
17	„	„	2 Prfs. Small Queen D.E.
19	„	„	26 The Queen
	„	„	2 Prfs. Small Queen D.E.
20	„	„	24 Prints The Queen
24	„	„	20 Prfs. B.A. Small Queen
	„	„	25 Prints the Queen
	„	„	2 Pfs. Hawking
26	„	„	25 Prints The Queen
27	„	„	25 „ „
	„	„	21 Prfs. B.A. Small Queen
1st May 1839	„	„	36 Prints The Queen
4	„	„	30 „ „
6	„	„	13 „ „
8	„	„	50 Autograph Prfs. Small Queen
16	„	„	50 Autograph Prfs. Small Queen
21	„	„	77 Autograph Prfs. Small Queen
24	„	„	40 Mr. Neeld
25	„	„	30 „ „
27	„	„	54 „ „
28	„	„	2 Prints The Queen
29	„	„	3 Prfs. Lady Clive Sht. Imperial
30	„	„	93 Autograph Prfs. Small Queen
1st. Jun.	„	„	63 Mr. Neeld
5	„	„	35 „ „
8	„	„	45 „ „
	„	„	4 as 3 Lady Clive
11	„	„	47 Mr. Neeld and the Plate
19	„	„	Cr. by Cash for Mr. Neeld 27. 9. 0
27	„	„	2 Sht. Imp. Lady Clive
	„	„	1 Do. Col.
29	„	„	2 Prfs. Abercorn Children Impl.
2nd. Jul.	„	„	1 Prf. Hawking
12	„	„	1 Impl. & 2 on Dble. Impl. Abercorn
25	„	„	3 Hawking
10th. Aug.	„	„	4 Pfs. Hawking
3rd. Sep.	„	„	1 Pf. Statue
16	„	„	2 Pfs. Bishop of Chester $\frac{1}{2}$ D.E.
23	„	„	2 Pfs. Statue $\frac{1}{2}$ D.E.
30	„	„	2 Malcolm $\frac{1}{2}$ D.E.
5th. Oct.	„	„	3 Pfs. Malcolm $\frac{1}{2}$ D.E.
12	„	„	1 Etching Queen Hayter's Ind. Sht. D.E.
14	„	„	2 Pfs. Bp. of Chester $\frac{1}{2}$ D.E.
17	„	„	4 Pfs. Egerton
	„	„	2 „ India 1 of these to Mr. Moon 20 Nov.

28	Mr. Cousins	4 Pln. Prfs. Hawking 1 to Mr. Moon the other 3 to do. 20 Nov.	
31 Oct. 1839	„	„	1 Hawking to strain
12th Nov.	„	„	2 Bolton Abbey
13	„	„	22 Hawking India
	„	„	16 „ „
	„	„	6 „ of which one on India
14	„	„	1 Hawking India to strain
15	„	„	1 „ „ „
	„	„	10 „ „ „
	„	„	10 „ „ „
16	„	„	3 Prfs. Malcolm $\frac{1}{2}$ D.E.
19	„	„	20 India & Plain (hawking)
20	„	„	2 Prfs. Bolton Abbey
21	„	„	2 „ $\frac{1}{2}$ D.E. & 1 Impl. Genl. Malcolm
26	„	„	45 Prints Hawking
3rd. Dec.	„	„	40 Hawking
7	„	„	3 Prfs. Malcolm $\frac{1}{2}$ D.E.
9	„	„	55 Hawking
12	„	„	33 Pfs. Hawking
13	„	„	2 Pfs. Bolton Abbey
	„	„	3 „ „Malcolm $\frac{1}{2}$ D.E.
19	„	„	50 Hawking
24	„	„	4 Pfs. B.A. D. Impl.
26	„	„	55 B.L. Proofs Hawking
8th. Jan. 1840	„	„	75 B.L. Hawking
	„	„	23 Prints Bolton Abbey Impl.
18			By Cash 9. 1. 6
21	„	„	71 Pfs. B.L. Hawking
	„	„	8 India Bolton Abbey
22	Recd. of Mr. Cousins for cases 6/- 1/- 7. 0		
24	Mr. Cousins	33 Hawking B.L. Pfs.	
25	„	„	22 Ind. Bolton Abbey
			2 Pfs. Bp. Chester Imp.
28	„	„	9 B.L. Pfs. Hawking
29	„	„	30 Bolton Abbey India
31	„	„	20 India Bolton Abbey
	„	„	26 Hawking
1st Feb.	„	„	55 „ B.L. Proofs
5	„	„	25 „ „ „
7	„	„	35 „ „ „
10	„	„	30 India Bolton Abbey
11	„	„	40 Pfs. B.L. Hawking
13	„	„	2 Malcolm $\frac{1}{2}$ D.E.
	„	„	21 Ind. Bolton Abbey
14	„	„	25 B.L. Proofs Hawking
18	„	„	46 „ „ „
	„	„	41 India B.A. making 220
25	„	„	55 „ Bolton Abbey
27th. Feb. 1840	„	„	38 Pfs. B.L. Hawking
28	„	„	1 Malcolm Impl.
3rd. Mar.	„	„	35 Pfs. B.L. Hawking (944)
(Mr. Becker	1 Pf. Writing of Hawking)		

7	Mr. Cousins	75 Ind. Bolton Abbey to complete 350
	" "	1 ½ D.E. & 2 Impl. Bishop of Chester
11	" "	75 Bolton 2nd. class Plain
12	" "	29 Ind. & 18 Pln. Hawking
14	" "	25 Bolton Abbey 2nd. Class
	" "	25 Hawking A.L.
16	" "	50 Bolton Abbey 2nd. Class
18	" "	30 A.L. Pfs. Hawking
19	" "	6 Pfs. Bp. Chester Imp.
23	" "	66 Pfs. A.L. Hawking
27	" "	4 Pfs. Bp. Chester Imp.
30	" "	37 Prints Bolton Abbey
31	" "	158 Sir John Malcolm
	" "	6 Pfs. Bp. Chester Imp.
1st. Apr.	" "	3 Pfs. Bp. Chester Imp.
3	" "	30 Prints Bolton Abbey
4	" "	79 Pfs. A.L. Hawking
	" "	9 " " " India
	" "	7 Bishop of Chester Impl.
6	" "	50 Prints Bolton Abbey
7	" "	50 "
13	" "	3 Prfs. Lady Clive Sht. Impl.
14	" "	50 Prints Bolton Abbey
	" "	26 Prfs. A.L. Hawking
	" "	8 " " " India
15	" "	2 Bishop of Landaff ½ D.E.
16	" "	56 Prfs. A.L. Hawking (346)
18	" "	25 Prints Bolton Abbey
20	" "	17 " " "
23	" "	38 Hawking Pfs. A.L. (384)
27	" "	31 Proofs A.L. Hawking Ind.
	" "	1 " " " Pln.
	" "	33 Prints B.A.
	" "	30 " Hawking
28	" "	70 " "
2nd. May	" "	17 B.L. & 103 A.L. Bp. of Chester on Sht. Impl.
4	" "	50 Prints Bolton Abbey (400)
6	.. "	2 Prfs. Bishop of Landaff
7	" "	50 Prints Hawking
9	" "	50 " B.A.
12	" "	60 " Hawking
13	" "	39 Sir J. Malcolm
	" "	2 Bishop of Landaff
	" • "	4 as 2 Lady Clive Impl.
16th. May 1840	" "	4 Pfs. Lady Clive Impl.
	" "	180 " Bishop of Chester
19	" "	50 B.A.
23	" "	100 Prints B.A.
	" "	106 Hawking
	" "	8 Lady Clive Sht. Col.
28	" "	50 Bolton Abbey
3rd. Jun.	" "	38 Lady Clive Impl.
	" "	36 Prints Hawking
	" "	4 " "

13	Mr. Cousins	3 Prfs. Sutherland Children Etching Sht. Col.
	" "	15 & 10 Lady Clive
15	" "	20 Lady Clive
17	" "	68 Hawking Prints
20	" "	55 Bishop of Chester
	" "	7 Etchings Sutherland Children
23	" "	17 B.L. Chester) 12. 0. 0.
	" "	183 A.L. ")
	" "	200 Sheets Impl. 4.12. 0
	" "	155 Prints Bp. Chester 9. 6. 0
	" "	77½ Shts. Plt. D.E. 2.16. 0
	" "	277½ " D.C. Tissue 0.11. 0
		29. 5. 0
25	" "	20 A.L. Prfs. Lady Clive
1st. Jul.	" "	30 Lady Clive B.L.
	" "	31 " " A.L.
7	" "	3 Prfs. Hawking
10	" "	3 Hawking
11	" "	13th. May 1840 To 358 Imprs. Sir John Malcolm 23. 5. 0
18	" "	2 Etchings Sutherland Children
	" "	By Check 24.10. 0
	.. "	To Cash 1. 5. 0
22	" "	51 Hawking
24	" "	3 Prfs. Sutherland Etchings Sht. D.E.
25	" "	10 Prints Hawking
27	" "	53 Hawking
29	" "	By Bill at 1 month from 25 June 33.11. 0 To Cash 4. 6. 0
31	" "	52 Hawking
6th. Aug.	" "	60 "
13	" "	37 "
15	" "	24 Prints Hawking
21st. Aug. 1840		49 Hawking
25	" "	50 Prints Hawking
29	" "	2 Etchings Albert
31	" "	34 Hawking
1st. Sep.	" "	2 Prfs. Sutherland Children
5	" "	By 21 Sheets of very lge. ½ size paper.
7	" "	50 Hawking
8	" "	3 Bishop of Landaff
19	" "	40 Hawking Prints (541)
21	" "	76 " "
26	" "	2 Prfs. D.W. D.E.
6th. Oct.	" "	86 Hawking Prints (705)
12	" "	2 Prfs. Sutherland Children

17	„	„	2 Prfs. Bp. Landaff ½ D.E.		
7th. Nov.	„	„	4 Wellington D.E.		
18	„	„	5 Duke of Wellington		
	„	„	4 „ „ „		
	„	„	1 „ „ „		
25	„	„	49 „ „ „		
	„	„	12 „ „ „ strained		
30	„	„	14 D.W. before the Autograph		
	„	„	43 D.W. since the Autograph		
4th. Dec.	„	„	5 as 4 Sutherland Children D.E.		
12	„	„	50 D.W. including 1 delivered to Jackson.		

Catalogue Number: 4
Item: Wages and Work Book
Dates: 13/7/1839 to 13/11/1845
Page Size: 4″ by 12⅜″

30th. Nov. 1839

10	Bull (Scott)		4. 0
60	Small Queen		2. 8. 0
		W. Ross	2.12. 0
	Prfs.		2.10½
200	Light & Shade		9. 0
250	Ancient World		3. 1½
		J. Dixon	15. 0
	Assistance		
		Jordan	2. 5. 0

29th Feb. 1840

18	India Bolton		1.13. 9
7	Plain do.		8. 9
100	Small Ruled Plt. Gardner		1. 3
12	Wilbraham		6. 0
		W. Ross	2. 9. 9
	Prfs.		1. 6
300	Coal Shaft		18. 0
200	Language of Flowers		7. 0
200	Title to do.		2. 6
150	Globe Plate		2. 3
			1.11. 3
		J. Dixon pd.	4. 0
			1. 7. 3

500	Ostend to Rugen		7. 6
500	Wrappers in Red		2.11
50	Ind. Prince Albert		2. 6
	Long Railway		2. 1½
		Smith	15. 0½
	Assistance		
		Jordan	2. 5. 0

15th. Sep. 1844

56	Plte.	51 Liber Veritatis		
57	„	52 Liber Veritatis		
55	„	53 „		
55	„	55 „		
55	„	56 „		
55	„	57 „		
57	„	60 „		
54	„	81 „		
56	„	82 „		
54	„	84 „		
52	„	85 „		
53	„	86 „		
53	„	90 „		
712			Backhouse	2. 9.10
60	„	61 „		
60	„	63 „		
59	„	65 „		
58	„	67 „		
59	„	68 „		
59	„	69 „		
59	„	70 „		
52	„	26 Vol. 1		
50	„	30 „		
516			Curtis	1.16. 4½
57	„	34 Liber Veritatis		
57	„	37 „		
59	„	38 „		
58	„	38 „		
52	„	19 „		
51	„	20 „		
51	„	17 „		
51	„	18 „		
436			Cockerill	1.10 7
100	British Isles			15. 0
20	Lord Combermere			8. 0
25	George 4th.			8. 9
25	Venus and Cupids			3. 9



25	Falstaff	3. 9
75	Hark	7. 6
50	Union	6. 0
50	Early Piety	4. 6
100	Noble Tips	1. 1. 3
50	British Isles	7. 6
25	Hannan	2. 6
25	School Mistress)	
25	Blind Beggar)	18. 9
25	Cerebus)	
35	Holy Family	8. 9
40	Earl St. Vincent	10. 0
50	Breaking Cover	7. 6
25	Going to School	6.10½
25	Ruebens and Wife	6. 3
6	Pfs. Tom Moody	3. 0
6	Pfs. British Isles	3. 6
58	Plte. 41 Liber Veritatis	
57	,, 42 ,,	
56	,, 43 ,,	
57	,, 44 ,,	
57	,, 45 ,,	
59	,, 46 ,,	
57	,, 47 ,,	
57	,, 48 ,,	
57	,, 49 ,,	
56	,, 50 ,,	
50	,, 1 Vol. 1	
51	,, 2 ,,	
52	,, 3 ,,	
52	,, 4 ,,	
51	,, 5 ,,	
52	,, 6 ,,	
51	,, 7 ,,	
52	,, 8 ,,	
52	,, 9 ,,	
51	,, 10 ,,	3.16. 0

1085	W. Ross	11. 9. 1½
	(4 weeks)	

	Pfs.	1. 4
59	Plte. 71 Liber Veritatis	
59	,, 72 ,,	
60	,, 73 ,,	
57	,, 74 ,,	
58	,, 75 ,,	
58	,, 76 ,,	
58	,, 77 ,,	
58	,, 78 ,,	

467		1.12. 8

	1.14. 0
Pd.	5. 0
J. Dixon	1. 9. 0

Catalogue Number: 5
Item: Ledger (D?)
Dates: 5/1/1840 to 26/5/1851
Page Size: 8⅝″ by 14½″

MR. JOHN MOORE Dr. Cr.

1840

8 Feb.	By 1 Frame Inch gilt		7- 6
15	,, 1 Maple wood frame		18- 0
11 June	8 Frames M. Jobson	6- 8- 0	
16 July	8 do do	7- 0- 0	
11 Sep.	1 do & glass	1- 2- 0	
12	a Dressing Glass	2-17- 6	
29	Glass polished & Silvered new gilding frame & fitting up	1- 1- 0	

1841

11 May	1 Confidence		10- 0
18 Aug.	2 Frames		17- 0
22 Sep.	1 Frame & Glass		12- 6
24	1 ,, ,,	1- 7- 6	
29	1 ,, ,,		14- 0
25 Nov.	1 ,, ,,	1- 0- 0	

1842
[etc., etc.]

1 Sep.	1 panel strainer 35 by 30		3- 8
	3 Maple & Gold frames to pattern with best flattened sht. glass pannel strainers fixing in glass plate rings &c &c		11-14- 6

1834
(etc., etc.)

21 Ap.	1 [frame] 3½ inch R.O.G. Maple G.I. Panel Strainer Patent plt. Glass 30½ by 23½		3- 8- 2

MR. ROSS SENR. Cr.

By Oil &c &c to Xmas	1833	12- 2- 2
	1834	24- 5- 0
	1835	29- 2- 8
	1836	59- 8- 3
	1837	54-10- 8
	1838	67- 5- 0
	1839	51-11-10½
	1840	60-17-10
	1841	26-10- 5
	1842	27- 5-11½
Sept.	1843	19- 6- 8
		433- 6- 7
1847 Errors in 1834 account		2- 1- 4
,, ,, 1845 do		9- 9-11½
12 Nov. Carried to new account		1-13- 2½
		466-11- 1



Copy of estimate sent to Mr. Samuel Cousins
26 May 1849 for Imperial Portrait

100 Plain	5-10- 0
100 Sheets of Impl.	2-10- 0
100 Sheets of Tissue	2- 0
	£8- 2- 0

Printing 100 india	8- 5- 0
100 Pieces of India	1- 5- 0
100 Sheets of Impl.	2-10- 0
100 of Tissue	2- 0
	£12- 2- 0

MR. SAMUEL COUSINS A.R.A.

		Dr.	Cr.
1846	Brought from Page 73	0- 0- 0	0- 0- 0
Feb. 27	To 100 Cards	2- 0	
Mar. 27	1 Pf. Christ Weeping &c	3- 0	
	1 Pf. „ „ India	4-10	
Ap. 7	1 „ „ „ Plain D. Imp.	3- 0	
	4 „ „ „ India	19- 4	
Ap. 11	Tracing Miss Peel	2- 6	
May 2	3 Pfs. Christ Weeping &c Ind. D. Imp.	14- 6	
7	2 „ „ „	9- 8	
18	2 „ Miss Peel Etching D.E.	4- 6	
June 24	2 „ Portrait on ½ D.E.	2- 2	
Aug. 1	1 „ Miss Peel Sht. Col.	2- 3	
	1 „ „ „ „ Ind.	3- 7	
5	2 „ „ „ „ „	7- 2	
8	2 „ „ „ „ „	7- 2	
14	2 „ „ „ „ „	7- 2	
25	2 „ Christ Weeping D. Imp	6- 0	
Sep. 4	3 „ Portrait ½ D.E. Ind.	5- 3	
	2 „ „ „ Pln.	2- 2	
Oct. 1	3 Miss Peel D.E. Ind.	11- 6	
	3 „ „ ½ D.E. „	11- 3	
8	2 „ „ Sht. Col.	7- 8	
14	25 J. Rackdall Ind.	2- 3- 8	
Nov. 21	2 „ Miss Peel	7- 8	
		£9- 6- 0	
1847			
Aug. 13	By Cash		6- 7- 6
	Deductions		5- 4
	Cancelings		2-15- 2
			£9- 8- 0

1847			
Jan. 2	To 2 Pfs. Miss Peel Sht. Col.	4- 6	
	2 „ „ „ Ind. D.E.	7- 2	
7	1 Etching Dabber	5- 0	
20	2 Pfs. Miss Peel Col.	4- 6	
	1 „ „ „ Ind.	3- 7	
21	1 „ „ „ Ind.	7- 2	
	2 „ „ „ Pln. D.E.	4- 6	
		£1-16- 5	
	Carried forward		1-16- 5

MR. BROWN

1847		Dr.
Oct. 12	Trimming, cleaning, mounting, straining &c &c	
	The Red Sea	3- 0
	Belshazzar's Feast	3- 0
	The Deluge	3- 0
	Joshua Commanding the Sun &c	3- 0
	4 first rate pannelled strainers for the above	16- 0

MR. G.R. WARD

1849		
	(To straining)	
Novr. 2	1½ D.E. Lithograph	1- 0

Catalogue Number: 6
Item: Delivery Book
Dates: 20/7/1840 to 30/5/1846
Page Size: 5⅛″ by 5⅞″

Catalogue Number: 7
Item: Day Book
Dates: 16/12/1840 to 18/5/1844
Page Size: 7⅞″ by 12⅜″

Ross Letters

Addressed to: Presumably Dixon & Ross

Dated: July 16th. 1842, Southampton St., Strand.

(Enclosed inside back cover of Cat. 7)

Gentlemen,

When you send home the proofs of the "Hop Garden", on Monday, please to let me know what you would charge for Printing the Plate per Hundred, in the very best manner, for

<u>Cash on delivery</u> – I think of selling the Plate to an Art-Union, but they wish to know the price of the printing plain & India – I would find the paper, both plain & india, myself, therefore you will <u>only</u> send me the <u>price of the Printing.</u>

Yours Obedtly

James Bulcock [?]

(D & R's quotation represented by a note on the letter:
Plain 3.13.6
India 5.10.3)

XMS. ACCOUNTS 1840

Messrs. Nichols & Hollis	25- 6- 9
P & D Colnaghi	43- 9- 8
Mr. Keeble	5- 4- 2
Dickinson Bond Street	37- 9- 0
Mr. Banks	6- 8- 1½
„ Parry	11-18- 3
„ Dower	2-15- 0
Colnaghi & Puckle	86-13-10
Mr. Boys	105-19- 9
Mr. Grundy	58-11- 4
Mr. Moon	14- 0- 0
Hodgson & Graves	24- 5-11
Mr. Gardner Senr.	
Mr. Gardner Junr.	11-12- 6
Mr. H. Cousins	16- 9- 9
Mr. Hollis	
Mr. Scott	13-10- 1
Mr. Shade	1- 1- 6
Mr. Sawyer	
Welch & Gwynne	
Mr. J. Dixon	
Mr. Saml. Cousins	7-17- 5
Moore St. Martin's Lane	
Mr. Lupton	
Mr. George	6-18- 0
Mr. Wright	
Mr. Burgess	3- 2- 5

Wednesday 16 Decr. 1840

Mr. Simpson 2000 Cigar Labels blue	1- 0- 0
Paid Thisleton	3- 1- 9
Mr. Gardner 20 River Severn Gloucester Plate and 20 Shts. of Drawing Atlas	
Mr. Scott	10
L. Smith Cr. By ½ qr. of Dble. Elpht.	6- 6
8 qrs of Colbr. to complete the ream	13- 2- 8
Paid for Enamel Cds.	1- 6
Mr. Linnell 2 Prfs Bishop ½ D.E.	
„ 2 „ Copper plt. ¼ D.E.	1- 0
Colnaghi & Puckle 1 D.W.	
Moon 12 D.W. Strained	
Christ to Bill at two mos. from 18 Dec.	50- 0- 0
„ by Checks £47.10- 0 to Dist. 2-10-0	50- 0- 0

Wallis by renewal	9-13- 0
Paid Mr. Wright	9- 6- 0
Paid omnibus Linnell 1/- Stamp 2/8	3- 8

17th.

Mr. Jobson By splicing Plank	
Mr. Dower 2 Prfs. Lge London	
Paid for Turps	5
Mr. Hollis 2 Small ¼	8

18th.

Mr. Hollis 3 Prfs	1- 0
„ Scott 2 „	1- 0
Recd for Prfs	4

19th.

Mr. Cousins 38 D.W.	
„ Hollis 7	2- 4
12 Impressions Ly. ¼ Impl.	
Mr. Keeble 50 Enameld Cds. Carter	
150 Cards Stansfield	
Recd. of W. Ross for 1 Ream of Post	18- 0
Mr. Grundy 50 Lettered Pfs Rev Mr Slade	
30 „ on India	
Packing cases &c	

Wages		
	W. Ross	2- 7- 2
	C. Jordan	2- 5- 0
	Edward	
	J. Dixon	1- 4-11½
	James & Charles	1- 0- 9
	Henry	1- 2- 6
Paid for cord Turps &c		10½

Monday 23 October 1843

Mr. Boys 22 Bolton	
Mr. Drummond By Cash for Nelson	2- 3- 0
Paid Tps 5d. James cab 1/6	1-11

24th.

Mr. McInnes 3 Prfs Wellington ¼ D.E.	
1 Pln & 1 India Family Party	
Sht Col	
Mr. Puckle 20 B.L. India Bishop of Gloucester	
Mr. Bacon 2 „ „ „ „	
deld. to Mr. Gush	
Mr. Moore 2 Tom Moody) on our ½ D.E.	
2 Johnny Walker) Paper	4- 8
Recd. for Prfs.	1- 4

25th.

Mr. Moore 3 Prfs Johnny Walker (on our Pte Paper)	3- 6
Paid for omnibus 1/6	

26th.

Mr. H. Cousins 2 Ind Mr. Arkwright Folio	1- 8- 0
Mr. Boys 28 Bolton Abbey	

27th.

Mr. Moon 42 Key* to Sacrament

Mr. Jackson By Bill at 4 Months 30- 0- 0

 To Cash £24-0-8 Dist. 19/4 25- 0- 0

Messrs. Graves & Warmsley 40 Prfs.

 Mg. of the Chase

Mr. Cousins 2 Napoleon ½ D.E.

Messrs. Price Brothers Drs To Bill on Jackson

 Crs By Cheque £28-16-9

 [?] 2/6 Dis 1/ 0/9 30- 0- 0

[* i.e. the key plate identifying the individuals in the picture]

28th.

Horwood & Watkins 120 Sheets of India

Paid omnibus 1/- Lr. Shavings 1/- Tps 4½ Cds 9 3- 1½

Mr. Ward 26 Autograph Ind Mr. Jones

 40 „ Plain „

 50 Prints „

Mr. Burgess 2 Prfs Ladies ½ W.E.

Mr. Raimbach By Cash 2- 4- 0

Paid for Wax -/10 Cab 1/- 1-10

Wages W. Ross 14-10

 J. Dixon

 H. Dixon

 James Polis[hin]g 3/- 1- 0- 0

 Beadell 2- 6

Monday 30th. October 1843

Graves & Warmsley 6 Lettered Prfs Chase

 Morning of the

Mr. McInnes 2 Wellington ¼ D.E.

31st.

Mr. Moon 100 Key to Sacrament

Paid omnibus 1/6

1st. November

Mr. Cousins 3 Prfs Sir C Forbes

Mr. Scott 2 Prfs 8

Recd of Mr. Humphries for 3 Scott 4 very small 3- 0

Mr. Moore 1 Pf Sht Col Moody Earthed 1- 4

Mr. Raimbach 6 Pfs Portt A. Raimbach Ind.

 ¼ D.E.

 Sent to No. 8, Park Terrace, Greenwich

 by Con. Comp.y

2nd. November 1843

Paid for Press Oil 10

Paid omnibus 1/- Potasse 8d. 1- 8

Mr. Boys 46 Prints Bolton

 „ 26 „ Bp Butler

 & the Plate

Graves & Warmsley 2 Shts of B.A Paper

3rd.

Mr. H . Cousins 2 Pln Dr Bull

 1 Pln & 1 India Mr Arkwright

Mr. Grundy 8 B.L. India Mr Hick on Sht Imp!

 99 Lettered Pfs Pln

 52 Prints

 Packing Case & Pair of Boards

Paid The London & Westminster Bank 5- 0- 0

Recd of Mr. Humphries 2- 8

Paid for Bill Stamp 2/7½ Cord 3d Booking &c 6d 3- 4½

4th.

Mr. Carpenter 50 Sets of 9 Plts)

 Composition 1/11/6)

 112½ Sheets of Plate)

 Demy 0/16/11)

 -8- 5

 By Cash 2/3/6 Dist! 4/11 2- 8- 5

Graves & Warmsley 4 Prints Morning of the

Chase

Paid for Ocre 1/4 James Oms 6d. 1-10

Wages W.R.

 J.D. 16-11

 H.D. 3 Weeks 7-18-10

 James 17- 0

 Beadell 2- 6

Catalogue Number: 8

Item: Day Book

Dates: 20/5/1844 to 27/7/1848

Page Size: $7\frac{5}{8}$" by $12\frac{3}{8}$"

28 May 1844	Mr. H.G. Bohn	1 Pf. each of 300 Plts.
		Liber Veritatis ¼ Col.
15 Jun.	Mr. Bohn	Pfs. Liber Veritatis
19 Jul.	„	1 Set of 300 Plates Reynolds ¼ Col
		1 „ „ „ „ „ ⅛ „
8 Aug.	„	8 of 5 Plts. on Samples of Paper
10 Aug.	„	2 Portraits Sir Joshua
		2 Dido
22 Aug.	„	Cr. By 1 Rm. of Plate Columbier pft.
		from Grosvenor
24 Aug.	„	By 9 Rms. of Columbier Perfect
		from Grosvenor & Co.
27 Aug.	„	25 Plates Waste (?) 1 Pf. of each
		Reynolds
10 Sep.	„	To the Book Liber Veritatis
12 Sep.	„	By 1 Rm. 12 Quires pft. P. Col. for
		Reynolds and Claude. Grosvenor
		& Co.
13 Sep.	„	By Return of Vol. 1 & 2 of Claude
		Pfs.
22 Oct.	„	1 Copy of Vol. 3 Claude
4 Nov.	„	25 Sets of 300 Plates Claude
26 Nov.	„	22 Sets Claude Liber Veritatis
17 Dec.	„	200 Sets 9 Plates Phillips on Colour
27 Dec.	„	15 Sets Reynolds
8 Jan. 1845	„	Paid Mr. Bohn's man Xms. Box
		10- 0

31 Jan.	Mr. Bohn 2 Sets of Reynolds deld. to C (?)		
13 Feb.	„ 25 Earlom		
	25 Boydell		
25 Feb.	„ By Cheque	100- 0- 0	
17 Mar.	4 Sets Reynolds (counting Nativity)		
27 Mar.	„ 16 Sets Vol. 1, 2 & 3 (Reynolds)		
14 May	„ By Cheque	30. 0. 0	
15 May	„ 5 Sets of Claude		
	6 „ „ „ Vol. 3		
20 May	„ By 6 Reams Plate Col) Claude		
	11½ Quires „ „) Grosvenor		
	1½ „ „ „) & C.		
9 Jun.	„ By Cheque 39.11. 6)		
	Dist. 18.16. 6) 58. 8. 0		
20 May 1844	Mr. Simpson By this Book	0. 9. 0	
21	Mr. Burgess 1 Pf. Sir J. Moore ¼		
	Mr. Paine 6 Pfs. Lady Grosvenor		
	(Graves)		
	Recd. for Pf.	6	
22	Mr. Scollen 12 Ind. Duke de		
	Palmella	10. 0	
	The Antiquarian Society 500		
	Bp. of Salisbury	2.10. 0	
	5 qrs. of ½ sized Atlas	1.17. 6	
	Writing &c	7. 6	
23	Paid for Pots and [?]	7	
	Recd. of Carpenter	9. 6	
	Mr. Walter Cr. By Bill at 5 Months	20. 0. 0	
	Mr. Jackson „ „ „ „ 3 „	25. 0. 0	
	Price Bros. Drs. To the Above		
	Crs. By Cheque £38. 8. 0		
	Acct. 5. 1. 0		
	Dist. 1.11. 0	45. 0. 0	
	Mr. Jackson Dr. To Cash		
	19. 7. 9		
	Dist. 12. 3	20. 0. 0	
	Paid Oms. 1/6 Stamp 2/1		
	Mr. H. Cousins 1 Pln. & 3 Ind.		
	Wilbraham Sht. D.E.		
24	Mr. Gardner 6 Sets of 9 Plts World		
	25 Europe		
	Mr. Davey 1000 Letters 4to.		
	1000 Letters 4to.		
	500 Letters 8vo.		
	Paid for Soap; Oil & Turps	2. 0½	
	Mr. Atkinson 53 Mr. Chapman B.L.		
25	Bishop of Sodor & Man 12 Pfs. &		
	the Plate		
	Plate Mr. Bridgford	1. 6. 0	
	Cr. By Cash for the Above		
	Graves & Co, 44 Sutherland		
	Children		
	6 Ind. & 6 Pln. Ld. Aberdeen		
	½ Col.		
	Mr. Lamb		
	25 each Plt. Tippo Saib)		
	25 Sailors Return)		

25 French Squadron)	Included	
28 Whitbread 6 Fidelity)	in	
16 Tempest 25 D. York)	Account	
25 Lady & Dog 50 St. Vincent)	Settled	
49 Garrick Lge. Richard)		
36 Infanta to complete 100)		
Paid Peake 1/6 Turps 4½ Cab to		
Davey 1/-	2.10½	
Mr. McInnes 2 Pln. & 1 Ind. Officer		
Mr. Carpenter 1 Tracing	6	
Mr. Dower 1½ Sht. Pfs (Writing)	9	
Wages W. Ross	1. 3. 3	
H. Dixon	5. 3.11	
James	18. 6	
Backhouse	2. 2.10½	
Beadell	4. 0	
Messrs. P. & D. Colnaghi & Co. Drs.		
To		
Repairing, mounting &c. on F.		
Paper Fishery		
Cleaning, mounting &c. on F.		
Paper Magdalen		
Cleaning, mounting &c. on F.		
Paper St. Cecilia		

Catalogue Number: 9
Item: Day Book
Dates: 28/7/1848 to 6/3/1851
Page Size: 7⅞″ by 12⅝″

Ross Letters

Addressed to: Messrs. Dixon & Ross

Dated: Philadelphia. April 6 1851
(Enclosed inside front cover, Cat. 9)

Gentlemen,

Some months since you were pleased to send me quite a number of impressions from steel plates which you had at that time for sale — I keep the impressions as a memorandum and whenever an opportunity offers to dispose of any of them I shall apprise you of it. At the present time I think I could sell quite a number of the "Trial of Strafford" provided I could buy the plate for a reasonable sum say $250 — or perhaps I could arrange with you to furnish me the impressions from the Plate at a low rate say 50 to 100 copies at a time — will you please have the kindness to answer as early as you conveniently can ———— very much

oblige yours truly

John M. Butler

P.S. Name your <u>lowest</u> price as your price will determine whether I publish or not. Pictures do not bring high prices here as they do in England — I will just mention that I can

have "the Trial of Strafford" copied in mezzotint by a good artist here, for $500.

Address John M. Butler
 Plate Printer
 6th & Chestnut Street
 Philadelphia
 Pennsylvania
 U.S.

Ross Letters

Addressed to: John M. Butler, Plate Printer, Philadelphia

Dated: No date
(Enclosed inside front cover, Cat. 9)

Draft:

Dear Sir,

We have to acknowledge your offer for the plate of Strafford which we cannot accept our price being £100 for the same but if you can order 100 impressions at a time we can supply you at a very low price say 1/6 each or if you can go to 500 impressions 1/3 each which number may be divided among the plates of Pluck – Young Chief – and Strafford all at 1/3 but only in the event of your ordering 500 impressions. We can supply you with the large plates at a very low figure by your having 100 impressions of the undermentioned

Waiting for the Ferry	7/-
Frugal Meal	6/-
Spanish Monks	3/6
Nothing Venture	3/6
Cranmer	3/6
Passage of the Red Sea	3/6
Game Keepers Return	3/-
Homage to Art	3/-
Highland Hospitality	3/-

independent of these plates already named we have a great variety consisting of nearly one hundred subjects all of the best class of engravings after Frank Stone, Herring, Brooks, Sir [?] W.[?] Allen, Goodall &c &c and this mode of doing business might perhaps answer your purpose better than purchasing the plates.

It may be as well to state the prices mentioned are for immediate payment and you may depend on the paper and printing being of the best quality

We are your Ob. Servants

Dixon & Ross
4 St James Place
Hamstead Road London.

Monday 11 June 1849

Mr. Moss 1 Proof Miraculous Draft Sht. Col.	2- 5- 0	
Solitude	2- 5- 0	
Democritus	2- 5- 0	
St Bernardus	2- 5- 0	

Cascade	2- 5- 0	
John Howard	3-11- 0	
Catherine	3-10- 0	
Queen of Scots	3-10- 0	
Ascension	5- 0- 0	
Holy Family	1-10- 0	

Mr. S. Marks 25 each of 16 Plates Studies
 50 „ Before & After $\frac{1}{2}$ Col.
 35 „ Gin Lane & Beer Street $\frac{1}{2}$ Imp.
 35 „ Paul & Felix Midnight Conversation $\frac{1}{2}$ Imp.
 13 pair prints Charles & Strafford D Imp.
 25 Geneva $\frac{1}{2}$ DE 25 Johanna $\frac{1}{2}$ DE
 25 Baptism $\frac{1}{2}$ DE 25 Holy Family $\frac{1}{2}$ DE
 25 Richmond Park $\frac{1}{2}$ DE 25 Richmond $\frac{1}{2}$ DE
 25 Dunking $\frac{1}{2}$ Col. 25 Cards $\frac{1}{2}$ Col.
 50 Queen of Scots $\frac{1}{2}$ Col
 25 each 4 Plates Don Quixote
 25 Gypsies $\frac{1}{2}$ DE

Messrs. H. Graves & Co 7 Prints Society of Friends	
Mr. G. R. Ward 1 Partial Pf. Harewood	
„ „ „ Boiling out do.	
Paid for Turps, Lees &c. Om.	2- 6
Mr. Ryal 3 Ind Christening	
Paid paper & Envelopes 1/6 Ombs. 2/9	

12th June

Mr. Ward by Bill at 3 Ms. (us to pay £19-0-0)	46- 0- 0
4 „ (us to pay)	46- 0- 0
Mr. McInnes By Bill at 3 Ms (McInnes to pay)	10- 0- 0
Messrs. Graves Drs To the Above & Crs By one in exchange 5 Ms.	102- 0- 0
Messrs. Graves 10 Prints Stephenson	
21 „ Virgin	
Straining Proof Drovers	
Mr. S. Marks 1 Proof each of 10 Sporting Plates	
Paid for Turps., Muslin	11

13th. June

Mr. S. Marks 25 each of two plates Grouse Shooting $\frac{1}{2}$ Col.
 47 Mary Queen of Scots $\frac{1}{2}$ Col.
 45 Boors Dunking $\frac{1}{2}$ Col.
 45 „ at Cards $\frac{1}{2}$ Col.
 25 Landscape $\frac{1}{2}$ Impl.
 25 do $\frac{1}{2}$ Impl.
 25 each 4 Landscapes $\frac{1}{2}$ Col.
 25 Cottages & 25 Jocund Peasants $\frac{1}{2}$ DE
 25 Faggott Binders Sht Impl.

Messrs. Graves & Co. 20 Ind. AP Autograph Stephenson	
15 Prints do	
2 Cartoons removing stains	4- 0
Mr. S. Marks 10 Pair of Ind Charles & Strafford (from Jones)	
Mr. Fuller 4 dry Proofs Calculator (our paper)	12- 0
Mr. Atkinson 1 Proof Taking the Veil	
Mr. Laird 300 Sheets of Impl. 64 DE 45 Columbier from Lepage Smith	

Messrs. Smith & Weedon By Columbier 10-16- 8
Messrs. Lepard Smith & Co. ½Rm. of Plate DE 7- 0- 0
Mr. Laird by 12 Umberrellas 1-10- 0

14th. June
Messrs. Graves 16 Prints Stephenson
 25 Ind. Lettered Proofs Do
Mr. Fuller 2 Pfs Calculator mounting dry paper
 on leather 8- 0
Mr. J. R. Jackson To 2 Pfs Sir Joshua ½ DE
 ,, Straining one
Mr. Atkinson To Boiling out Oxford
 ,, 1 Pf Ind. do. Sht. Imp.
Messrs. Grosvenor Chater & Co By 100 Sht. P. DE.
 1 Rm. Col.
 ½ ,, Imp.
Messrs. Spalding & Co. ½ Rm.
 5
 10¼
Mr. David Marks By Bill at 3 Ms. for
 G. Pensioners 42- 2- 0
Messrs. Graves Drs to the Above and Crs By one
 in Exchange
Messrs. Warmsley & Burt Drs to the Above
 Crs By Cheque 40-11- 6 Dist 1-8-6 42- 0- 0
Messrs. Grosvenor Chater To Bill on Graves 102- 0- 0
Crs by Greenwich Pensioners 40- 0-0
Discount 2- 7-0
Cheque 59-13-0 102- 0- 0
Mr. McInnes Dr. To Cash 5- 0- 0
Stamp & Interest 4- 6
Account 4-15- 6 10- 0- 0
Mr. Ward To Cash 6-10- 0 Dist &c. 10/- 7- 0- 0
Paid the Bill on Ward 47- 0- 0
Bill Stamps 14/8 Cab 1/6 Cab. Omns Walter 2/3

15th. June
Messrs. Graves 19 Prints Stephenson
 12 B.L. India Knox
Mr. Padgett to Charles & Strafford Ind. Proofs in
 Maple Frames 5- 0- 0
Mr. S. Marks By the Two Proofs C & S 1- 6- 0
Mr. Finden 18 Proofs Plays on ¼ Col.
 2 Tracings
Mr. Jackson 17 Holmon inclug 2 to Mr. H. & F.
 Graves
Recd. for Proofs 1-10
Paid for Canvass 12/6 A. Ross 2/- Cord 6d.
George Griffith By Box for Mr. Herbert 1-17- 0
Paid G. Griffith on Acct 1- 0- 0
Mr. Herbert To 50 A.P. Ind. Alarm Bell
 7 do for Mr. J.R. Herbert
 Box for the Proofs 1-17- 0
 ,, ,, By Cash on Account 20- 0- 0

16th. June
Messrs. Nesbett 200 Ind. Proofs) Portrait of a Lady
 100 Plain) Engr. by Mr. Finden

Mr. McInnes 1 Proof Portrait
Mr. S. Marks By Bill at 6 Ms. on Mr. Morrison for
 the 20 pair of Charles & Strafford deld 6th. 20- 0- 0
Paid for Turps 5d. Bill Stamp 2/1
Messrs. P. & D. Colnaghi 12 Proofs Earl Fitzwilliam
 ½ Col.
Mr. Sweet To Cash 2- 0- 0
Mr. Stackpool To 1 Pf. Weighing the Deer D. Imp.
Messrs. Graves 2 India B.L. Knox
 6 Prints Stephenson
Paid for Carting &c. 1- 9- 0
George Griffiths balance for Box 17- 0
Mr. Arnett Engraving Mr. Hopton's 6d. Plate 8- 0
Mr. Finden 2 Proofs ¼ Col.

[one or two indecipherable entries follow]

Wages W. Ross
 H. Dixon
 Wilden 2-18- 5
 Albany 2- 0-11
 Thomas 2/6 extra 12- 6
 Chapman 1- 5- 0
 Hilliard 2- 5- 7
 Green 1- 1- 0
 Walter 5- 6

Saturday 9th. Feb. 1850
Wages W. Ross 5- 1- 1½
 H. Dixon
 Chapman 3-11- 1½
 Wildin 4- 9- 1½
 Knight 2-13- 9
 Taylor 2-17- 9
 Albany
 Danford 2-17- 7
 Clarke 2- 9- 6
 Roberts 1-17-11
 Thomas 1- 9- 2
 Green 1-10- 0
 A.R. 6- 0
 Walter 7- 6
 John 6- 6

Catalogue Number: 10
Item: Ledger
Dates: 1849 to 1854
Page Size: 9½" × 14½"

Ross Letters

Addressed to: Messrs. Dixon & Ross, London

Dated: Great Yarmouth, 6 April, 1857
(Enclosed Cat. No. 10)

Dear Sirs,

Before I refer you to the annexed statement I must make a
remark or two on the subject of your last letter.

My relative Mr. Marsh had it is true been in communication with Mr. Wallis about the purchase of the Plate & was offered £200 for it & which I believe he had agreed to take if it were paid for <u>cash:</u> But as a long <u>acceptance</u> was offered instead – it was <u>altogether</u> rejected. Then came your <u>direct</u> offer of £250 with Bills at 3 & 5 months which was accepted – by no means an unreasonable price, considering the state of the money market had I been in a position to require their being discounted & you expressed yourselves well satisfied with the bargain & my liberality. So far you will admit that there was everything on my part perfectly straight forward. Now as to Mr. Somers [?]. That gent.ⁿ came over to Yarm.ᵗ, as he alleged – purposely to see me. He told me that he had given you £330 for the Scoffers Plate & Stock (or after that rate [?] for a part as a joint speculation I forget which) & begged that I tell him in confidence whether those were the terms on which they had been purchased of me, as <u>you</u> had given him the assurance was the case. Of course, not knowing anything about Mr. Somers' [?] veracity I supposed it <u>possible</u> that this was a mere "feeler" on his part & in fact that he wanted to get at information which I had no authority to divulge. I therefore begged to be excused for my silence as to my transaction with you as I could recognize no right to intermeddle with any bargain which had ———— [?] you and himself. I finished up by saying do not seek to destroy your confidence in Messrs. Dixon & Ross; I entertain a high opinion of their being very honourable men & would not be guilty of an act of injustice to you or any one – therefore return to London with that impression and be well satisfied if your speculation turns out to your profit. His answer was – "well I think you are right & I shall adopt your advice".

With regard to the account between us I & Mr. Marsh have had a long discussion & according to our recollection of the bargain entered into it was that you were to have 4/- each including paper for Proofs on India paper & 2/6 each for prints, but to be on the sure side I have calculated the latter at 3/- each & have further added the sum of £5 to make "assurance doubly sure". I have however made a deduction of 5/- for half a crown charged by the Bankers for presenting each Bill at your domicile for payment. The result therefore is £33. 7. 0. balanced in your favour for which I enclose you a check trusting that this settlement may be satisfactory to you & with much esteem

I remain Dear Sirs

Yours very truly

William Yetts

Impressions

	£ s d
423 on India paper @ 4/-	84.12. 0
155 Plain @ 3/-	23. 5. 0
Plate Cleaning	15. 0
Allowance gratuitously	5. 0. 0
	113.12. 0

Checks remitted £30, £30 & £20 – £80
Bank charges on 2 Bills 5/- 80. 5. 0

33. 7. 0

Check 6 Apl. 1857 33. 7. 0

Catalogue Number: 11
Item: Work Book
Dates: 12/1/1850 to 10/2/1853 then 23/2/1863 to 27/4/68
Page Size: 7⅝" by 12⅝"

a. **Friday Jan. 21, 1853**
T. Ross	10 Virgin and Child 8 India Scoffers
W. Ross	15 Soldiers Dream
Wilden	12 Autumn 20 Small Strafford
Chapman	25 Haredale
Pomeroy	50 Evening
Knight	25 Gamekeepers Return

b. **Thursday Feb. 23, 1863**
W.B. Ross	18 Farm Yard
H. Dixon Senr.	22 India Small Windsor Castle
T. Ross Junr.	25 Prints Drovers
T. Wilden	21 Tribunal of the Inquisition
A. Knight	26 Young Prince 10 Expected Penny
E. Oates	4 India Drover 7 Milton Composing
H. Dixon Junr.	10 India Bethlehem

Friday Feb. 24, 1863
W.B. Ross	18 Farm Yard
T. Ross Junr.	20 Prints Drovers
T. Wilden	17 Tribunal of the Inquisition
A. Knight	37 Expected Penny
H. Oates	10 Milton Composing
H. Dixon Junr.	10 India Bethelhem

Saturday Feb. 25, 1863
W.B. Ross	15 Farm Yard
H. Dixon Senr.	28 India Small Windsor Castle
T. Ross Junr.	18 Prints Drovers
Pomeroy	13 India Tay
T. Wilden	19 Citation of Wycliffe
A. Knight	23 Napoleon at the Battle of the Pyramids
H. Dixon Junr.	10 India Bethlehem
E. Oates	14 Highland Bride

Catalogue Number: 12
Item: Day Book
Dates: 8/5/1851 to 22/4/1854
Page Size: 7⅞" by 12⅝"

Monday 9 May 1853
Mr. Cousins 66 India Peter Barlow inclug 12 to W. Saunders
„ 32 Pln Do.

10th. May

Mr. D. Marks 27 Chip 12 Dying Camel
 12 Israelites 6 Hearts Resolve
Mr. Plympton 2 Bolton Abbey
Paid for Cab 1/6 Oms. 1/2 Canvass 1/17/0 1.19. 8
Paid Mr. Graves for D. Marks Ticket 1. 1. 0
Mess. Graves 1 India Etching Christ on the Mount

11th. May

Mr. Moss 25 Sets of 4 Plates Grand Stand &c. D.E.
Mr. Jackson 12 Sir T. Aubusey 19. 0
Mr. G.R. Ward To Boiling out Wiseman
 „ „ 3 Pfs. on Sht. Imp. do.
Recd. of Mr. Gregory for Mountain Daisy Lily
 .Wild Brier Spring Ruth & Boaz 14. 6
Mr. D. Marks. By above Sale. To Prints & Paper.
Mr. Huntingdon 25 Small Plate ¼ D.E.
 6 Portraits ½ Col.
 22 Hieroglyphics ½ D.E.
Mr. Samuels 1 Windsor Castle 1.11. 6
 1 Peace 2. 2. 0
 1 First of May 1. 1. 0
Paid for Glass 3/7 Wax

12th. May

Mr. S. Marks 3 Death of Nelson to Plympton
Mr. S. Jackson To Frame & Glass for Royal Children 17. 0
 Do. A.* of York
 Do. Small Duchess 11. 6
 Packing Case 8. 6
Paid for Turps 1. 2

Mr. A. Lucas To large Tracing 4. 0
Paid for Turps 1. 9

Mr. Hollyer 6 Last Supper
Mr. D. Marks 3 pair Dawn & Parting)
 2 „ Ruth & Rebecca) To Mr.
 21 Imperial Flowers) Hollyer
 3 R & White Rose)
Paid for Glass 2. 2
Mr. Davey 2 proofs Dog
Mr. D. Marks 15 Cross Purposes inc. 12 delid)
 „ 4 Pilgrims 7 Nothing Venture)
 „ 2 Dr. Johnson 4 Dawn)
 „ 4 Parting to Mr. Boys)
Mr. S. Marks 10 Slave Market 15 Game Keeper)
 12 Pair Charles & Strafford)
 8 Hospitality to Mr. Boys)

[* i.e.: Archbishop]

13th. May

Mr. D. Marks 8 India Alpine Guardians)
 „ 1 Out for a Day)
 „ 1 Morning Call)To Mr. ?
 „ 1 Patience 1 Watts)
 „ 1 Set of 10 Plates Small Flowers)

14th. May

Mr. D. Marks 21 Navarino & Cross Purposes
 „ 33 Hearts Resolve
 „ 14 Greenwich Pensioners
 „ 35 Soldiers Dream
 „ 16 Dying Camel
 „ 11 Diet of Spiers
 „ 13 Pilgrims
 „ 18 Ld. of the Manor
 „ 34 Nothing Venture
 „ 31 Out for a Day
 „ 34 Mother & Child
 „ 19 Village Recruits
 „ 30 Chip of the Block
 „ 27 Morning Call
 „ 27 Patience
Mr. S. Marks 12 Constant Friends
 „ 3 Love in a Tub
 „ To Mr. Blackwood

Due 16th. Sep. Mr. Gwynne By Bill at 4 Ms.
 Renewal 25. 4. 6
Mr. Plympton By Cash for 2 B.A. on the 16th 16. 0
Mr. Yetts 15 Prints Scoffers delid. on the 11th.
 To Herring & Co.

Mr. S. Marks 1 Red Sea 12 Slave Markets to S & I
Mr. D. Marks 1 Israelites to Somers & Isaacs
 19 Pensioners
Mess. Graves 4 Duck Shooting 10. 0
 4 Rabbit Do. 10. 0
 2 Partridge 7. 6

Mr. S. Marks By above Sale To print & paper

Paid for Wax 2/6 Oms. 10d.

George Ross To Cash 2. 0. 0
Spalding & Hodge By Cash 40. 0. 0
Mr. Cornford To Cash Stout &c 2. 0. 0

W. Ross	3.10. 0	H. Dixon	3. 5. 0		6.15. 0
Beadell	3. 7. 0	T.R. Junr.	1. 5. 9		4.12. 9
Wilden	2. 3. 0	Chapman	2.16. 0		4.19. 0
Knight & Murray					6. 2. 0
Braley	3. 3.10½	Crampton	1.10 0		4.13.10½
Curtis	1.15. 0	Delaney	1.13. 6		3. 8. 6
Danford	3. 7. 0	Pomeroy	2. 2. 0		5. 9. 0
Green	1.10. 0	Walter	8. 6		1.18. 6
Watson	10. 0	H. Ross 5/-	Yates 12/-		1. 7. 0
Simes	15. 0	Lynne	5. 6		1. 0. 6

 [In pencil: Henry 6/-]
Mr. David Marks By 3 Reams of Impl. 390 lb. at 11d.
 1 Ditto of Colr. from Blackwood 150 lb. at 11d.

Paid for Soap 6d. Turps 1/9 2. 3

Mess. Graves 2 Grouse 2 ?
 3 Chase
Mr. S. Marks By above Sale To Print & Paper

Mess. Grosvenor By Cheque 24.13. 8)
 Discount 8. 4) 25. 4. 0
 To Bill on Gwynne)

[Printed List pasted inside back cover. Prices handwritten.]

Trial of Charles the First	Fisk	7/6
Trial of the Earl of Strafford	,,	7/6
Ditto (Small)	,,	1/9
Cromwell Dissolving the Long Parliament	B. West	1/9
Slave Market of Constantinople	Allen	8/-
Members of the Agricultural Society	J.F. Herring(Sen.)	7/6
Friendly Meal	,,	7/6
Horses Drinking at the Fountain	,,	7/6
Passage of the Red Sea	Danby	4/6
Bishop Cranmer revoking his Recantation		4/-
Highland Hospitality	Lewis	3/6
Gamekeeper's Return	Sidney Cooper	3/6
Mountain Spring	Frederick Taylor	3/-
Lassie Herding Sheep	,, ,,	
Escape of Alaster McDonald	Mclan	1/9
Soliciting a Vote	Buss	1/9
Independent Voter	Hancock	1/9
Horse Feeder	Morland	1/6
Expected Meal	,,	1/6
Death of Nelson	B. West	1/9
Last Supper	,,	1/9
Grand Stand at Ascot (coloured)	J.F. Herring (Senr.)	6/-
Ditto at Doncaster (ditto)	,,	6/-
Going out of the Derby ,,	,,	6/-
Coming in of the Derby ,,	,,	6/-
Gipsey Party	Jones	1/-
Gipsey Warning	,,	1/-
Boyhood's Reverie	Lawrence	1/-
Childhood's Companion	,,	1/-
Love in a Tub	Wolstenholme	1/-
Constant Friends	Lucas	1/-
Expected Return	Middleton	1/-
Mary Queen of Scots	Fradelle	1/-
Braggart	Landseer	5/-
Faithful Guardian of the British Isle	Ansdel	4/-
Train up a Child in the Path he should Go	Bromley	1/6
Effects of Extravagance	Jones	1/6
Effects of Economy	,,	1/6
Looking In	Parker	3/-
Looking Out	,,	3/-
Rent Day	Wilkie	6/-
Blindman's Buff	,,	6/-
Reading of a Will	,,	6/-
Village Politicians	,,	6/-
Blind Fiddler	,,	6/-
Bolton Abbey in the Olden Time	Landseer	9/-
First Appeal	Frank Stone)	
Last Appeal	,,)	
Cromwell's Family interceding for the Life of Charles)	£1.1.0 the set

Charles's Last Moments)
Pet Lamb	Collins)
Sunday	,,)
Wesley's Escape from the Fire		6/-
Waiting for the Ferry Boat	Herring	7/-
Frugal Meal	,,	6/-
Hero and his Horse on the Field of Waterloo	Haydon	6/-
Fetching the Doctor	Collins	6/-
Wellington (full length)	Lilley P.B.L.	6/-
Sir Robert Peel ,,	,,	4/-
Attack	Hunt	1/3
Defeat	,,	1/3
Diffidence	Hannah	1/3
Confidence	,,	1/3
The Young Prince's First Ride	Taylor	1/9
Undine	Chalon	1/9
I've a Letter for You		1/6
Prince Albert (full length)		4/-
Wellington (From the Daguerreotype)		2/6
Pluck	Bateman	1/-
Knight of the Garter	,,	2/6
Dress Maker		1/-
Dress Wearer		1/-
Earl of Durham	Sir T. Lawrence	1/-
Soldier's Dream of Home	Goodhall	6/-
Lord of the Manor — Benevolence	Brooks	6/-
Famous Protest at the Diet of Spiers	Cattermole	6/-
Canterbury Pilgrims assembled at the Talbot, Southwark	Corbould	6/-
Cross Purposes	F. Stone	4/-
Dawn of Love	Brooks	3/6
First Parting	,,	3/6
Israelites' Departure from Egypt	Roberts	4/6
Opening of the Sixth Seal	Danby	4/6
Pandemonium	Martin	4/-
Satan in Council	,,	4/-
Eve of the Deluge	,,	3/6
Dr. Johnson Rescuing Goldsmith from his Landlady		3/6
Scene from the Early Life of Goldsmith		3/6
Successful Deer Stalkers		3/6
Distinguished Member of the Benevolent Society	Bateman	3/6
Nothing Venture Nothing Have	Bateman	3/6
Afternoon's Nap		3/6
Poor Teacher		3/-
Queen (full length)	Hayter	4/-
Queen	Aglio	1/9
Biter Bit	Bateman	1/9
Defiance	,,	2/6
My Chicken's for Sale	Corbould	1/9
Children with Flowers		1/9
Davis on Traverser		1/9



Long on Bertha		1/9
Chorister Boys	Barraud	6/-
Chorister Girls	,,	6/-
For Ever and Ever, Amen	Tomkins	5/-
Young Waltonian	Constable	1/-
Battle of Worcester		3/6
Homage to Art		3/6
Battle of Navarino		4/-
Greenwich Pensioners		3/6
1st. and 2nd. Royal Horse Guards		each 1/-
3rd. Royal Guards		1/-
Don Juan and Haidee, and Ali Pasha	Colin	1/9 each

Catalogue Number: 13
Item: Wages and Work Book
Dates: 16/4/1853 to 8/11/1856
Page Size: $6\frac{1}{2}''$ by $15\frac{3}{4}''$

14 May 1853

65 Ind. Mr.Barlow		2. 8. 9
24 Pln. ,,		12. 0
Proofs		4. 4
	H. Dixon	3. 5. 1
25 Rabbits India		10. 6
50 Partridge Pln. 50 Duck		1. 2. 6
50 Black Game 50 Chase		1. 2. 6
120 Small Retriever)		
120 ,, Dist. Member) 350 at 19/-		3. 6. 6
110 Wife & Dog)		
	Knight & Murray	6. 2. 0
65 Diet of Spiers		2. 5. 6
20 Christ Weeping		1. 4. 0
	W. Ross	3. 9. 6
50 Constant Friends		7. 6
25 each of 2 Plates Gipsey Party		7. 6
25 each Man & Spirit		7. 6
50 Reverie		7. 6
	Crampton	1.10. 0
30 Johnson 30 Goldsmith		1. 1. 0
50 Ind. Alpine Guardians		1. 1. 0
2 proofs E[?]		1. 0
	Wilden	2. 3. 0
50 Returning Home		11. 3
125 My Horse		1. 3. 9
	Curtis	1.15. 0



400 Monograms		6. 0
100 each 2 Plates Steeple Chase Moss		1. 0. 0
25 each 3 Plates Fox Hunts		7. 6
	Delaney	1.13. 6
20 Homage to Art		7. 0
50 Nothing Venture		17. 0
50 Dolly Varden		8. 9
50 Watts on Steam		8. 9
50 Israelites		1. 5. 0
	Danford	3. 7. 0
100 Deer Distinguished		1. 2. 6
50 Rabbits		11. 3
27 Red		13. 6
25 Dawn of Love		8. 9
	Chapman	2.16. 0
14 Aubery 34 Peter Barlow		1. 4. 0
35 Literary Party Ind.		1. 6. 3
16 Sanctuary		14. 5
2 Pfs. Guardians		2. 6
	Beadell	3. 7. 2
	Pomeroy	2. 2. 0
25 Pheasant 5/$7\frac{1}{2}$		
50 Grouse 11/3		16.10$\frac{1}{2}$
110 The Return		1. 4. 7
125 Smithy		1. 2. 6
	Braley	3. 3.11$\frac{1}{2}$
22 Slave Market		10. 0
22 Time of Peace		13. 9
2 Pfs. Etching G.E.		2. 0
	T. Ross Jun.	1. 5. 9
25 Watts on Steam 9 Diet of Spiers		
12 Lord of the Manor 6 Rent day		
12 Dolly & H[aredale]		
	Walter	

Catalogue Number: 14
Item: Ledger (E)
Dates: 4/2/1854 to 6/12/1861
Page Size: $9\frac{1}{4}''$ by $14\frac{3}{8}''$

1858 MESSRS. AGNEW & SON, MANCHESTER

4 Feb.	To 6 India Wg.* Proofs The Slide	2. 2. 0
	Estimate for Printing Plain 3/6 ea.	
	India 6/- „	
5 June	44 India A.P. The Slide W. Book at 6/-	13. 4. 0
	44 Sheets of Plate Paper at 1/4	2.18. 8
	Railway & Cabs to Mr. Webster & Mr.	
	Robert Graves	1.14. 0
	Workman's time in conveyance	12. 0
	To a Large Case for the Proofs with	
	Board & Screw Plates	1.19. 0
29	30 India A.P. Slide White Book	
	17 „ „ „ Dark „	
	12 „ delivered to Mr. Webster &	
	Mr. Robt. Graves	17.14. 0
	Cabs to Mr. Graves	10. 0
	Railway & Cabs to Mr. Webster	1.14.10
	Workman's time & to Mr. Webster	12. 0
	59 Sheets of Plate paper	3.18. 8
4 Aug.	2 Ind. A.P. Slide in Box To Manchester	14. 8
26	60 India A.P. Slide	18. 0. 0
	Cabs to R. Graves 8.0	
	Carriage & Railway to Mr. Webster 1.12.0	
	Workman's Time 12.0	2.12. 0
	60 Sheets of Plate Paper	4. 0. 0
30	By Bill at 3 Months	£72

£72. 5. 0

[* i.e.: Working Proofs]

1859 W.H. PHILLIPS R.A.

30 May	Estimate Col. Freer Plain £8.8.0. India £12.12.0.	
11 July	1 Ind. proof Col. Freer deld. To Order	
29	98 India Autograph Sir H.B.E. Freer	
	8 India Lettered To Colnaghi & Co.	
8 Aug.	50 India „	
12	20 Prints	
18	41 India	
	30 Prints	
	6 India Proofs To Mr. Cousins	
	Total on India 203 at 12.12.0	25.11. 6
	Plain 50 at 8. 8.0	4. 4. 0
	250 Sheets tissue	5. 0
	Engraving Artists Names Title &c	18. 0

£30.18. 6

Printed list pasted to page 304

[Handwritten heading: Sent to W. Samuels 18 April 1860.
Prices handwritten]

List of Engravings	Painters	Engravers	
Confidence	Hannah	Bellin)
Diffidence	Hannah	Bellin)
The White House	Edmondson	G.H. Phillips)
The Early Dawn	Christall	S. Cousins R.A.)	

Shakespeare before			
Lucy	Chisholme	J. Egan)
The Water Lily	Chalon	Robinson)
Rural Amusement	Sir T. Lawrence	J. Bromley)
The Scrub	Hunt	J. Egan)
Pluck	Bateman	Huffam)
Sterne and Grizette	Newton	George T. Doo)	
Mrs. Lister	Newton	S. Cousins R.A.)	
Guilt & Innocence	Herbert	J. Egan)
The Betrothed	Dabuffe	Coombs)
Friendship's offering	Drummond	Zobell)
Hide & Seek	Herbert	Simmonds) all at
The Pet Rabbit	Corbaux	S. Cousins R.A.) 9/- a	
The Attack	Hunt	C. Fox) dozen
The Defeat	Hunt	W. Finden)
The Deserted	Newton	Sangster)
Expected Penny	Frazer	Bell)
Prince's First Ride	Taylor*	J.W. Reynolds)
Disputed Fare	Holmes	J. Egan)
Letter for You	Bouvier	Huffam)
Proffer'd Kiss	Sir T. Lawrence	George T. Doo)	
The Rose	Parris	J. Egan)
Lily	Parris	Phillips)
The Waltonians	Constable	Phillips)
Fisherman on the)
Look Out	Collins	Phelps)
Blighted Hope	Parris	Bromley)
Sporting Dogs	Handes	Lemon)
Woman taken in)
Adultery	Rembrandt	Phillips)
Travelled Monkey	Sir E. Landseer	Huffam)

[* i.e.: Frederick Tayler]

List of Engravings	Painters	Engravers	s.d.
Greenwich			
Pensioners,			
Reading the			
Gazette of the			
Battle of			
Trafalgar	J. Burnett	J. Burnett	
Grand Canal Venice	C. Turner	Lucas	2/6
Corsair's Isle	C. Turner	D. Lucas	2/6
Momentous			
Question	Suchell	Bellin	2/6
Cottage Piety	Webster	G.H. Phillips	2/6
Spirit's Flight	Wehnert	Davis	5/0
Prince Albert, W.L.	John Lucas	S. Cousins &	
		Bellin	3/0
Gardner	Ansdell	J.G. Chant	6/0
Pilgrim Fathers	Lucy	Simmonds	6/0
Highland Bothy	F. Taylor	Scott	6/0
Highland Drovers	Sir E. Landseer	Davis	7/0
Crossing a Highland			
Loch	J. Thompson	C. Mottram	7/0
English Homestead	Herring	Paterson	7/0
English Farm Yard	Herring	Paterson	7/0

Bolton Abbey in Olden Times	Landseer	Davey	4/0
Bolton Abbey in Olden Times	„	Jackson	3/0
Poachers Bothy	„	C. Fox	2/6
Deer to Rise	„	J.H. Robinson	2/6
Get the Deer Home	„	Thomas Landseer	2/6
The City of Venice	Prout	Lequex	2/6
Trial of Strafford	Fisk	Scott	1/4
Cromwell Dissolving the Long Parliament	Sir B. West	G.T. Payne	1/6
Trial of Lord William Russell	Sir G. Hayter	J. Bromley	
The Last Return from Duty	Glasse	Faed	6/0
Hero and Horse	Haydon	Lupton	5/0
Rainbow	Constable	D. Lucas	6/0
Napoleon and Pope	Sir D. Wilkie	J.H. Robinson	5/0
Angels appearing to the Shepherds	Countness of Westmoreland	D. Sanders	2/6
Paphian Bowen	Martin	D. Lucas	3/6

Catalogue Number: 15
Item: Day Book (No. 8)
Dates: 22/4/1854 to 4/7/1857
Page Size: 7⅝" by 12⅝"

List of Prints ordered by Mr. D. Marks for despatch to America

Friday 9th. November 1855
Mr. D. Marks 25 Wd. Hound 6 Dying Camel 20 Chase
50 Feeding 25 Halt 40 Snap Apple
25 Duets 25 Pilgrims 100 Dreams
20 Lord of the Manor 100 Diet of Spiers
40 Joshua 40 Deluge 40 Dg. Angel
15 Pair of Herves 60 Baptism 60 Preaching
60 School 10 Vine Hounds 10 Ascot
10 Wife's Appeal 25 Israelites
12 Napoleon & Generals 10 Wellington at 82
10 How to Live 20 Deer Hounds 25 Burns
15 Ruth 15 Rebecca 20 Nothing Venture
30 Eve of Deluge 25 G. Pensioners
50 For Ever & Ever 20 W.Rose 50 Grip
20 Luna 25 Chip 25 Out for a Day
10 Homage to Art 10 Recruits 20 First Appeal
20 Last Appeal 25 Dawn of Love
25 First Parting 40 Drum Clog 25 Suspense
25 Bloodhound 300 Imperial Flowers
50 Courtesy 20 Dolly Varden 50 Plain &
50 India Holy Family 10 Poor Teacher
20 Don Juan 20 Ali Pacha 20 Tarantella
20 Children with Flowers 20 Vivandier

20 Reverie 20 (?) Enjoyment 20 Patience
20 Mg. Call 20 Maid of Athens 20 Herd Boy
20 Supplication 20 Maid of Mill
20 Meekness 20 Bracelet 240 ½ Col. Flowers
10 Marguerite 10 Ellen 20 Morning
20 Evening 15 Mt. Toilet 25 Irish Mother
25 Mother's Blessing 15 Nature's Delight

Three Large Cases lined with Tin £5.2.0

Catalogue Number: 16
Item: Wages Book
Dates: 25/10/1856 to 24/6/1865
Page Size: 4" by 12⅜"

15 Nov. 1856

Wages

W. Ross	4. 8. 0
H. Dixon	5.14. 2
Ross Junr.	6. 6. 0
Beadell	5.11. 4
Pomeroy	2. 5. 0
Watson	3.14. 6
Braley	6. 3. 5
Ross Senr.	1.19. 7½
Wilden	2.14. 6
Knight	3.10. 4
Chapman	2.15.11
Murray	3.13. 0
W. Braley	6. 4. 0
Hunt	1.18. 8
Claret	2. 3.10½
Henry N.W. [?]	1.10. 0
Campbell	18. 0
Greene	1.12. 0
Charles	15. 0
David	8. 0
John	7. 6
Edward Ill	6. 0
Gad & Kenn[?]	2. 3. 6
Beadell for Zinc lost in the Fire [?]	1. 6. 0
Green touching Bolton	5. 0
Chls David & John extra	3. 6

Catalogue Number: 17
Item: Wages and Work Book
Dates: 15/11/1856 to 11/10/1862
Page Size: 6⅛" by 15¾"

15 November 1856
124 India Streams

W. Braley	6. 4. 0

18	Charles	14. 4
70	Angels Whisper	2.16. 0
		————
	Knight	3.10. 4
		————
18	Slave Markets	14. 4
22	Cross Purposes	13. 4
32	First Appeal)	
30	Last „) 95	1.13. 3
16	Dawn)	
17	Parting)	
		————
		3. 0.11
	Paid	5. 0
		————
	Chapman	2.15.11
		————
434	Bibles	12.11
165	Ovals Mothers Blessing &c	1. 0. 5½
50	Wild Boar	10. 6
		————
	Claret	2. 3.10½
		————
55	India Streams	2.15. 0
25	Strafford Lge.	1. 0. 0
17	Coronation	15. 4
14	India Deer	1. 1. 0
		————
	Beadell	5.11. 4
		————
10	Naughty Dog	5. 0
2	Proofs Village School	2. 0
110	Sympathy	2.15. 0
25	Holy Watchers	12. 6
		————
	Watson	3.14. 6
		————
25	Woollsey	12. 6
10	Israelites	5. 0
8	Holy Watchers	4. 0
60	Contrabandists	1.10. 0
2	India and 1 Plain Proofs	3. 0
		————
	Wilden	2.14. 6
		————
266	Nisbets Bible Views	8. 0
50	Daisy 30 Lily of the Valley)	1. 7. 0
30	May Blossom 20 Songstress)	
12	Rose of England	1.10
12	Camilla	1. 7
		————
	Hunt	1.18. 8
		————
10	Brute of a Husband	4. 0
10	Do India	6. 0
19	Juliet „ Col.	10. 0
75	Bloom of Heather) 115	1. 4. 0
40	Forest Flower)	

24	Israelites	12. 0
4	Proofs ½ D.E.	2. 0
50	Sterne & Grizette	15. 0
		————
	Murray	3.13. 0
		————
	Assistance	
		————
	Pomeroy	2. 5. 0
		————
40	Guilt & Innocence	1. 0. 0
34	Lge. Strafford)	3. 8. 0
51	Charles)	
		————
	W. Ross	4. 8. 0
		————
100	Beaming Eyes	2.10. 0
12	India Proofs Sermon	1. 4. 0
25	India Waite	15. 0
30	Ferry Boat	1. 4. 0
2	Proofs	1. 2
		————
	Henry Dixon	5.14. 2
		————
46	Angels Whisper (Graves)	2.16. 0
25	Ferry	1. 0. 0
50	Feeding	2.10. 0
		————
	Ross Junr.	6. 6. 0
		————
18	Strafford	14. 5
54	Chase	2.14. 0
30	Marriage	1. 7. 0
35	Whisper	1. 8. 0
		————
	Braley	6. 3. 5
		————
30	Spring	5. 3
10	Braggart	2. 0
30	Autumn 20 Spring	10. 6
50	W & R Rose	17. 6
25	Morning Call	4. 4½
		————
	Ross Senr.	1.19. 7½
		————

Catalogue Number: 18
Item: Day Book (9)
Dates: 4/7/1857 to 11/1/1862
Page Size: $7\frac{7}{8}''$ by $12\frac{3}{8}''$

Catalogue Number: 19
Item: Ledger (F)
Dates: 17/12/1858 to 11/6/1874
Page Size: $9\frac{1}{2}''$ by $14\frac{3}{8}''$

Catalogue Number: 20
Item: Delivery Book
Dates: 1/1/1861 to 25/8/1868
Page Size: $7\frac{7}{8}''$ by $12\frac{5}{8}''$

22 Sep. 1862	Mr. S. Cousins 3 Ind. Maid & Magpie						
24	Went to Mr. Cousins with 2 Maid & Magpie then took them to Mr. H. Graves						
25	Preparing for Maid & Magpie						
26	Messrs. H.J. Graves & Co.						
	9 Ind. A.P. Maid & Magpie						11
27	8	„	„	„	„	„	19
29	8	„	„	„	„	„	27
30	8	„	„	„	„	„	35
2 Oct.	11	„	„	„	„	„	46
3	11	„	„	„	„	„	57
4	11	„	„	„	„	„	68
6	7	„	„	„	„	„ Plate to Mr. Cousins	75
7	8	„	„	„	„	„ Plate from Mr. C.	83
8	10	„	„	„	„	„	93
9	8	„	„	„	„	„	101
10	11	„	„	„	„	„	112
11	10	„	„	„	„	„	122
13	9	„	„	„	„	„	131
14	12	„	„	„	„	„	143
15	8	„	„	„	„	„ Plate to Mr. Cousins	151
16						Prepared papers for Maid & Magpie Plate from Mr. C.	
17							
18	10	„	„	„	„	„	161
20	10	„	„	„	„	„	171
21	11	„	„	„	„	„	182
22	10	„	„	„	„	„	192
23	11	„	„	„	„	„	203
24	11	„	„	„	„	„	214
25	9	„	„	„	„	„	223
27	10	„	„	„	„	„	233
28	10	„	„	„	„	„	243
29	11	„	„	„	„	„	254
30	10	„ •	„	„	„	„	264
31	10	„	„	„	„	„	274
1 Nov.	10	„	„	„	„	„	274
3	9	„	„	„	„	„	284
4	11	„	„	„	„	„	293
5	10	„	„	„	„	„	304
6	10	„	„	„	„	„	324
7	11	„	„	„	„	„	335
8	8	„	„	„	„	„	343
10	5	„	„	„	„	„	348
11	9	„	„	„	„	„	357
12	9	„	„	„	„	„ Plate to Mr. Cousins	366

13) (Cousins	
14) working	
15) on plate)	
17	7	„	„	„	„	„	373
18 Nov. 1862	11	„	„	„	„	„	384
19	9	„	„	„	„	„	393
20	10	„	„	„	„	„	403
21	10	„	„	„	„	„	413
22	9	„	„	„	„	„	422
24	7	„	„	„	„	„	429
25	9	„	„	„	„	„	438
26	10	„	„	„	„	„	448
27	9	„	„	„	„	„	457
28	9	„	„	„	„	„	466
29	9	„	„	„	„	„	475
1 Dec.	8	„	„	„	„	„ Plt. to Mr.	483
3	10	„	„	„	„	„ Cousins	493
4	6	„	„	„	„	„	499
	2 Plain						
5	11	„					13
6	8	„					21
8	9	„					30
9	10	„					40
10	9	„					49
11	11	„					60
12	11	„					71
13	10	„					81
15	9	„					90
16	11	„					101
17	12	„					113
18	11	„					124
19	10	„		Plate to Mr. Cousins		134	
29	2 Ind. A.P. Plate [from?] Mr. Cousins						501
30	7	„	„	„	„	„	508
31	4	„	„	„	„	„	512
	6 Plain					140	
1 Jan. 1863	1	„				141	
	8 Ind. A.P. Maid & Magpie						520
2	10	„	„	„	„		530
	1 Plain					142	
	9 Ind. A.P.	„	„	„			539
5	9	„	„	„	„	„	548
6	9	„	„	„	„	„	557
7	11	„	„	„	„	„	568
8	10	„	„	„	„	„	578
9	9	„	„	„	„	„	587
10	8	„	„	„	„	„	595
14	7	„	„	„	„	„	602
15	9	„	„	„	„	„	611
16	8	„	„	„	„	„	620
17	8	„	„	„	„	„	628
20	6	„	„	„	„	„	634
21	10	„	..	„	„	„	644
22	10	„	„	„	„	„	654
26	8	„	„	„	„	„	662
27	10	„	„	„	„	„	672
28	9	„	„	„	„	„	681
29	9	„	„	„	„	„	690

30	10 „ „ „ „ „		700
31	7 „ „ „ „ „		707
	2 Plain	144	
2 Feb.	9 Ind. A.P. Maid & Magpie		716
3	8 „ „ „ „ „		724
	2 Plain	146	
4	5 „	151	
	4 Ind. A.P. „ „ „		728
5	10 „ „ „ „ „		738
6	9 „ „ „ „ „		747
7	6 „ „ „ „ „		753
9	1 Plain	152	
	6 Ind. A.P. „ „ „		759
10	9 „ „ „ „ „		768
11	8 „ „ „ „ „		776
12	6 „ „ „ „ „		782
	Mr. S. Cousins 2 Ind.		
13	9 „ „ „ „ „		791
14	7 „ „ „ „ „		798
17	2 B.L. Ind. Maid & Magpie		2
18	7 „ „ „ „ „		9
19	9 „ „ „ „ „		18
20	3 „ „ „ „ „		21
	3 Plain B.L.	3	
21	10 „ „ „		13

[etc.: entries continue until 17/12/1863]

28 Feb. 1861	J.R. Jackson – Press altered
4 Mar.	Correcting Press
1 Apr.	Wimbledon Common Volunteers
21 Jun.	Harry's second son born
13 Jul.	The Review Wimbledon
17 Jul.	Chelsea – The Colourer Bayfield
24 Jul.	Dixon going to Scotland
26 Aug.	Junior killed
14 Sep.	Pomeroy, Dixon at the International
17 Sep.	Mr. Pomeroy Crystal Palace
14 Dec.	Photograph R[oyal] H[orticultural] Gardens and the Great Exhibition
25 Jan. 1862	Grand Exhibition with Harry, William & Harry
17 Mar.	Visited Mr. Bayfield respecting Printing in colours of Mr. Graves Derby Day & Exhibition
24 Apr. 1863	Curing Red Harry's press of Laddering
27 Apr.	Improving the Press
9 Apr. 1864	Dixon to Islington New Drill Ground
23 Apr.	Pomeroy Shepperton Dixon preparing
30 Apr.	Pomeroy Shepperton Dixon Drill
7 May	Pomeroy Shepperton Dixon Drill
14 May	Pomeroy Shepperton Dixon Drill
2 Jul.	Dinner after being almost drowned at Hampton
16 Jul.	Dixon with Red Harry off for Ireland
30 Jul.	Dixon with Red Harry from Ireland
29 Nov.	Dixon's 62nd. Birth Day
26 Aug. 1865	Dixon going to Dublin
15 Mar. 1866	Pomeroy at Home Dixon in bed Coughing

24 Mar.	Dixon ready but Pomeroy Ill
2 Apr.	Volunteer Review Brighton
25 May	Cradle to the University
1 Jun.	Cradle to Mr. Healy
30 Jul.	Come from Shepperton and buried Quarter Master Serjeant Newenham
21 Sep.	Dixon at the Scrubs
26 Feb. 1867	Lions Nelson Column
29 Jul.	Pomeroy at Home Dixon to Paris
23 Sep. 1868	Off for Dublin
4 Oct.	Back from Dublin

Catalogue Number: 21
Item: Day Book (10)
Dates: 11/1/1862 to 7/2/1867
Page Size: $7\frac{7}{8}$" by $12\frac{3}{4}$"

Mon. 16 June 1862

Messrs. Hy. Graves & Co. To 1 Pln. 2 Ind.
 Nativity & the Plate.
Mr. Plimpton To 12 Ind. B.L. Drovers
 12 „ A.P. Summer Time

Tues. 17

Messrs. Hy. Graves To 28 Prints Plough
Recd. for 2 Pts. of H.D. 1. 6
Mr. Tomkins To 3 Ind. First Step D.E.
Paid for Flour -/6 Oms.

Weds. 18

Paid Oms. Chant -/8
Mr. S. Marks By Cash 2. 8. 1
 To 3 pr. Marriage & Coronation
 2 pr. Charles & Strafford
 3 prints Ld. Russell
 1 Pair Queen & Albert
Mr. Revell By Return of 6 Prints Spirit's Flight
 To 6 pair Ind. Chls. & Strafford
 6 „ „ Marriage & Coronation
 6 Ind. Literary Party 3/6
Ross Junr. To our Acceptance on account) due 21 Nov.
 of Bill for £200 due 15 Nov.) 1862
 1861 105. 0. 0
 By Interest 5. 0. 0
Mr. Revell 50 Plain Stag at Bay

Thurs. 19

Paid for Oms. Tacks Paste Muslins &c. 1/-
Mr. J.R. Jackson To 2 Ind. Windsor Castle
Messrs. Graves 6 Grand Canal prints deld. 16 June
Mr. Dodson 6 Sets of Shootings
Paid Bill Stamps 4/2 Turps 2/5½ Oms. 1/8
Mr. Revell 50 pair India Dover & Hastings

Fri. 20

Mr. Plimpton 6 India A.P. Lock
 6 Ind. B.L. Summer Time
 6 Middle Bolton
 6 Sets of Shootings
Mr. Dodson 6 Sets of 6 Stalkings
Paid Om. Chant -/7

Mr. S. Marks To Prints	1. 0. 0	
By Cash	1. 0. 0	
Recd. of Whorley for 1 Drovers & 1 Bothy	9. 0	
Mr. Plimpton By above Sale		
Mr. Ross Junr. By our Acceptance	105. 0. 0	
Graves & Co. To the Above 105.0.0		
„ „ „ Bill on Jerrard 78.15.0		
„ „ „ By one in Exchange at 6 months	185.15. 0	
Spalding & Hodge To Bill on Graves		
By Cheque 178.16.3		
Discount 4.13.9	183.15. 0	
Ross Junr. To Discount 2.10.0		
Cheque 50. 0.0		
Do. 5. 0.0		
Do. 50. 0.0	107.10 0	
Recd. of Mr. Newbold for Prince Albert	4. 0	

Paid Oms. 1/4 Charles 6d. Soap 6d.
Colourer Stags 12/6

Sat. 21

Mr. Revell 50 pair Plain Dover & Hastings
Mr. Genese By Bill at 4 Months Jerrard 45.10. 0

Wages:

W. Ross 3. 4.6 H. Dixon 2. 0.0 Ross Jun.
Beadell 2. 0.0 Pomeroy 2. 5.0 Watson 5/- 4.10. 0
Ross Sen. 1. 6.2 H. Dixon Jun.1.19.4½ Knight 17/6 4. 3. 0½
Edward 1.10.0 Greene 1.12.0 John 15/6 4.12. 6

Mr. Tomkins By Bill on Graves, for discount 45. 0. 0

Catalogue Number: 22
Item: Wages and Work Book
Dates: 18/10/1862 to 20/6/1868
Page Size: $6\frac{1}{4}$" by $15\frac{3}{4}$"

18 October 1862

60	Farm Yard		2. 8. 0
		On. Acc.	1. 0. 0
			———
		W. Ross	3. 8. 0
75	Stag at Bay		3. 0. 0
			———
		Beadell	3. 0. 0
			———
10	Christ Blessing		12. 0
30	Ind. Bulls		2. 5. 0
	Adding Writing to 28 Plain Bulls		5. 4
			———
		H. Dixon Jun.	3. 2. 4
			———

30	India Highland Bride		———
		Watson	1.11. 6
50	Rent Day		———
		Wilden	17. 6
100	Smallest Bolton		———
		Knight	15. 0
100	Shootings		———
35	Stalkings		
			———
		Ross Sen.	1.17. 6
			———
		On Account	
			———
		H. Dixon	3. 0. 0
			———

25 April 1863

Henry Dixon's Account from 21 Dec. 1861

To:

33	India Hopes of the Future	1. 9. 6
21	Plain do.	14. 9
50	India Lord Save Me	3. 0. 0
14	Plain do.	11. 3
22	Light and Shade	11. 0
28	Ind. Cock Robin	9. 0
50	Plain do.	12. 6
16	Samuel	8. 0
8	India Dresden Flower Girl	6. 0
140	Plain do.	3.10. 0
285	India Plough	12.16. 6
300	Plain do.	10.10. 0
51	Albert	1. 5. 6
21	Home & Homeless Ind.	1.11. 6
47	„ „ „ Plain	2.16. 4
270	Fairy Tales	6.15. 0
158	Persuasion	5.18. 6
15	Temperance	10. 6
25	Pilgrim Fathers	1. 0. 0
190	India Senorita	7. 2. 6
105	Plain do.	2.12. 6
57	Charles & Strafford	2. 5. 7
100	Scotch Lassie	1.15. 0
12	Osbourne	6. 0
50	Ind. Harrowby	1.17. 6
266	Plain	6.13. 0
	Adding Writing to 132	11. 0
39	Parable of the Lilies	2. 6. 9
115	Ind. Wood Gatherers	5. 3. 6
122	Plain do.	4. 5. 4
12	India Saved	18. 0
66	Village Politicians	1. 3. 0

42	Bothy	1.13. 8
50	Ind. Hammersley	2. 5. 0
18	Ind. Brittany Cattle	1.17. 0
10	Plain do.	12. 0
25	Lord Gough	1. 0. 0
6	Ind. & 2 Plain Governess	10. 0
118	Prince Alfred	8.17. 0
200	Plain do.	10. 0. 0
23	Ayrshire Lass	13. 9
341	Plain & India Proofs	19. 7. 7
50	Ind. Christian Maiden	2. 1. 3
50	Plain do.	1. 7. 6
		141.10. 3

8 July 1865

30	Ind. Sir W. Joliffe	1.10. 0
57	Wood Gatherers 8 Plough	2. 5. 6
	H. Dixon	3.15: 6
75	Coronation	
	W. Ross	3. 0. 0
25	Deer to Rise	8. 9
150	Stalkings	1.10. 0
15	Gamekeeper	5. 3
		2. 4. 0
	Paid	12. 0
	Wilden	1.12. 0
	Assistance	
	Pomeroy	1.17. 6
50	Expected Penny 50 Guilt & Innocence	15. 0
40	Shipwreck Family	14. 0
	Knight	1. 9. 0
65	Spirits Flight	
	Braley	2. 5. 6
60	Farm Yard	
	David Green	
54	Gamekeepers Daughter	
24	India Summer	
2	Ind. Pfs. Lady Home	
	Edward	
100	Oval Horses	
	John	

Catalogue Number: 23
Item: Wages Book
Dates: 1/7/1865 to 21/5/1881
Page Size: 4″ by $12\frac{5}{8}$″

8 July 1865

W. Ross	3. 0. 0
H. Dixon	3.15. 6
Pomeroy	1.17. 6
Wilden	1.12. 0
Braley	2. 5. 6
Knight	1. 9. 0
Edward	2. 5. 0
John	1.15. 0
David	1.15. 0
Greene	1. 2. 0
William	1. 4. 0
Charles	1. 4. 0
Steers Painting	1.10. 0

Catalogue Number: 24
Item: Day Book
Dates: 8/2/1867 to 30/12/1871
Page Size: $9\frac{5}{8}$″ by $14\frac{3}{4}$″

Catalogue Number: 25
Item: Ledger (G)
Dates: From 14/2/1867
Page Size: $9\frac{5}{8}$″ by $14\frac{3}{4}$″

SAMUEL COUSINS R.A.

1882

7 July	1 Plain & 1 India Pomona	7. 0
19 „	3 India Proofs „	12. 0
18 Aug.	3 India Proofs „	12. 0
25 „	Tracing The Portrait	3. 0
23 „	3 India Pomona	12. 0
5 Sept.	1 Plain & 1 India Pomona	7. 0
14 „	1 „ Etching Portrait	2. 0
19 „	2 India „	6. 0
25 „	2 „ W.P.* Pomona	8. 0
24 Oct.	2 Plain Proofs Portrait	4. 0
1 Nov.	2 India „ „	6. 0
17 „	2 „ „ „	6. 0
24 „	2 „ Pomona Lettered Pf. Repair	8. 0
8 Dec.	A Tracing	3. 0
21 „	2 India Portrait	6. 0

[* i.e.: Working Proofs]

1883

22 Jan.	4 India Proofs The Portrait Samuel Cousins	12. 0
22 Feb.	2 „ „ Lady	4. 8
10 „	2 „ „ „	4. 8
10 Mar.	1 „ „ „	2. 4

22	„	2	„	„	Zeyra	4. 8
30	„	1	„	„	„	2. 4
18 Apr.	1	„	„	„		2. 4
24 May	3	„	„	„		7. 0
21 July	1	„	„	„	Retouch	2. 4
Dec.	Mounting Cherry Ripe & Pomona					8. 0

1884

9 May	1 India Proof The Portrait					3. 0
13	„	1	„	„	„	3. 0
19	„	1	„	„	„	3. 0
24	„	30	„	„	„ To F.A.S.	
26	„	10	„	„	„) both to Camden Sq.	
		4	„	„	„)	
27	„	60	„	„	„ To F.A.S.	
30	„	50	„	„	„ To F.A.S.	
4 Sept.	Cleaning & Remounting					
	Sutherland Children 5/6					
	Abercorn Children 5/6					
	Lady Gower 5/6					
	Miss Peel 5/6					
	Lady Acland 3/6					1 5. 0
	To Engraving Publication Line					
	to Portrait					7. 0

ESTIMATES

1882

19 July Rev. J. Brown St. Paul's Rectory Wokingham
for Printing Bishop of Oxford
Engraved by B.O. Stocks

100 Plain on Atlas Paper	10.10. 0	
100 India on „ „	15.15. 0	
100 Plain on Columbier	9. 9. 0	
100 India on „	13.13. 0	

Messrs. Leggatt for Cat & Dog Etchings

India pr. 100 including paper	10. 0. 0	
Plain „ „ „ „	6. 0. 0	

Messrs. Tooth & Sons
Pomona

India including India per 100	17.17. 0
D. Elpht.	3. 0. 0
Plain	10.10. 0
D. Elpht	3. 0. 0

Revd. W. Chevalier St. Peter's Rectory Winchester
Paper & Printing 2 Copper Etchings 7/- per 100

Field & Tuer Leadenhall Press
Printing Lady Smyth 3. 0. 0 per 100

1886

25 Oct. Mr. Martin Colnaghi
estimate for printing a Portrait
to be engraved by Atkinson, 25 per cent of this to
Mr. Colnaghi

India Grand Eagle	21. 0. 0	
Plain „ „	14. 0. 0	
India Columbier	16. 0. 0	

Plain „	12. 0. 0	
India Imperial	13. 0. 0	
Plain „	9. 0. 0	

1887

20 Oct. To S. Redrup Per 100
for Printing The Scramble
Plain Proofs on Impl. in No. 3 Brown Ink 5. 5. 0
for Printing Dogs of the Union
Plain Prints on ½ Impl. in No. 3 Brown Ink 3. 3. 0
on Hand made Tinted Paper paper included.

Catalogue Number: 26
Item: Wages and Work Book
Dates: 27/6/1868 to 20/7/1878
Page Size: $5\frac{1}{4}''$ by $12\frac{3}{8}''$

1 April 1871

	Boxes to Glasgow		1. 1. 3
	Rail to do.		1.13. 0
	Porter & Cab		2. 6
	Cab 2/- Greenock 3/- Stamps 2/2		
	Rope 6d Rail to Edinburgh 4/-		
	Boxes 2/1 Porters 2/- Hotel Glasgow 16/2		1.12. 4
	Hotel Edinburgh 17/5 Porters &c 2/4		
	Rail & Cab home 1.14.6		2.14. 5
	Boxes home 10/-		10. 0
	Packing 10/-		10. 0
		W. Ross	8. 3. 6
13	Ind. Marriage)		1.11. 3
13	„ Coronation)		
40	Pln. M & Coronation		1.12. 0
	Pfs. Mr. Atkinson		2. 0
		H. Dixon	3. 5. 3
60	Lucknow		
		Ross Jun.	3.12. 0
50 Penny 30 Mon 20 Spirit			
25 Whittington 25 Spinning Wheel			
25 Vicar of Wakefield			
		Knight	1. 6. 3
20 Mt. Spring 25 Lassie			9. 7½
225 Mounting Bibles			7.10½
25 Chase 25 Duck			10. 0
		Wilden	1. 7. 6
On Account			
		Edward	1. 0. 0

Catalogue Number: 27
Item: Bill Book
Dates: 23/9/1871 to 24/11/1879
Page Size: $5\frac{1}{4}''$ by $12\frac{5}{8}''$

1871		1871	
23 Sept.		**23 Sept.**	
Spalding & Hodge		Spalding & Hodge	
To Our Acceptance		By Cheque 146.1.0.	
due 26 Feb. 1872	150.0.0	Discount 3.19.0.	150.0.0
Mr. Graves To		Mr. Graves	
Spalding's Cheque	146.1.0	By Cheque	96.1.0
		Our Acceptance given for	
		Exchange due 26 Feb.	
		50.0.0	146.1.0
26 Sept.		**26 Sept.**	
Mr. James Hodge		Mr. James Hodge	
To Our Acceptance		By Cheque 125.13.6	
due 3 March 1872	130.0.0	By Discount	
		&c 4.6.6	130.0.0
Mr. James Hodge			
To Plates of			
Bolton Abbey			
Crossing the Tay			
as Security			
30 Sept.		**30 Sept.**	
Spalding		Spalding Cash 47.15.0	
To Bill Tomkin		Discount 1.0.0	
2 Feb.			
20.0.0.			
Jeffries 31 Dec.			
14.7.0			
31 Jan.			
14.7.0	48.15.0		48.15.0

Catalogue Number: 28
Item: Day Book
Dates: 1/1/1872 to 30/12/1881
Page Size: $7\frac{7}{8}''$ by $12\frac{5}{8}''$

20th April, 1872
The Society of Arts &c. Dr.
To 12 Sets of 16 Plates Barry's Etchings on Dble. Elepht.
To 12 „ „ 13 „ „ „ on $\frac{1}{2}$ „ „
Cleaning the Plates &c &c &c &c 43.10. 0

Mr. J. Chant To Tracing The Milk Maids Song.
Mr. S. Cousins To Trimg. & Mountg. A Sir Joshua on Impl.
 „ „ „ „ Mounting „ „ „ „
Mr. Mason To Cash for Colouring Martins &c. 4. 6. 6

Wages
W. Ross 2.0.0 H. Dixon 2.11.0 Ross Jun. 3.9.6

Wilden	1.8.0	Knight	16.0	Edward	2.4.0
David	2.0.0	John	2. 0.0	Charles	1.7.0

Mr Rees 1 Christ Blessing 6. 0

1st. March 1875
G. Richmond Esqr. R.A. Dr.

To Taking off of Yellow Drawing Paper 37
 Impressions Sir Joshua Reynolds's
 Washing Soaking &c. 85
 Mending, Cleaning, Lining 26
 Mounting 43 on Sheet D.E. (including Mrs. Siddons)
 Mounting 27 „ $\frac{1}{2}$ „ „
 4 Sheets of Plt. D.E. 15.0.0

21st. Oct. 1875
Messrs. J. Dickinson & Co. 1 India Montrose 8. 0

Mr. G. McQueen 1 Pr. Gamekeepers 8. 0

Mr. J. Richardson Jackson
 7 Ind. Mr. Blyth to Mr. Blyth 5 Clifton Place
 6 „ Miss Blyth 24 Hyde Park Gardens
 1 „ Mr. J.P. Carrie K. William St.
 1 „ Phillip Blyth 53 Wimpole St.
 1 „ Mrs. Green 25 Kensington Palace
 Gardens
 1 „ Alfred Blyth 38 Westbourne Terrace
 2 „ Mrs. Alex. W. Cobham 24 Hyde
 Park Gardens
 4 „ Mrs. Barton Schobell 24 H.P.G.

 making 23 of 26 sent to Mr. Jackson

Mr. Ovens
1 Summer 6/- 1 Bride 6/- 1 Rainbow 4/-)Cash
1 D. Member 4/- 1 G. Darling 3/-)
 1. 3. 0

Catalogue Number: 29
Item: Work Book
Dates: 1/1/1872 to 31/12/1874
Page Size: $5\frac{1}{8}''$ by $12\frac{3}{4}''$

[Record of the printing of the Plates of Barry's Etchings, delivered to the Society of Arts on 20 April 1872. See Cat. No. 28]

21 March 1872
Mr. Dixon 14 Barry's Etchings (Tartarus)

22
Mr. Dixon 4 Tartarus, 6 at Olympia, Barry's Etchings

23 & 25
Mr. Dixon 7 Olympia, 9 Jupiter & Juno, Barry's Etchings

26
Mr. Dixon 5 Jupiter & Juno. 13 C.J. Fox. (Barry's Etchings)

27
Mr. Dixon 12 Fall of Saturn (Barry's Etchings)

28
Mr. Dixon 6 Fall of Saturn, 7 Adam & Eve (Barry's Etchings)

30 March and 2 April
J. Oates 23 Barry's Etchings

3
Mr. Dixon 11 Barry's Etchings

4
Mr. Dixon 14 Barry's Etchings

5
J.E. Oates 2 Christ Weeping, 9 Barry's Etchings
Mr. Dixon 22 Barry's Etchings.

6
Mr. Dixon 11 Barry's Etchings

8
H. Dixon 41 Barry's Etchings ($\frac{1}{2}$ D.E.)
J.E. Oates 34 Barry's Etchings (,,)
Mr. Dixon 15 Barry's Etchings

9
H. Dixon 5 Russell, 16 Barry's Etchings ($\frac{1}{2}$ D.E.)
J.E. Oates 27 Barry's Etchings
Mr. Dixon 18 Barry's Etchings

10 April
J.E. Oates 19 Barry's Etchings ($\frac{1}{2}$ D.E.)
Mr. Dixon 17 Barry's Etchings

11
J.E. Oates 4 Day of His Wrath, 7 Barry's Etchings ($\frac{1}{2}$ D.E.)
Mr. Dixon 17 Barry's Etchings

12 and 13
Mr. Dixon 18 Barry's Etchings. 5 Prints Relayed for
 Mr. Cousins.

List pasted inside back cover:

Feby. 1st. 1873
Lucknows under the Boards

32 India
254 Plain

March 5th. 1873 24 Plain Left out
April 10th. 20 ,, ,, ,,
June 17th. 25 ,, ,, ,,
Sept. 10th. 13 ,, ,, ,,
Nov. 25th. 12 ,, ,, ,,
Dec. 22nd. 26 ,, ,, ,,
 ,, ,, 13 India ,, ,,

1874
March 5th. 53 Plain ,, ,,
April 30th. 30 ,, ,, ,,

Catalogue Number: 30
Item: Work and Wages Book
Dates: 27/7/1878 to 17/3/1883
Page Size: $5\frac{1}{4}''$ by 14''

Catalogue Number: 31
Item: Wages and Work Book
Dates: 28/5/1881 to 29/5/1886
Page Size: 4'' by $12\frac{5}{8}''$

10 May 1884

80 Hearts of Oak		1. 4. 0
	H. Dixon	
600 Linnean		10. 6
25 Dogs (Rees)		3. 9
	Kinsella	14. 3
130 Dorothy (prints)		3. 5. 0
8 Fascinating Tale		2. 0. 0
	Ross Jun.	5. 5. 0
On Account (Portrait)		3.10. 0
	John (Oates)	
On Account		2.10 0
	Edward (Oates)	

17 May

40 Shakespeare		1.12. 0
18 Hearts of Oak		4. 6
50 Horses D.E. Rees		15. 0
	H. Dixon	2.11. 6
40 Fascinating Tale		1. 0. 0
50 Farm Yard		2. 0. 0
35 Homestead		1. 8. 0
Pfs.		13. 0
		5. 1. 0
Account mountings		7.17. 1
deduct 2.10.0		
,, 2.10.0		
,, 10.0		5.10. 0
	Edward (Oates)	2. 7. 1

15	prints Milkman	9. 0
20	India Trophy	1. 0. 0
	Proofs	4. 3
130	Ind. Portraits Mr. Cousins	5.17. 0
		11

		7.11. 2
Pd. for last week		3.10. 0
John (Oates)		4. 1. 2

200	Linneans	3. 6
50	Hearts of Oak	15. 0

Kinsella	18. 6

Catalogue Number: 32
Item: Order Book/Work Book
Dates: 18/8/1881 to 11/1/1882 and 5/2/1883 to 2/9/1887
Page Size: $5\frac{1}{8}''$ by $12\frac{5}{8}''$

Thursday 8th. May 1884
T. Ross	40 Prints Dorothy
J.E. Oates	Remountings
J. Oates	15 India A.P. Mr. Cousins Portrait
H. Dixon	20 Hearts of Oak
J. Kinsella	200 McLachlans Plate 3.

9th.
T. Ross	7 Dorothy 17 A Fascinating Tail
J.E. Oates	Remounting
J. Oates	17 India A.P. Mr. Cousins Portrait
H. Dixon	17 Hearts of Oak
J. Kinsella	200 McLachlans Plate 4.

10th.
T. Ross	30 A Fascinating Tail
J.E. Oates	Remountings
J. Oates	12 India A.P. Mr. Cousins Portrait
H. Dixon	7 Hearts of Oak
J. Kinsella	McLachlan's Plate

12th.
T. Ross	12 A Fascinating Tail
	Proving Landaff, Godiva, Heathcote
J.E. Oates	Remounting & Proving 8.
J. Oates	16 India A.P. Mr. Cousins Portrait
H. Dixon	18 Hearts of Oak
J. Kinsella	200 McLachlan's Plate 1

13th.
T. Ross	40 Fascinating Tail
	Proof Hinda
J.E. Oates	Remountings
J. Oates	13 India A.P. Mr. Cousins Portrait

H. Dixon	6 Hearts of Oak
J. Kinsella	200 McLachlans Plate 2

14th.
T. Ross	16 Farmyard
	Proof Landaff
J.E. Oates	Remountings
J. Oates	18 India A.P. Mr. Cousins Portrait
H. Dixon	19 Shakespeare &c.
J. Kinsella	17 Hearts of Oak

15th. May 1884
T. Ross	17 Farmyard
J.E. Oates	Remounting
J. Oates	19 India A.P. Mr. Cousins Portrait
H. Dixon	21 Shakespeare &c.
J. Kinsella	12 Hearts of Oak

16th.
T. Ross	12 Farmyard 6 Homesteads
J.E. Oates	Remountings
J. Oates	15 India A.P. Mr. Cousins Portrait
H. Dixon	25 Robert the Devil
J. Kinsella	12 Hearts of Oak

17th.
T. Ross	11 Homesteads
J.E. Oates	Remountings
J. Oates	7 Ind. A.P. Mr. Cousins Portrait
H. Dixon	12 Isomony [?]
J. Kinsella	6 Hearts of Oak

19th.
T. Ross	12 Homesteads 9 Tay
J.E. Oates	Remounting
J. Oates	16 India A.P. Mr. Cousins Portrait
H. Dixon	7 Scott & Friends
J. Kinsella	12 Hearts of Oak

Catalogue Number: 33
Item: Day Book
Dates: 2/1/1882 to 11/2/1887
Page Size: $7\frac{7}{8}''$ by $12\frac{5}{8}''$

30th. Apr. 1884
Messrs. Dalziel Brs. By Cheque for various Pfs. £1. 0. 0

9th. May 1884
Mr. Cousins 1 India Proof The Portrait

13th.
Fine Art Society 30 Ind. A.P. Portrait of S. Cousins, R.A.
Mr. Cousins 1 Ind. Pf. Portrait (Mr. Cousins)

19th.
Mr. Cousins 1 Ind. Proof the Portrait

24th.

Mr. Cousins 30 Ind. A.P. Portrait to F.A.S.

26th.

Mr. Cousins 10 Ind. Pfs. Portrait Stampd) both to Camden
 ,, ,, 4 ,, ,, ,, unstampd) Square

27th.

Mr. Cousins 60 India A.P. Portrait to F.A.S.

30th.

Mr. Cousins 50 ,, ,, ,, ,, F.A.S.

10th. Nov. 1884

Fine Art Society 140 Sheets Double Elephant used for Mr. Cousins Portrait.

30th. Apr. 1886

Mr. Leggatt Mr. Cousins signature 2. 6

28th. Jun. 1886

Messrs. Graves Cleaning the Light of the World 4. 0

31st. Jan. 1887

Mr. Robinson 3 small proofs Photogravures
 on Whatman 4. 0
Mr. Leggatt To cleaning and remounting
62 Cheapside EC small Photogravures 1. 6

Notes to the Catalogue

Catalogue No. 1

P. 175 For an explanation of abbreviations see p.171 above.

G.R. Ward: i.e. George Raphael Ward (1798/1878/9), portraitist and mezzotint engraver, a regular exhibitor at the Royal Academy between 1821 and 1864. Resident at 38 Fitzroy Square at the time of this entry.

Moon: i.e. Francis Graham Moon, publisher and printseller. See p.22, above.

Boys: i.e. Thomas Boys, publisher and printseller. See p.xxiv, above.

P. 176 'Boards gd. aigle': i.e. boards of Grand Aigle paper size (40" by 27").

The work on the sign-board may have entailed adding the name of one of the partners in the newly-formed business.

'Shaving box': i.e. a box to contain shavings of leather for cleaning plates.

'Ross Senr.' was probably Thomas Ross, engraver and Frankfort black maker of 8 Giltspur Street. He was one of the firm's chief suppliers of ink, ink-dabbers and wiping-canvas.

P. 177 In 1976 a new bottom roller and its installation cost Thomas Ross & Son over £1,000, and the bill for dismantling and re-erecting a copper-plate press was £118.

Swanskin: i.e. the material for the thicker kind of blanket used on a copper-plate press. It is usual to use two thicker blankets and two finer, the latter known as 'fronting'. For a full discussion of blankets see Lumsden, E.S., *The Art of Etching*, re-printed London & New York, 1962, pp.92 ff.

'Altering a Press to 3 wheel motion': i.e. adding gears.

Muller was obviously an engraver of lettering, known at the time as a 'writing engraver'. The names and addresses of several such specialists appear in the Dixon & Ross records: for example, 'Mr. W. Downey, Writing Engraver, 38, Frederick Place' in Catalogue No. 1.

Catalogue No. 2

P. 178 'Mr. Linnell': i.e. John Linnell. See p.22, above.

'Bennison': i.e. Lawrence Benneson of Commerce St., Lord Street, Liverpool, for whom at this time Dixon & Ross were printing maps. A note of 1/9/1835 records the agreement to print for the client a '4 Sht. D. E. Map of Liverpool in the best style at £2 per hundred each Sheet.'. (Enclosed in Catalogue No. 1).

'Liq. Potasse': i.e. potash for cleaning plates.

Shade was a client residing at 95 Charlotte Street, Rathbone Place.

A 'Gardner Junr.' is listed in Catalogue Nos. 1 & 5. The printers supplied him with many impressions of maps and of railway subjects.

H. Wallis: i.e. Henry Wallis, engraver, of Warren St., Fitzroy Square.

The 'Bolton Abbey' entry probably refers to proofs of an early stage of Samuel Cousins's work on the plate engraved after Landseer's Royal Academy exhibit.

'Q' refers to one of the many engraved portraits of the newly crowned Queen Victoria.

'Village Recruits' is likely to refer to engravings of Wilkie's 'The Village Recruit'.

'Hawking': i.e. probably engravings after Landseer's 'Return from Hawking'.

'Sir. R. Peel': i.e. Cousins's engraving of Lawrence's 'Sir Robert Peel'.

'Abercorn Children' refers to engravings after the painting by Edwin Landseer.

'Mr. Sadd': i.e. H.S. Sadd, engraver, of 17 Great College Street, Camden Town.

'Mr Scott': i.e. probably James Scott, engraver, of 12 Gee Street, Clarendon Square and later of 8 Eden Grove, Holloway.

'Strained proofs': i.e. proofs stretched on a light wooden frame.

Catalogue No. 3

Pp.
179–
82

This list – a compilation of some of the very many entries in Catalogue No. 3 relating to the engraver – gives an idea not only of the sheer volume of business Samuel Cousins gave to the printers but also of the manifold enterprises simultaneously undertaken by him. In the two years from November 1838 to November 1840 there are in this Day Book nearly three hundred entries relating to Cousins. Five and a half thousand proofs were taken off for him in a single year.

Catalogue No. 4

Pp.
182–3

For a brief discussion of the printing of Henry Bohn's publication of *Liber Veritatis*. See p.16 above,

Catalogue No. 5

P. 183 'Confidence': i.e. one of a pair of subjects originally painted by Hannah. The companion was entitled 'Diffidence'.

P. 184 'Christ Weeping': i.e. Eastlake's 'Christ Weeping over Jerusalem', exhibited at the R.A. in 1841.

'Miss Peel': i.e. Lawrence's portrait, exhibited at the R.A. in 1828, of Julia, eldest daughter of Sir Robert Peel. Originally engraved by Cousins in 1833 and published by Moon, Boys & Graves.

Catalogue No. 6

Among the clients referred to in this Delivery Book are: Thomas Agnew; Henry Bohn; Thomas Boys; John Burnet; P. & D. Colnaghi; Colnaghi & Puckle; Samuel Cousins; Henry Cousins; Henry Graves; John Linnell; Francis Graham Moon; and George Raphael Ward.

Catalogue No. 7

P. 184 'Hop Garden' probably refers to William Frederick Witherington's 'The Youthful Queen of the Hop Garden'.

P. 185 'Dickinson': i.e. Joseph Dickenson, printseller and publisher, of 114 New Bond Street.

Parry: i.e. E. Parry, a client from Bridge Street, Chester.

Grundy: i.e. either John Clowes Grundy of Manchester or Robert Hindmarsh Grundy of Liverpool both printsellers and publishers. (See p.23, above).

Hollis: a client whose addresses appear in the records as 4 Gloucester Buildings, Walworth, and 16 Apollo Buildings, E. Walworth.

Scott: i.e. James Scott who, since small batches of proofs were supplied to him, seems to have been an engraver.

Lupton: i.e. probably Thomas Goff Lupton the engraver. (See p.20, above).

George: Catalogue No. 1 records that many proofs of 'The Language of Flowers' were supplied to a Mr. George.

Pp.
185–6

These transcripts indicate that such jobs as the printing of cigar labels and trade cards formed a not inconsiderable aspect of the firm's work.

'D. W.' refers to engravings of a portrait of the Duke of Wellington.

P. 186 'Sacrament': i.e. Baxter's 'The Queen Receiving the Sacrament at her Coronation'.

'Tom Moody' and 'Johnny Walker': sporting subjects.

The proofs of Abraham Raimbach's portrait were ordered by his son M.T.S. Raimbach who in the same year published the *Memoirs and Recollections of Abraham Raimbach*.

'B. A. Paper': i.e. paper for impressions of 'Bolton Abbey in the Olden Time'.

Catalogue No. 8

Pp.
186–7

Most of the entries refer to Bohn's publications of *Liber Veritatis* and *The Works of Sir Joshua Reynolds*.

P. 187 'Mr. Jackson': probably J. Richardson Jackson the engraver. (See p.23, above).

'Mr. Atkinson': i.e. Thomas Lewis Atkinson (1817–1889), the engraver. (See p.21, above).

'Sutherland Children' refers to the subject by Landseer.

Catalogue No. 9

P. 187 For further details of the correspondence see pp. 17, 68, 141 above.

P. 188 Mr. S. Marks: i.e. Solomon Marks, printseller, publisher and picture-frame maker.

P. 189 Messrs. Lepard Smith & Co.: i.e. the paper merchants (See pp.167, 169, above).

P. Messrs. Grosvenor Chater & Co.: i.e. the paper merchants. (See pp.167 ff. above).

Mr. David Marks: i.e. the printseller and publisher.

'Greenwich Pensioners' refers to the subject by John Burnet.

'Charles & Strafford' refers to the subjects 'Trial of Charles I' and 'Trial of Strafford' by William Fisk. (See p.29, above).

P. 'Mr. Finden': probably Edward Finden, the engraver. 'Alarm Bell' refers to the subject painted by J.R. Herbert, R.A. and engraved by F. Bromley.

'Mr. Stackpool': i.e. Frederick Stacpoole, A.R.A., the engraver. See p.23, above. His name and various

addresses as follows appear in the records: Upton Park, Slough (Cat. No. 9); 19 Eldon Grove, Kensington New Town; 10 Albert Terrace, Notting Hill; 10 Edith Villas, North End, Hammersmith (Cat. No. 15); 19 Eldon Road, Kensington (Cat. No. 21); etc.

'Weighing the Deer' refers to the subject by Frederick Tayler. It is not clear why Stacpoole was supplied with a proof in the summer of 1849 since T.L. Atkinson was probably working on the engraving of 'Weighing the Deer' at that very time. The two engravers did sometimes collaborate, however (see p.65, above). The engraving by Atkinson, published by Henry Graves & Co. and Thomas McLean was declared to the Printsellers' Association in October 1849.

Catalogue No. 10

Pp. 189–90 The writer is William Yetts of Yetts & Marsh, Great Yarmouth. The 'Somers' referred to was probably one of the partners in the firm of Somers & Isaacs, stationers and printsellers of 67 Houndsditch, London, regular clients of Dixon & Ross. The plate in question is that engraved by H.T. Ryall after the painting 'The Scoffers' by A. Rankley.

Catalogue No. 11

P. 190 The marginal 'a' and 'b' are simply to draw attention to the fact that the two groups of entries are transcribed from different parts of the Work Book.

'Haredale' is probably an abbreviation of 'Dolly Varden and Miss Haredale' painted by W.P. Frith and engraved by S.W. Reynolds.

'Gamekeeper's Return' refers to the subject by Abraham Cooper.

'Young Prince': i.e. 'The Young Prince's First Ride' painted by Frederick Tayler.

'Highland Bride': i.e. 'The Departure of the Highland Bride' painted by Jacob Thompson and engraved by J.T. Willmore, published by Leggatt, Hayward & Leggatt, 1 January 1857.

Catalogue No. 12

P. 191 'Boiling out': i.e. cleaning solidified ink from the plate with potash.

'Death of Nelson': i.e. the subject by Benjamin West, engraved by James Heath.

Mr. A. Lucas: i.e. Alfred Lucas, engraver, of 11 Milner Street, Chelsea.

'Hollyer': i.e. C. Hollyer, engraver.

Catalogue No. 14

P. 193 Entries refer to 'The Slide' by Thomas Webster, R.A., engraved by Robert Graves, A.R.A. 'White Book' and 'Dark Book' refer to motifs on the remarque proofs.

P. 194 'W.H. Phillips': probably Henry Wyndham Phillips (1820–1868) – despite the reversed initials – portraitist, of 8 George Street, Hanover Square. The portrait of Col. Freer was engraved by Samuel Cousins.

Catalogue No. 15

P. 195 Most of the titles in this entry are abbreviations. For example:

'Wd. Hound': i.e. Richard Ansdell's 'The Wounded Hound';

'Feeding': i.e. J.F. Herring's 'Feeding the Horse';

'Pilgrims': i.e. either Charles Lucy's 'Landing of the Pilgrim Fathers' or the same artist's 'Departure of the Pilgrim Fathers';

'Baptism': i.e. probably J.J. Jenkins's 'Ministration of Holy Baptism';

'Ruth': i.e. probably W.P. Frith's 'Ruth in the Field of Boaz';

'W. Rose': i.e. A. Bouvier's 'The White and Red Rose';

'Drum Clog': i.e. Harvey's 'Battle of Drumclog';

'Dolly Varden': i.e. probably W.P. Frith's 'Dolly Varden and Miss Haredale'.

Catalogue No. 16

This Wages Book overlaps Catalogue No. 15 (Wages & Work Book) by a week or two. The overlapping entries tally exactly, suggesting that Wage Books and Work Books (sometimes containing details of wages) were kept simultaneously. Not all those persons listed were necessarily regular employees. According to lists of names and addresses in Cat. No. 10 and Cat. No. 15, the man named Green who was paid 5/- for 'touching [the plate of] Bolton [Abbey]' seems to have been an engraver of 6 Camden Terrace, Camden Town. The names Monnington (a gas fitter according to a list in Cat. No. 1) and Hollyer (an engraver who, according to a list in Cat. No. 18 lived at 31 Tavistock Place, but for whom various other addresses are recorded) also appear occasionally on the lists in this Wages Book.

General conclusions may be drawn from this book as follows: there seems to have been much work and therefore large pay-rolls during the latter half of the 1850s, but things seemed to fall off during the first half of the 1860s. During the first 88 weeks covered by this book the highest number of wages was 26, the lowest 14 and the average 17.6. The highest weekly hand-out (to 29 individuals, £2.3.6d being given to 'Gad and Kenn' together, and 3/6d to 'Chls. David & John') was that recorded in this transcript – £68.16.10d (15 November 1856). By 1861 the number of wages barely reached double figures.

Catalogue No. 17

P. 196 'Angel's Whisper' refers to the subject by F. Goodall, R.A.

'Slave Markets' refers to Allen's 'The Slave Market'.

'Cross Purposes' refers to the subject by F. Stone.

'Coronation' may refer to Hayter's 'The Coronation Oath'.

'Naughty Dog' refers to the subject by Davis Cooper.

'Brute of a Husband' refers to the subject by H. Richter.

'Sterne & Grizette' refers to the subject by Newton.

'Beaming Eyes' refers to the subject by Charles Baxter.

'Chase' refers to one of a set of stalking pictures by Richard Ansdell.

Catalogue No. 20

Pp. The entries set out here are in fact interspersed with
197–8 many others relating to other jobs, but they have here been brought together so that the reader may follow without distraction the progress of work by the engraver and the printers on a single plate. The plate, still held by Thomas Ross & Sons, is relatively large, and it is evident from these entries that only about ten impressions could be made in a day. For references to the engraving and printing of 'The Maid and Magpie' see p.45, 143, above. ('A.P.': Artist's Proof; 'B.L.': Proof Before Letters).

P. 198 This Delivery Book is interesting in that for some inexplicable reason it contains much biographical detail, from which the transcripts on these pages are a selection. Entries show that Dixon was an enthusiastic part-time member of – or was at least associated in some way with – a volunteer regiment, and also that he was something of a traveller. The cradle referred to in the entries of 25 May and 1 June 1866 was a suspended device for minimising the discomfort of bed-ridden patients. A printed leaflet of 1865 (loose in the pages of Cat. No. 20) indicates that the Nightingale Cradle, as it was called, was invented by Thomas Dixon in 1856 and that 'models may be seen in the Court of Inventions at the Crystal Palace, Sydenham, and at the West London Industrial Classes, Floral Hall.'. The entry of 17 July 1861 refers to Bayfield, a colourer, of 14 Cadogan Street, Chelsea. The exhibition visited in December 1861 and January 1862 must have been the International Exhibition at South Kensington.

26 August 1861: it is not known who the unfortunate 'Junior' was – nor whether he was man or beast!

17 March 1862: it is not clear what is meant by 'Mr. Graves Derby Day', unless Bayfield was being consulted about the prospect of hand-colouring (rather than 'printing in colours') a batch of the engravings after Frith's 'Derby Day' published by Gambart in 1858. If 'printing in colours' was meant

literally, the entry becomes even more puzzling: it suggests that a completely new publishing venture was being contemplated by Graves, yet nothing of the kind is recorded in the *Alphabetical List* of the Printsellers' Association (1892).

24 April 1863: none of the copper-plate printers I have spoken to has come across the term 'laddering'. I can only guess that it refers to a zig-zag passage of the plank between the rollers.

The lions referred to on 26 February 1867 were, of course, Landseer's.

Catalogue No. 21

It is interesting that the entries in this book referring to 'The Maid and Magpie' are out of step with those in Cat. No. 20; and it is even more interesting to note that the contemporary Wages and Work Book (Cat. No. 22) records no printing of the plate during much of the time that the prints were being delivered to Graves. The only possible explanation for these apparent discrepancies seems to be that prints must have been made and stocked by the printer and that the publisher called for their delivery in small batches as needed.

This book contains a particularly full and interesting list of clients and collaborators: colourers (e.g. 'Bennett, colourer, 6, Providence St., South St., Walworth', and a note of 12 January 1865 to the effect that his charge for colouring 100 Fox Hunts was £1.10.0d); ground-layers (e.g. 'Mr. Bastin, Ground-layer, 25 Grafton Place, Euston Square'); and plate-cleaners (e.g. 'Farley, Plate Cleaner, 18 New Winchester St., Pentonville').

P. 198 'Ind. B. L. Drovers': i.e. a proof 'before letters', on india paper, of Landseer's subject 'Highland Drovers Departing for the South' (engraved by Herbert Davis and published by Dixon & Ross, 1859).

'H. D.': another abbreviation of the same title.

'Summer Time' probably refers to 'The Nearest Way in Summer Time' by T. Creswick and R. Ansdell, engraved by J.T. Willmore and published by Dixon & Ross, 1860.

'Paid Oms. Chant -/8' refers to an omnibus fare to the Camden Town address of J. Chant (the engraver of, for example, Hayter's 'Trial of Lord William Russell').

'Marriage & Coronation': i.e. Hayter's subjects 'The Marriage of the Queen' and 'The Coronation of the Queen'.

'Ld. Russell': i.e. Hayter's 'Trial of Lord William Russell'.

'Stag at Bay': i.e., of course, Landseer's subject. It had by this date been engraved in two sizes (large, by Thomas Landseer, published 1847; and small, by Charles Mottram, published 1852). This entry could refer to either, but probably the former, since this version was advertised in Dixon & Ross's 1871

catalogue. A medium-sized version of the subject was engraved by George Zobel and published in 1866.

'Sets of Shootings': i.e. sets of shooting subjects, probably by Richard Ansdell, many of whose works were advertised in the firm's 1871 catalogue.

P. 199 'Dover & Hastings' refers to the two subjects by J.M.W. Turner.

'Lock' probably refers to J. Thomson's 'Crossing a Highland Loch', engraved by Charles Mottram and published by Dixon & Ross in 1860.

'Middle Bolton': i.e. medium-sized version of 'Bolton Abbey in the Olden Time'.

'Stalkings': i.e. probably Ansdell's set of stalking subjects.

'Bothy' probably refers to F. Tayler's 'Highland Bothy'.

Genese was a printseller based at Paradise Street, Liverpool. There was also a Genese in Leicester Square, London.

'Tomkins': i.e. probably Charles Tomkins, engraver.

Catalogue No. 25

P. 200 'Pomona': i.e. the subject by J.E. Millais, engraved by Cousins and published by Arthur Tooth & Sons, 1882.

'The Portrait Samuel Cousins': i.e. the portrait of the engraver by Edwin Long, R.A., engraved by Cousins himself and published by the Fine Art Society in 1884.

'Zeyra': i.e. the subject by Frederick Leighton, engraved by Cousins and published by the Fine Art Society in 1883.

'Cherry Ripe': i.e. the subject by J.E. Millais, engraved by Cousins and published by Thomas McLean in 1881.

Catalogue No. 26

P. 201 'Lucknow': i.e. Thomas J. Barker's 'The Relief of Lucknow', engraved by Charles G. Lewis, published 24 April 1860 by Thomas Agnew & Son.

Catalogue No. 28

P. 202 'Barry's Etchings': i.e. subjects by James Barry (1741–1806) published by the Society of Arts.

Catalogue No. 29

P. 203 'Under the Boards': i.e. drying under boards and weights.

Catalogue No. 31

P. 203 '600 Linnean': i.e. 600 prints for a publication of the Linnean Society. (See pp.247 ff.)

Catalogue No. 33

P. 205 'Cleaning the Light of the World': the charge must have been for cleaning an impression of Holman Hunt's subject, engraved in the large version by W.H. Simmons and published by Gambart & Co. in 1858. (A smaller version was engraved by W. Ridgway and published by the same company in 1865).

Appendix II

Transcripts of Correspondence in the McQueen Archives

Introductory Note

The letters form part of a collection owned by Mr. P.N. McQueen. Unfortunately, comparatively little survives in the way of written documentation of the McQueen family business, which seems already to have established a reputation for skilful plate-printing before 1800, which was awarded a First Class Silver Medal at the Paris World Exhibition of 1855 for the excellence of its craftsmanship, and which only finally went out of business in 1956. There exists little more than an early-nineteenth-century Delivery Book (p.xxix, above), a late-nineteenth-century Ledger (p.xxix, above), and the bundle of letters from which are selected the transcripts that follow.

The letters are still kept in a brown paper wrapping bearing the scarcely decipherable words 'Kept for the Autographs'. Most of them were written during the second and third quarters of the nineteenth century. Those transcribed here are intended, like the extracts from the Dixon & Ross records, to illustrate or to supplement passages in the main text of the book. The arrangement is chronological, and in the absence of a date a likely position in the sequence has been estimated.

McQueen Letter File No. 1

Addressed to: Presumably McQueen. Addressed half of sheet missing.

Paris. August 3rd. 1818

Sir.

I send you a copper plate No. 29 and hope that in a few days I shall be able to send you two more, No. 16 & 36 as I have to request you will send to Mr. Combe at the British Museum who will deliver to you two others, No. 33 & 35. If you add to them No. 26. 27. 28. 30. 31. 32. & 34 which I left with you you will have the 12 plates that are to compose the 3rd. Part of my work, I will thank you to inform my son, if they are duly numbered as I directed, & as soon as I receive satisfactory information from him on this point, I shall desire you to proceed with the printing. You have a quantity of paper sufficient for a 100 copies of each plate.

I remain very truly

Sir

Your obed. humb. Servt.

J. Millingan

McQueen Letter File No. 2

Addressed to: Mr McQueen
Copper Plate Printer
Newman Street
London

Edinburgh 10. Feby. 1824

Sir/

In a work which I am about to publish on the Bell Rock Lighthouse, extending to Twenty-three Plates, there are three which I wish to be printed with care and attention. The Engravers Messrs. Horsburgh and Miller have accordingly suggested that they should be sent to you. As I have not made any final agreement with a Bookseller — though I have spoken on the subject to Mr. Murray in Albemarle Street — I am rather at a loss to give you a reference — being an entire stranger to you. I may however mention the names of Mr [JMW] Turner who did the Drawing for one of the Plates — or Mr Ralph Price of the House of Sir Charles Price & Co. of Blackfriars Bridge — for my credit.

By this Evening's Mail I am therefore to send you a Box containing what I may call two half and one whole Plate — which in the Book requires to be folded with a Gaurd [?] in the middle in binding the work. You have also a sheet as a specimen of the Paper on which the other 20 Plates are to be printed. I might have sent you paper from this, but it was thought unnecessary as you, I understand, can easily procure equal if not superior paper to the specimen sent.

I beg you will at the same time notice that 330 impressions of each are wanted — and that the two half or smaller sized Plates are to be done with Indian Paper & the large Plate with the best Paper agreeably to specimen and <u>with</u> <u>out</u> Indian Paper.

I shall be glad to hear from you when the Plates come to hand & that you at the same time acquaint me when you can complete the order & have it ready for packing as the work is now ready — and also that you inform me of the expence.

I am

Sir

Your mo. ob. sr.
Robert Stevenson
Civil Engineer PS. Please be careful in unscrewing the
Edinburgh nails of the Box.

McQueen Letter File No. 3

Addressed to: Mr McQueen
Copper Plate Printer
Newman Street
Oxford Street

June 30th. 1824
4 Rodney Buildings
New Kent Road

Sir

I am informed that you told Davis this morning that my lamented husband Charles Stothard died in your debt — I now write to state that this is an <u>error</u>, as the bill in question I find upon looking over Mr C Stothard's papers was paid to your house on the 14th. of May 1821 — only a few days before he quitted town on the last most fatal journey.

Upon my return to town I shall have another and a larger quantity of head plates to print, and I shall be very glad if you could contrive to do it without spoiling so many, but I know it is a difficult task.

I remain Sir

Your obedt. Servt.

Anna L Bray

McQueen Letter File No. 4

Addressed to: Messrs. McQueen
Newman Street

Saturday Mng.
36 [?] St.

Mr. Clare Smith will thank Messrs. McQueen to take off <u>immediately</u> 700 of the Duke of Yorks Plate and not to fail in letting him have 300 By <u>12 OClk on Monday</u> & the remaining quantity without delay, all of them to be Oct size —

McQueen Letter File No. 5

Addressed to: McQueen Junr. Esq.
Newman Street

June 28th.

Dear Sir,

I fear you will think me very troublesome to you in asking you to do anything like business for me in town, but I know of no one else on whom to depend in the way of engraving. Will you oblige me by proving the enclosed three plates and if they are very indistinct get some experienced hand to <u>rebite</u> them to give sufficient depth to please <u>me and</u> the public, in short to match with the generality of the others. Will you favor me further by getting the dates altered of those which I have left undone. The fact is I am <u>very</u> considerably behindhand and cannot make the alterations, rebiting &c so well or so expeditiously as a more practiced hand. Let me have one proof of each plate as before on plain paper, both <u>before</u> and after the rebite if the latter is necessary. I shall not be in town for some time and shall not have the power to attend to these things myself if therefore you will get it done you will confer a great obligation upon

Yours very truly

Frank Howard

NB – Has the plate altered from 11 to 13 been altered again to 12 as it should be? Did I mention to you in my last that I would wish you to get some one to remove the superfluous lines which I have not quite burnished out?

McQueen Letter File No. 6

Addressed to: Mr McQueen
Newman Street

Woburn Abbey
Jany. 19th.

Miss Russell requests Mr McQueen will have the accompanying Plates cleaned, with fresh grounds laid, & sent to 13. St. James' Square, to be forwarded – with the exception of the landscape, of which Mr McQueen lately sent her some impressions – Miss Russell will be much obliged to him to <u>stop out the two Figures in the foreground</u> of this plate, & shade the part over – after which, she would wish to have half a dozen more impressions taken from it, & the plate returned with the rest.

McQueen Letter File No. 7

Addressed to: Mr. McQueen
Newman St.

105 Gt Russell St. June 1st 1830

Dr Sir

I regret having given you so much trouble about your last bill, but as my business is greatly increasing I am obliged to

become very particular to prevent confusion. Now it is all right and I request you to draw on me for the amount of your bill.

Please to send for the coppers of Nos. 2 & 3. Examples to print <u>50</u> of each Small paper as soon as you can having none left. Be very particular as to the size of the paper which is to be the size of the Number I have send.

I am

Dr Sir

yours truly Augs. Pugin

McQueen Letter File No. 8

Addressed to: Mr McQueen

June 21st. 1830
31 Penton Place

Sir/

I herewith send one of the plates of Mr Agnew's you are to take off 15 India for Mr Agnew <u>before</u> the letters & then return the plate for me to get the writing engraved, which I will do without delay & send the plate again to you; you are then to take off 150 India & 150 French & <u>again</u> return the plate to me to have the letters strengthened & <u>the</u> word proof taken out; I shall then finally send the plate to have 350 plain printed – off the second plate which I shall send to you in a few days you are to take off 50 India & return the plate for the writing, to me, on your receiving it again you are to take off 200 India & 150 French, return the plate to have the writing altered & I will again send it for you to take off 350 prints:– I will send the direction of the number of proof(s) I wish for myself of this <u>latter</u> plate; of the one <u>now</u> sent I shall want only six india (light colour), when the writing is engraved . . . [?]

I am yours truly

J Le Keux

PS – I also send a note for Ackerman for him to deliver the paper to you.

McQueen Letter File No. 9

Addressed to: Mr McQueen

[no date]

Dr Sir/

I beg to explain that when last I made two applications requesting that the coppers of Part I Examples should be sent for the answer was that they could not be attended to immediately it being the latter part of the month under such circumstances and having not a single No I by me, I could not delay even an hour, therefore I sent the Coppers to Mr Barnett, and it was attended to immediately.

I am now preparing and making alterations to Part <u>IV</u>, and as

soon as I am ready, I will write to you to send for the coppers.

I never expected to have such rapid sale otherwise I should not have delayed to the last.

I send you herewith 10 Coppers to take 2 proofs of each, one on hard paper, the other on soft, and please to send them with the Coppers when they are well <u>dried</u> and <u>flat</u>.

Believe me,

Dr Sir

yours truly

Augs Pugin

McQueen Letter File No. 10

Addressed to: Mr McQueen
 Newman Street

105, Gt. Russell Street
Novr. 19th. 1830

Dr. Sir

I send you herewith 18 Coppers, forming Part IV of my Examples of Gothic architecture requesting you to print 44 copies of them – Small paper very exact in size to the Number sent herewith also to the quality – please to remember that I am very particular as to the impressions doing full justice to the merit of the plates – you are (as before) to supply me with the paper in order to prevent any errors as to size or quality – I shall send you in succession the four parts of this work, but I am beginning by part IV my having less of that Number by me.

In order to save you the trouble of the other orders I state here that I shall want <u>40</u> of part III
 25 only of part II
 and 36 of part I
and whenever you return me one part, another will be sent back to you. I adopt this plan, being unwilling that many of my plates should be out of my house at the same time – with the completion of this order I particularly request you should send me your bill – which I intend to settle immediately by my acceptance at six months date with the supposition that it will meet your own wishes.

I am just returned from Paris where I have met with many serious desapointments besides losses.

Hoping that yourself and family are well I remain

Dr Sir

Yours faithfully

Augs. Pugin

Mr McQueen Junr.

[postscript] please to take care that the wrappers should not
 be changed as owing to that I have been thrown
 into great confusion.
[and beneath the address] please to send today for the coppers.

McQueen Letter File No. 11

Addressed to: Mr MacQueen
 Newman St.

August 11 1831 [Postmark: August 12 1831]

Dear Sir

Will you oblige me by sending me states of all my plates on Mr. Dickenson's paper and also on Smith's [?]. It is idle for me to have engravers proofs unless they are something more like engravers proofs than these I have. Either they are very carelessly printed or the paper is bad. I think it right to say that I have the same complaint to make of Messrs. Dixons two plates. Let me beg you will send me immediately specimens of the ordinary printing of my plates. Of some plates I have not seen one good impression after the proof of the engraver himself. The Engravers complain on all hands of the hardness of the paper if this be the case I had rather sacrifice the quantity that remains than destroy the appearance of my toil.

Yours truly

Al. A. Watts.

McQueen Letter File No. 12

Addressed to : Mr. McQueen
 Tottenham Ct. Road

Foley Place
Tuesday
2 o'clock

Mr. Barry will feel obliged to Mr McQueen to send him as many of the Impressions of the National Gallery Designs as are dry enough; and if it is possible to expedite the printing of them by the employment of two men, Mr. Barry will cheerfully pay any extra expence that may be incurred thereby – at any rate Mr Barry hopes Mr McQueen will allow the man or men employed to work over hours – The entire number required will be 350.

McQueen Letter File No. 13

Addressed to: Mr McQueen
 Copper Plate Printer
 No 184
 Tottenham Court Road

Salopian Coffee House
Charing Cross
Wednesday evg. 20th. January
[Postmark: 12 noon Ja. 22 1835]

Mr Dawson Turner begs to inform Mr McQueen that he has brought with him to London 11 Copper Plates, which he will thank Mr McQueen to send for to the Bar of this Coffee House, where they are left addressed to him. And Mr Turner requests that 10 Impressions may be struck off from each,

excepting that of a Lady without a name, of which he would be glad of 30.

Shd it not be inconvenient, Mr Turner wd like to receive back his plates & the impressions & the bill by Saturday evg. He needs hardly say that he begs no other impressions may be taken off from these, or from any other plates he may send at a future time, except what he may order for himself –

Salopian Coffee House

Charing Cross

McQueen Letter File No. 14

Addressed to: Messrs McQueen & Co
 184 Tottenham Court Road

2d March 1835
2 Duchess Street

Messrs. McQueen & Son

Gent

In case there should be any mistake in the orders lately given I think it right to acquaint you that the whole number of copies for each plate required for my work is
8000 viz 5500 Royal and
 <u>2500</u> Demy
making 8000 – which are to be delivered to Messrs. Remnant and Edmunds – as soon as possible, I shall be glad to see Mr. McQueen Junr. on Tuesday morning if convenient to give him further orders for the 800 Edition

I am yours obediently

John Ross

McQueen Letter File No. 15

Addressed to: Mr McQueen
 184 Tottenham Court Road
 London

Decr. 21, 1835

Dear Sir,

At the same time that I send this by Post I have the pleasure to send for your acceptance a Turkey and a few dried apples, in a Basket directed to you, by the North Devon Coach and which I trust will reach you in due course –

I have just received a letter from Mr. Delacour of 28 Newman Street, the Secretary to The Artists Annuity Fund informing me that the amount of half years subscription &c due on the 22nd. instant is £2 s8 d11 which sum I shall feel obliged to you if you will call upon him and pay for me & for which he will give you a printed Receipt which you will be so good as to keep 'till my next parcel.

With my best wishes for your health & that you may enjoy a happy and prosperous New Year believe me

Yours very truly

Henry Le Keux

PS. I received the Copper Plates quite safe.

McQueen Letter File No. 16

Addressed to: presumably McQueen

30, Allsop Terrace, New Road
February 16th. 1848

Having determined upon retiring entirely from that branch of my profession that relates to engraving, printing and publishing I propose disposing of the whole of the large plates in my possession comprised in the following list upon the subjoined terms.

JM

The Belshazzar's Feast
The Fall of Babylon
Deluge
Joshua
Fall of Nineveh
Destroying Angel – but little circulated having been withdrawn shortly after publication to receive material alterations and improvements.
Death of First Born ditto the proposed alterations, however not being yet completed.
Marcus Curtius only a few impressions taken off, the plate having been withheld with a view to selling it.
Sadak – a smaller plate from the first oil picture I ever exhibited.

As I am not disposed to separate the above I would not take less than 500 Gs. for any individual large plate, and 250 Gs. for the smaller; whereas I am willing to sell the whole together for 3,000 Gs., or an abatement of nearly one third.

As it is my intention in my new residence to exhibit my pictures and engravings by invitation at stated periods, it is almost needless to observe how much this exhibition would promote the sale of the engravings

John Martin

McQueen Letter File No. 17

Addressed to: W.B. McQueen Esq.
 184 Tottenham Court Road

2 Furnivals Inn 23rd. Oct. 1849

Dear Sir

I am authorized by the Misses Turk to say that they consent to grant you a lease of their premises in Tottenham Court Road for the remainder of their term/ less a few days/ upon the terms agreed on between you and me on the 17th. inst viz £220 per ann to commence from Michaelmas last you paying the Sewers rate in addition to the Taxes now paid by you & a moiety of the expence of the Lease & Counterpart the Draft of which I will forward your Solicitor for perusal & remain

Dear Sir

Yours truly

Michl. Fraser.

McQueen Letter File No. 18

Addressed to: Mr. Wm. McQueen

24, Camden Square NW
Octr. 13th. 62

Dear Sir

The plate of The Maid & Magpie has been put into the hands of Mr. Dixon at the particular desire of Mr. Graves, who complains, and <u>with reason</u> I <u>think</u>, of the Manner in which you printed the plate of Lord Clyde.

Dear Sir

Yours truly

S. Cousins.

McQueen Letter File No. 19

Addressed to: ?

122 Regent Street.
21st. April

My dear Sir

The awkward situation into which I am put by the delay and neglect of Mr. Finden is really very annoying. I repeatedly entreated that proofs of the vignettes should be sent to me; and yet I was called upon to supply the writing for the title of England Vol: II without having any proof or copy of the vignette before me. I supplied of course the subject as given by Sir J. Mackintosh, viz. Sir Thomas More <u>answering</u> Cardinal Wolsey. At length a copy of the vignette <u>has been</u> sent to me, and I find that instead of Sir Thomas More answering Cardinal Wolsey it represents Cardinal Wolsey <u>addressing</u> Sir Thomas More. Thus the subscribed writing is inconsistent with the vignette. I enclose some observations of Sir J M on it, which are however matters of mere criticism. You had better I think send immediately to the Printer, and direct that the writing be changed thus:– Sir Thomas More, as Speaker of the Commons, addressed by Cardinal Wolsey. Perhaps however you will not think the matter of sufficient importance.

Yours very truly

[Signature illegible]

McQueen Letter File No. 20

Addressed to: S. Rogers Esq.

5, Clarence Terrace, June 8

My dear Mr. Rogers

My brother and his wife, who are acting 'country cousins' in town for a few days, are anxious to see your pictures. They have happily nothing else to do than roam from gallery to gallery, and having exhausted those of Italy and Germany, are now returned to inspect what we have in England.

Will you be kind enough to name to me any hour on any morning in the early part of next week, when you can indulge their wish without disturbing your own arrangements?

Always, my dear Sir,

and most sincerely yours

W.C. Macready

Notes to the Appendix

No. 1
This, together with Nos. 7, 8, 9 and 10 gives some indication of the care needed to avoid confusions of numbering and titling when the comparatively large numbers of plates related to book jobs were being handled.

No. 2
The erection of the Bell Rock light-house was the most important achievement of the engineer Robert Stevenson (1772–1850). Among Stevenson's many improvements to light-houses – of which he constructed twenty – was the invention of intermittently flashing lights. The first edition of the *Account of the Bell Rock Light-House* was published in Edinburgh in 1824. Mr. P.N. McQueen still has proofs of at least one of the plates printed by his ancestors for Stevenson: Plate XVIII, a general view of the tower nearing completion, engraved by William Miller (of the partnership of Horsburgh & Miller) after a drawing by G.C. Scott based on the original painting by A. Carse. Mr. McQueen has india as well as plain proofs of the subject. There is an interesting epilogue to J.M.W. Turner's connection with the project: in 1864 Miller, with the assistance of H. Graves & Co., published as an independent print his engraving after Turner's painting of the Bell Rock light-house (see *Alphabetical List*, Printsellers' Association, London, 1892).

No. 3
Anna Bray was the daughter-in-law and biographer of Thomas Stothard, and author of *Letters Written during a Tour through Normandy, Brittany, and other parts of France, in 1818*, London, 1820, illustrated with plates after the drawings by Charles Stothard. Charles Stothard met his death two weeks after leaving London on 28 May 1821; he fell whilst tracing a church window at Beer Ferrers. Anna subsequently married the vicar (Redgrave, *A Dictionary of Artists of the English School*, Kingsmead reprint, Bath, 1970). Charles Stothard's *Monumental Effigies of Great Britain* first appeared in 1817. Entries in a McQueen Delivery Book (see p.xxix, above) show that the firm was involved in the printing of its plates (e.g. 20 December 1817: 'Deld. to Mr. C. Stothard 2 Plates outlines Sir Guy Bryan and Earl of Pembroake'). Iain Bain ('Thomas Ross & Son', *Journal of the Printing Historical Society*, No. 2, 1966, p.14) suggests that the 'difficult task' referred to in the letter was that of registering engraved illustrations with previously printed letterpress text.

No. 4
See p.49, above.

No. 5
See p.43, above.

No. 6
The letter must have been written prior to 1832, by which date the McQueen workshop was in Tottenham Court Road. The writer's requests give an idea of the variety of tasks expected of a printer; some of these would no doubt be farmed out to the appropriate specialists. See p.43, above.

No. 7
For references to Pugin, see pp.140, 142.

No. 8
An interesting reflection of the complexity of the whole business of producing various states of impression.

No. 9
See p.50, above.

No. 10
Could the 'desapointments' and losses have been in connection with Pugin's most recent enterprise in book illustration: 200 drawings for the 2 volumes of *Paris and its Environs* (A. Pugin & C. Heath), 1829–1831?

No. 11
See p.166, above. Whilst engravers would complain of the lack of absorbency of certain papers, colourers would welcome it (see p.161).

No. 12
See p.49, above.

No. 13
See p.49, above.

No. 14
The writer seems to be Sir John Ross, whose *Narrative of a Second Voyage in Search of a North-West Passage* was published in London in 1835. The work was illustrated with coloured lithographs, coloured mezzotints and plain engravings. The letter may have been in connection with this publication. (In 1819 Ross had published an account of his first voyage in search of a North-West passage: *A Voyage of Discovery . . . for the purpose of exploring Baffin's Bay, and Inquiring into the Probability of a North-West Passage*).

No. 15
Henry Le Keux (1787–1868) was the younger brother of John (see pp.33, 45, above). He did much engraving for the annuals (e.g. *Forget-me-Not*) and after Turner for Roger's *Poems* (see Letter No. 20 and Note No. 20, below). The courtesy of a Christmas gift is a custom not entirely extinct in the printing trade today!

No. 16
For references to Martin, see pp.60, 119, above.

No. 17
See p.85, above.

No. 18
See p.45, above.

No. 19
See p.38, above.

No. 20
W.C. Macready was the celebrated actor. Samuel Rogers, banker and poet (for whom Dixon & Ross did much printing: see Cat. No. 1), frequently presided over gatherings of the intelligentsia of London at his splendid house overlooking Green Park. (For a description of the house, see Boase, T.S.R., *English Art 1800/1870*, Oxford, 1959, p.92). In a letter of 1856, Rogers was described thus: 'He was the very embodiment of quiet, from his voice to the last harmonious little picture that hung in his lulled room ... an elegant, pale watch-tower, showing for ever what a quiet port literature and the fine arts might offer, in an age of 'progress', when every one is tossing, struggling ... where people fight even over pictures, and if a man does buy a picture it is with the burning desire to prove it is a Raphael to his yelping enemies, rather than to point it out with a slow white finger to his breakfasting friends.' (*Mr. Hayward's Letters*, London, John Murray, quoted in Redford, *Art Sales*, Vol. I, London, 1888).

Technical Glossary

Albion Press

An iron platen press for letterpress printing, invented and manufactured by Richard Whittaker Cope of North Street, Finsbury Square, London, by about 1822. (See Stone, R., 'The Albion Press', *Journal of the Printing Historical Society* No. 2, 1966, pp.58–73).

Aquatint

Aquatint is so called because plates etched by this method produce prints with the effect of watercolour – superficially, at least. The polished plate is sprinkled evenly with resin or asphaltum, either by hand (through a muslin filter) or in a specially constructed box in which the powder is agitated and then descends like a light snowfall onto the plate. The plate is heated until the grains of resin or asphaltum melt and adhere to it in tiny globules. On immersion in an acid solution the areas of metal exposed between the globules are attacked or 'bitten into', and the required image is produced by successive immersions, between which biting is controlled by stopping out appropriate areas of the plate with acid-resistant varnish. Areas bitten for the shortest time produce the palest tones; those bitten longest, and therefore most deeply, print darkest. Globules and varnish are removed with solvents before printing. See pp.125–6, above.

Artist's Proof

An impression signed in pencil by the artist, usually in the left lower margin. If of sufficient standing, the engraver of the work would frequently be invited to add his signature in the right lower margin. Such proofs carry publication details in the top margin, and are usually printed on india paper.

Blankets

Blankets used for intaglio printing are made of fine woollen felt (often referred to in the Dixon & Ross records as 'swanskin'). It is usual to lay from three to five blankets over the plate and paper during printing; they provide resilience, pressing the damp, supple paper into the ink-laden crevices of the plate.

Burin

Also called a graver, this is a tool used on metal plates (and on boxwood blocks for wood-engraving). It consists of a slender steel rod, four or five inches long, square or lozenge-shaped in cross-section, and mounted in a bulbous wooden handle. The end of the rod is ground and sharpened at an oblique angle to form the cutting point. See Pl. 72, Nos. 5, 6, 8 and 12.

Burnisher

A steel tool with a smooth rounded point, used for polishing those parts of a mezzotint plate's surface which are to hold little or no ink and are thus to print lightest. A burnisher is also used to modify the granular texture of an aquatint plate in passages which are judged to be printing too dark; or to smooth away traces of an erasion made with a scraper. (See Pl. 72, Nos. 3 and 4).

Colour separation

One method of colour-printing entails using a different plate for each separate colour. Plates must of course be identical in size and the engraved images must correspond precisely, so that when each is printed in succession, the superimposed layers of colour will fit to produce the fully chromatic print. Accurate registration is achieved by piercing a small hole at opposite ends of each plate. These holes correspond from plate to plate, and this enables the printer to make sure, by means of a pair of needles, that each plate is positioned correctly in relation to its companions. It is usual for all the plates to be inked and then printed one after the other whilst the paper remains damp.

Columbian Press

An iron platen-press for letterpress printing. The Columbian was invented in America by George Clymer and was introduced into Britain in 1817. (See Kainen, J., *George Clymer and the Columbian Press*, New York, 1950).

Copper-plate Press

See *Rolling-Press*

Dabber

A mushroom-shaped implement for applying ink to the surface of a plate. A metal disc to which a wooden handle is attached is padded and covered with thin leather which, in turn, is often covered with a piece of fine felt. The latter can be replaced from time to time as it becomes stiff with ink.

Declaration

Most reputable print-publishers subscribed to the efforts of the Printsellers' Association (established in 1847 under the presidency of Dominic Colnaghi) to regulate the sale of prints by limited editions. Anyone planning to publish would declare his intention to the Association, submitting the following details: title of the work to be reproduced; artist; engraver; style (e.g. line-engraving, mezzotint); size of work

(as distinct from size of plate); states (Artist's Proofs, Presentation Proofs, Proofs Before Letters, Lettered Proofs, ordinary prints etc.); whether on india or on plain paper; number and price of impressions in each state; the name of the publisher and the date of declaration. (See Printsellers' Association, *Alphabetical List of Engravings*, London, 1892).

Drypoint

A method of producing an intaglio print by simply scoring the metal plate with a steel point, pulled across the surface towards the engraver. The tool displaces (rather than removes) the metal, raising a ridge alongside each furrow. The ridge (called a burr) retains ink when the plate is wiped, and prints a characteristically soft, velvety line. Due to the friction of the inking and wiping process and to the pressure of printing, the burr of a drypoint begins to flatten (and the prints therefore to be reduced in brilliance) after very few impressions – perhaps twenty-five.

Electrotype

A method of reproducing an engraved metal plate by electrolysis. See pp.52–5, above.

Engraving

A term often loosely used to refer to all intaglio prints. Strictly speaking, though, an engraving is a print made from a plate engraved with a burin or graver rather than through the action of acid. Engraving and etching are, of course, frequently combined in a single plate. An engraved line may be distinguished by its crispness from the rather more ragged line bitten by acid. See p.118, above.

Etching

Etchings are prints made from metal plates whose crevices are formed through the action of acid. The image is drawn with a needle (or etching point) through a thin coating of wax on the plate. The plate is then placed in acid so that the lines of the drawing are bitten in. Both the extent and the depth of the biting can be controlled by successive immersions in the acid, intermittently protecting with an acid-resistant varnish those parts of the plate where biting is judged to have gone far enough. The general principle: the most deeply bitten areas print blackest.

Etching Ground

A ball or cake of wax which softens and melts on contact with a heated plate, across whose surface it is thinly and evenly spread to form a protection against acid. See pp.119–120, above.

Etching Point

Popularly called an etching needle. This is the implement used for drawing through the layer of wax on a metal plate. See Pl. 72, No. 1.

Ground Colour

The neutral colour worked into the crevices of a plate before superimposition of the full chromatic range in single-plate colour printing. See *Printing à la Poupée*.

Ground-layer

One who specialised in putting wax grounds on plates and/or in texturing the surface of a mezzotint plate.

Hand Colouring

The application of transparent washes of watercolour to black and white prints. See pp.158–162, above.

'Huntings'

The print-publishing trade's shorthand for hunting scenes.

Impression

The generic term for all prints.

Intaglio Prints and Printing

Intaglio prints are prints made from metal plates engraved by hand or by the action of acid. The paper receives ink from the crevices of the plate rather than (as in relief prints) from the unengraved or unbitten surface. The printing is begun by working ink into the heated plate and subsequently wiping the surface clean, leaving all the crevices filled with the pigment. Damped paper is laid on the inked plate, then – for resilience – several layers of woollen felt blanket, and the whole sandwich is passed between the rollers of the press. The pressure is such, and the dampness of the paper so calculated, that the ink is transferred from the plate's indentations to the paper to yield the print, the sunken plate mark and the raised quality of the lines being evidence of the process.

Key Plate

A small plate with labelled outlines identifying the characters in a larger engraving – usually a group portrait or a history subject.

Lettered Proof (or Proof After Letters)

A proof with the title of the subject engraved on the bottom margin. If declared to the Printsellers' Association, the proof carries the appropriate stamp in the bottom right-hand corner.

Line-engraving

An engraving in which all the contours, tones, and textures are expressed in line, usually incised with a burin or graver, but also frequently etched. A complicated vocabulary of linear pattern was evolved by line-engravers: skies, architecture, vegetation, water, draperies and flesh each receiving special and distinct treatment. See p. 115, above.

Lithography

A printing process depending on the incompatibility of grease and water. The method was perfected c.1798 in Bavaria by Alois Senefelder. Prints were (and, by artists, often still are) made from slabs of limestone ground flat and smooth. Today, specially sensitized zinc (and even paper) plates provide a less cumbersome printing surface. The process is chemically quite complex (see, e.g., Hullmandel, C., *A Manual of Lithography*, 3rd. edition, London, 1832). This is the method in outline: the image is drawn onto the stone or other surface with a greasy crayon or ink. When the surface is sponged, it all becomes wet except the drawn image, which repels the moisture. When greasy ink is rolled onto the damped surface it will adhere only to the image and not to the wet areas. A press with a scraping action transfers the image to paper.

Manière Noire or Manière Anglaise

See *Mezzotint*.

Mezzotint

The process is referred to by the French as *la manière noire* or, because of its popularity in this country, as *la manière anglaise*. The process was first used in the mid-seventeenth century by Ludwig von Siegen, a German, and was developed by Prince Rupert whilst he was in exile in Frankfurt after the English Civil War. The method was extensively used in England during the eighteenth century, mainly for the reproduction of portraits, and was taken up again (though frequently mixed with other techniques) by Samuel Cousins and many other engravers in the 1830s. The surface of the plate is evenly and systematically roughened all over with a rocker (a tool like a chisel with a short, broad blade whose cutting edge is curved and serrated. See Pl.72, No. 10). The dense texture raised by the rocker will print solid black. The engraver achieves the full tonal range required in the final print by proceeding from this black to the lighter tones, scraping and burnishing the textured surface of the plate to varying degrees. The areas left roughest retain most ink and thus print blackest; those polished smoothest retain little or no ink, and therefore provide the highlights. See Bayard & D'Oench, *Darkness into Light*, Yale University Gallery, 1976.

Mixed Mezzotint

When, in the 1830s, mezzotint became once more popular in reproductive engraving (see pp.114–115, above), it was seldom used in its pure form. Tones and textures were built up in a combination of mezzotint, etching and engraving, and the roulette was used as freely as the mezzotint rocker in the making of what came to be known as mixed mezzotints or, simply, mixed engravings.

Monotype

A monotype is a unique impression usually achieved by depositing ink on an unengraved plate or other suitable surface in such a way that it forms an image which may be transferred to paper, either in a press or by hand pressure. Such a process is of course never exactly repeatable; nor is selective wiping of an engraved plate (i.e. deliberately removing more ink from certain parts of a plate to enhance the effect of chiaroscuro).

Muller

A roughly hemispherical lump of marble of a size convenient to grasp in both hands. The muller is worked backwards and forwards over a stone or glass slab, its flat surface grinding powdered pigment and linseed oil into a smooth, stiff printing ink.

Photogravure

Photogravure involves the photographic transfer of an original image to a light-sensitive ground on a metal plate. The ground reacts in such a way that it will ultimately allow acid to attack the metal in exact conformity with the tonal patterns of the original. The process ensures that the plate's surface is pock-marked so as to retain ink, and is thus intaglio. Inking and printing are carried out precisely as for all other kinds of intaglio plate, except that a slightly thinner ink is required. The process became so popular in the 1890s that it threatened to eclipse hand-engraving. See pp.75, 76, above; see also Denison, H., *A Treatise on Photogravure*, London, c.1895.

Plank

The flat bed of a rolling-press, so called because (although eventually supplanted by iron) originally made of hard wood. Wooden planks were up to 2″ thick and were tapered at one end to allow easier insertion between the press's rollers. See pp.104, 107, above.

Presentation Proofs

Some nineteenth-century publishers included in their editions a small number (customarily 25) of complimentary proofs for distribution to favoured clients and friends. These were termed Presentation Proofs.

Prints or Plain Prints

The typical edition of a nineteenth-century engraving included Artist's Proofs, Presentation Proofs, Proofs Before Letters and Lettered Proofs, all in limited numbers. In addition, impressions with no numerical restriction (except one imposed by the plate's condition) were made. Because unrestricted and because made at a stage when the plate had begun to lose its pristine crispness, such impressions were sold considerably more cheaply than the earlier states. For example, Artist's Proofs of Landseer's 'Monarch of the Glen' (engraved by Thomas Landseer and declared 30 March 1852 by Henry Graves & Co.) were sold at 10 gns., Proofs Before Letters at 8, Lettered Proofs at 5, and Prints at only 3.

Printing à la Poupée

The term for intaglio printing in a full range of colours from a single plate. After the ground colour (see above) has been applied, all the other colours are laid in one by one with small

rolls (or dollies) of cotton fabric. The complete colour print is then obtained by a single passage through the press. See pp.154–8, above.

Proof

An impression taken whilst engraving is in progress to enable the artist and/or engraver to make decisions about the further development of the work. During the nineteenth century the word took on a different meaning when it became customary to produce limited numbers of 'proofs' to be sold at a higher price than the unrestricted impressions that formed the bulk of the publication.

Proof Before Letters

In a Proof Before Letters there is usually no publication line in the margin above the print. Instead, it appears beneath the work, in the centre. The artist's and the engraver's names are also engraved beneath the work: the former at the left, the latter at the right. Proofs Before Letters are normally printed on india paper and, if under the auspices of the Printsellers' Association, are embossed with the Association's stamp in the bottom right-hand corner.

Publication Line

This includes the name and address of publisher or publishers, date and place of publication, and any copyright details. All this usually appears in a single engraved line of small script either just above the top edge of the work or just below the bottom edge. The lettering was undertaken by specialists termed in the nineteenth century 'writing engravers'.

Reproductive Engraving

An engraving reproducing an original painting or drawing (or even, sometimes, a relief or a sculpture), as distinct from a completely autonomous print.

Retouching

The term used in the nineteenth century to refer to the repairs made by an engraver to a wearing plate.

Rolling-Press

The rolling-press (also loosely called an etching-press or a copper plate-press) consists simply of a frame supporting two rollers between which a flat plank or bed passes under pressure. Rolling-presses were invariably of wood (the framework often of oak and the rollers of elm or lignum vitae) until gradually replaced by iron models from about 1830. In simpler presses, pressure was adjusted by means of packing. More usually it was (and is) regulated by pressure screws. Ungeared presses are usually fitted with long arms radiating from the spindle of the upper roller, and are referred to as cross-presses (if having four arms), and as spider-presses or star wheel-presses (if having five or more). Geared presses are usually (though not always) fitted with a large fly-wheel. See Chapter 5, above.

Roulette

An implement with a small toothed wheel (see Pl. 72, No. 9). The wheel may be evenly or randomly patterned, and can be used either to make indentations on bare metal or to pierce the wax ground of a plate which is then textured by the action of acid.

Ruling Machine

A device for reducing the labour of ruling parallel lines on a plate. See pp.126–130, above.

Scraper

A steel tool used in the first stages of erasing unwanted passages from an engraved or etched plate, or of smoothing areas of a mezzotint or an aquatint plate. The process is normally completed with a burnisher. See Pl. 72, No. 2.

Scraping

This is the term usually given to the work done on a mezzotint plate. After the textured ground has been prepared, the scraper and burnisher are the chief tools used in the mezzotint process.

'Shootings'

The print-publishing trade's shorthand for game-shooting scenes.

Single-Plate Colour Printing

See *Printing à la Poupée*.

Sky Tint

A passage of finely-ruled parallel lines incised or bitten into a plate. This texture was often used in nineteenth-century engravings as the basis for sky effects.

Soft-Ground Etching

The wax used in etching is usually hard – i.e. it solidifies after application as the plate cools, and can thus be handled without disturbance. A softer wax will, however, faithfully take the imprint of a thumb or finger through to the bare metal. Soft-ground etching is a process which takes advantage of this property of soft wax. For example, thin grease-proof paper can be laid on a plate grounded with soft wax; pencil lines made on the paper will lift the wax from the plate beneath. A detailed drawing can in this way be reproduced in the wax and subsequently bitten into the plate by etching in the usual way. See pp.124–5, above.

'Stalkings'

The print-publishing trade's shorthand for game-stalking scenes.

Stanhope Press

An iron platen-press for letterpress printing, invented by Charles Earl Stanhope and in use in Britain by about 1803. See Hart, H., *Charles Earl Stanhope and the Oxford University Press*, ed. J. Mosley, Printing Historical Society, London, 1966.

States

Impressions taken at different stages in the development of an engraving. The term was used in the nineteenth-century print-publishing trade to denote different phases of the printing, changes of paper (e.g. from india to plain), and marginal alterations (e.g. to lettering), rather than to indicate modifications to the pictorial part of the plate.

Steel-Facing

A method of depositing by electrolysis a thin protective coating of steel (or, more accurately, iron) onto an engraved plate of softer metal to prolong its printing life. The process is effective only on copper, though zinc plates may first be copper-flashed and subsequently steel-faced. Copper plates are thoroughly cleaned before immersion in the bath of electrolyte (sal-ammoniac): first with turpentine or white spirit; next with a solution of caustic soda, rubbed into the crevices of the heated plate to remove all vestiges of ink from previous printing; then, after a thorough wash, a 10% solution of nitric acid is quickly applied, and again the plate is washed; it is next polished with precipitate chalk and subsequently rinsed; and lastly, a 4% solution of acetic acid is applied with a chalky rag, to act as a final de-greasant. After a last rinse, the plate is ready for immersion. The thickness of the steel face is determined by the duration of the immersion. This will normally last for at least half an hour; but whatever the length of time, the plate is removed from the bath at 15-minute intervals and treated with a very mild abrasive such as flour-emery (or, nowadays, optical abrasive). On final removal from the bath the plate is once more abraded, dried by heat and coated with wax until needed for printing. During the process, a hooked metal strap is temporarily soldered to the back of the plate so that it can be suspended in the electrolyte from a metal bar bridging the bath. This bar is connected by a wire, via an accumulator, to a large plate of almost pure (98%) iron that stands on edge in the electrolyte. It is this metal that provides the protective deposit.

Stipple-Engraving

A stipple-engraver pierces the wax ground of his plate with a series of pecks (often in imitation of the granular effect of crayon – the 'chalk manner'), using an etching point or a burin. Each peck reveals a dot of copper (or steel) which is subsequently attacked by acid to create a small pit in the metal. In particularly delicate passages the ungrounded metal is stippled with a burin rather than etched. Stipple engraving became popular in England largely through the work of the Florentine expatriate Francesco Bartolozzi (1727–1825) and his followers. The method was virulently criticised by such adherents of line-engraving as John Landseer (1769–1852)

who in his *Lectures on the Art of Engraving* (1807) attacked the 'infantile indefinity' of stipple. Nevertheless, line-engravers frequently used stipple in the representation of hands and faces.

Straining

A synonym for stretching. Engravings were often pasted onto a support of fine linen stretched over a wooden frame. As the moisture in the paste evaporated, the print would shrink and become perfectly flat, all disfiguring cockling eliminated. The print on its stretcher would then be framed under glass in the usual way.

Sugar Aquatint

A variation of aquatint. An image is brushed onto the plate with a solution of sugar and black drawing ink. Then, a layer of quick-drying varnish is laid over the image and the plate immersed in warm water, whereupon the sugar solution will lift away from the plate, revealing the image in bare metal. If then the usual aquatint procedure is followed (see *Aquatint*, above), the image will be bitten into the plate. An advantage of the sugar method is that the image can be applied positively rather than be achieved by elimination.

Touched Proof

A proof modified by the artist in black and/or white chalk to guide the engraver in the further development of the work.

Wheel and Pinion

A simple gear fitted to a rolling-press.

Wood-Engraving

An engraving made with a burin on the end grain of a hard wood such as boxwood. Thomas Bewick (1753–1828) was the earliest exponent of the craft which, in somewhat degraded form, became very widely used for the illustration of books and newspapers in the mid-nineteenth century. Since wood blocks could be printed with type rather than in a separate process, wood-engraving was economically more attractive than intaglio for work where some illustration was required to be combined with text on the same page.

Work Size

The area of a plate occupied by the pictorial composition, as distinct from the whole area of the plate itself.

Writing Engraver

See *Publication Line*.

Bibliography

ABBEY, John Roland. *Scenery in Aquatint and Lithography, 1770–1860*, London, 1952; *Life in England in Aquatint and Lithography, 1770–1860*, London, 1953; *Travel in Aquatint and Lithography 1770–1860*, 2 Vols, London, 1956–1957.

ACKERMANN, Rudolph. *Repository of Arts*, London, 1809–1828.

ADAMS, Alexander B. *John James Audubon*, London, 1967.

AGNEW, Geoffrey. *Agnew's, 1817–1967*, London, 1967.

AGNEW, Thos. & Son. *Thomas Shotter Boys* (catalogue), Nottingham & London, 1974; *English Portrait Mezzotints* (catalogue), London, 1976; *Master Drawings and Prints* (catalogue), London, 1976.

ARTIFICIANA, or a Guide to Principle Trades, London, 1820.

ARTS COUNCIL. *Pictorial Photography in Britain, 1900–1920* (catalogue), London, 1978.

AUSTIN, Richard. *Richard Austin, Engraver to the Printing Trade, 1788–1830*, Cambridge, 1937.

BAIN, Iain. 'Thomas Ross and Son, Copper- and Steel-Plate Printers since 1833', *Journal of the Printing Historical Society*, No. 2, London, 1966; Introduction to *A Memoir of Thomas Bewick written by himself*, Oxford, 1975.

BALSTON, Thomas. *John Martin, 1789–1854*, London, 1947; *William Balston, paper-maker 1759–1849*, London, 1954; *James Whatman, father & son*, London, 1957.

BAYARD, Jane and D'OENCH, Ellen. *Darkness into Light: the Early Mezzotint* (catalogue), Yale, 1976.

BAYNE, William. *Sir David Wilkie, R.A.*, London & New York, 1903.

BECK, Hilary. *Victorian Engravings* (catalogue). London, 1973.

BERTHIAU & BOITARD. *Nouveau Manuel Complet de l'Imprimeur en Taille-Douce*, Paris, 1836.

BLOY, Colin. *A History of Printing Ink, Balls and Rollers, 1440–1850*, London, 1967.

BOASE, T.S.R., *English Art, 1800–1870*, Oxford, 1959.

BOSSE, Abraham. *Traicté des manières de graver en taille-douce*, Paris, 1645.

BOURDIEU, P. 'Intellectual Field & Creative Project', in Young, M. (ed.), *Knowledge and Control*, London, 1971.

BOWNESS, A. 'Vincent in England', in *Vincent Van Gogh* (catalogue), Arts Council, London, 1968.

BRAY, Mrs. *Life of Thomas Stothard*, London, 1851.

BRYAN, Michael. *Dictionary of Painters & Engravers*, London, 1889–1893.

BURCH, R.M. *Colour Printing and Colour Printers*, London, 1910.

BURLINGTON FINE ARTS CLUB. *Exhibition of English Mezzotint Portraits, from c. 1750 to c. 1830* (catalogue), London, 1902.

CARTER, John and MUIR, Percy H. (ed.). *Printing and the Mind of Man* (catalogue), Cambridge, 1967.

CARTWRIGHT. *Photogravure*, London, 1939.

CHAMBERLAINE, John. *Portraits of Illustrious Personages of the Court of Henry VIII*, London, 1812.

CHATER, Michael. *Family Business: a History of Grosvenor Chater 1690–1977*, St. Albans, 1977.

CHRISTIE'S. *English, Old Master and Modern Prints* (Sale Catalogue, 25 May 1977), London, 1977.

CLAIR, Colin. *A History of Printing in Britain*, London, 1965.

CLAYTON, C.H. 'Electrotyping', in *St. Bride Trade Lectures*, London, 1919.

CLIFFORD, GRIFFITHS and ROYALTON-KISCH. *Gainsborough and Reynolds in the British Museum* (catalogue), B.M., London, 1978.

COURTNEY-LEWIS, C.T. *The Story of Picture-Printing in England during the XIXth century*, London, 1928.

CUST, Lionel. *History of the Society of Dilettanti*, London, 1898.

DANIELL, William. *Voyage round Great Britain*, London, 1814–1825.

DAWSON RARE BOOKS. *Fine Colour Plate Books* (catalogue 264), London, 1977.

DE CHAMPOUR & MALPEYRE. *Nouveau Manuel Complet de la Fabrication des Encres*, Paris, 1856.

DELABORDE, Henri. *La Gravure*, Paris, c.1885.

DELESCHAMPS, P. *Des mordans, des vernis et des planches dans l'art du graveur*, Paris, 1836.

DENISON, H. *A Treatise on Photogravure*, London, c.1895.

DIXON & ROSS. *Trade List of Fine Engravings*, London, 1871.

DYER, J.C. *Specimens and Descriptions of Perkins and Fairmans Patent Siderographic Plan to prevent forgery . . . of Bank Notes*, London, 1819.

DYSON, Anthony. 'The Ross Records', *Journal of the Printing Historical Society* No. 12, London, 1977–1978; 'The Engraving and Printing of the Holbein Heads', *The Library*, September, 1983.

EGGER, E. *Le Papier dans l'antiquité et dans les temps Modernes*, Paris, 1866.

ENFIELD, William. *Young Artist's Assistant*, London, 1822.

EVANS, Joan. *The Endless Web: John Dickinson & Co. Ltd., 1804–1954*, London, 1955.

EVELYN, John. *Sculptura, or the History of the Art of Chalcography*, London, 1662.

EXPOSITION UNIVERSELLE DE 1855. *Extrait des Rapports du Jury de la XXVIe Classe*, Paris, 1856.

FAWCETT, Trevor. *The Rise of English Provincial Art*, Oxford, 1974.

FIELDING, T.H. *The Art of Engraving*, London, 1841.

FIELDING, Mantle. *American Engravers upon Copper & Steel*, Philadelphia, 1957.

FORD, John. *Ackermann's*, London, 1976.

FOX, Celina. 'The Engravers' Battle for Professional Recognition in Early Nineteenth-Century London', *The London Journal*, Vol. II, No. 1, London, May 1976.

FRANKAU, Julia. *Eighteenth Century Colour Prints*, London, 1906.

FRÈREBEAU, Mariel. *Histoire d'une Imprimerie en Taille-Douce: l'atelier Salmon-Porcabeuf 1863–1914*, Thesis, Ecole du Louvre, Paris, 1973: 'L'Imprimerie en Taille-Douce', *Nouvelles de l'Estampe*, No. XVI, Paris, July/August, 1974.

GILBERT, L. *The Beauties & Wonders of Nature and Science* (Paper), London, 1840.

GOODWIN, G. and ROSE, J.A. *A Collection of Engraved Portraits* (2 Vols.), London, 1894.

GRAVES, Algernon. *A Dictionary of Artists, 1760/1893*, London, 1895.

GRAVES, Henry & Co. *Catalogue of the Publications*, London, 1894; *Complete Supplementary Catalogue of the Publications*, London, 1899.

GREAT EXHIBITION, 1851. *Official Descriptive and Illustrated Catalogue*, London, 1851; *Official Catalogue* (Supplementary Volume), London, 1851; *Reports by the Juries*, London, 1852.

GREGG, Pauline. *A Social and Economic History of Britain, 1760–1950*, London, 1950.

GROCE, George C. and WALLACE, David H. *The New York Historical Society's Dictionary of Artists in America, 1564–1860*, New Haven, Yale Univ. Press, 1957.

GUICHARD, Kenneth. *British Etchers, 1850–1940*, London, 1977.

HADEN, Seymour. *About Etching*, London, 1879.

HANSARD, T.C. *Treatise on Printing*, London, 1841.

HARDIE, Martin. *English Coloured Books*, London, 1906.

HARDIE, M. *Frederick Goulding, Master Printer of Copper Plates*, London, 1910.

HARRIS, Elizabeth M. 'Experimental Graphic Processes in England 1800–1859' (Parts I–IV), *Journal of the Printing Historical Society* Nos. 3–6, London, 1967–1970.

HARVEY, John. *Victorian Novelists and Their Illustrators*, London, 1970.

HASLOCK, P.N. *Engraving Metals*, London, 1901.

HAYTER, S.W. *New Ways of Gravure*, London, New York & Toronto, 1966.

HERKOMER, Hubert. *Etching and Mezzotint Engraving*, London, 1892.

HERRING, R.A. *A lecture on the origin, manufacture and importance of paper*, London, 1853.

HIND, Arthur M. *A Guide to the Processes & Schools of Engraving*, British Museum, London, 1914; *A History of Engraving & Etching*, Reprint, New York, 1963.

H.M.S.O. *Reports on the Paris Universal Exhibition*, Parts I, II, and III, London, 1856; *Patents for Inventions: Abridgements of Specifications. Class 101: Printing other than Letterpress or Lithographic*, 1855–1866: London, 1905; 1867–1876: London, 1904; 1877–1883: London, 1893; 1884–1898: London, 1896.

HOBSBAWM, E.J. *Industry and Empire*, London, 1979.

HOLME, Charles. *Modern Etching and Engraving*, London, 1902; *Modern Etchings, Mezzotints and Dry Points*, London, 1913.

HOUSE OF COMMONS. *Minutes of Evidence, Select Committee on Patents*, London, 1829; *Minutes of Evidence, Select Committee on Arts and Manufactures*, London, 1835 (Irish University Press re-print, 1968); *Report and Minutes of Evidence, Select Committee on Art Unions*, London, 1845 (Irish University Press re-print, 1968).

HUBBARD, Thomas. *Valuable Secrets Concerning Arts & Trades*, Norwich, 1795.

HULLMANDEL, Charles. *A Manual of Lithography* (3rd. edition), London, 1832.

HUNNISETT, Basil. 'Charles Warren, Engraver', Parts i & ii, *Journal of the Royal Society of Arts, July & August, 1977; English Steel-Engraved Book-Illustration*, Scolar Press, London, 1980.

HUNTER, David. *Paper-making*, London, 1957.

INTERNATIONAL EXHIBITION, 1862. *Reports by the Juries*, Class XXVIII, Section C: Plate, Letterpress and other modes of Printing, London, 1863.

JACOBI, C.T. *Printing*, London, 1890.

JAMES, P.B. *English Book Illustration, 1800–1900*, London, 1947.

JOHNSON, Lee. 'The Raft in Britain', *Burlington Magazine*, Vol. XCVI, London, August 1954.

JOPPIEN, Rüdiger. 'John Webber's South Sea Drawings for the Admiralty', *British Library Journal*, Vol. VI, No. 1, 1978.

KELLY. *Directory of Stationers, Printers, Booksellers, Publishers and Paper Makers*, London, 1880.

LABARRE, E.J. *Dictionary and Encyclopaedia of Paper and Paper-making*. Oxford, 1952.

LA LANDE. *Arte de faire le papier*, Paris, c.1750.

LALANNE, Maxime. *Etching* (English Edition), London, 1884.

LAMB, Sir Walter R.M. *The Royal Academy*, London, 1951.

LANDSEER, John. *Lectures on the Art of Engraving*, London, 1807.

LEVIS, H.C. *A descriptive bibliography of the most important books in the English language relating to the art and history of engraving & the collecting of prints*, London, 1912–1913.

LINDSAY, Jack. *J.M.W. Turner*, London, 1966.

LINNEAN SOCIETY, *Transactions*, London, from 1791.

LUMSDEN, E.S. *The Art of Etching*, Reprint, London & New York, 1962.

MAAS, Jeremy. *Gambart, Prince of the Victorian Art World*, London, 1975.

MANSON, J.A. *Sir Edwin Landseer, RA*, London, 1902.

MARTIN, T. *The Circle of Mechanical Arts (paper-making)*, London, 1813.

MARTINDALE, Percy H. *Engraving Old and Modern*, London, 1928.

MATHIAS, Peter. *The First Industrial Nation*, London, 1978.

McQUEEN, F.C. & SONS. *Catalogue of Engravings, Sporting Engravings, Chromo-Lithographs, and Coloured Lithographs, Autotypes & Photographs*, London, c.1882–c.1886.

MEIER, Henry. 'The Origin of the Printing and Roller Press', *Print Collectors Quarterly*, Vol. 28, Kansas City, 1941.

MURRAY, J. *Practical remarks on modern paper*, Edinburgh, 1829.

NICHOLSON, J. *The operative, mechanic, and British machinist* (Printing presses; paper-making), London, 1825.

NORTON, J.E. 'The Post Office London Directory', *The Library*, 5th. series, vol. xxi, No. 4, London, Dec. 1966.

OWEN, Roderic. *Lepard & Smiths Ltd., 1757–1957*, London, 1957.

PAPER MAKERS CIRCULAR. London, 9 April 1887; London, 10 March 1891.

PAPER RECORD. No. XI, Vol. V, London, June 1890.

PARTINGTON, C.F. *The Engravers Complete Guide*, London, c.1825.

PERKIN, Harold. *The Origins of Modern English Society*, London, 1978.

PETTIFER, Maureen. *Some 19th c. British invoices relating to Philadelphia* (MS hand-list), University of London Library.

PIGOT. *London & Provincial New Commercial Directory*, London, 1822–1823; *Commercial Directory*, London, 1826–1827.

POST OFFICE. *London Directory*, 1820.

PRIDEAUX, S.T. *Aquatint Engraving*, London, 1909.

PRINTING HISTORICAL SOCIETY. *Printing Patent Abridgements, 1617–1857*, London, 1969; *Henry Bankes's Treatise on Lithography*, London, 1976.

PRINTSELLERS' ASSOCIATION. *Alphabetical List of Engravings, 1847–1891*, London, 1892; *Alphabetical List of Engravings, 1892–*, London, 1892.

PUGIN, Augustus Charles and ROWLANDSON, Thomas. *The Microcosm of London*, London, 1808.

PYE, John. *Evidence Relating to the Art of Engraving Taken before the Select Committee of the House of Commons on the Arts*, London, 1836.

PYE, John. *Patronage of British Art*, London, 1845.

RAIMBACH, M.T.S. *Memoirs and Recollections of Abraham Raimbach*, London, 1843.

RAWLINSON, W.G. *The Engraved work of J.M.W. Turner*, Vols. I & II, London, 1908, 1913.

REDGRAVE, Samuel. *A Dictionary of Artists of the English School*, Reprint, Bath, 1970.

REDFORD, George. *Art Sales* (2 vols.), London, 1888.

REES' *Cyclopaedia*, Vol. 13, London, 1809.

ROBSON. *London Commercial Directory*, London, 1835.

ROLT, L.T.C. *Isambard Kingdom Brunel*, London, 1974.

ROSS, Thomas. *Catalogue of Important Engravings after Landseer, Turner, Ansdell and other eminent Artists*, London, 1903.

ROYAL ACADEMY OF ARTS. *The First Hundred Years of the Royal Academy*, London, 1951–1952.

RUSKIN, John. *The Seven Lamps of Architecture* (5th Edition), Orpington, 1886.

SALAMAN, Malcolm C. 'Mezzotint in England', *Studio Special Number*, London, 1910–1911; *The Graphic Arts of Great Britain*, London, 1917.

SAUL, S.B. *The Myth of the Great Depression, 1873–1896*, London, 1969.

SAVAGE, William. *On Printing Ink, both Black and Coloured*, London, 1832; *A Dictionary of the Art of Printing*, London, 1841.

SCHOMBURGK & BENTLEY. *Twelve Views in the Interior of Guiana*, London, 1841.

SILVER, Rollo G. 'Trans-Atlantic Crossing: the Beginning of Electrotyping in America', *Journal of the Printing Historical Society*, No. 10, London, 1974–1975.

SMART, A. *Thomas Shotter Boys*, Nottingham University and Agnew's, London, 1974.

SOTHEBY & CO. *The Bignold Library: Catalogue of the Collection of Colour-Plate Books*, London, 1971.

STAUFFER, David M. *American Engravers upon Copper and Steel*, 2 vols., New York, 1907.

STEVENSON, Robert. *An Account of the Bell Rock Light-House*, Edinburgh, 1824.

STOCKS, J.P. *A catalogue of Line Engravings by Lumb Stocks, R.A., Engraver, 1812–1892*, Penticton, British Columbia, 1978.

STONE, Reynolds. 'The Albion Press', *Journal of the Printing Historical Society*, No. 2, London, 1966.

STRANG, DAVID. *The Printing of Etchings and Engravings*, London, 1930.

STRUTT, J. *A Biographical Dictionary, containing an historical account of all the engravers . . . to the present time*, London, 1785.

THORNTON, R.J. *Temple of Flora*, London, 1799–1807 (folio), 1812 (Quarto).

TIMPERLEY, Charles H. *The Printer's Manual*, London, 1838.

TODD, William, B. *A Directory of Printers, London & Vicinity, 1800–1840*, London, 1972.

TOMLINSON, C. *Cyclopaedia of Useful Arts*, London, 1854.

TOOLEY, R.V. *Some English Books with Coloured Plates*, London, 1935.

TREBLE, Rosemary. *Great Victorian Pictures* (catalogue), Arts Council, London, 1978.

TUER, A.W. *Bartolozzi and his Works*, London, 1882.

TWYMAN, Michael. *Lithography 1800–1850*, London, 1970; *Printing, 1770–1970*, London, 1970; 'A Directory of London Lithographic Printers 1800–1850', *Journal of the Printing Historical Society*, No. 10, London, 1974–1975.

UWINS, Mrs. T. *A Memoir of Thomas Uwins, R.A.*, London, 1858.

VILLON, A.M. *Nouveau Manuel Complet du graveur en creux et en relief*, Paris, 1894.

VOET, Leon. 'Een aantekenboek van Franciscus Joannes Moretus', *De Gulden Passer*, 44, Antwerp, 1966; *The Golden Compasses*, Amsterdam, 1972.

WATKINS. *Commercial and General London Directory*, London, 1852.

WEITENKAMPF, F. *The Illustrated Book*, Cambridge, Massachusetts, 1938.

WHITMAN, Alfred. *Samuel Cousins, Engraver*, London, 1904.

WIBORG, Frank B. *Printing Ink*, New York & London, 1926.

WILLIAMS, J.F.C. *An historical account of inventions & discoveries*, Paper, 2 vols., London, 1820.

WILSON, F.J.F. *Stereotyping and Electrotyping*, London, 1880.

WOIMANT, Françoise. 'Répertoire des Imprimeurs de Gravures', *Nouvelles de l'Estampe*, No. XVI, July/August, Paris, 1974.

WOODWARD, David. 'The Decline of Commercial Wood-Engraving in Nineteenth-century America', *Journal of the Printing Historical Society*, No. 10, London, 1974–1975.

Index